PAWNSHOP
AND PALACES

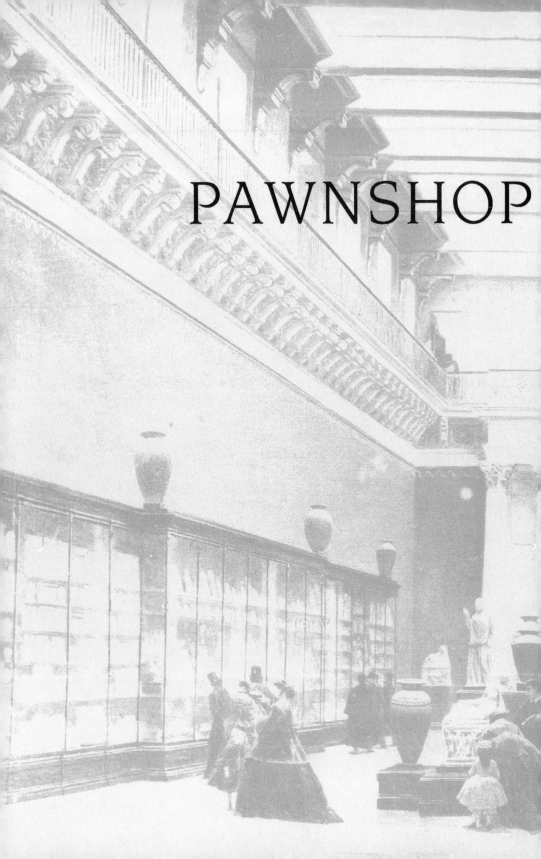

PAWNSHOP

AND PALACES

THE FALL AND RISE OF THE CAMPANA ART MUSEUM

HELEN AND ALBERT BOROWITZ

SMITHSONIAN INSTITUTION PRESS
WASHINGTON AND LONDON

Edited by Jennifer Lorenzo
Designed by Linda McKnight

Library of Congress Cataloging-in-Publication Data
Borowitz, Helen Osterman, 1929–
 Pawnshop and palaces: the fall and rise of the Campana art museum/Helen and Albert
 Borowitz.
 p. cm.
 Includes bibliographical references.
 ISBN 1-56098-010-9
 1. Campana, Giampietro, marchese di Cavelli, 1808-1880—Art collections. 2. Art—
Private collections—Italy—Rome. 3. Campana, Giampietro, marchese di Cavelli, 1808–
1880—Art patronage.
I. Borowitz, Albert I., 1930– . II. Title.
N5273.2.C36B67 1991
709'.2—dc20 90-10228

British Library Cataloging-in-Publication Data available

Manufactured in the United States of America

97 96 95 94 93 92 91 5 4 3 2 1

♾ The paper used in this publication meets the minimum requirements of the American
National Standard for Permanence of Paper for Printed Library Materials Z39.48–1984

For permission to reproduce the illustrations appearing in this book, please correspond
directly with the sources; the Smithsonian Institution Press does not retain reproduction
rights for these sources or maintain a file of addresses for sources.

CONTENTS

PHOTOGRAPHIC CREDITS

We wish to thank the following photographers and photographic institutions for
providing photographic material and permitting its reproduction:

Bibliothèque Nationale: Figs. 29, 32.

Documentation photographique de la Réunion des Musées Nationaux: Figs. 4, 5, 7,
20, 24, 25, 31, 33, 34, 35, 36, 37, 38, 39, 40, 41, 42, 43, 44, 45, 46, 47, 48,
49, 50, 51, 52, 53, 54, 55, 56, 57, 58, 59, 60, 61, 62, 63, 64.

Fogg Art Museum, Harvard University: Fig. 23.

Sir Brinsley Ford, C.B.E., F.S.A., Hon. F.R.A.: Fig. 30.

New York Public Library: Fig. 6.

Victoria and Albert/Art Resource, N.Y.: Figs. 10, 11, 12, 13.

LIST OF

ILLUSTRATIONS

For our children,
Peter, Talanat, Joan, Andy, and Sue

ACKNOWLEDGMENTS

We wish to thank the museums, archives, libraries and other institutions that have provided research material for the book: in France, Archives Nationales, Archives du Louvre, Bibliothèque de l'école du Louvre, Bibliothèque Nationale (Paris and Versailles), Bibliothèque Sorbonne de l'Université de Paris, and Banque de France; in Italy, Archivio di Stato di Roma and Istituto archeologico germanico, Rome. In the United States, we are indebted to The Library of Congress, University of North Carolina Library, Case Western Reserve University Freiberger Library, The Cleveland Museum of Art Library, The Cleveland Public Library, The Metropolitan Museum of Art Library, The New York Public Library, Harvard University Libraries, Johns Hopkins University Libraries, Ohio State University Libraries, University of Cincinnati Library, University of Michigan Library, University of Minnesota Library, and Princeton University Library.

We are grateful to the staff of the Smithsonian Institution Press, particularly acquisitions editor Amy Pastan, editor Jennifer Lorenzo, and designer Linda McKnight, for their professionalism and encouragement. We appreciate the interest Mme. Nicole Villa-

Sebline and M. Charles-Hubert Sebline have shown in our project. We also thank Professor Jennifer Neils, Chairman of the Department of Art History, Case Western Reserve University, for drawing our attention to material on Campana antiquities. Finally, we wish to express our gratitude to Michel Laclotte, Director of the Louvre, for his willingness to read and comment on the manuscript prior to publication. Any errors in the book are our responsibility alone.

A NOTE ON
CURRENCY RATES

In 1858–1860 the value of a Roman scudo was equivalent to 5 French francs of the same period. It is notoriously difficult to translate nineteenth-century currencies into present-day values. According to rates published by the Banque de France, 5 French francs (or 1 scudo) of 1860 are, in terms of buying power, worth about 85 French francs of 1988. However, another conversion system, based on comparable salary rates for unskilled labor, would produce a modern equivalent value many times higher. See Maurice Rheims, *Les Collectionneurs* (Paris: Ramsay, 1981), 289–97.

PROLOGUE

Prince Louis Napoleon had been an exile since he was a child of eight, when a French law banished his whole family. The prince's relationship to Napoleon Bonaparte had a complexity in which operetta delights: He was both Napoleon's nephew and a close equivalent of an adoptive grandson. His father was Napoleon's brother, Louis, and his mother was Hortense de Beauharnais, the daughter of Napoleon's first wife, Josephine. Obsessed with vindicating his rights as an heir of the emperor, the prince became a confirmed revolutionary when he was in his early twenties. He was undaunted by a string of early failures, dating from his enlistment with his elder brother in an ill-starred campaign to drive the pope from Rome in 1831. After Austrian troops crushed the uprising, the elder of the two Bonaparte rebels died ingloriously of measles, but Hortense came to the rescue of her rash younger son. She brought him safely across the Tuscan border dressed as her footman; that was the first in a series of successful disguises that would make Louis Napoleon the Lon Chaney of revolutionaries. Despite his unpromising debut, Louis Napoleon briefly thought of joining Polish rebels, but the project was frustrated by the fall of Warsaw to Russian forces. The depth of the young prince's political futility was sounded with the collapse of his plot

to incite a revolt of the French garrison at Strasbourg in October
1836. The prince's oddly assorted group of coconspirators included
a singer named Eleonore Gordon. It was to become a habit of Louis
Napoleon to rely on women in times of emergency.

After the Strasbourg fiasco, the prince became a wanderer.
King Louis Philippe, fearing to make him a martyr to the Napo-
leonic cause, deported the pretender to America, but he returned
under a false passport identifying him as "Mr. Robinson," a U.S.
citizen whom he knew.[1] After his arrival in London he easily eluded
the pursuit of English police and took a steamer for Rotterdam; he
reached Switzerland in time to rejoin his mother before her death in
October 1837. The French government could not bear having its
dangerous enemy domiciled within such close range and threatened
Switzerland with war unless it expelled him. Louis Napoleon de-
fused the mounting crisis by voluntarily leaving for England.

The prince took up residence at Fenton's Hotel in St. James's
Street, London, where crowds gathered to gawk at the man who
had made up his mind to rule France as Napoleon's rightful succes-
sor. For a time Prince Louis seemed content to vacation from poli-
tics; he threw himself heart and soul into the social seasons of 1838
and 1839, acquiring a dazzling set of friends, including Disraeli,
Bulwer Lytton, the Irish actor Tyrone Power, and Lady Blessington.
His heart, it seemed for a while, would not emerge unscathed from
his society adventures, for he was soon captivated by a sixteen-year-
old girl, Emily Rowles *(Fig. 1)*. Emily was the daughter of Henry
Rowles, of Mayfair and Chislehurst (Kent), a wealthy builder who
had served as a contractor in the reconstruction of the Theatre
Royal, Drury Lane. Mrs. Rowles, a Spanish lady, had been cele-
brated on the Continent for her beauty and, if we are to judge from
the prince's infatuation and Emily's portrait statue made several
years afterward, the daughter must have resembled her mother. The
lively dark-haired girl, whom Florentine friends were to nickname
Mimi la brune, saw Prince Louis during his ever more frequent
visits to the Rowles's home in Chislehurst. Londoners, struck by his

obvious delight in her company, spread rumors that Emily and Louis were to become engaged. The prince was said to have lavished valuable gifts on the young girl, including furs that had belonged to his grandmother, the empress Josephine.[2]

Rumor, as is its custom, was less than reliable, for the fickle Louis Napoleon moved on to other intrigues, romantic and political. His friendship with Emily Rowles, though, remained a fixed point in his stormy life. When he was imprisoned at the fortress of Ham in Picardy following the failure of his second attempted coup d'état at Boulogne in 1840, Emily sent him gift packages, making the first returns of his generosity in England. In 1846, the bewigged prince calmly walked out of the front gate of the prison, dressed as a carpenter in a dirty blouse and coarse blue linen trousers and carrying a plank over his shoulder.[3] Gossip had it that a woman had provided covert aid to his escape plot. According to one common account, the female conspirator was a Lady or Mrs. Crawford, Emily Rowles's mother, who "had lived at Ham during the prince's captivity and had lent the carriage used for [his] escape."[4] A variant of this intriguing story was that both Emily and her mother were involved in the jailbreak. We are told that the prince "was led away by those spirited ladies, and received at London in the bosom of their family, where he was treated like a brother."[5] Five years later, when Louis was making his plans for the final coup that would carry him to power as Napoleon III, Emily gave him a sorely needed loan of 33,000 francs.[6]

By then the young debutante of Chislehurst had married the marchese Campana of Rome. Before the decade was past, Napoleon would find a dramatic opportunity to remember the many kindnesses of the marchesa.

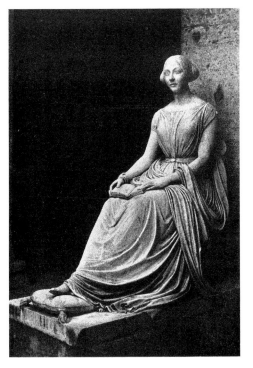

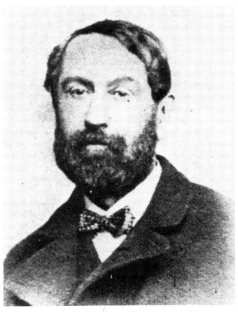

Fig. 1. *Above left*: Statue of Emily Rowles, shortly after her marriage.

Fig. 2. *Above right*: Giampietro Campana, Marchese di Cavelli, c. 1850. Contemporary photograph.

Fig. 3. *Left*: Monte di Pietà, Rome. Photo source: Donato Tamila, *Il Sacro Monte di Pietà* [Rome, 1900].

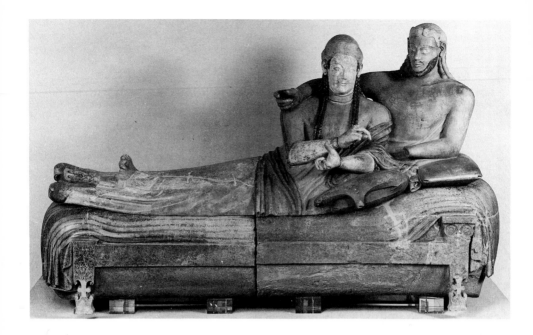

Fig. 4. *Above*: The Large Sarcophagus of the Reclining Couple (known as the Lydian Sarcophagus in the nineteenth century), terracotta, Etruscan, from Cerveteri, sixth century B.C.

Fig. 5. *Right*: One of the most famous of Roman antiquities, a fragment of *Ara Pacis*, was not given to a Roman museum, but became part of the Louvre collection. Marble relief, 13–9 B.C.

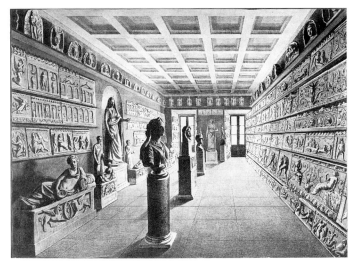

Fig. 6. Interior of Campana Museum, Rome. Frontispiece illustration from Giovanni Pietro Campana, Marchese di Cavelli, *Antichi opere in plastica* [Rome, 1851].

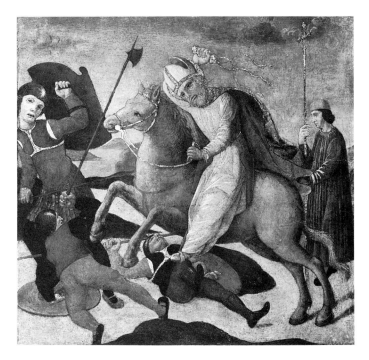

Fig. 7. Master of the Sforzesca Pala, *The Apparition of Saint Ambroise at the Battle of Milan*, oak panel.

Fig. 8. Cardinal Antonelli. Photo source:
R. de Cesare, *The Last Days of Papal Rome.*
1850–1870 [London, 1909].

Fig. 9. Colored engrav-
ing after James Tissot,
'King Cole' (Henry Cole).
In *Vanity Fair,* 1871.

Fig. 10. Donatello, *As-*
cension with Christ Giving
Keys to Saint Peter, marble'
relief.

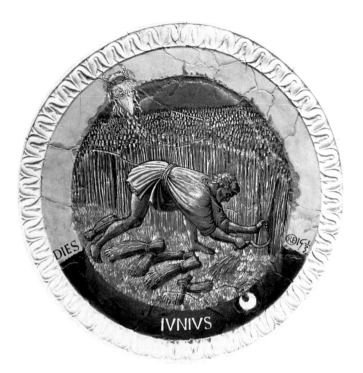

Fig. 11. Luca della Robbia, "June" from *Labors of the Months*, majolica medallion series.

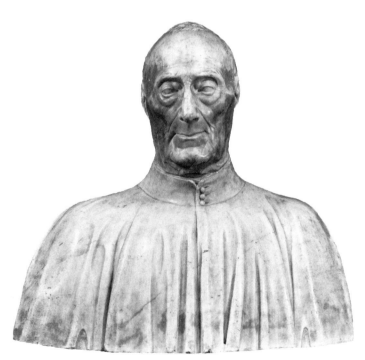

Fig. 12. Antonio Rosellino, *Bust of Giovanni Chellini*, marble.

Fig. 13. Verrocchio, *Sketch-model for Monument of Cardinal Forteguerri in Pistoia*, terra-cotta relief.

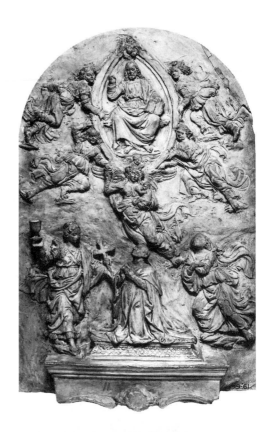

Fig. 14. Augustus Room with seated statue: Augustus as Jupiter, marble, first quarter of first century A.D. (derived from Phidias's Zeus of Olympia). Hermitage, Leningrad.

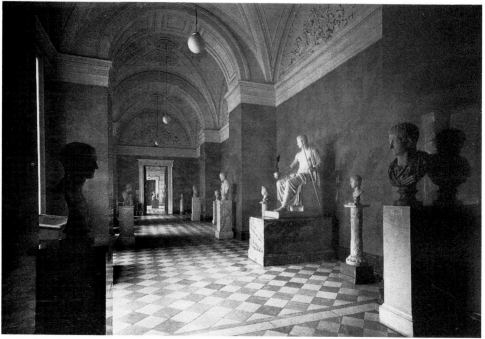

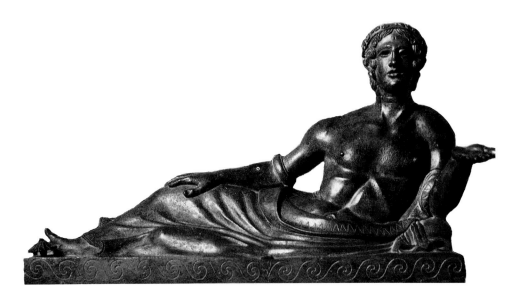

Fig. 15. Bronze cinerarium: Reclining youth, Etruria, mid-fourth century B.C. Hermitage, Leningrad.

Fig. 16. Euphronius, Red-figure psykster, hetaerae feasting, Attica 505–500 B.C. Hermitage, Leningrad.

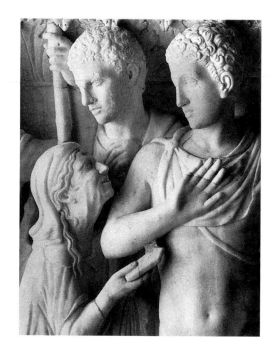

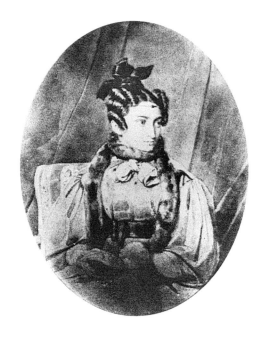

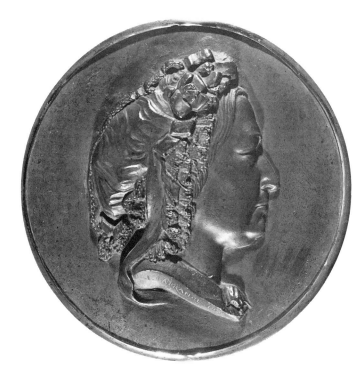

Fig. 19. Jules Théodore LaFrance, *Portrait of Princess Mathilde*, signed and dated 1864, bronze medallion. Authors' collection.

Fig. 20. *Below*: Charles Giraud, *Salon of Princess Mathilde, Rue de Courcelles*, 1859, oil on canvas. The bald man leaning over the round table may be Count Horace de Viel-Castel, a regular visitor to Princess Mathilde's "Wednesdays." The princess sits near the table in a white gown.

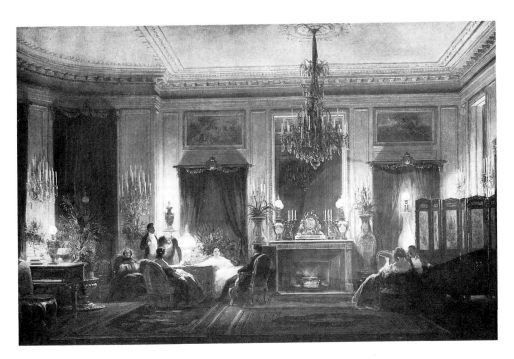

Fig. 21. Count Alfred-
Emilien de Nieuwerkerke,
*Bust of Mlle de Montijo, later
Empress Eugenie*, plaster. Re-
produced from contempo-
rary photo.

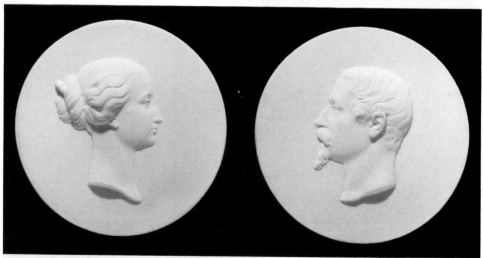

Fig. 22. Portrait medal-
lions of Napoleon III and
Eugenie, porcelain. In-
cised: Made by J. Peyre
under the direction of
Nieuwerkerke. Authors'
collection.

Fig. 23. Jean-Auguste-Dominique Ingres, *Portrait of Count de Nieuwerkerke*, 1856, graphite and white chalk on cream wove paper, darkened.

Fig. 24. *Below*: Auguste-François Biard, *A Soirée at the Louvre, in Count de Nieuwerkerke's Lodgings in 1853*, oil on canvas, Nieuwerkerke stands at the left shaking hands with a guest.

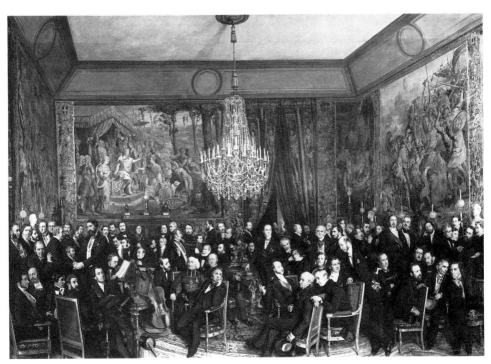

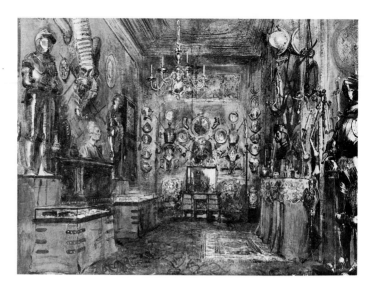

Fig. 25. Tetar van Elven,
*The Collection of Count de
Nieuwerkerke*, 1866, oil on
canvas. This painting
shows how Nieuwerkerke
displayed his armor
collection.

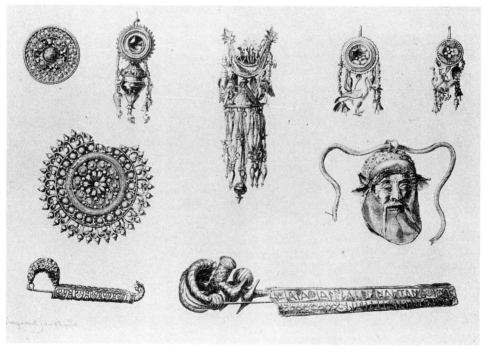

Fig. 26. Jules Jacque-
mart, illustration of ancient
jewelry from the Campana
collection, from François
Lenormant, "Musée Napo-
léon III. Les Bijoux," in
Gazette des Beaux-Arts, 1863.

Fig. 27. *Left*: Henri Oulevay, *A Visit to the Campana Collection* (detail), in *Journal amusant*, 1862.

Fig. 28. *Below left*: Henri Lehmann, *Portrait of Ludovic Vitet*, illustration from Louis Gonse, "M. Vitet," in *Gazette des Beaux-Arts*, 1873.

Fig. 29. *Below right*: Jean-Auguste-Dominique Ingres. Photo by Disdéri.

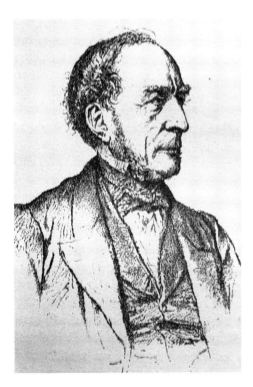

Fig. 30. *Right*: Jean-Au-
guste-Dominique Ingres,
Frédéric Reiset, drawing,
1844.

Fig. 31. *Below left*: Lor-
enzo Veneziano, *Madonna
and Child*, 1372, panel.
This was one of the paint-
ings retained for the Louvre
by the intervention of the
Academy of Fine Arts.

Fig. 32. *Below right*: *Eu-
gène Delacroix*. Photo by
Pierre Petit.

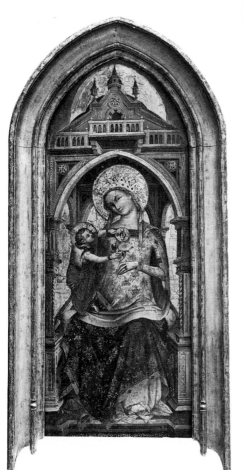

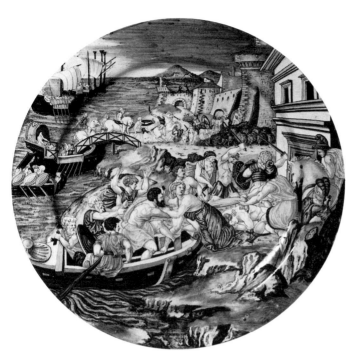

Fig. 33. *The Abduction of Helen*, Majolica plate.

Fig. 34. *Below*: Charles Giraud, *Napoleon III Museum, Gallery of Terra-cottas in the Louvre*, 1866, oil on canvas.

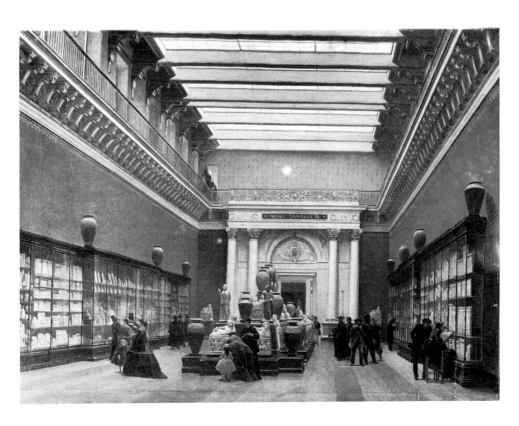

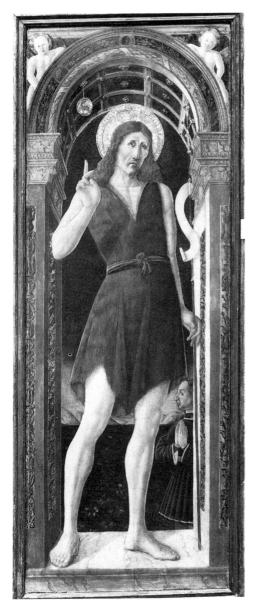

Fig. 36. *Above*: Master of 1310, *Madonna in Majesty with Six Angels and Donors*, inscribed and dated 1310, poplar panel.

Fig. 37. *Left*: Girolamo di Giovanni da Camerino, *Saint John the Baptist with a Donor*, poplar panel.

Fig. 35. *Opposite page*: Paolo Veneziano, altarpiece: (a) central panel, *Madonna and Child* dated 1354; (b) left wing, *Saint Francis of Assisi, Saint John the Baptist*; (c) right wing, *Saint John the Evangelist, Saint Anthony of Padua*, wood panels. The wings of this triptych, sent by Reiset to museums in Toulouse and Ajaccio, Corsica, in 1863, were brought back to the Louvre in 1956.

Fig. 38. Marco Palmez-
zano, *Calvary with Penitent
Saint Jerome*, signed and
dated 1505, inscribed, pop-
lar panel.

Fig. 39. *Below*: Bernardo
Daddi, *Annunciation*, part
of a predella, wood panel.

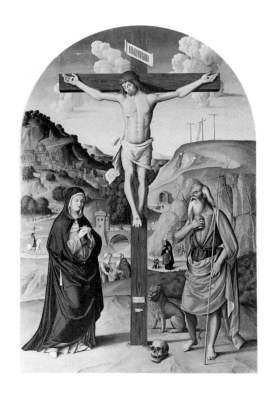

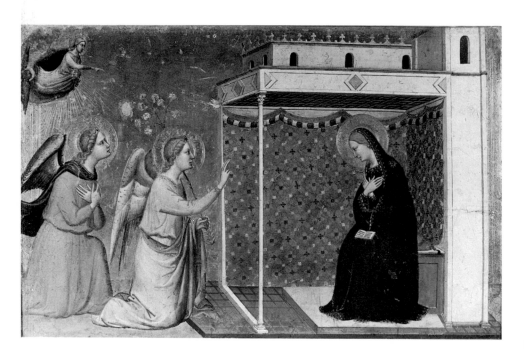

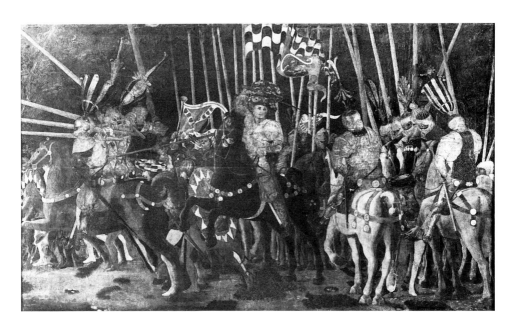

Fig. 40. Paolo di Dono, called Uccello, *The Battle of San Romano: The Counter Attack of Micheletto da Cotignola*, wood panel (one of series of three panels, others in National Gallery, London and Uffizi, Florence).

Fig. 41. Lorenzo d'Andrea d'Uderigo di Credi, called Lorenzo di Credi, *Annunciation* (attributed by some experts to the young Leonardo), part of a predella of an altarpiece commissioned from Verrocchio in 1475, wood panel.

Fig. 42. Bartolo di Fredi, *Presentation in the Temple*, wood panel.

Fig. 43. *Below*: Liberale da Verona, *The Abduction of Europa*, cassone panel.

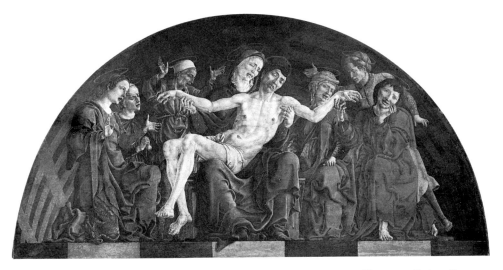

Fig. 44. Cosimo Tura, *Pietà*, lunette of altarpiece, wood panel.

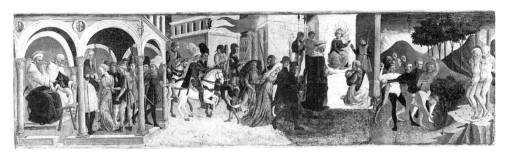

Fig. 45. Domenico di Michelino, *The Judgment of Susanna*, cassone panel.

Fig. 46. Sandro Botti-
celli, *Madonna and Child*,
poplar panel.

Fig. 47. *Below*: Vittore
Carpaccio, *Sacra Conversa-
zione*, signed, poplar panel.

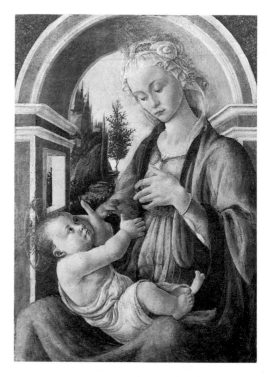

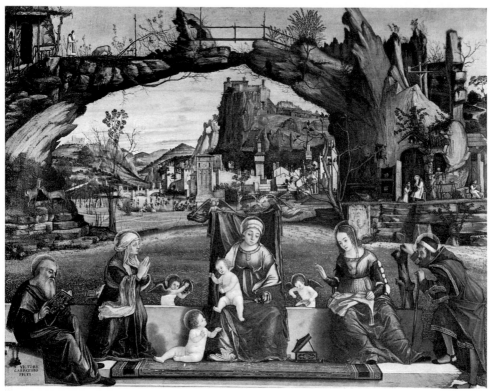

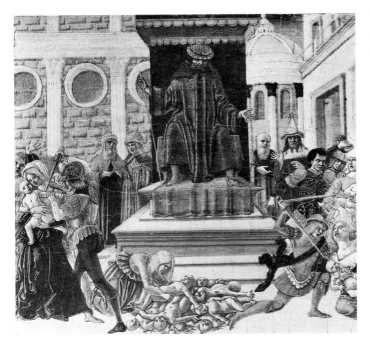

Fig. 48. Benvenuto di Giovanni, (a) *Massacre of the Innocents* and (b) *Martyrdom of Saint Fabian (?)*, predella panels.

Fig. 49. Giovanni da
Milano, *Saint Francis of As-*
sisi, wing of polyptych,
wood panel.

Fig. 50. *Below:* Master of
the Madeleine (studio of),
Last Supper, fir panel.

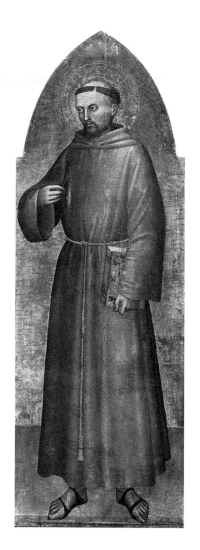

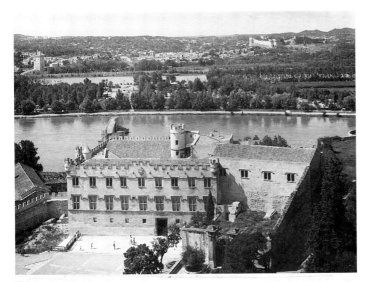

Fig. 51. Exterior view of Musée du Petit Palais, Avignon.

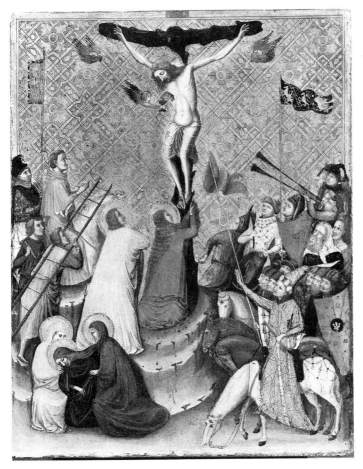

Fig. 52. "Pseudo Jacopino di Francesco," *Crucifixion*, poplar panel.

Fig. 53. Paolo Veneziano, *Madonna and Child*, central panel of small polyptych, poplar.

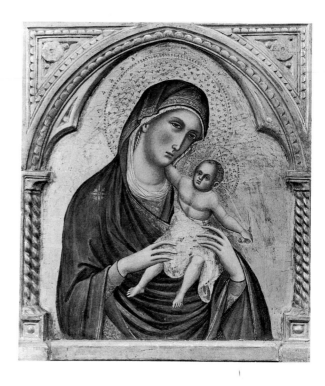

Fig. 54. Paolo di Giovanni Fei, *Saint John the Baptist*, part of polyptych, wood panel.

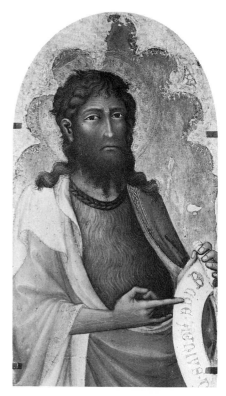

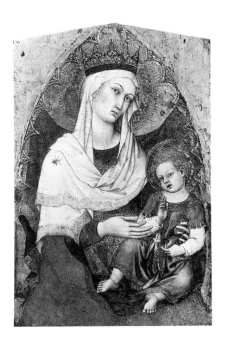

Fig. 55. Taddeo di Bartolo, *Madonna and Child*, central panel of polyptych, probably cut down, poplar.

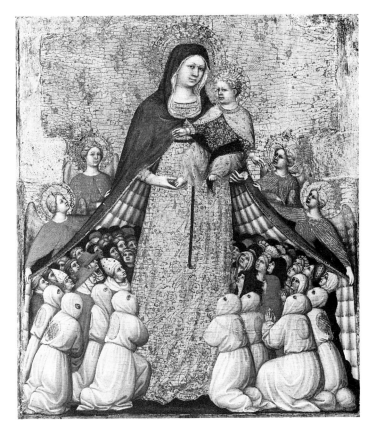

Fig. 56. Pietro di Domenico da Montepulciano, *The Madonna of Mercy*, poplar panel.

Fig. 57. Giovanni di
Paolo, *Saint Clement*, right
panel of triptych, poplar.

Fig. 58. *Below*: Bartolo-
meo della Gatta, *Annuncia-
tion*, lunette of altarpiece.

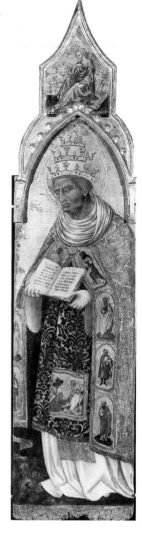

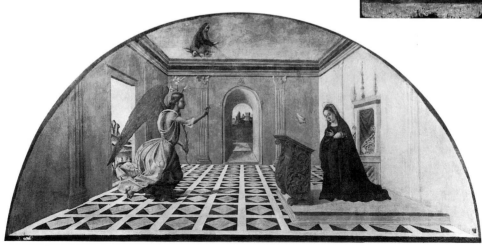

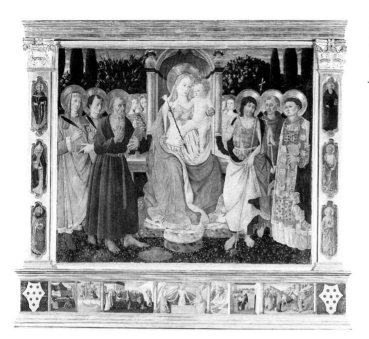

Fig. 59. Master of the
Madonna of Buckingham
Palace. *Altarpiece of Saint
Jerome*, wood panel.

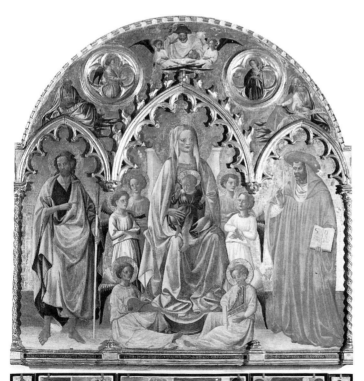

Fig. 60. Francesco d'An-
tonio, *Rinieri Altarpiece*, in-
scribed, poplar panel.

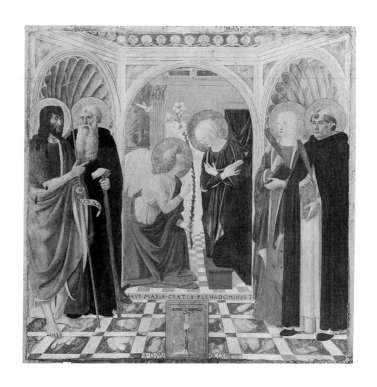

Fig. 61. Cosimo Ros-
selli, *Annunciation and Four
Saints*, dated 1473, poplar
panel.

Fig. 62. Francesco di
Giorgio, *Madonna and
Child*, poplar panel.

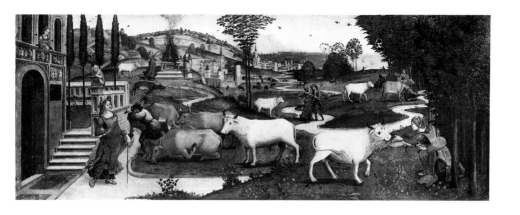

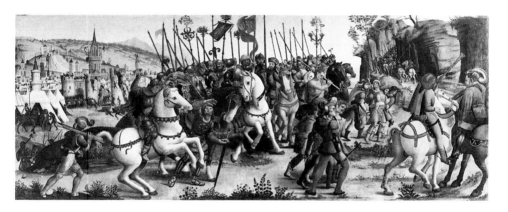

Fig. 63. Master of the
Campana Cassoni, (a) *The
Loves of Pasiphae* and (b) *The
Taking of Athens by Minos*,
two of four poplar cassoni
panels.

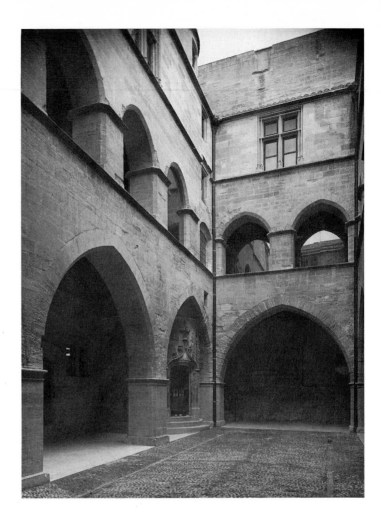

Fig. 64. Interior Court,
Musée du Petit Palais,
Avignon.

THE PAWNSHOP

⟨~~⟩ Giovanni Pietro (Giampietro) Campana the younger *(Fig. 2)*, born in Rome in 1808, inherited from his noble ancestors a guaranteed career as superintendent of the pope's pawnshop in the Eternal City.

Although the association of the Church with moneylending seems surprising from a modern viewpoint, it originated in a charitable enterprise. The Observant Order of Franciscan monks, passionately opposed to usury, founded a so-called Monte di Pietà (Mount of Compassion) at Perugia in 1462 to lend money to the poor on pledge without interest. The lending activities of the monte were guided by a few basic principles. Small loans would be made to the needy without interest for terms of up to six months. The funds advanced were to be well secured by the pledge of saleable goods reliably appraised at double the loan amount and entrusted to faithful custodians during the term of the loan; the entire process of loan, custody, redemption, and sale were to be under responsible administration. In 1463 Pope Pius II sanctioned the opening of a second monte in Orvieto, and similar institutions began to appear in other Italian cities. Rome, where economic conditions were more favorable than in most other localities, was slow to respond to the new philanthropic concept of interest-free lending.

In 1527, however, the sack of the city by mercenaries of Charles V created an urgent need for relief of the urban poor. About a decade later, under the leadership of Friar Giovanni da Calvi, general commissioner of the Order of Saint Francis, money was collected from charitable Romans for the formation of a Monte di Pietà in the Eternal City. By 1542 over 900 subscribers had responded to the persuasive solicitations of the humble Corsican friar.[1]

The pawnshop operations of the Roman monte had their small beginnings in the shop of a Milanese goldsmith who was one of the institution's early benefactors; it was on these premises that the first loans were made in April 1539. Later that year Pope Paul III issued a bull approving the opening of the monte and enjoining, on pain of excommunication, that its capital be used exclusively for the benefit of the poor. To punish any greedy relatives who might be tempted to interfere with intended gifts to the monte, the pope threatened not only excommunication but also a penalty of twice the amount of the blocked donation.

In its early years the fledgling monte's growth was fostered by the religious, legal, and economic support of the Church. Charitable gifts to the pawnshop burgeoned as priests appealed for contributions in their sermons. The pope granted special indulgences to benefactors and conferred on the monte the remarkable privileges enjoyed by its sister institutions in other cities: the power to confer doctorates, commute vows, legitimate children, grant matrimonial dispensations, and transfer to its own coffers sums bequeathed for the general relief of the poor. Beginning in 1546, annual religious processions to the Church of San Lorenzo in Damaso were held after Easter for the benefit of the monte.

The early governors of the monte sometimes proposed fundraising incentives that reflected more zeal than wisdom. For example, deputies of the Congregation of the Monte floated a scheme to pay family lawyers a commission of 10 percent on all sums bequeathed to the monte and, dissatisfied with this modest program, asked the pope to decree that any will providing no legacy to the

monte would be invalid. Finally, the monte's spokesmen backed an offer of Roman artisans to pay the monte a bounty of 500 scudi a year if legislation could be secured to prohibit Jewish merchants from selling firsthand goods at all or, if lobbyists could manage no better, to anyone other than their co-religionists.[2]

Nothing came of these projects, but papal legislation was obtained to protect the monte's pawnbroking against competition from Jewish moneylenders, the bêtes noires of the Franciscans. It was feared that usurers could engage in interest-rate arbitrage, borrowing from the monte and relending the same funds at higher rates. As a result, a law of 1670 banned all Jews, regardless of profession, from pledging goods at the monte. The final step to thwart Jewish competition was taken in 1682, when Pope Innocent XI flatly prohibited Jews from lending money at interest. Despite the latter measure barring their traditional sources of credit, indigent Jews who attempted to borrow at the monte after 1682 were rigorously prosecuted.[3]

The economic steps taken by the popes to strengthen the monte were also effective. In its early days, the pawnshop obtained a major portion of its funds from deposits, some bearing interest and others interest free, from charitable supporters. In 1584, Gregory XIII freed the monte from its heavy reliance on these deposits; he ordered that the monte would take over administration and investment of the large sums paid into court by litigants. This step assured depositors that their funds would be safeguarded and at the same time it allowed the monte to profit from investment income on the deposits during the pendency of the related lawsuits. From this point on, the Monte di Pietà had a powerful financial base for its twin functions as a lender and a deposit bank. Its flourishing strength was evidenced by its move in 1603 into an elegant palazzo in the Piazza di San Martinello.

As the bank grew, some of its founding principles were impaired. The Franciscan insistence on lending without interest had to yield to the harsh necessity of servicing income-bearing obliga-

tions of the monte; however, the transfer of judicial deposits and other papal accounts to the monte provided cheap capital that enabled it to maintain low interest rates on its pawnshop loans. A more fundamental change in the monte's policy was its failure to heed Pope Paul's admonition to restrict its loans to the poor. By the seventeenth century the monte became a credit institution of the papal government, lending substantial sums without security to noble Roman families, religious orders, and urban institutions, advancing money as needed to the treasury, and investing free funds, by governmental order, in real-estate-backed securities of the Papal States. Even prominent foreign borrowers began to apply for credit. As early as 1660, Pope Alexander VII required the monte to lend 20,000 scudi to the queen of Sweden on a pledge of her jewelry.[4]

With the vast expansion of the bank's operations and the loss of the monte's original charitable purpose came corruption. In 1753, Tommaso Besozzi, a pawn custodian, threw himself into the Tiber after having committed massive thefts. The Congregation of the Monte reacted rather mildly to this disquieting news; it simply appointed a new custodian and hoped for the best. Still more disturbing events, though, lay ahead. In 1759, another bank custodian, Carlo Favelli, fled from Rome, anticipating discovery of his fraud. In the following year defections of the guilty multiplied at an alarming rate; first a custodian and an appraiser decamped together, and two months later police chased a caravan of fugitives, including another appraiser and his son, and a custodian who, accompanied by son and servant, had carried off a hoard of pledged jewels.

In 1760 Pope Clement XIII reacted to this recurrent wrongdoing in the time-honored manner of chief executives: He appointed an investigator. The pope's choice fell on Cardinal Giuseppe Maria Castelli. At the conclusion of a seven-year inquiry the cardinal recommended and obtained a double dose of reform: the appointment of a superintendent-inspector responsible for the ongoing examination of the pawnshop operations, and the toughening of criminal

sanctions—death for thefts in excess of 100 scudi and life sentences to the galleys for lesser frauds.[5] The Castelli statutes may have sent a shudder down the spines of would-be embezzlers, but these measures did nothing to address the principal source of the monte's sharpening financial distress, the continual loans that it was required to make to the treasury of the Papal States.

The demand for funds increased when French Republican armies entered the territory of the Papal States in 1796 and Pope Pius VI was in desperate need of financing for military defense. In 1798 the French occupied Rome, imprisoned the pope, and proclaimed the Roman Republic. The monte was an early victim of the invaders, who closed its doors after seizing the liquid assets that had survived the exigencies of war, as well as many of the articles that remained on pledge.

The pope's pawnshop, which had been born of the sixteenth-century sack of Rome, rose again like a phoenix from the ravages of the French occupation. The Republican government, fearing public disfavor, indicated that it favored reopening the Roman monte. A tentative step in that direction was taken by Cardinal Aurelio Roverella, appointed apostolic "visitor" to the monte in 1800 by the newly elected Pope Pius VII. Under Roverella's direction the monte, a year later, reopened two pawnshops that were to restrict themselves to making loans of up to one scudo on pledge to the poor. The monte limped along in this sadly reduced state until 1809, when Napoleon decreed the annexation of the Papal States and deported Pius VII to France. Most of the administrative personnel of the monte abandoned their posts in the face of the new political disaster, but four stalwart deputies successfully pressured the French government to keep the institution alive. By that time, however, the monte was debilitated in resources and charitable commitment; since payment on the bank's investments in Papal States securities had been suspended, its administration was constrained to reduce the number of its loans and to increase interest rates beyond the means of indigent borrowers.

The year 1814, which marked the return of Pope Pius from exile, also proved to be a turning point in the history of the Roman Monte di Pietà. Under reforms instituted during that year, the monte lost all vestiges of autonomy, becoming an appendage of the Papal States treasury under the leadership of the treasurer general. When the treasurer general beckoned, the monte's officials, their posts arrayed in fixed hierarchical order, hurried to receive his directions. At the top of the bank's administrative pyramid was the inspector general of the monte's records, Prospero Campana, a Roman lawyer.

Prior to resettling in Rome, Campana's family had lived in the Abruzzi area to the east of the city. The Campanas claimed a distinguished genealogy stemming from the barons of Cavelli, an ancient castle of Terra di Lavoro in the region of Naples. Among Prospero's ancestors was "Antonio Campano di Cavelli di Campana, bishop of Crotona and Teramo around 1450, historian, poet, secretary of three popes and of King Ferdinand I of Aragon, as well as Cesare Campana of Aquila, historian of the Flemish war and the war between the Christians and the Turks." Another eminent Campana invented a telescope of such enormous dimensions that it was dubbed the "monster telescope."[6] Prospero had literally been born to his monte post, for his father Giampietro (who died in Rome in 1793) had served in the same capacity. The senior Giampietro had an adeptness for political self-advancement that he passed on to his descendants; he was "president of the papal galleys" under Clement XIV and Pius VI, and a dignitary of the court of Elector Frederick of Saxony.[7]

Shortly before his death in 1815 Giampietro's son Prospero had assured that the monte inspectorship would descend to a third generation of Campanas. In July of that year Pope Pius VII issued a rescript (an official response to Prospero's petition) stipulating that Prospero's post would pass to his son, Giovanni Pietro (Giampietro) the younger, on his twenty-fifth birthday. Since Giovanni Pietro

was only seven at the time, the pope's action blessed nepotism of the most farsighted variety.

Fortunately, the young Campana inherited the business acumen of his forebears as well as their official position. Preparing for the time when the papal order would ripen, Giovanni Pietro studied at the Nazarene College in Rome until 1831. In that year he entered the service of the Monte di Pietà as assistant to Inspector Gaspare Azzurri. Two years later Pope Gregory XVI fulfilled the promise of Pius VII by appointing the young Campana to Azzurri's post with the grand title of director general. Although the pope had faithfully performed his predecessor's commitment, the selection of Campana may not have been universally acclaimed within the Church hierarchy. The powerful Giacomo Antonelli (subsequently cardinal and secretary of state) is said to have coveted the position for a younger brother and to have nursed a long-lived resentment against Campana.[8]

As he embarked on his new responsibilities, Giovanni Pietro faced chaotic financial circumstances at the monte that could well have daunted an administrator with experience far exceeding his own brief apprenticeship. The monte's treasury was saddled with an unpaid 1818 borrowing of 80,000 scudi from the papal government, and its pawnshops could not afford to make advances in excess of three scudi for any one borrower. Worse, the monte had granted a contract for the management of its operations to Jourdain-Rabaille, a firm of French speculators who were not necessarily inspired by principles of Franciscan mercy. Campana studied the fine print of the contract and found a way to have it canceled for breach of obligations on the part of Jourdain-Rabaille. With the administration now firmly in his own hands, Campana moved swiftly to put the finances of the monte onto an even keel. In 1834 he obtained a papal order that authorized the monte to invest its funds more productively, and as income mounted Campana was able to increase maximum pawnshop loans to fifty scudi. The young direc-

tor general then turned his attention to the deposit bank that was allied to the pawnshop operations. Campana persuaded the treasurer general, Antonio Tosti, that in order to provide self-sufficient funding for pawnshop loans, the bank should be authorized to attract increased deposits by paying interest to depositors. Tosti agreed, and the interest rate was fixed at 4.5 percent, with a requirement of advance notice of withdrawal. As a result of this program the monte's coffers began to bulge, and by 1845 it was able to make loans to the papal treasury amounting to more than 425,000 scudi.[9]

The triumphs of Campana's financial genius made him a great favorite of the pope. On February 12, 1835, Gregory XVI showed his esteem for the director general by paying an official visit to the palazzo of the Monte di Pietà *(Fig. 3)*. The palazzo had been expanded to meet the needs of the institution, but its spiritual heart, the chapel dedicated to the Pietà of our Lord, had remained intact since decorations were added in the early eighteenth century. The chapel walls that Pope Gregory viewed were adorned by four statues celebrating charity, almsgiving, faith, and hope. For Campana the high point of the papal visit was the pontiff's call at the director's offices. The jubilant young administrator ordered two Latin inscriptions to be placed in the atrium and in the principal ground-floor room to commemorate the occasion. In the latter memorial, Campana appeared to praise himself as much as the pope, noting that the monte had been "almost overthrown by the wretched disorders of recent times," but that "now that conditions were settled and with the help of correct administration, [the holy institution] growing from day to day and restored to its original splendor under the auspices of Pope Gregory XVI, was opening richer founts of beneficence."

The pope must have agreed that much of the credit for the monte's revival belonged to its director, for in August he admitted Campana to the equestrian order of Saint Gregory the Great.[10]

2

THE COMPULSIVE
COLLECTOR

⚜ Another inheritance of Giovanni Pietro
Campana was his passion for art collecting. His grandfather, Giam-
pietro senior, excavated and collected a variety of antiquities; Pros-
pero, Giovanni Pietro's father, assembled a large collection of coins.
In his early twenties, Giovanni Pietro followed in his ancestors'
footsteps by devoting himself to classical archaeology. In his *Antique
Works of Sculpture* (1842), he wrote floridly of his discoveries of Ro-
man and Etruscan remains: He had "gazed into the mirror of testi-
monies of the past and had assiduously retraced, among the venera-
ble ruins and the envious dust that covers them over, the buried
trophies of the past times of Italian glory."[1] In 1831 he excavated
the Augustan columbarium of Pomponius Hylas in a vineyard bor-
dering the Via Latina, an ancient highway running southeast from
Rome. This was a structure of vaults (lined with recesses resem-
bling those of a dovecote, hence the name *columbarium*) that were
used to store funerary urns. Shortly after this discovery, when digs
at Ostia, Rome's seaport, were renewed, Cardinal Bartolomeo Pacca
entrusted the direction of the project to the young Campana. The
work at Ostia continued until 1835, yielding results that have been
the subject of varying appraisals.[2]

Despite the frenetic pace of his first years at the monte, Campana threw himself into new archaeological endeavors. Between 1838 and 1840 he extended his exploration of the vineyards along the Via Latina, uncovering another columbarium and a tomb. In gratitude for Campana's gift of the latter monument to the state, the papal chamberlain in May 1841 permitted Campana to widen the area of his vineyard digs. Other venues of Campana's searches in ensuing years were the Etruscan cities of Veii, nine miles north of Rome, and Caere (the modern Cerveteri), situated six miles from the coast and thirty miles north of Rome. The two Etruscan settlements played very different roles in Roman history. Veii, which has been called the Troy of Italy, posed a constant military threat to the Romans, while wealthy Caere maintained friendly relations with its Roman neighbors, many of whom sent their sons to the highy cultured Etruscan city for their education. Digging in the necropolis of Veii in 1842 and 1843, Campana uncovered a tomb "containing the oldest known Etruscan wallpaintings," which he donated to the government, and made other finds on Monte Abatone near Caere in the winter of 1845 and 1846, including a less important tomb.[3] He made a more dramatic discovery on the same site in 1850, "the so-called 'grotto dei rilievi' (a large tomb chamber, displaying in its painted reliefs an abode of the living with correct copies of household furniture and utensils), as well as the so-called 'Lydian sarcophagus' (now known as the Sarcophagus of the Spouses {Fig. 4}) a great painted terra-cotta sarcophagus representing a bed upon which rested a couple, in extremely archaic style."[4] At Caere Campana also retrieved a large array of vases in a style then unknown, which was subsequently called Caeretean.

Important as his finds were, Campana's ancient objects suffered from the marchese's adoption of "the wretched Roman custom of restoring arbitrarily broken statues and reliefs, and finally covering the whole with a dull white paste."[5] Even today the stigma of doubt hovers over Campana antiquities, as Dietrich von Bothmer, curator of ancient art at the Metropolitan Museum points out:

The exploration of Cerveteri and the resulting collection of the
Marchese Campana may be termed the last of the old-fashioned
endeavors. Though almost as many important vases were found
at Cerveteri as were included among the 1828/1829 finds at
Vulci, the haste of assembling an impressive private museum
coupled with the incompetence, if not fraudulence, of the re-
storers—the Penelli brothers—represent a regrettable taint
from which the Campana vases in Leningrad, Brussels, and
above all the Louvre have not yet recovered.[6]

In Italy Campana's archaeological work was saluted by his col-
leagues; in 1846 he took part in the proceedings of the general
consultative commission of antiquities and fine arts, and was
elected treasurer and subsequently president of the Pontifical Acad-
emy of Archaeology. The marchese's zeal for excavations was not,
however, matched by scholarly instinct. Only under pressure from
colleagues in the archaeological institutes of which he had become a
member did he publish descriptions of his discoveries. Often the
information he provided was brief and vague, but occasionally, per-
haps in support of quests for further government commissions, he
disclosed the results of his work in further detail, as in his 1840
report to the pontifical academy regarding the tombs of the Via
Latina. Campana's reticence about his finds may also have been due
to a remarkable penchant for secrecy about his personal collection.
For example, Heinrich Brunn, the secretary of the German Archae-
ological Institute, who assisted in preparing a catalog of Campana's
vases, was long unaware of the existence of an Etruscan terra-cotta
sarcophagus and painted terra-cotta reliefs.[7]

Despite Campana's distaste for scholarship, he seemed to have
conceived early in his career a scheme for an encyclopedic assem-
blage of the arts of Italy. Although he gave significant monuments
to the Papal States, a large portion of his archaeological finds ended
up in his own growing collections, where they joined the numerous
acquisitions he had made from various quarters. His friends in the

art world began to speak of Campana's long-term plans for a "model museum" that would fill the gaps of existing collections from classical periods through the Renaissance. The marchese buttressed such speculation in his introduction to *Antique Works in Sculpture*, in which he announced his resolution to return to the public domain his collection of Roman reliefs *(Fig. 5)* (from the middle of the first century B.C. to the middle of the second century A.D.) so that European understanding of this little-known branch of ancient art would be advanced.[8] The revelation of this generous ambition must have helped the marchese deflect possible criticism that he had become a compulsive collector driven by the need to accumulate art treasures beyond reasonable bounds. Did not the vision of a future museum justify both the scale and the mode of his collecting? It was the demands of "the museum," he could assert, not a hoarder's blind instincts, that had accounted for acquisitions far exceeding what could have been explained by the most unappeasable hunger for personal possession. Then too, did not the shadowy dimensions of the projected Campana museum explain the fact that the marchese was obviously less interested in individual masterpieces than in categories of related objects? Within the genres of art that engaged his interest he had a horror of leaving a void.

In 1846, eleven years after Pope Gregory's visit had certified Campana's achievements at the monte, Pope Pius IX paid homage to Campana the collector by calling at the marchese's sumptuously renovated villa on the Coelian Hill, near the Church of Saint John Lateran. In 1853, the Villa Campana was the site of the annual banquet held by the Pontifical Academy of Archaeology in commemoration of the founding of Rome. Among the distinguished guests on that occasion was the king of Bavaria, who expressed great pleasure as his dark-bearded, dreamy-eyed host, married to the beautiful Emily Rowles since 1851, proudly escorted him through galleries filled to overflowing with busts, columns, vases, and sculptured bas reliefs *(Fig. 6)*. Other treasures were housed in two other residences, Campana's palazzo on the Via del Babuino

near the Corso (to which he had brought his bride after their wed-
ding) and another house on the Via Margutta. The artworks in the
Marchese's collection, ultimately totaling 15,000 objects, included
some 4,000 Etruscan and Italo-Greek vases, 600 antique bronzes,
2,000 Greco-Roman terra-cottas, and other archaeological finds in-
cluding glassware, jewelry, coins, and medals.[9]

By making shrewd purchases Campana had extended his hold-
ings to objects of later periods, including Italian majolicas of the
sixteenth and seventeenth centuries and a magnificent collection of
Italian paintings of the early Renaissance. His success as a painting
collector was due in large part to his willingness to desert the well-
beaten paths that led to Florence, Siena and Venice. Instead, he
favored the less-well-known schools of the regions near Rome—
Umbria, Romagna, Emilia, and the Marches—and he also ac-
quired objects from more remote regions including Calabria and
Sicily.

Campana's interest in early Renaissance paintings may seem
out of character for an archaeologist who built his reputation
through excavations of ancient sites. In fact, however, many ama-
teurs of classical art showed a great affinity for the paintings of the
dawning Italian Renaissance. In the nineteenth century, early Ren-
aissance paintings were sometimes termed "primitive" because they
preceded the development of scientific perspective and anatomy. To
classicists, though, these works appeared in quite a different light;
in its simple forms often placed in shallow space, early Renaissance
art recalled the Attic vase painting which students of the antique
admired. Thus in the catalog of William Hamilton's collection,
Etruscan, Greek and Roman Antiquities, published in 1766, P. F. H.
d'Hancarville noted a shared emphasis on line in early Greek vase
painting and in the works of Cimabue, Gaddo Gaddi, and
Giotto.[10]

Beginning in the eighteenth century, publications on early
Italian Renaissance art appeared both in Italy and abroad. A
twelve-volume *Series of the Most Illustrious Men in Painting, Sculpture*

and Architecture was issued in Florence between 1765 and 1775.[11] In England collectors studied Thomas Patch's 1770 engravings of works by Massaccio, Giotto, and Ghiberti.[12] On the obligatory Grand Tour to Italy the English discovered that it was possible to put together quite cheaply a collection of early Italian masters. It was such an English enthusiast who hired the French connoisseur Alexis-François Artaud de Montor to research paintings for him while in Florence.[13] Thirty years later, in 1808, Artaud de Montor called attention to this untapped area for collecting by publishing a catalog of his own holdings of early Italian paintings entitled *Considerations on the State of Painting in Italy in the Four Centuries Preceding That of Raphael.*[14] In this work he made a strong case for the study and acquisition of the work of artists who preceded Raphael (whom the early nineteenth-century connoisseurs regarded as the very embodiment of High Renaissance painting). Artaud's catalog covered the period beginning with thirteenth-century Sienese and Florentine painting and ending with the work of Perugino, the fifteenth-century teacher of Raphael. Artaud pointed to the important innovations of these earlier artists, declaring: "Raphael did not fall suddenly from the sky, . . . his talent is the culmination of all the talents which had existed before him."[15]

Artaud was not the first Frenchman to promote early Italian painting. He admitted his debt to Séroux d'Agincourt, a retired cavalry officer and wealthy revenue collector, who installed himself in Rome in 1787 and hired a staff of art copyists with the intention of showing the world the glories of early Italian painting.[16] Describing himself as "the Winckelman of the barbaric period," Séroux d'Agincourt published between 1811 and 1823 *History of Art by Monuments from its Decadence in the Fourth Century to its Renewal in the 16th Century*, a panoramic work with 300 folio illustrations.[17] His book promulgated the concept that in Italy the classicism of antiquity had been preserved during the medieval period; that early Italian painting represented the continuity of Mediterranean classi-

cism and not medieval decadence as had been previously sup-
posed.[18] One of Séroux's followers, Paillot de Montabert, returned
to Paris and joined David's studio in 1796, the same year that
Ingres did. There he propagated among a group of fellow students,
who called themselves les barbus or les primitifs, Séroux d'Agin-
court's belief in the superiority of painting before the age of Ra-
phael.[19]

Like the sixteenth-century art historian Giorgio Vasari, Séroux
d'Agincourt gave precedence to the Florentine painters. It was in
this respect that Artaud de Montor differed. He insisted that other
centers of art had contributed as much as Florence to the Renais-
sance and pointed out that Pisa, Siena, Venice, Milan, Bologna,
and Parma all had their indigenous styles that influenced the re-
newal of Italian art.[20] This geographical broadening of the apprecia-
tion of Italian painting was important for the enterprising collector
Campana, who developed a network of agents to search for paint-
ings throughout the Papal States.

Campana also followed Artaud de Montor in extending his
purchases to include decorated wedding chests (cassoni). Artaud de
Montor prized cassoni panels for the high quality of their paint-
ings, which he pointed out were often executed by major artists like
Fra Filippo Lippi and Paolo Uccello.[21]

In the early decades of the nineteenth century, when connois-
seurs were developing a passion for early Italian paintings, many of
these works were being wrenched by political turmoil from the
shadow of the churches, convents, and private collections where
they had hung in obscurity for centuries. In the upheavals of the
times, churches and monasteries were secularized or destroyed, pri-
vate collections were confiscated, and many art treasures were seized
by Napoleon.[22] The trophies of conquest on display at the Louvre
included many works of the primitives, some of which were re-
turned to Italy after the fall of the Empire. Art amateurs also began
to acquire paintings in this previously neglected genre; one out-

standing collection of the period was that assembled by Napoleon's maternal half-uncle, Cardinal Fesch. Joseph Fesch, who became an aficionado of early Italian paintings while posted as French ambassador to Rome, employed as secretary of the French legation none other than Artaud de Montor. Perhaps with Artaud's advice the cardinal acquired some 3,000 pictures, many by the masters of the High Renaissance and Baroque periods. The Fesch collection also included one of the most exceptional groups of Italian primitive paintings yet assembled. When his paintings went on the auction block between 1841 and 1845, the sale had a resounding impact on collecting all over Europe.[23] The most important auction of Fesch's holdings took place in Rome in 1845, and it was at this sale that Campana's agents bought for him the nucleus of his collection of early Italian paintings (Fig. 7).[24]

Beginning with the Fesch purchase Campana became one of the most important European collectors with "Pre-Raphaelite" taste, a predilection that was gathering in influence throughout Europe during the first half of the century. Not only were collectors becoming interested in these little-known artists of the early Renaissance, but some of the more romantic young artists of the day, in their search for a style of purity and emotional depth and their nostalgia for the past, turned to the Pre-Raphaelite painters for inspiration; they viewed these early artists as more naive and sincere than the masters of the High Renaissance and Baroque. In 1810 the German Nazarene artists established themselves in Rome in an empty monastery. Inspired by the intensity of religious feeling they found in early Italian painting, they modeled their art on works they saw in Rome and tried to revive fresco painting. For artists and amateurs part of the appeal of the dawn of Italian painting was its embodiment of spirituality. The religious aspect of Pre-Raphaelite painting was celebrated by a Breton writer who knew the Nazarenes, Alexis-François Rio, in The Poetry of Christian Art of 1836.[25] Early Italian art had something for everyone: For the classicist it

offered a continuation of the antique style and for the Christian a
profound mystical expression.

The English Pre-Raphaelites, who formed their brotherhood
in 1848, found in early Italian painting an alternative to "slosh,"
the slang term they applied to the grand manner of paintings by
academic artists. Inspired by the engravings after Benozzo Gozzoli's
frescoes in the cloister of the Campo Santo at Pisa, published in
1828 by Carlo Lasinio (the curator of the Campo Santo from whom
Campana bought a triptych), the Pre-Raphaelites tried to capture
in their paintings the naiveté and "truth to nature" that they ad-
mired in Gozzoli. Many critics responded to the Pre-Raphaelites'
painting and aesthetics with great hostility. Imbued with prevail-
ing notions of art's evolutionary nature, they viewed the Pre-
Raphaelites' painting, and the early Italian models on which it was
based, as retrogressive.[26]

Similar prejudices against Italian primitives affected museum
acquisition policies. The idea of the museum as a training school
for artists was firmly entrenched, and early Italian paintings were
not regarded as suitable objects for study. The logical consequence
of this attitude was that Italian primitives were far from universally
popular with nineteenth-century accession committees. On at least
one occasion an early work was purchased in England to serve as a
cautionary example of "bad art." In 1857 London's National Gal-
lery bought a painting by the thirteenth-century artist Margarito of
Arezzo for the avowed purpose of demonstrating "the barbarous
state in which art had sunk even in Italy previous to its revival."[27]
Clearly the early Italian paintings that crowded Campana's private
museum in Rome were not highly valued by all the museum ad-
ministrators of his time.

Campana was well aware that in large measure his tastes in
Italian painting were not in keeping with institutional preferences.
Still, he was convinced that, given enough time, the art market
would eventually turn in his favor. Meanwhile, he counted on his

energy and demonstrated business skills to keep his personal for-
tunes afloat. To the high-born guests invited to his 1853 fête he
was proud to show the treasures of the Villa Campana, but in a
workshop in Rome he manufactured imitation marble for the homes
of the nouveaux riches; his other commercial enterprises included a
terra-cotta factory, a typesetting establishment, and extensive
farms. The maintenance and expansion of his huge art collections
themselves made strong demands on his business sense. Any long-
range projects he may have had for a public museum remained
misty, and the discrepancy between his collecting tastes and pre-
vailing fashions in Renaissance art posed a threat to the value of his
holdings. Apart from his need to sell off the inevitable superfluous
items that found their way into his houses and storerooms, Cam-
pana's enormous financial stake in art prices apparently impelled
him to become a market-maker in antiques and paintings; he prob-
ably intended that his purchases and sales of artworks would have a
favorable influence on the acquisition criteria of museums and other
collectors and on the prices they would be willing to pay.

Professional controversies over the merit of the Italian Pre-
Raphaelites did not dim the renown of the wide-ranging Campana
collections, which became known internationally as one of Rome's
greatest treasures. Campana jealously guarded his museum from
the public gaze, and distinguished tourists regarded a visit to the
galleries as a rare privilege. Campana's guests included such lumi-
naries as Emperor Alexander II of Russia, United States President
Martin Van Buren, French artists and writers including Ingres and
Scribe, and Prince Albert, who stopped by on his journey to marry
Queen Victoria. Honors poured in from the European art establish-
ment; Campana was named a nonresident member of the Institute
of France and of academies and institutes in Bologna, Naples,
Turin, London, and Copenhagen.[28]

As his fame grew throughout Italy and abroad as a giant of
the art world, Campana also followed his family tradition of public

service. He became treasurer of a commission appointed to provide relief to victims of the Tiber flood of December 1846 (contributing over 5,000 scudi from his personal funds to the campaign). In the political arena Giovanni Pietro attempted to pick his way cautiously, without excessive commitment to any faction whose hold on power might prove to be insecure. When the size of Rome's civil guard was increased in 1847, Campana was named Colonel of the Seventh Battalion. However, when public disorders followed in the spring of 1848, the civil guard, to apply W. S. Gilbert's words, did nothing in particular and did it very well. Campana and his battalion are even said to have subscribed to the declaration made by the civil guard in favor of Count Terenzio Mamiani della Rovere, a moderate leader who opposed the temporal power of the pope. On the other hand, during the brief 1849 regime of the Roman Republic under the leadership of Giuseppe Mazzini, Campana worried about alienating the exiled Pope Pius IX and his supporters; it is reported that "to ingratiate and reinstate himself in the favor of the clerical party," whose return to power seemed to be near, Giovanni Pietro was involved in a pro-papal conspiracy in the spring of 1849.

Even as a conspirator Campana left room for retreat. The uprising seems to have been scheduled for Easter, April 8. In support of the plot, Campana appears to have persuaded a number of guardsmen to join the pope's cause. A contemporary letter states that he planned to use in the military operation as many Swiss guardsmen as could be hidden at the monte and that at least one company of his battalion had agreed to follow his lead. However, the conspiracy was discovered and suppressed by the Republican government. Campana was fortunate to survive the failed coup without being compromised; in fact, he continued to serve in the civil guard (now renamed the national guard) while withholding any public show of devotion to the Republic. For example, when troops of the national guard were reviewed on April 28, 1849, in

the Piazza di Santi Apostoli, Campana stayed away, pleading a household accident.[29]

When the Roman Republic fell before the onslaught of French troops and the national guard was disbanded, Campana was named to the municipal commission by the French authorities and confirmed in that position by Pope Pius IX; Giovanni Pietro's responsibility was to safeguard Rome and her monuments for a period of a year and a half.

He also found time for a dizzying array of public and charitable causes: a campaign for the abolition of the slave trade, the promotion of railroads connecting Rome with the port at Civitavecchia and with the Naples area, and agrarian development (a cause to which he proved his devotion by distributing his Frascati farmlands among more than 300 families). A philanthropic interest that he shared with his wife was the operation of poor children's homes. Soon after their marriage Emily, who had inherited a devout Catholicism from her Spanish mother, abandoned the fashionable world and immersed herself in charitable work on behalf of orphans and the children of impoverished families; fated to remain childless, she took a special interest in young girls. In her own right Emily acquired a great reputation for humanitarian commitment, enhancing the enviable popularity that Giovanni Pietro had already enjoyed in all sectors of Roman society.[30]

After his marriage, Campana appeared to be entering his golden years. In recognition of his accomplishments in art and philanthropy, he was named Marchese di Cavelli by King Ferdinand II of the Two Sicilies (who earned the nickname King Bomb by ordering the violent bombardment of rebellious Sicilian cities). This royal favor restored a designation that Campana claimed his Neapolitan ancestors had first enjoyed around 1600. Around this principal title clustered knighthoods conferred on him by rulers of Prussia, Greece, Russia, and several German principalities.[31] These patents of nobility, his overwhelming fame and prestige as bank

executive and master of Italy's art treasures, and his palatial resi-
dences and sumptuous life-style made him appear to be an equal of
the great prince-patrons of the Renaissance. Among the guests who
thronged his galleries at the Villa Campana when he hosted Rome's
anniversary celebration in 1853, nobody paused in admiration long
enough to ask an essential question: How does the marchese Cam-
pana pay his bills? ∿

3

THE ARREST OF
THE MARCHESE

Pericoli's name meant *dangers*. That worrisome coincidence cannot have escaped the marchese when he was notified in September 1847 that the treasurer of the Papal States had appointed Vincenzo Pericoli an official visitor, charged with conducting an inquiry into reported maladministration of the Monte di Pietà. The treasurer had acted at the instance of the monte's secretary, Giuseppe Azzurri, the nephew of the aging superintendent replaced by Campana in 1832. Although Campana subsequently promoted Giuseppe to the secretarial post and made him his deputy, the younger Azzurri secretly nourished his family's grievances for fifteen years; the Pericoli mission was his conspiratorial brainchild. Before the investigation was well underway, Giuseppe claimed to have suffered for his whistle-blowing. Campana, he asserted, had retaliated by suspending him and ordering Swiss guards to bar his entry to the monte's offices.

In November Pericoli summarized his findings; the investigation had confirmed the existence of serious irregularities in administration and accounting, some of which he attributed to subordinates while ascribing others to the marchese. The director, he reported, had taken it upon himself to authorize pawnshop loans far above the limits approved by the treasury; some of the advances

were as high as 1,000 scudi. Pericoli also criticized Campana's
management of the monte's third pawnshop, which the treasury
had authorized him to open in 1834 for the sole purpose of accept-
ing pledges of gold and silver objects and jewelry. The visitor dis-
covered that Campana, on his sole authority, had also approved
loans on the security of bronze artworks and raw gemstones without
obtaining appraisals from recognized experts. Finally, the investiga-
tor determined that, contrary to the regulations of the monte,
Campana had advanced bank funds against commercial obligations
and bills of exchange and that many of these instruments had either
defaulted or bore insufficient endorsements.[1]

Out of courtesy Pericoli gave Campana an opportunity to
point out any factual inaccuracies in the proposed report. Campana
returned the draft without comment, and the visitor assumed that
he had no objection. The assumption was erroneous, however, for
Campana had secretly prepared and submitted to the treasurer a
point-by-point rebuttal of Pericoli's criticisms. When he was later
called upon to explain this clandestine procedure, Campana justi-
fied his conduct: "I don't deny that [Pericoli] invited me to make
observations, but I thought it the more regular course to make
them in connection with the official communication of the report to
the Treasury."[2]

In his defense to the treasury, Campana resorted to a tech-
nique much employed by public officials uncomfortable under close
scrutiny: He extolled himself and attacked the investigator. Even
Pericoli had conceded, Campana wrote, that the director stood high
in public esteem. How could it have been otherwise, when no man
could serve in an office that provoked so much envy, without being
severely tested for outstanding integrity? The visitor, by contrast,
had not measured up to exacting standards of official conduct; he
had consulted with Campana very little, was generous with blame
and stingy with praise.

According to Campana, all Pericoli's criticisms were without
merit. As director of the monte, he could exceed the fixed loan

limits from time to time because he was entitled to exercise the broad discretion formerly enjoyed by the institution's overseers. In order to increase lending amounts on pledges of gold, silver, and jewelry he had, moreover, obtained the verbal permission of the treasury. Contrary to the visitor's assertions, the monte's director was not forbidden to take pledges of art objects; although regulations prohibited the official appraisers of the monte from reviewing such collateral, Campana had arranged for other qualified experts to fix the true market value of all this property. Responding to the visitor's last charge, Campana admitted to having occasionally discounted small bills of exchange but claimed that he had done so only in exceptional risk-free situations in reliance on secure signatures and short maturities.

When Campana's secret reply was called to Pericoli's attention, he was outraged by the administrator's deception and therefore broadened his attack. In an appendix written in January 1848, the visitor branded a lie the assertion that he had neglected to consult with Campana. In fact, he wrote, the director had tried to dictate the contents of Pericoli's report. The marchese was a disastrous manager, Pericoli now declared. Campana was poorly informed on internal affairs of the monte and rarely inspected the pawnshops; he had even mishandled distribution of relief to victims of the 1846 flood. Worse still, Campana was a despotic man impatient of laws and restraints. Strong words, but Campana thought it prudent to make no further response.

Pericoli later claimed that the papal administration was so alarmed by his report that the treasury decided to appoint a formal oversight commission but that the political upheavals in Rome in 1848 had distracted the government's attention.

Freed of the unwanted attentions of the bank examiner, the marchese grappled with the emergencies that faced the monte under Republican rule and the papal restoration that quickly followed. The Roman Republic showed little interest in the charitable or financial aims of Campana's institution. The Republican leadership

requisitioned pledged guns for the defense of the city, and in a
token display of populism ordered a return to poor debtors of small
pledges amounting to 20,000 scudi. For the most part, however,
Campana's diplomatic skills protected the monte's assets from seri-
ous erosion. When the French occupiers returned Pope Pius IX to
power, Campana was confronted with a new crisis—a massive out-
flow of funds to meet pressing governmental demands, including
withdrawals of 300,000 scudi in deposits for reinvestment at 15
percent. Nevertheless, Campana had transformed the monte into a
major credit institution strong enough to weather these new
storms, and by 1852 the monte's deposit bank had cash assets of
1,700,000 scudi.

During this period Campana determined to pursue further one
of the internal administrative courses that had been heavily criti-
cized in the Pericoli report—lending on the security of artworks.
In a petition of November 29, 1849, to the acting finance minister
Galli, Campana asked for a "special and more formal delegation of
authority to receive in pledge at the Holy Monte art objects of some
merit, within the scope of the Holy Monte's purpose to assist in
their needs and misfortunes citizens who might have no other ob-
jects to pledge to help them face harsh necessities." These objects
would be appraised by the most scholarly and best qualified experts
in Rome, who would calculate "the realizable value of the artworks
in accordance with the spirit of the Monte's regulations, and they
would be purchased in the event of sale not only by amateurs but
by dealers who might find that they offered a wider profit margin
than other objects sold at the Monte's auctions." Campana added,
perhaps with a backward glance at Pericoli's accusations, that simi-
lar pledges had already been permitted in exceptional cases by the
"higher administration of the Holy Monte."[3]

In a rescript of December 12, 1849, Minister Galli granted
Campana's petition, stipulating that the appraisals of the artworks
must be made by professors of first rank who belonged to the Acad-
emy of San Luca, Rome's renowned painting school; that the

pledged objects had to be immediately marketable; and that ad-
vances could not exceed 1,000 scudi or one-third of appraised
value.[4]

The marchese's stated objective of aiding the poor who had
nothing but art to pledge had a noble sound, but it is not evident
that Rome abounded in debtors meeting that description. That
there was at least one such person whom the director may have had
prominently in mind became more apparent five years later. On
April 11, 1854, Campana decided to speak for himself. He advised
Galli that, since he had to absent himself from the capital for a
brief period, he had deposited in the bank's treasury "as a place of
safekeeping" two wooden chests containing his precious collection
of antique gold objects and jewels of Etruscan and Greek origin.
Now that these valuables were safely entrusted to the bank's care,
Campana thought it convenient to propose their use as collateral for
a personal borrowing. In order to complete a pending acquisition of
"extensive farmlands," the director needed to borrow substantial
funds, of which he required 15,000 scudi immediately. He there-
fore proposed that he be granted an interest-bearing loan secured
by his deposited collections. Although he estimated that the de-
posit alone had a total value above 150,000 scudi, he believed that
he should provide ample security because the transaction involved
his own property and the monte should be generously protected "in
the event the loans should be extended to greater amounts." The
marchese therefore voluntarily obligated himself to subject to the
same line of secured credit "the entire Museum possessed by him,
that is, the vast gallery of statues, the Etruscan vase collection, the
bronzes, terra cottas, etc." Because these enormous collections
could not be physically transported to the monte, Campana de-
clared himself to be their custodian for the benefit of the monte "to
the same extent as if the objects had been deposited in the custody
of the Charitable Establishment." To provide further assurance to
the papal treasury, the marchese added that he was on the verge of
concluding a contract with a foreign court, pursuant to which he

would sell the bulk of his museum for a sum exceeding 500,000 scudi.[5]

A rescript from Minister Galli followed on April 12. The document read, "In view of the imposing sum of the values of the objects mentioned, loans on their security are authorized for the present up to the sum of 20,000 scudi."[6] According to Galli's subsequent recollection, he had orally instructed Campana that a further application would be required should additional sums be needed; he had cryptically reflected this understanding by inserting the phrase "for the present" in the rescript. The issuance of the rescript was not logged at either the finance ministry or the monte.

Campana did not, either at the time he applied for the loan or after he received the rescript, give Galli a list of the objects in the deposited boxes or in the balance of his collection, and he failed to back his own high evaluation of his museum by obtaining an appraisal from the luminaries of the Academy of San Luca. In other respects as well he may have been less than frank. His representations about the imminent sale of his collection were overoptimistic, at the very least. Moreover, he thought it best not to disclose to the accommodating minister that he was laboring under mounting financial pressures; that he was in default under previous borrowings of 15,000 scudi from the monte on the security of his artworks; and that the true purpose of the new borrowing was to finance new acquisitions for his museum.

During the rest of Minister Galli's tenure there was no official record of additional borrowings on Campana's part; nevertheless, the marchese, on the strength of his pledged collection, soon advanced himself sums far in excess of the 20,000 scudi that Galli's rescript had authorized "for the present." To what extent these supplementary loans were taken with Galli's express or tacit approval remains a matter of speculation.

The procedure Campana followed in obtaining access to new funds was simplicity itself. At some date that cannot be fixed with assurance, Campana called into his office Antonio Seni, cashier of

the deposit bank. Seni not only owed his director the usual respect due a chief executive but was also under a personal obligation of gratitude: By order of Campana the cashier's monthly salary of forty scudi had been supplemented by periodic gratuities amounting to about twelve scudi a month. When the compliant Seni stood before him, Campana told him of his concern for the security of the deposit bank's uninvested funds. He instructed the cashier to turn over to him the bank's excess cash and securities for transfer to a credenza safe to which the director alone would retain the key. Seni raised no objection, and Campana relieved the cashier's concerns about the transfers that followed by giving him successive written receipts in which the director acknowledged responsibility for the aggregate sums taken.

In 1855 Minister Galli retired and Giuseppe Ferrari was appointed treasurer and finance minister of the Papal States. Despite the comfort supposedly provided by Campana's receipts, cashier Seni could no longer hold his peace; he found an early opportunity to tell the new minister of his worry that the bank's coffers now held acknowledgments from Campana instead of cash. Minister Ferrari wasted no time in acting on Seni's disclosure; he ordered that financial statements be prepared as of December 1, 1855, for his review. When the statements were submitted, Ferrari observed that the cash reconciliation showed an account receivable from Campana in the amount of 498,641 scudi. Opposite this figure were the words: "safe, the key to which is retained by our director with responsibility [for the contents]." The accounting was signed by Antonio Seni, with a declaration acknowledging the deposit of Campana's two chests of valuables, the only portion of his vast collections that had ever been delivered to the monte as collateral for his debt.[7] Seni attached Campana's most recent receipt, dated December 1, 1855, in which he acknowledged the total amount of his debt and declared that "the cashier of the [deposit] bank is not responsible for any sums referable to the safe, but the undersigned director [is responsible] since he retains the key to it in accordance

with custom, and is obligated to account for the safe to His Excellency the Finance Minister."[8]

Ferrari, who does not appear to have been as close to Campana as was his predecessor, Galli, demanded an explanation. The director readily acknowledged his debt; he had borrowed the funds to increase the market value of his collection and had therefore greatly enhanced the monte's collateral. Ferrari responded by taking decisive action on several fronts. He required the marchese to reconfirm his debt and to enlarge the related pledge to include all his property. In addition, he insisted on expeditious negotiations for the sale of the collections, which the overextended Campana had described as imminent two years earlier in his application for Minister Galli's loan approval. To provide better protection of the monte's interest in the collateral, Campana delivered to Ferrari the agreement of Charles Newton of the British Museum (with whom Campana was then bargaining) that the proceeds of the sale, if consummated, would be paid directly into the account of the papal finance ministry at the Rothschild Bank in Paris. Campana also forwarded an appraisal valuing the collections at 5 million francs. Finally, Treasurer Ferrari instructed Seni to make no further advances to Campana and ordered the safe key to be returned to the cashier. In August 1855, Ferrari had previously decreed the general termination of any further loans on artworks.

Although Ferrari must have thought that he now had Campana's self-dealing well in check, the monte's balance sheet of December 31, 1856, showed that the cash-hungry director had not changed his ways. In connection with the preparation of that statement, it was discovered that Campana, now that his access to Seni's funds was blocked, had borrowed a total of 36,500 scudi from the cash drawer of Giovanni Tedeschi, a paying agent at the deposit bank. In the course of his duties, Tedeschi was regularly given operating cash provisions by cashier Seni but also directly received deposits from the public. Seni, after Ferrari's intervention, had told Tedeschi not to give a single scudo to Campana and ad-

monished him that to make any advance to a man already indebted
to the monte would be a crime. This injunction was flatly ignored
by Tedeschi who, like Seni, was personally beholden to Campana:
The paying agent was moonlighting as a rent collector for some of
the marchese's real property.[9] The December 1856 balance sheet
was accompanied by a receipt from Campana in its customary form,
together with declarations by Seni and Tedeschi. The distraught
paying agent stated that, in the course of the audit, he had shown
Seni Campana's receipt for 36,500 scudi paid "at various times to
various people" at the director's order and concluded on a remorse-
ful note, "Although Marchese Campana has made himself responsi-
ble for said sum to the bank, nevertheless, recognizing the duties of
my office, I accept responsibility for the regular recovery of said
sum."[10]

No doubt the marchese received another scolding from Trea-
surer Ferrari, but his response remained the same: The new borrow-
ings were well secured and had financed acquisitions that would
improve the prospects for sale of the collections, a happy finale that
he predicted was closer at hand than ever. Ferrari listened noncom-
mittally but pressed Campana to conclude the sale. Campana
smiled his usual assent but continued to make his periodic visits to
Tedeschi's cash drawer. In 1857, the paying agent gave him another
7,918 scudi.

Although Campana continued to flout the prohibitions on his
borrowing, he earnestly explored all avenues for the sale of his col-
lections, abandoning with sorrow his dream of establishing in
Rome a universal museum of Italian art. As recently as 1847 he
had emphatically rejected English overtures for the purchase of his
Etruscan works. However, in 1853 his financial position had
changed for the worse and he opened sale talks with the Russian
court, only to have them founder with the outbreak of the Crimean
War in the following year. The scene of Campana's efforts then
shifted to England; he tried to whet William Gladstone's appetite
by sending him a catalog. Gladstone, then chancellor of the ex-

chequer, sent him a letter of thanks from Downing Street on September 20, 1854, in which he expressed hopes for an acquisition:

> I do not doubt that your museum, famous as it is everywhere, is worthy in all respects of the beauty and richness of this work, and if happily I could be in a position to entertain formal communications with Your Excellency on the subject of the purchase of your treasures for the embellishment of my country, it is thanks to you that I have in hand the means to inspire myself without personal intermediary at least with respect to a part of the contents of your galleries. [11]

Although the Marquess of Lansdowne, an art collector and former minister, subsequently informed Campana that Gladstone was less disposed to propose an acquisition to Parliament because of war expenses, Campana by 1856 was well advanced in discussions with the British Museum.

However, the sale talks dragged on interminably. Pinned down in Rome by the demands of administering the monte under the ever more watchful eye of Minister Ferrari, Campana asked his wife, Emily, to undertake personal negotiations with potential buyers in both England and France. It was as a result of the marchesa's endeavors that representatives of the British Museum inspected the Etruscan collection in Rome and issued their letter promising to deposit the sale price to the credit of the papal government in the event of the completion of an acquisition. Entree to Paris museum circles was provided the marchesa by a letter of recommendation from the papal secretary of state, Cardinal Antonelli (who was well informed of the Campanas's need to liquidate the collection), to the nunzio at Paris.

Despite promising developments in the discussions, war thwarted the hopes of the Campanas. In 1857, the Indian Mutiny chilled English interest, so the Campanas concentrated their attention on Baron James de Rothschild in Paris. The marchese twice

sent his representative, Cavaliere Bonichi, to negotiate with the baron, who showed considerable interest at the outset, but the European financial crisis frustrated the mission.[12]

Although the sale of his collections was still no more than a vain wish, the marchese had good reason to believe that his political fences were well mended. He remained in the top post at the Monte di Pietà with his administrative prerogatives undiminished. The ministers continually assured him that Pope Pius knew nothing of the huge debt, and Cardinal Antonelli dissuaded Emily from following her impulse to throw herself at the feet of the pontiff to beg forgiveness for her husband. The cardinal's advice seemed sound, for in two audiences in October and November 1857 the pope received the marchese with his usual cordiality, and when Campana reported to Antonelli in late November a favorable turn in the Rothschild talks, the cardinal shook his hand and assured him that all would end well.[13]

The sense of security that Campana enjoyed was, however, an illusion. The papal ministers were, without his knowledge, conducting their own negotiations with Rothschild, seeking massive loans to shore up state finances. As discussions advanced, the decision was made to increase the borrowing by 6 million francs to be obtained for the account of the monte; this sum was deemed necessary to restore liquidity that had been impaired by the nonperforming loans to Campana and other operating reverses. On August 7, the pope, while on vacation in Bologna, issued a rescript authorizing the monte's borrowing, and at the same time approved a secret protocol that stated ominously:

> That when there were assembled the necessary means to deal with the needs of the Holy Monte di Pietà, recourse should be had to the regular steps provided by the criminal laws against whoever abuses money of a public establishment, and there should be adopted at the same time all the measures of assurance necessary to guard the interests of the Monte di Pietà.[14]

Thus begins the history of the Campana prosecution. To a remarkable extent, the events that followed transpired behind closed doors, and the rights and wrongs of the affair are hard to disentangle. The best account of the political and legal ramifications of the case is provided in an 1858 manuscript narrative (interspersed with printed trial documents) entitled *Documenti della Causa Campana (Causa Campana),* deposited in the archives of the German Archeological Institute of Rome. Although the authors were ardent partisans of the marchese's cause and some of their legal arguments are dubious, their relation of events, purportedly based on reports of well-connected Romans, seems generally trustworthy.

According to the *Causa Campana,* once the 6 million franc borrowing was concluded, the Council of Ministers debated the steps to be taken to comply with the pope's related protocol. Treasurer Ferrari supposedly reported that, with the money in hand, it was possible to proceed immediately to the "repression" of the "inconvenient" people in the administration of the monte. He concluded his presentation with the rather mild suggestion that Campana should be "called to account." The ministers could not agree whether Campana had committed criminal acts, and Cardinal Antonelli declined to take a position on the matter. Therefore, the ministers called for the advice of Monsignor Benvenuti, the procurator general. Benvenuti, who had been transplanted from the police to the magistracy, was not slow to recognize the Campana case as a magnificent career opportunity; not only did he maintain with complete assurance (unjustified by his superficial legal training) that Campana could properly be charged with embezzlement, but he also urged the ministers to give him responsibility for the prosecution. The council acceded to all his suggestions.

Benvenuti's arrest of the marchese had all the subtlety of a coup d'état. About 10 A.M. on November 28, 1857, a large detachment of policemen and of carabinieri in civilian clothes, under the personal command of the procurator general, surrounded the monte and its neighboring squares, "as if it were a matter of catch-

ing a great miscreant, who planned to steal the Pope's tiara and to snatch, like a new Prometheus, the light from the sun."[15] Benvenuti, followed by the trial magistrate Laurenti, who had been assigned to the case, the chief government accountant, the captain of the carabinieri, and a portion of his troops, marched into the director's office where the marchese was signing a document. Benvenuti described the incursion to the startled director as a simple matter of verifying operations of the business. At his command the invaders began to ransack the books and coffers of the monte and were hard at work well into the night. To allay the marchese's suspicions, Benvenuti told him that he was expected by Monsignor Mertel, the interior minister, to whom he would be conducted. Under this pretext Benvenuti invited Campana to enter his own carriage, closely guarded by policemen. Instead of proceeding to Mertel's residence, the carriage stopped in front of the police guardhouse at Monte Citorio. There Campana, after being asked to dismount, found a group of gendarmes who escorted him into the police room, where he was kept under watch. In order to continue his game-playing, Benvenuti told Campana that Minister Mertel could not see him anymore that evening.

It was growing late and Campana still had not eaten; he asked for a little food, which a policeman brought him from a nearby inn. Meanwhile, in the procurator's office a wrangle had broken out between the trial magistrate and the captain of the gendarmes concerning the proper means of putting the marchese under arrest. The captain insisted that the arrest required a warrant from the magistrate, and the magistrate refused to issue the warrant without an order from the procurator, who had emerged early as the commander in chief of the operation. Benvenuti, finding himself in the midst of this imbroglio, sent for instructions from Cardinal Antonelli, but the secretary of state maintained his distance from the sensitive affair; he responded tartly that he had his hands full acting as secretary of state and that Benvenuti should discharge his responsibilities as procurator. The ambitious Benvenuti was quick

to yield and drafted a criminal complaint, accusing Campana of embezzlement and demanding his arrest. Magistrate Laurenti, appeased at last, issued the warrant.[16]

When the marchese was formally placed under arrest, he asked to read the court order and, returning it to the police without comment, calmly finished his dinner. He then obediently turned over all the papers he was carrying and five keys. One of the policemen wrapped all these objects in a paper package closed with wax seals stamped with Campana's coat of arms; the stamp was left with him for safekeeping.

Having surrendered his possessions, Campana asked for permission to write to his wife. His letter optimistically requested "for this evening" a pair of woolen stockings, a nightshirt, dressing gown, beret, and slippers. He expressed the hope to be able to see her tomorrow. A little afterward he was transported in a covered carriage to the prison of San Michele. For some reason, the police decided not to deliver his letter to the marchesa; instead it was pointlessly entered among the first exhibits in his trial record.[17]

Within a few days the news of the marchese's arrest had been telegraphed across Europe. On December 8, the *Journal de Débats* reported receipt of the following dispatch from Rome dated December 1:

> During the night of November 28, the authorities have arrested in his palazzo (sic) a person who was surrounded by the brilliance of a great position and to whom certain archaeological work and especially the beauty and richness of his collection of Etruscan vases, antique jewelry and all sorts of precious artwork had given a kind of celebrity. It would be a pointless discretion to keep his name quiet: it is the Marchese Campana, Director General of the Monte di Pietà.
>
> At Rome this establishment does not have the sole purpose of providing relief to the poor through loans on pledge; it is also a kind of savings bank with high accreditation. The motives that have brought about the arrest of M. Campana are

irregularities of the most serious nature in his administration. It will be understandable that we will not repeat all the suppositions in which the loquacity of the rumormongers indulges itself against a man for whom a long and brilliant prosperity had made an ample provision of enemies for his days of adversity.

The Marchese Campana is not yet accused and the funds that he applied to his personal enterprises, even if they exceeded two million francs, as is said, would probably be covered by his properties and different collections. It appears that M. Campana never drew upon the coffers that were confided to him without placing therein an acknowledgment of the exact amount of the sum that had been improperly applied.

With respect to the authorities, they have shown in this affair cleverness and prudence. The Marchese Campana, who had been under suspicion for several months, seems not to have had any premonition and, what is more, the government delayed in striking at him only because it was awaiting receipts that would put it in a position to pay promptly all depositors whom this catastrophe might alarm.

The *Journal de Débats* published a further report ten days later, noting that on the next day "the Marchesa Campana will spend three solemn days of prayer at the crucifix of Campo Valcino in order to interest Heaven in the misfortunes of her husband."[18] ✑

4

TRIAL AND
TRIBULATIONS

It was in Rome that reports of the
armed occupation of the Monte di Pietà and of the arrest of its
director general caused the greatest excitement. The apprehensive
government doubled regular patrols, and a squadron of dragoons
made the rounds in those quarters, such as Trastevere, where the
beneficent marchese enjoyed the greatest popularity. To calm the
public ferment, the authorities spread rumors that the marchese had
not been arrested, or that he was already freed or on the verge of
being released.[1] While these conflicting stories circulated, Emily
desperately haunted the ministries, hoping to learn the truth. Inte-
rior Minister Mertel pretended to know nothing of the affair, and
Cardinal Antonelli, in embarrassment, said that it was not he but
the pope and Council of Ministers who had ordered the proceedings
against Campana. Only on the day following the siege of the monte
did the marchesa learn from the French ambassador that her hus-
band was in the prison of San Michele, commonly employed for
political detentions.

When the marchese's jailing and impending prosecution be-
came generally know, varying explanations were offered for his
downfall. Some said that Campana had long been a thorn in the
side of the present conservative regime because of his outspoken

advocacy of liberal reforms that had been backed by the pope in the
first years of his reign. Others speculated that Campana had not
been forgiven for the failure of the Roman counterrevolution while
the pope's government was in exile. Perhaps his greatest crime, it
was said, was to have increased the size of the monte too much and
to have aided too many, thereby earning a "dangerous popularity."[2]

Some of the marchese's supporters blamed influential enemies.
Powerful sponsors of the rival Banca Romana, which had fallen on
hard times in recent years, envied Campana's administrative suc-
cesses and his ability to avert the financial crisis that their own
mismangement had threatened. It was also rumored that Interior
Minister Mertel was waging a vendetta against Campana because
the monte had sold rights for the cutting of certain of its wood-
lands formerly exploited by Mertel's relatives, without payment, for
hunting and timber.[3]

A central figure in the gallery of reputed political foes of
Campana was the secretary of state, Cardinal Antonelli *(Fig. 8)*.
Born in 1806, Antonelli became a deacon but never entered the
priesthood. After being named a cardinal by Pope Pius IX in 1847,
he began his first term as secretary of state in the following year
and, except for a short interval, held the office until his death in
1870. Over the course of the years Antonelli's policies, according to
the *New Catholic Encyclopedia*, became "frankly reactionary"; he was
"severely criticized as a morally lax man, avid for money, who
strove by authoritarian means to concentrate all power in his own
hands, and did not hesitate to break those who opposed him."[4]

Whatever political motivations may have spurred the prosecu-
tion, the judiciary system to which the marchese's fate was now
entrusted posed perils of its own that would have daunted the bra-
vest spirit. William Roscoe Thayer states that the Roman courts
were in "hopeless confusion." He explains:

> The numbers and variety of courts, the exemptions granted to
> nobles and ecclesiastics, the different penalties attached to the

same offense, the refusal to confront the accused with their
accusers, the secrecy surrounding the trials of political pris-
oners, the allowing judges to conduct the prosecution as well
as to pass sentence, the lack of *habeas corpus* and of bail, the
long delays in cases of appeal, the great expenses, the uncer-
tainty, the general belief that the result of a suit depended
upon the prejudices or venality of the judges—these things
indicated that the Papal department of justice was mediaeval
and incompetent. The judges received so small a stipend that
they might easily give way to the temptation of taking bribes.
The upper courts at Rome—the Rota, the Segnatura, the Con-
sulta—were all in charge of high ecclesiastics; but since legal
knowledge was not necessarily imbibed with theology, each
cardinal or prelate had lay lawyers to prepare the cases for
him.[5]

The criminal procedures that Campana faced bore little re-
semblance to modern-day practice. A trial magistrate compiled at
leisure a record consisting of depositions from the accused and from
witnesses, together with documents accumulated in the govern-
ment's investigation. When the record was complete the magistrate
submitted a summary account to the trial court, and defense coun-
sel had an opportunity to file a brief in response. Arguments would
then be heard before the court (with the public barred), but no live
evidence was presented.

The defendant's examination before the magistrate Laurenti
began on November 30, 1858, and Campana soon decided that he
could not hope for fairness or speed from Roman criminal justice.
He therefore instructed his defense lawyer, Raffaele Marchetti, to
file a challenge to the jurisdiction of the Criminal Court on the
grounds that Campana had done no more than incur a debt that
should be adjudicated in a civil forum.

The records relating to the appeal were lodged with the Su-
preme Court of the Sacra Consulta on December 4, and a hearing
was scheduled for a week later. On December 10 Marchetti re-

quested a delay, representing that he had met only twice with Campana and had not had time to prepare for the defense of his motion. The Sacra Consulta granted a week's delay but warned Marchetti that there would be no further deferment. Under pressure to move forward quickly, Marchetti filed a request for documents he deemed indispensable to his motion, including the written declarations that Campana had given his subordinates concerning the various borrowings; the prosecution, however, refused to supply these papers.

Meanwhile, the procurator Benvenuti gave Marchetti more bad news, advising him orally that by order of Interior Minister Mertel, the brief supporting the defense's jurisdictional motion must be submitted for advance review by the presiding judge of the Sacra Consulta. Marchetti, in disbelief, went to see Mertel, who confirmed having given these instructions but added that the required advance submission was not intended to "damage the liberty of the defense."[6] In fact, however, Marchetti found that a nightmarish multiple censorship was in store. On December 16 he dutifully presented his brief to the presiding judge who, after leafing through it and discarding portions that met his disfavor, bundled the surviving papers and delivered them to a deputy. While Marchetti kept the typesetters in readiness at the printer, the deputy read the manuscript at a laborious pace, chopping out anything he deemed harmful to the prosecution. He returned the mutilated draft to Marchetti around 10 in the evening and marched him back to Benvenuti for final revision. On the following morning the printer told Marchetti that the manuscript had not yet been delivered by Benvenuti. Setting out to do battle with the prosecutor, the frantic Marchetti met en route police inspector Valentini, who had been delegated to carry the brief to the printer. He told Marchetti that if any further change were made other than to correct typographical errors, fresh approval must be obtained from the presiding judge of the Sacra Consulta.

The high court's hostility to Campana's appeal could not have been plainer. On the morning of December 18, before the Sacra

Consulta was to convene, the marchese revoked his challenge to the court's jurisdiction, declaring before the magistrate Laurenti that his counsel had not been able to obtain the information he sought in support of the appeal and that because of the printing delay, the judges had not even had time to read his brief. Campana added that he was all the more decided to revoke his jurisdictional appeal because he was resolved to solicit the pope's clemency. When the terms of this revocation were shown to the prosecutor Benvenuti, he was greatly irritated and ordered the marchese to make a pure and simple renunciation of the appeal, without setting out any grounds; Campana, swallowing this additional humiliation, had to comply.[7]

On the same day, Campana submitted a handwritten petition to Pope Pius. The prosecutor exacted two conditions for its delivery: The document must be transmitted by Benvenuti, the defendant's accuser and trial adversary, and then only after certain deletions were made. In his letter, Campana cited his "noble but excessively ardent passion" for archaeological studies and for "the illustrious memorials of this country so dear to [him]" as well as "the precious monuments of ancient Italian civilization that preceded the glories of eternal Rome." Through his excavations and purchases he had come to form "that marvelous ensemble of Italian, Greek and Roman monuments that very quickly acquired fame throughout Europe."[8] But his passion had no limits and impelled him toward his fatal misstep:

> It was then that there came to my mind the unfortunate idea
> of having recourse to the Monte di Pietà so as to be able to
> dispose of greater sums to expand further the already colossal
> museum; I had decided to give to the Monte as a guarantee the
> considerable value of the latter. My conscience didn't find an
> obstacle in this plan, since during that period there was a very
> large uninvested fund in the bank coffers that I had preserved
> almost miraculously throughout the various phases of the revo-
> lution. The use of this fund in the borrowing I proposed

would give the Monte an advantageous annual interest and was
at the same time more than adequately secured by the pledge
that I was going to undertake in its favor.[9]

Campana had no doubt concerning his authority to make this
borrowing since the bank for twenty years had lavished loans on
others and had made huge advances to the papal treasury without
interest. Nevertheless, for his greater peace of mind, he had
thought it best to advise Minister Galli of his plan. Through his
rescript, the minister had assented to the proposal. He had speci-
fied that a loan of 20,000 scudi was accorded "for the present"
because he intended to reflect his understanding with Campana
that additional sums could be taken subsequently in accordance
with the director's needs and the circumstances of the monte.

Campana recounted the efforts he had made to sell his collec-
tion at the urging of Cardinal Antonelli and Treasurer Ferrari. He
added:

> I acted in the fullest good faith and with the greatest frankness
> towards the same two respectable ministers of Your Holiness,
> whom (according to them) they had kept ignorant of my great
> debt. When I was comforted by the sweet flattering thought
> that I would shortly be able to breathe freely after the distress
> by which my mind for so long had been worried and op-
> pressed, there was suddenly exploded over my head a tremen-
> dous thunderbolt. I suddenly saw my debt converted into em-
> bezzlement, I saw all my good faith disregarded and I was
> treated as a public thief! It was the fatal 28th of November.[10]

In conclusion, the marchese petitioned for the abolition or sus-
pension of the trial proceedings; he did not ask, however, "to be
exonerated from a severe rendering of accounts or from the restitu-
tion of the loans and of their interest, and much less, for immunity
from the expiation of the acts that [he] had committed, though

with a noble intention."[11] Unfortunately, if his words reached the
pope, they met with silence.

On December 4, while Campana's appeal was still pending,
the police arrested Dr. Camillo Petacci (the prisoner's physician,
who had been attending him at San Michele) under suspicion of
conspiracy to obstruct justice. According to the police report, Dr.
Petacci came to San Michele around 9:30 that morning to pay his
usual visit to the marchese; a member of the prison brigade was
ordered to maintain surveillance over the interview. While Petacci
took the prisoner's pulse, the sharp-eyed guard saw him pass a
glove to the marchese with his free left hand. The gendarme or-
dered Campana to turn over the glove and found that it contained a
letter in his visitor's handwriting. The secret message read:

> It was with greatest displeasure that last evening I was unable
> to give you news of the brothers; if not entirely, at least in
> part, they hope to be able to accomplish the work. With re-
> spect to the others everything is as can be desired. Be cautious
> in your writing and if possible avoid giving me letters, and be
> on your guard because there is always the probability that
> someone will catch us out. When I want to speak about the
> "brothers" I will speak of the Lega brothers and about the
> factory. If I come with gloves, this will be a sign that I have
> something to give you, and otherwise I will have nothing for
> you.[12]

Dr. Petacci was put in prison and his papers were searched for
information relating to Campana. The interrogation of the marchese
was suspended so that the doctor could be questioned. On Decem-
ber 5 Petacci told the prosecution that he had been caring for Cam-
pana for many years and that the marchesa had asked him to visit
her husband at San Michele. The prison authorities had ordered
him not to talk about the case. During his visit on the previous
Tuesday, however, the prisoner had surreptitiously passed him a let-

ter written in small script. Two days later Campana handed him another note in a glove. In this note the marchese asked Petacci to talk to the Lega brothers, employees at his imitation-marble factory, asking them to use their best efforts to remedy an unsuccessful installation. When the doctor spoke to the Lega brothers, they were not sure what project Campana had in mind; perhaps it was an altar or a pavement in the factory itself. In a effort to obtain better instructions, Petacci had the day before attempted to pass Campana the note that the gendarme had intercepted. Petacci swore that this was the only written message he had delivered to the marchese and that he didn't think he was doing anything wrong; he claimed that the "brothers" referred solely to the Legas and to the marble establishment.

The government found that in at least one instance Dr. Petacci, despite his protestations of noninterference in the case, had tried to influence a witness. The cashier Antonio Seni stated in his second examination that through an emissary (whom the police believed to be Petacci) the marchese had tried to induce him to date the origin of the credenza safe to 1847 and had assured Seni that he was protecting him in his own depositions. Seni told the authorities that the testimony suggested by Campana was false and that the marchese's safe began to function only in 1854. The origin, and indeed the existence of, the so-called safe remained in doubt. Campana's supporters contended that the safe was never used for the custody of the appropriated funds but was purely a myth devised by the marchese to protect Seni from the appearance of complicity in the diversion of the money. Campana's selection of 1847 as the birthdate of the safe was perhaps intended to give it an innocent life span antedating the avowed 1854 borrowing, but his logic is hard to decipher: On the merits, he persisted with the outlandish claim that he had borrowed close to 500,000 scudi, without the general knowledge of the bank staff, in a few short months after the Galli rescript of April 1854, whereas the government urged (with support from Seni's testimony) that the bulk of these funds

must have been taken in prior years. It is therefore not clear
whether Seni's adoption of 1847 as the beginning of the credenza
safe operation would have advanced Campana's cause.[13]

After each of his interrogations Dr. Petacci was returned to a
cell in San Michele that was at a safe distance from Campana's. The
physician's health suffered from the imprisonment and on Decem-
ber 12 he was released.[14]

The marchese, less fortunate, saw his detention stretch out
interminably. His room in the prison was rather large, but the win-
dows were so high that the light and air they admitted gave him
little relief. A restless man, Campana was troubled most by having
to remain shut up for long months. He had a cot brought from
home, together with a small table, chairs, and a few devotional
books, including a work of his beloved Saint Francis de Sales. Suf-
fering from his solitude, he requested company during the night
and the prison governor permitted him the society of a fellow in-
mate. During the course of the investigation, Campana was allowed
to see his wife two or three times a week, and on urgent occasions
his lawyer Marchetti was authorized to visit, but always upon spe-
cial application and in the unwelcome presence of the magistrate
Laurenti or the gendarmes.[15]

By the third month of his imprisonment the marchese's physi-
cal condition began to deteriorate. On February 8 prison doctor
Caetani reported that in addition to nervous disorders that caused
him sleepless nights, the prisoner suffered an affliction in the upper
abdomen and a sharp pain in the liver. Caetani prescribed the ap-
plication of leeches to the anus, purges, bile medicine, and seda-
tives, but was disappointed to find their benefits short-lived. After
four days of this treatment, the prisoner's abdominal pains returned
and "a restriction in his chest and headaches rendered him very
anxious, deprived him of sleep and gave him an aversion to food."
By the end of the month Dr. Caetani reported that Campana had a
sharp pain under the left nipple, was experiencing breathing dis-
tress, and was much agitated at night.[16]

Doubting his ability to survive further detention, Campana
appealed to the magistrate Laurenti for freedom:

> At hand is the dawn of February 27; a few hours ago I thought
> I would not live to see it. The pain in my liver and the oppres-
> sion of my heart that have tormented me for many days sharp-
> ened with the advance of night to the point of becoming un-
> bearable and of almost making me faint. I tried to rouse the
> inmate who sleeps in my room from the heavy slumber in
> which he lay; but I was unsuccessful. To call the gendarmes it
> would have been necessary to bang strongly on the walls and
> on the tightly closed door of my room, but beyond the fact
> that my condition made me weak, I told myself that it was
> useless to disturb them and that I could expect no relief at
> that hour from the gendarmes. I comforted my thoughts with
> the flattering hope that my illness was subsiding. But it soon
> increased instead to the point that for some interval of time I
> doubted whether I would survive. It was then that, foregoing
> any further call on men, I turned my mind to my Creator and
> invoked the aid of the God of the oppressed. It did not grieve
> me to leave the world that held little promise for me but I was
> only grieved not to be able first to see again my beloved wife,
> and I was immensely anguished by the idea of so many unde-
> served misfortunes and sorrow to which I had become prey; I
> grieved to see myself deprived of Christian comforts. And I
> was not able to persuade myself that in Rome, center of the
> Catholic faith, a man could be held, for three months already,
> far from any religious practices, far from the sacraments, from
> hearing mass or the religious holidays or especially confession.
> And all this for what reason? For purely human motives and
> through rigorous measures which, if they could find a cold
> justification and excuse in the case of a political plot or an
> assassination of which the authors remain to be discovered, be-
> came absurd and pointless with respect to me, whose deeds
> were completely open and whose administration is in the hands
> of the same government. [17]

Campana purported to believe that the magistrate was very unhappy with his prisoner's condition but could do nothing for him. He cautioned the magistrate, however, that he might, by causing the defendant's death, be reduced to producing the trial evidence "before the empty walls of a prison."[18]

Despite this cry from the depths, the prosecution went on relentlessly. Procurator General Benvenuti was far from satisfied to stand on the evidence of embezzlement that he had in hand at the time of Campana's arrest. In his depositions, the marchese had vehemently rebutted the two principal charges; it was his position that he had made the major borrowings of Seni's funds with Minister Galli's tacit consent, and that the 36,500 scudi taken from paying agent Tedeschi had actually been borrowed prior to Treasurer Ferrari's ban on further advances. Because of these nettlesome questions, Benvenuti and his staff pressed employees of the monte, fearful for their own skins, to disclose other misdeeds on the part of the imprisoned director; and government accountants led an inexorable paper chase through the records of the monte and Campana's palazzo on the Via del Babuino, hoping to be able to charge Campana with further defalcations.

From the very moment that the marchese's arrest was announced, his friends and relatives, fearing the seizure of his personal papers, determined to take defensive measures. It was not, they told each other, that Campana might have compromising documents, but they knew that in his palazzo he kept an enormous hoard of papers filling rooms that nobody was permitted to enter. They did not want to grant the prosecution first access to this new material that might provide an excuse for an indefinite extension of the investigation. Under the direction of one of Campana's most faithful domestic servants, a contingent of the marchese's household staff broke into the secret rooms and were appalled by the spectacle before them. Bookshelves, tables, the floor, everything was encumbered with heaps of papers; half-open books were piled one on top of the other, together with notebooks, parchments, prints, draw-

ings, and scraps of paper in the marchese's handwriting. There was such disorder that nobody had any idea how to proceed. The marchese had imposed such a strong ban against intrusion that only he would have been able to "hold the thread of that labyrinth."[19] It was said that he had even kept the windows barred for fear that a gust might scatter his papers irretrievably. Still the domestics who had now invaded their master's sanctum for the first time worked through the night, having no clear notion of what they were to accomplish and succeeding only in advancing the state of confusion in which the prosecution found the records when the dreaded search order was issued.

Despite this preemptive strike on behalf of the marchese, the government plowed through his personal records with maddening deliberation and continued the examination of records and witnesses at the monte. In this evidentiary jungle, Benvenuti proclaimed, he had tracked proof of three more misappropriations of funds. One of the charges was so minor and its factual issues so tangled that its very assertion showed signs of strain on the part of the government. Investigators found that the loan bank had issued a certificate of deposit for 5,000 scudi to one Francesco Basseggio but that there was no record that this sum had ever been deposited. Basseggio deposed that he had given the cash to Tedeschi, and the prosecution maintained that Campana had diverted the funds. Campana admitted his responsibility for the money but contested Basseggio's story.[20]

A second charge was more serious: that during the period from September 14, 1856, Campana had, in the face of Ferrari's general prohibition on further art pledges in August 1855, borrowed a total of 85,900 scudi on pledges of 218 paintings. Since Seni and Tedeschi were no longer permitted to give him funds, the marchese had found a third source, Francesco Canestrelli, cashier of the loan bank and custodian of pledged artworks. The government alleged that the new borrowing operation was known only to Canestrelli and that Campana furnished only general descriptions of the

pledged paintings, without expert appraisal, and often caused ficti-
tious names and addresses of pledgors to be entered in the bank's
registry. Further, the director did not deliver any of the pledged
paintings to the monte, keeping them instead in his own galleries.
He explained his procedure in the documents he delivered to Ca-
nestrelli: "The above articles, by reason of lack of space in the exhi-
bition halls of the Monte, and to protect them from humidity, are
retained in a separate place, for which the key is retained by the
undersigned. G. P. Campana, Director."[21] Confronted with these
documents, Campana asserted that only 8 of the 218 paintings in
question belonged to him and that the rest belonged to other own-
ers, whom he declined to name "because of honest considerations."

The final charge that Campana had appropriated about
350,000 scudi between January 8, 1856, and November 7, 1857,
was by far the foggiest. In 1855 the papal government had induced
Campana to restore the monte's treasury by borrowing from foreign
lenders, including the Profumo firm of Turin. Profumo, instead of
advancing cash, gave the monte obligations with three-month ma-
turities in exchange for longer-term notes of the bank. The monte
discounted the Profumo obligations and thus became liable to pay
their full principal amount when the Profumo firm subsequently
became insolvent. At the time of Campana's arrest, the monte was
still in the process of accounting for the losses suffered in the Pro-
fumo fiasco.

Government investigators found in the expense accounts of
cashier Canestrelli three notes handwritten by Campana stating: "It
is declared by the undersigned Director General of the Monte that
he has received from the loan bank cashier Francesco Canestrelli,
the indicated sums which are needed in the liquidation of accounts
of the foreign borrowings made by agreement with governmental
authorities."[22] These pages listed ninety successive receipts of small
sums totaling 316,712.26 scudi. Michele Guidi, accountant gen-
eral of the Reverend Apostolic Camera (the administrative body of
the Papal States) concluded that instead of devoting this cash to the

affairs of the monte, Campana had appropriated the full amount as well as another 36,288 scudi that Guidi had calculated from the mass of papers examined at the marchese's palazzo. Campana denied the charge, claiming that the government's accountants had erred. He added vaguely that in the administration of the foreign loans certain sums might have gone astray through the fault of persons whom he did not want to accuse, but that the total computed by the government was excessive. His lawyer, Marchetti, complained that the marchese's close imprisonment did not permit him to make his own examination of records necessary to refute the allegations.

Procurator General Benvenuti also amassed records of the Campana family fortune and of the marchese's personal and business expenditures to support his thesis that the accused embezzler must have secretly tapped monte funds long before the ambiguous borrowing authorization of Minister Galli in 1854. Among the documents examined were the will and estate inventory of Campana's father, Prospero, Emily's dowry instrument, and records of the mounting costs of the museum, the Lateran villa restoration, the marble enterprise, and a factory in Frascati. Many of the values and outlays in question remained shrouded in controversy, and the most this evidence clearly showed was undisputed at the start—that the defendant's optimism and extravagance had ultimately been his undoing.[23]

The record compiled by Benvenuti and Laurenti continued to grow, but still no trial date had been set. Fearing for the marchese's health and legal fate, foreign courts bestirred themselves on his behalf. The close tie between Napoleon III and the Campanas was well known and, anticipating his intervention, Roman authorities, through their nunzio at Paris, tried to depict the marchese's misdeeds in the blackest of colors. Nevertheless the French ambassador did what he could to convey the concern of his government, and the king of Naples also spoke up for the man he had ennobled. In response to inquiries of foreign ambassadors, the papal court

defended itself with vague promises, which by March of 1858 had
been reduced to such formulas as "when Campana is condemned
the Pope will be merciful to him," or "after the sentence will come
pardon." From these intended words of comfort it was obvious that
the Roman government regarded the marchese's conviction as a fore-
gone conclusion.[24]

On March 30, 1858, Laurenti's résumé of the trial record,
which he prepared in concert with Procurator General Benvenuti,
was finally published; the 86-page printed document detailed evi-
dence supporting the government's charges that Campana had com-
mitted six appropriations of the Monte's funds totaling 983,959.25
scudi. In their contemporary narrative, the *Causa Campana,* the
marchese's partisans assert that the prosecutor Benvenuti was well
aware of the "monstrosity" of his work and that the publication of
the trial résumé would make him a public laughingstock. Having
advanced the thesis that Campana was a thief, he had failed to
explain in the lengthy document how it was that the government
had seen fit to keep the supposed embezzler for two years as guard-
ian of the monte's coffers. It was rumored that Benvenuti himself
had asked for a termination of the trial but that an audience he had
requested with the pope to make this recommendation was refused
him.[25]

When they read Laurenti's trial summary, Campana's sympa-
thizers were indignant to find fully secured borrowings magnified
into evidence of theft and to read new claims of misappropriation
premised on the confused accounting for the foreign borrowings.
Seizing on the favorable moment, Giacomo Benucci, the marchese's
administrator, obtained government permission to open the rooms
of the museum to the public. Visitors who flocked to the Campana
galleries were persuaded that the fabulous artworks could have more
than satisfied their owner's debt. According to the authors of the
Causa Campana, the public outcry proclaimed that the marchese,
instead of imprisonment, had "merited a golden statute."[26] Unset-
tled by this wave of sympathy for the marchese, the prosecution

took a new tack, proposing covertly that Campana agree to be summarily condemned with a view to obtaining the pope's pardon.

This empty promise no longer carried weight with the weary prisoner. His lawyer, Marchetti, considered a fresh offensive of his own: the initiation of a court proceeding to require the Reverend Apostolic Camera to accept trusteeship of the pledged museum. The risk of a clash with the ministers, however, persuaded him to put his plan aside. Instead, he devoted his full attention to the defense of the case, which was scheduled for a hearing on May 15. Fearing that the minds of the judges would be shut to arguments on the merits, he renewed his attack on the jurisdiction of the Criminal Court. On May 7, the trial court unanimously upheld its own jurisdiction and Marchetti had only twenty-four hours to appeal to the Sacra Consulta. Protesting that he had insufficient time to prepare the necessary documents, he made his filing as best he could before expiration of the deadline, but all in vain; the Sacra Consulta quickly confirmed the lower court's decision, and the date of May 30 was fixed for the hearing of the case.[27]

Now facing imminent trial, Marchetti readied additional demands for document production by the government. Many of his requests sought information designed to show that the monte's operating losses were due to causes other than the marchese's borrowing. Marchetti also asked for copies of any ministerial rescripts authorizing pledges of artworks after the allegedly final prohibition of August 1855. On May 27 the trial court rejected an interim request for delay but deferred until May 31, the very day that hearings were to commence, its decision on the new requests for documents. At the opening of the May 31 session, Marchetti defended his documentary requests one by one and moved for a trial delay of twenty days. Benvenuti was uncompromising in his response. He stood firm on the government's refusal to supply any documents and characterized the requested delay as excessive; if a shorter time were accorded by the court, the prosecutor submitted, Campana's lawyer should be subject to a daily fine if he were not ready to

proceed on the designated day. After retiring for deliberation, the trial judges unanimously rejected the document requests and irrevocably fixed June 26 as the trial date, with the defense brief to be distributed three days earlier.[28]

In the first pages of his brief, Marchetti sounded the keynote of the defense:

> A generous passion, irresistible as a vocation, inflamed [Campana] from his tenderest years, devoured his paternal inheritance, saddled him with debts and, not ceasing to push him on, suggested to his mind the fatal idea of making a large pledge of his museum, already unique in the world, and of taking a loan from the funds of the Monte which he administered. This loan . . . was irregular procedurally and arbitrary in its grant, and, although it was within the limits of the value of the pledge, nevertheless a combination of adverse circumstances rendered it burdensome. But how can irregularity, imprudence, and arbitrary decision be changed into a crime?
>
> I am not going to maintain that the Marchese has acted well and prudently; I am not going to defend either the high post that he held for twenty-five years to the great benefit of the public and with universal applause, nor the honors with which he was lavishly distinguished by the government for his inestimable merits. Nor shall I claim that these merits should be placed in the scale of justice to compensate for his shortcomings. What I am going to defend is his reputation which I see savagely attacked; what I am to take off his back is the villainous cape of a criminal, which suits him badly.[29]

Marchetti sketched the history of the monte, pointing out that its administration had long ago departed from the original principle that its funds were to be used for the poor alone; the expansion of the operations of the institution was one of the very reasons for its remarkable growth. He then recounted the brilliant successes of Campana's administration, emphasizing the director's

diversification of the monte's investments not only through loans on pledges of precious objects but also by transactions in securities, commercial paper, and real estate.[30]

In discussing the establishment of the credenza safe, Marchetti accepted Campana's deposition testimony: that the director had begun to use the safe in 1847 as a security measure, thereby restoring a traditional safeguard that had given custody of the key of the bank's treasury to its oldest overseer, leaving the cashiers no more than a weekly cash provision. Under Campana's system, the cashier Seni still retained the key to the depository room, so that the director could not make withdrawals from the credenza safe without the cashier's knowledge. Regarding his major borrowing of 490,641 scudi, the marchese had no doubt of his authority to lend to himself the money that he was empowered to lend to others; he had obtained the Galli rescript merely as a prudent confirmation.[31]

A cautious advocate, Marchetti took pains to deal kindly with the pope. In authorizing criminal proceedings, the pontiff had referred to "abuse of funds"; this phrase, Marchetti argued, indicated that neither Pope Pius nor Cardinal Antonelli had raised any question of theft or embezzlement. Although deferential to the highest authorities, Marchetti dealt more harshly with the procurator Benvenuti's conduct of the prosecution; his comments on this score would not go unnoticed.

As a supplement to his brief, Marchetti filed the opinions of six noted Italian lawyers, who concurred that the evidence did not support a charge of embezzlement. Typical of their reasoning is the opinion of Giovanni Di Falco of Naples:

1. Because the monte was authorized to make extraordinary loans of deposited funds and the director was under no formal prohibition against borrowing on the same terms as he could lend to third parties, he had not diverted money from its regular use but had incurred only a civil debt.

☞ 2. Since the marchese had, in connection with each loan, delivered his written acknowledgment of indebtedness and provided collateral that had been faithfully preserved, however irregularly it may have been recorded, the facts cited by the prosecution lacked the elements of criminal intent and of fraud, which were prerequisites to the crime of embezzlement not only under the Roman criminal laws but under the related codes of France and Naples as well.

☞ 3. The first loan of up to 20,000 scudi was expressly approved by Minister Galli. The following loans, increasing the total to approximately 498,000 scudi, though not preceded by special authorization, were known to the minister of finance, who regulated the borrowing terms and the supporting pledges. The third borrowing of 36,500 scudi was backed by a pledge of new collateral deposited with the monte and was equally known to Treasurer Ferrari. By reason of these arrangements and the government's knowledge, these borrowings were mere commercial contracts that could not give rise to more than civil actions.

In contending that embezzlement could not be premised on acknowledged and secured borrowings, even if made in violation of bank regulations, Di Falco and his colleagues were asserting a legal position that is still embodied in modern American legislation and case law: The crime of theft or embezzlement as distinguished from breach of trust or self-dealing continues to require an "intent to keep" the funds received.[32]

According to the anonymous authors of the *Causa Campana,* Marchetti's brief was well received in Rome:

> All the bar found the defense sound and legally unanswerable; all classes of society liked it; in conversations, clubs, cafés, on the street, in the squares, everybody clearly declared themselves in favor of the accused and against the government.[33]

On the morning of June 26 when the case was to be heard, the
doors of the courtroom were closed, but crowds filled the courtyard
and the neighboring square. After two hours of arguments, the
trial court, with Judge Terenzio Carletti presiding, issued a decree
that only added to the public suspense:

> In the name of His Holiness Pope Pius IX, the first panel of
> the Criminal Court of Rome, having on June 26, 1858 heard
> the case of embezzlement against Marchese Giampietro Cam-
> pana, unanimously defers decision of the case and orders the
> Procurator General to write and publish his comments and
> conclusions. [34]

Many of the onlookers interpreted the order as a prelude to
victory for the defense, believing that the court was implying that
the marchese could not be condemned on the basis of the record
and arguments presented. When defense counsel Marchetti left the
court, he was greeted with a boisterous ovation and had to escape
the attentions of the crowd by taking a detour through the police
offices, which were next to the court.

The fond hopes of the public were soon dashed. The *Causa
Campana* blames the turnabout on secret negotiations, claiming
that no sooner had the court decree been issued than the presiding
judge went to see Cardinal Antonelli and prosecutor Benvenuti
sought an audience with the pope. What the government officials
may have been pondering was not immediately known, but word
leaked out that the prosecutor did not desire to make any further
filing with the court. Marchetti triumphed prematurely on hearing
this news, concluding that the prosecution was acknowledging de-
feat.

The marchese was not so easily deluded. On July 4, the eve of
the next court date, he wrote to the judges, acknowledging having
been guilty of arbitrary decisions and irregularities but asserting
that his borrowings had taken on the force of a civil contract that

he could have discharged by sale of the collections if given more time. Pointing to his public achievements and to the assembly and pledge of a "gigantic museum of which it had been his first intention to leave his country heir," he argued that only his seven long months of imprisonment had kept him from making the monte whole. He concluded:

> I will not address my prayers to you, Signori, I will not implore your pity. That bespeaks a man who has a guilty conscience. I will not restate the services rendered to the state and the public, nor the titles of merit from my country, there is no need of that. I demand your justice.[35]

On the morning of July 5, the antechambers of the court were guarded by gendarmes who prevented the crowd from getting too close; troops of police agents controlled the stairs and the courtyard. When the judges assembled, prosecutor Benvenuti told them that he did not intend to submit a further brief as their decree had required because, in his view, current criminal procedures dispensed with the former rules under which the prosecutor could be ordered to file a supplementary statement. Benvenuti's true reason for silence, according to the marchese's sympathizers, was his reluctance to enter into new legal debates "from which he would emerge with his bones broken."[36] Marchetti was not willing to allow Benvenuti's noncompliance with the court order to go unchallenged. He argued that, because of the procurator general's recalcitrance, the court should revoke its former order and acquit the marchese, since it could not condemn the defendant on the basis of the original record without contradicting its last ruling.

The court heard Marchetti's argument in silence and retired; shortly it returned to issue still another interim order. The judges ruled first that the prosecutor was correct in concluding that he could not be compelled under current criminal rules to file a supplementary brief. Chief Judge Carletti explained for his colleagues

that their decree of June 26 requesting such a brief was not moti-
vated by reasons affecting the merits of the case but was intended
to permit Benvenuti to weigh better his arguments in response to
the many attacks that the defense had made in its published brief.
Having found a way out of the procedural maze it had created, the
court then ordered the arguments to be resumed.

Sensing that the tide was turning in his favor, Benvenuti did
not even bother to recapitulate and combat the defense arguments,
limiting himself to a few comments about the opinions of Italian
jurists that Marchetti had filed in support of his brief. The defense
counsel, on the other hand, took this last opportunity to persuade
the court of the inappropriateness of criminal sanctions; he asked
the judges to order a current appraisal of the museum, offering to
stake his client's freedom on a finding that the value of the collat-
eral exceeded his debt.

After three hours of deliberation, the court reemerged from its
council chambers to issue the long-awaited judgment. It found that
the prosecution had established that Campana was guilty of contin-
ued theft or fraudulent appropriation of no less than 900,000 scudi
from the Monte di Pietà of Rome and condemned him to twenty
years at hard labor. In addition, it taxed him with the expenses of
the trial and adjudged him liable for the reparation of damages in
favor of the monte in an amount to be fixed in a civil judgment. It
ordered further that the criminal investigation be extended to in-
clude Campana's confederates and accomplices.

There was a sting in the tail of the judgment that was aimed
at Campana's lawyer. Because of arguments he had made to the
injury of the prosecution and the government in his published
brief, the judges ordered Raffaele Marchetti suspended for three
months from practice before the Criminal Court.[37] ༄

5

THE COSTLY
PARDON

Roman procedure required that within three days after condemning a defendant the Criminal Court must issue a formal judgment detailing its reasoning. According to rumor, the judgment in the Campana case had been drafted and shown to certain officials even before the July 5 hearing. The writing of the final judgment was the responsibility of Judge Alliata, whom Campana's friends regarded as the most ignorant and fanatical on the Roman bench. It was Alliata's misfortune, however, to lose his favorite child during the final stages of the Campana case, and he therefore delegated his drafting task to the magistrate Laurenti, who had already been rewarded for his willing compliance with the prosecution by a promotion to the post of assistant procurator.

When Laurenti's draft was submitted to the Criminal Court, Chief Judge Carletti was highly displeased; it seemed to him that the court's reasoning was not adequately explained and that the defense's positions were ineffectively rebutted. Accordingly, with the agreement of his colleagues, he reassigned the writing chore to the assistant procurator Gioacchino Mazza, who was the most highly respected of the prosecutorial officials. In the meantime, Romans whispered that Pope Pius, dissatisfied with the language of

the judgment and moved by public sentiment, was vacillating, and had deputed a group of cardinals to consider the possibilities of suspending the sentence or granting a pardon. The mess Laurenti had made of the judgment draft inspired various satires, including a burlesque public notice that read: "Notice: Whoever finds the reasons for the condemnation of the Marchese Campana and reports them to the Chancellory of the Criminal Court will receive a good tip."[1]

When the formal judgment was still not issued after twenty days, the trial judges became reluctant to appear in public. Those who were brave enough to face their fellow citizens were mocked on the street. In their own councils the judges completely lost their composure and, when the new Mazza draft was presented, they tore it apart like "men possessed."[2] Chief Judge Carletti, unable to win a consensus, turned to ministers Antonelli and Mertel for advice, but neither wanted to get involved. Finally, the trial judges, being unable to agree on any other course, adopted and published as their judgment the version prepared by Laurenti.

Despite the fact that Vatican authorities had long promised that condemnation would be swiftly followed by pardon, Campana's suffering had far from run its course. The marchese's camp attributed his protracted ordeal to the duplicity of Cardinal Antonelli. To Emily and to the friends of the condemned man the secretary of state had made a great show of sympathy; he recalled that he had been a friend and college companion of Campana's, conceded his merit, and promised to do his best to rescue him. When approached by cardinals, prelates, and other distinguished persons on the marchese's behalf, Antonelli repeated the assurance (often voiced in the course of the trial) that pardon was preordained. Despite those tranquilizing words, Campana's supporters worried that the secretary of state might have taken umbrage at the marchese's decision to present a formal defense; and when the issuance of the final judgment was delayed for more than a month, the prospects for clemency began to appear doubtful. The skepticism in the

marchese's camp grew as the government found one excuse after
another to postpone consideration of leniency. While the trial
judges quarreled over the wording of their decree, the administra-
tion argued that pardon could not yet be granted because the crim-
inal proceedings were incomplete. After the judgment was at last
issued, it was announced that pardon must await the trial of the
marchese's accomplices, Seni, Canestrelli, and Tedeschi. The new
trial was entrusted to the magistrate Laurenti, who was, according
to the *Causa Campana*, the only judicial official willing to "continue
a job that revolted all consciences."[3]

Meanwhile, Secretary of State Antonelli, continuing to profess
concern for Campana, advised the marchese's relatives and his ad-
ministrator, Benucci, to petition for Campana's transfer to a health-
ier place, such as Ancona, until his pardon could be issued. The
prisoner's friends, now thoroughly disillusioned about the cardinal's
motives, assumed that his true purpose was to get both the Cam-
panas out of Rome so that he would no longer have to stand guard
against Emily's incessant petitions to the Holy Father for the release
of her husband. Ultimately, Antonelli's advice was disregarded and
the marchese stayed in San Michele, without having to bear the
indignity of wearing convict's garb. This was the only dispensation
granted him, for he remained under close surveillance and was not
permitted to receive any visitors except his wife, the administrator
Benucci, and a number of cardinals and other important guests
whom the government could not decently refuse.[4]

Not only did the papal regime defer Campana's release but it
also increased his torments by putting him under greater financial
pressure: While the trial of the accomplices remained unresolved
(allegedly because of Canestrelli's refusal to testify), Treasurer Fer-
rari ordered all Campana's real property subjected to a general lien.
By seizing Campana's assets, the government alarmed his numerous
creditors and enhanced the risk that they would initiate bankruptcy
proceedings.[5]

Campana's administrator, Giacomo Benucci, a man of high

reputation and considerable personal credit, did his utmost to avert this new calamity. Benucci persuaded creditors that there was a means of paying all of them if they would remain patient; he presented settlement plans and obtained the backing of a majority of creditors. Pope Pius, finding merit in Benucci's effort, gave him words of encouragement and promised to instruct Ferrari to negotiate directly with him regarding the liquidation of Campana's obligations to the monte—it seemed to Benucci that the pontiff still harbored a desire to see the Campana collection converted into a Roman museum. Spurred by the pope's apparent support, Benucci entered into discussions with Treasurer Ferrari and with the new director of the monte, a lawyer named Massani. Their talks resulted in a deal contemplating the government's release of its lien on Campana's real property; Benucci, under Ferrari's supervision, would sell the real estate and at the same time seek a reduction of creditors' claims in order to arrange an overall settlement. When these steps were completed the Campana museum would emerge free and clear and would be available to satisfy the debt to the monte.

Because of the difficulty in setting the market value of the collection, the following terms were agreed to: (1) the government would buy the collection for a price equal to Campana's adjudged debt to the monte, and the marchese would be generally released from any further liability; (2) the sale would not be regarded as final until the passage of one year from the date of the agreement, and in the meantime the marchese would be permitted to negotiate abroad for a better offer; (3) if the offer of a better price was obtained within that period, the marchese would notify the government, which would have the first right to purchase, and if it did not exercise that right, would permit the sale to third parties, receiving the amount of Campana's debt from the proceeds; and (4) if the marchese did not succeed in obtaining a better offer within a year, the temporary sale to the government would become irrevoca-

ble and Campana would not be permitted to make any claim for adjustment.

Treasurer Ferrari reported these terms to the pope, who appeared to be satisfied but added, much to Benucci's disappointment, that in an affair of such importance Secretary of State Antonelli must be consulted. When the treasurer summarized the tentative agreement for Antonelli, he received a tongue-lashing; Antonelli said that the arrangement was completely unacceptable and that the Campana collection should be publicly auctioned. To strengthen his hand, the cardinal won support for his position from the Council of Ministers.[6]

Antonelli's counterstroke did not break the spirit of the Campanas or Benucci. Emily submitted a mildly worded petition to the pope arguing against the auction of the collection. Benucci took a stronger position, threatening to resign as Campana's administrator, thereby leaving the creditors free to take any actions they deemed best. Pope Pius was upset by Benucci's resolute tone and asked him to put off his resignation for a few days so that appropriate measures could be taken; what the pope had in mind was suspending the action of the Council of Ministers so that negotiations with Campana's representative could resume.[7]

Meanwhile, the trial of Campana's subordinates had finally concluded. Magistrate Laurenti had used different tactics with the three defendants. With Seni, who was the most deeply involved in the marchese's withdrawals, Laurenti tried jokes and backslapping because the cashier had greatly aided the Campana prosecution with his testimony. Toward Tedeschi, who was frank in his disclosures, the magistrate behaved courteously, but Canestrelli was timid and uncooperative and became the prime target of Laurenti's hostility. By the time the case was heard, the government showed no great interest in convicting the employees because its main concern was to avoid a judgment that would undermine the prior condemnation of the marchese. The trial court read the prosecution's intentions

astutely; Tedeschi was ordered dismissed from his post, but Canestrelli and Seni were declared innocent. The marchese was greatly disturbed by the trial of his subordinates because he believed they were suffering for him. His friends said that he rejoiced in their final triumph as if it had been his own.[8]

With the secondary trial now out of the way, the determination of the museum's fate remained the principal roadblock to pardon. Fearing that Secretary of State Antonelli would be outraged by the pope's defection from the auction strategy, Benucci decided to break the news to the cardinal personally. The administrator used all his formidable powers of persuasion, suggesting that despite his great perspicacity and wisdom, His Eminence might not have assessed the pernicious consequences of a creditors' proceeding and a public auction. While the cardinal obviously hoped for the monte to be made whole and for creditors to be satisfied, the auction plan would bring about general ruin and would cause half of the Campana estate to be devoured by expenses. In the lawyers' opinion, the creditors' claims were so involved that a bankruptcy would require a year or two before accounts could be settled.

Antonelli was impressed by Benucci's arguments and consulted the legal views of the monte's new director, Massani. The director told him horror stories about creditors' proceedings that could last for ten years while feasting on the debtor's estate. Massani ticked off all the formalities that must be observed: selection of expert appraisers, trial, notices, and ultimate rulings by the Sacra Rota to which appeal could be taken. Then, too, in cases involving assets as vast as those of the Campana museum, the date of public auction would have to be fixed enough in advance to facilitate the participation of all Europe. Since the marchese lacked the financial means to sustain protracted litigation, creditors were sure to use their best efforts to attack the monte's position and carve out for their own benefit as large a portion of the museum assets as possible. The cardinal was forcibly struck by Massani's warnings and also worried about the pope's inconstancy. He therefore gave up the

idea of the auction and did not oppose Treasurer Ferrari's resumption of negotiations with Benucci.[9]

Antonelli, however, was determined to stiffen the bargaining terms. The monte would take in payment not only the Campana museum but also the large collection of Chinese vases; Campana would not have an opportunity to achieve a higher price through sale abroad. In return, the government would release the lien and sequestration orders against the marchese's real and personal property and would lend him considerable sums to finance the administrative costs of his settlement with creditors. Benucci accepted these new terms and, before reporting his assent to the pope, took the precaution of making a prior visit to the treasurer, who assured him that the deal was set. The minister had spoken too soon, though, for the new agreement, instead of being presented to the pope, was submitted to Antonelli, who decided to extract some additional concessions. The cardinal entrusted the preparation of the proposed settlement contract to Monsignor Giansanti, a lawyer more noted for ostentatious churchgoing than for professionalism. In his draft Giansanti included among the assets to be surrendered all art objects, whether or not included in the Campana museum, industrial shares, the typography establishment, the marble factory, and even household furnishings. What is more, the price tag of 900,000 scudi, the amount of the adjudged debt, was attached to all this property and the monte would no longer provide the marchese a general release but would reserve its right to make additional claims in the future.

When these extortionate conditions were conveyed to the marchese, his old pride reawakened and he refused with disdain. Benucci complained bitterly to the treasurer of this breach of faith, but the minister shrugged his shoulders, placing the blame elsewhere; nevertheless, he advised Benucci to calm down and promised to use all his influence to see that the marchese retained the marble factory and some personal property.

Treasurer Ferrari was able to obtain this promised moderation,

but then the parties began to wrangle over the terms of a power of attorney by which the marchese, still a prisoner at San Michele, would authorize Benucci to sign the settlement contract on his behalf. Substantially revising the first draft submitted to him, the government's attorney Giansanti inserted a preface including admissions of guilt that were offensive to Campana; the entire settlement might have evaporated if monte director Massani had not found a way to delete this narrative from the instrument. Bent on further humiliation of Campana, however, the government insisted that the text of the criminal judgment be attached to the power of attorney and that the title of marchese be omitted from Campana's name. This last indignity rankled since that title had been awarded by the King of Naples, and was therefore not within the power of the papal government to rescind.

The revised power of attorney was scheduled to be signed on Holy Saturday, April 23, 1859. On that day the marchese was invited to leave his prison room and was led by a gendarme into the official hall of the commander of San Michele prison. There, a notary exhibited the proposed power of attorney, which declared that the marchese, pursuant to special authorization, had been put in a state of "freedom" for the purpose of executing that document. The gendarmes who were present served as witnesses to Campana's signature and then led him back to his cell, terminating his short-lived liberty. Inadvertently the notary, in supplying his attestation, added a reference to the proscribed title of marchese. It was therefore necessary to bring Campana back to sign a marginal note disclaiming his embattled title.[10]

Pursuant to the authority of the power of attorney, Benucci executed the oppressive settlement contract, concluding that it was the best that could be obtained. Under the contract, Campana conveyed to the monte all art objects, personal property, industrial shares, and business assets, except the marble factory and certain furniture described in an exhibit. The retained personal property is identified room by room with pitiful exactness: four divans, eleven

cushions, a clock, two girandoles with pedestals, and other modest
items. On behalf of the monte, Treasurer Ferrari accepted the prop-
erty transfers in partial reduction and payment of the Campana
debt up to the amount of 900,000 scudi, with excess claims re-
maining in effect. The delivery of the art objects was to proceed
class by class according to Campana's twelve printed catalogs.[11]

The reservation of claims against the marchese in excess of the
adjudicated 900,000 scudi was a political rather than an economic
weapon; this provision assured the government that after Campana
was freed to go into exile he would not dare to return to Rome for
fear of facing additional proceedings. This punitive overreaching by
the Antonelli administration deeply offended the marchese's sup-
porters, already shocked that the government would give a prisoner
the option of signing a one-sided contract or spending twenty years
in penal servitude. The authors of the *Causa Campana* compared
Campana's situation to that of a man, attacked by a highwayman,
who surrenders property requested of him politely with a knife at
his throat.[12]

With the settlement contract signed and delivered, the mar-
chese had finally bought his freedom. The prisoner, with the sup-
port of his wife, was brought before a notary of the Criminal
Court, who read the decree of clemency stating that His Holiness
"on the petition of Giampietro Campana condemned by the Crimi-
nal Court of Rome, for continuous theft to the damage of the
Monte, to twenty years of prison has benignantly deigned to com-
mute the sentence to perpetual exile from the entire state." The
notary dryly called upon the marchese to declare whether he ac-
cepted the commutation and, if so, where he intended to go. Cam-
pana cried for a moment but was comforted by Emily. Recovering
his composure, he declared that he accepted the pope's decree and
wanted to go to Naples; when the notary proffered a document of
acceptance, he signed without hesitation. The authors of the *Causa
Campana* noted the irony that the commutation was the same as
that conceded to the anarchist Orsini (later to attempt the assassi-

nation of Napoleon III) for a crime against the state and was less generous than that granted to a four-time forger.

Secretary of State Antonelli had wanted Campana to leave the papal territory immediately but permitted him to stay another week to arrange his affairs. Even this minor favor was conferred grudgingly; all Campana's actions had to be taken by proxy, for the cardinal ordered him kept in prison until the last possible moment. Campana was also enjoined to keep the day of his departure secret, and the director of the prison was instructed not to let him leave if there were people on the streets around San Michele. The government had heard that a public ovation had been prepared for the famous prisoner and was determined to prevent it.

The closing pages of the *Causa Campana* describe the desolation of Campana's final hours in Rome. When he left prison, only a servant was in attendance. A plainclothed gendarme mounted with him the carriage that was to take him to the border. At the Lateran villa he embraced his relatives, a free man after a year and a half of imprisonment; the loyal Emily "waited for him at the gate of the city."[13]

6

THREE NATIONS
GO SHOPPING

When in 1856 it became known in
England that the hard-pressed Campana was willing to sell art-
works, the trustees of the British Museum sent Charles Thomas
Newton, curator of antiquities, and his colleague Samuel Birch to
Rome to report on the collections. After careful examination the
men recommended acquisition of nine of the twelve sections of the
museum as the only feasible means to obtain the ancient objects
they desired—all the antique works except for the marble statues.
Campana considered their offer of 34,246 pounds (850,000 francs)
insultingly low and rejected it out of hand. Though Messrs. New-
ton and Birch had ignored all works outside their province—anti-
quities—the National Gallery afterward tried unsuccessfully to pur-
chase selected paintings.

After a full catalog of the collections had been published in
Rome in 1858, the English again attempted to make a purchase.
This time the newly formed South Kensington Museum made a
bid, but by then Campana had been required to cede his owner-
ship. Once the collection became the property of the papal govern-
ment, which was bent on its prompt liquidation, not only the Eng-
lish but the Russian and French governments as well hovered over
the artworks like vultures disputing their prey.

The Campana collection was probably the most diverse ever put together during the nineteenth century, even greater in variety than the art treasures gathered by Lord Hertford on his trips to the Continent that would become known as the Wallace Collection, after his heir. It was small wonder that the marchese's confiscated collection elicited the interest of many buyers, each of whom was eager to garner the finest works for his institution.

In 1859 a German archaeological journal published a rumor that the pontifical government had itself acquired the entire collection for a million and a half scudi "to the joyous surprise of all friends of antiquity."[1] Perhaps this false news was an attempt to attract buyers at a higher price.

The English were the first to make a purchase, acting for the South Kensington Museum, predecessor of the Victoria and Albert. The newly formed South Kensington Museum was actively adding works of decorative art to its meager holdings. The museum exemplified a new approach to art collecting: Instead of seeking to acquire masterpieces, its founders established a museum of "practical art," that is, of decorative works from which the artisan could model designs for manufacture. First located in Marlborough House, the museum had been established in 1852 with surplus funds from the Great Exhibition of 1851, which had demonstrated England's progress in technical and industrial fields at the same time as it revealed its inability to compete with other countries in design. Originally called the Museum of Manufactures (and later renamed the Museum of Ornamental Art), the institution aimed to improve English design by exhibiting artworks as patterns for commercial use. A brainchild of Prince Albert and Henry (later Sir Henry) Cole, who had worked together in organizing the Great Exhibition, the museum was moved in 1857 to a new setting, temporary buildings of iron and wood nicknamed the Brompton Boilers, housing the enlarged holdings near the grounds of the Great Exhibition in South Kensington, from which the museum took its new name. Its back rooms were given over to the art school (later

to be known as the Royal College of Art), to which the museum
was linked not only physically but also philosophically, its founders
believing that only through aesthetic education could the future
designers of England improve the quality of English products. But
although the museum and the art school shared the same site, the
new superintendent of the Schools of Design, Henry Cole, stated a
broader goal than the training of craftsmen. In a lecture that Prince
Albert attended, Cole stated that "in order to improve manufac-
tures the earliest work is to *elevate the Art education of the whole people*,
and not merely to teach artisans, who are the servants of manufac-
turers, who themselves are the servants of the public."[2] Cole com-
pletely revitalized the Schools of Design by allying them with the
South Kensington Museum and expanding them to form a national
network of vocational schools.

Cole's philosophical outlook had roots in his youthful contact
with men like Thomas Love Peacock and John Stuart Mill. Their
radical ideas instilled a reforming zeal in the young man, who had
not had a university education.[3] In his various civil-service jobs,
from the public records commission to the treasury, Cole, whose
power and girth won him the press nickname King Cole *(Fig. 9),*
was devoted to reform, and even outside of his professional work he
attempted to elevate public taste by producing tasteful children's
books and tea sets and promoting educational exhibitions of indus-
trial arts.

Cole's zeal was lampooned by Charles Dickens in *Hard Times*
(1854), in which an art official, probably based on Cole, is de-
scribed as "a professed pugilist; always in training, always with a
system to force down the general throat like a bolus . . . ready to
fight all England."[4] This gentleman takes over Mr. Gradgrind's
classroom and teaches the children the rules of taste in "the practi-
cal arts." He sternly admonishes one Sissy Jupe, who confesses she
favors flowered carpets: " 'You are not to have, in any object of use
or ornament, what would be a contradiction in fact. You don't walk
upon flowers in fact; you cannot be allowed to walk upon flowers in

carpets. You don't find that foreign birds and butterflies come and perch upon your crockery; you cannot be permitted to paint foreign birds and butterflies upon your crockery . . . This is the new discovery. This is fact. This is taste.' "[5] This satire of principles of "taste" was probably derived from Dickens's reading of a Marlborough House catalog on ornamental art, and apparently he caricatures the feisty Henry Cole (who in 1852 had become superintendent of England's newly formed Department of Practical Art) as the "government officer" in the classroom.

Although to today's reader Dickens's introduction of an art official into the elementary schoolroom may appear ludicrous, in actuality Cole's Department of Practical Art not only established provincial schools of design for artisans but also trained teachers of art for elementary schools throughout the country. Any schoolteacher with a little ambition could, by taking a course at a local school of design, be certified to teach art according to Cole's principles at the elementary level and thereby increase his salary. By 1864 Cole proudly announced in his report to a select committee that his teachers were promulgating his rules of art to some 70,000 schoolchildren.[6]

The results of this network of education reaching out from Cole's South Kensington office would be disputed. The stubborn notion that if elementary schoolteachers were trained their charges would achieve a greater understanding of art and a higher level of taste would be questioned not only by Dickens but in a more serious manner by the powerful art critic and educator John Ruskin. Looking back on Cole's regime some twenty years later, Ruskin wrote: "The Professorship of Sir Henry Cole at Kensington has corrupted the system of art-teaching all over England into a state of abortion and falsehood from which it will take twenty years to recover."[7]

At the same time as he was expanding the Department of Practical Art, Cole also added to the art collection for the public to study at the South Kensington Museum. With an eye toward rein-

forcing his doctrine of emphasis on the "practical arts" he searched out groups of decorative arts that could serve as models of taste for both producer and consumer of English design. The collection concentrated mainly on objects of the medieval and Renaissance periods, works that had only recently been regarded as worthy of collecting. Still thought of as secondary to ancient art, however, these works were viewed as suitable models for manufacture rather than as artworks of importance in themselves. With a new building to fill and a substantial acquisition budget, Cole and his curator (John) Charles Robinson, a connoisseur of Renaissance sculpture, went about acquiring sculpture and ceramics from private collections. Such purchases included the Gherardini collection of Renaissance sculpture bought from a Florentine family in 1854 and the Soulanges collection of majolica and bronzes acquired from a Toulouse family in 1856. The Gherardini collection consisted of wax sketch models, which were considered more suitable for teaching purposes than finished sculpture. It was under the guise of models that Robinson was able to introduce works of aesthetic quality into the museum.[8] For this curator, who was more concerned with collecting outstanding artworks than with supplying artisans with examples suitable for copying, the Renaissance sculpture in the Campana collection must have appeared very tempting.

Often in the forefront of taste, Campana appears to have sensed the coming popularity of the decorative art of the Renaissance when, only shortly before his arrest, he began collecting such objects. Most of these works had been chosen by one of the marchese's agents, a Roman man of letters, Ottavio Gigli, who not only scouted for Campana but also assembled his own important collection of Italian sculpture. Gigli negotiated for the sale of his sculptures to Campana, but the transaction was not consummated; instead, the marchese obtained financing for Gigli's holdings by arranging that they be pledged to the Monte di Pietà to secure a borrowing that reached 35,500 scudi (about 180,000 francs) with interest. By combining the Gigli pledge with his own vast borrow-

ings from the monte, Campana acquired effective control of his agent's collection. When Campana was arrested, Gigli's collection was sequestered along with Campana's, and the unhappy agent found it impossible to pay off the overdue loan and repurchase his holdings. Gigli's collection was probably of higher quality than many of his finds for Campana, a fact that the English would emphasize after their purchase.[9]

In 1859 Charles Robinson was instructed by a committee of the Council on Education, which oversaw the South Kensington Museum, to travel to Rome in order to study and report on what material could be garnered for the museum from the Campana and the Gigli collections. Robinson informed the committee that he found 69 of the 124 objects of the Gigli collection and 15 of the Campana collection desirable, but Gigli demanded too high a price and the papal government refused to sell separately the 15 objects of sculpture and majolica from the Campana collection. After these negotiations failed, Gigli went to England and then traveled to Paris and Saint Petersburg with an album of photographs of his objects hoping to interest buyers, but he met with no success. Robinson, however, did not give up. In the autumn of 1860, judging that the political difficulties arising from the Italian Risorgimento might make Rome more accommodating, he decided that the moment had come to reopen negotiations with the papal government. At the end of December 1860, after protracted bargaining, Robinson succeeded in closing the deal for 5,836 pounds, or 1,314 pounds less than the amount lent by the Monte di Pietà on the Gigli collection. He also managed to make the Roman government waive the 20 percent value added tax customarily placed on ancient art leaving the Papal States. Robinson returned to London with all the eighty-four works he had originally chosen, most of which came from the Gigli collection.

Though Robinson had struck a good bargain, the English appear to have kept the acquisition secret, or at least not to have publicized it. The French were not aware of the purchase until

1861. One reason for British reticence about the acquisition may have been the then current criticism by conservative English collectors of the purchase of medieval and Renaissance decorative objects rather than ancient works. In 1856 when the English museum attempted to purchase the Soulanges collection of majolica and bronzes and displayed the objects at Marlborough House, Lord Palmerston, horrified at the notion of featuring Italian medieval or Renaissance objects in the museum, asked, "What is the use of such rubbish to our manufacturers?"[10] After the exhibition, Palmerston's views were supported by the treasury, which refused funds for the purchase. Thus when a similar collection was acquired from Campana a few years later, Robinson did not make an immediate public announcement. In 1862, when he published the Campana works in a museum catalog, he was careful to justify purchases of sculpture and decorative arts of later periods, stating that they continued a series begun with the ancient art collected by the British Museum. He also tried to draw the teeth of criticism when he explained the importance of providing original works rather than casts as objects for the design students to study: "It may here be asked, why casts might not serve instead of original specimens, only to be obtained with such difficulty and cost? The answer is, that apart from that natural feeling of the human mind, which attaches the highest value only to original works, plaster casts are by no means such exact reproductions as is generally supposed."[11] He went on to state that the South Kensington Museum was the "proper repository of this class of the National acquisitions" because of the "intimate connection of medieval and renaissance sculpture with the decorative arts in general."[12]

Today Robinson's acquisition is considered by the expert on Renaissance art, Sir John Pope-Hennessey, to be a "triumphant purchase . . . which brought to the museum most of its incomparable series of Donatellos and Luca della Robbias and a host of other important sculptures. The purchase was made with the support of Gladstone, and was the taking-off point for the finest collection of

Italian sculpture in any museum outside Italy."[13] Although Glad-
stone approved, Robinson would suffer for his connoisseur's taste.
Pope-Hennessey states: "Posthumously deep gratitude is due to him
for his achievement, but that was not the official reaction at the
time. The more great works of art arrived at the museum, the
more evident did it become that there was a conflict between his
view of the role of what had by then become the South Kensington
Museum and that of Sir Henry Cole, who was in overall charge.
Throughout the 1860s Robinson's purchasing powers were circum-
scribed, and thereafter matters went from bad to worse. Finally in
1867 the authorities abolished his post."[14]

Included in Robinson's purchase were many masterpieces.
Donatello's marble relief, *Ascension with Christ Giving the Keys to
Saint Peter (Fig. 10)*, is today considered the most important work
of the sculptor exhibited outside of Italy. An example of flattened
relief (*rilievo stiacciato*), in which through slight variations in depth
of carving the sculptor creates an illusion of deep space, this impor-
tant work probably came from a Medici collection. Purchased by
Campana around 1850, it was known in the late sixteenth century
to belong to the Florentine Salviati family, related by marriage to
the Medicis, and is thought to be identical to a relief listed in the
inventory made at the time of Lorenzo de' Medici's death.[15] Other
works from a Medici collection in the English purchase are the
twelve roundels in enameled terra-cotta depicting the *Labors of the
Months*, by Luca della Robbia *(Fig. 11)*. Commissioned by Piero de'
Medici to decorate the ceiling of his study, the roundels are all that
remains of the room, admired by Vasari, which was gutted in 1659
when the Palazzo Medici was sold to the Riccardi family. Pope-
Hennessey states: "In the context of Luca's work the ceiling is ex-
ceptional in almost every respect. The figures in the roundels are
not modelled, but are drawn in white and dark blue on a blue
ground . . . They are thus the only figurated paintings in Luca's
entire oeuvre." It is probable that the scenes are derived from "a
northern manuscript in Piero de' Medici's collection."[16] The Cam-

pana purchase also included the first signed and dated work by Antonio Rosellino, a marble *Bust of Giovanni Chellini (Fig. 12)*, the only such portrait bust in the fifteenth century to have been sculpted from a life cast.[17] Another extraordinary work is the *Sketch Model for the Forteguerri Monument*, by Andrea Verrocchio *(Fig. 13)*. Verrocchio died before Cardinal Forteguerri's monument, a cenotaph in Pistoia Cathedral, was finished; this late work in terra-cotta is the only model of its kind from the fifteenth century.[18]

The English, recognizing that the finest of the objects they had purchased came from the Gigli collection, designated those objects in their catalog as Gigli-Campana, a term that the French art historian Ernest Desjardins later derisively termed an attempt to "ennoble" their acquisition.[19] Robinson and his colleagues, however, were probably under pressure from local critics to prove that their holdings merited the funds spent, for in 1860 the museum had been attacked as extravagant by a member of the House of Commons, Danby Seymour, who declared with indignation: "While no attempt was made to popularize the other national collections, large sums were being spent at Kensington in giving lectures, in lighting with gas the buildings erected there, in establishing schools, opening the galleries at night, giving conversaziones, and sending out cards of invitation to all whose support might be valuable hereafter."[20] The efforts to attract and educate the public at South Kensington were considered by many to be extravagant and even ridiculous. In 1861 *Punch*, in an article entitled "Sightseeing and Sneezing," poked fun at the uncouth public who frequented the South Kensington Museum and coughed on the exposed surfaces of the pictures.[21] The museum officials, who found themselves forced to put their objects under glass to protect them from the crowds, hoped to avoid further criticism by keeping a low profile on the Campana purchase. If their maintenance expenses were regarded as excessive by members of Parliament, the sums spent for original specimens of unfashionable Renaissance sculpture and majolica would certainly be rated exorbitant.

Thus the English museum officials, in their belated publication of the collection catalog, took pains to justify the expense. Russia, the second country to make a purchase from the extensive Campana collection, took the opposite tack, proudly trumpeting its prizes to the world as soon as the deal was completed. The Russians had probably first learned of the collection when Gigli traveled to Saint Petersburg with his album of photographs. Shortly before the Russian purchase in 1861, it was reported that a private company had been organized with capital of 7 million francs for the purpose of buying the Campana collection as a speculation. However, although two scholars, Taigny and Desjardins, refer to this consortium, Reinach doubts whether so large a sum would have been available for an art purchase during this period of political unease.[22]

Apparently the Russians believed they had been offered the entire collection, and following negotiations by Stepan Gedeonov, who was sent to Rome in 1860 by Czar Alexander II, a deal was struck on February 20, 1861. Russia acquired for 650,000 francs (26,000 pounds) 767 objects including sculpture *(Fig. 14)*, bronzes *(Fig. 15)*, and 518 vases, some of great value *(Fig. 16)*.[23] The pope was so pleased that he gave the Russians as a premium the superb hydria from Cumae. With depictions in colored and gilt relief of the Eleusinian gods, this vase was greatly admired throughout Europe and very much desired by the Louvre. Among the sculpture, the most important work was the Athenian marble Niobid relief, referred to by the ecstatic Gedeonov as "a poem in marble."[24] By March 1861 the Russians published a catalog listing some eighteen sections. Aside from the few well-known pieces, the collection was composed mainly of ancient statues, sarcophagi *(Fig. 17)*, vases, bronzes, armor, and mirrors. Some were of good quality, but many of the statues were restored and some were fakes. The only paintings the Russians purchased were a series of badly restored frescoes mistakenly attributed to Raphael.[25]

The Russian purchase acted as a spur to the French government. It was rumored that Adrien de Longpérier, the Louvre's cura-

tor of antiquities, made a hurried trip to Rome and after viewing what was left of the Campana collection dispatched to Paris an un-favorable report on its acquisition by France. Longpérier was a bril-liant scholar who knew many ancient languages and had a prodi-gious memory and a tremendous fund of knowledge. However, the director of the Department of Fine Arts, Philippe de Chennevières, recalled of Longpérier that despite all his knowledge "never has one seen a scholar more lightly baggaged with publications."[26] Despite his eye for designing exhibition installations, eventually his "invin-cible laziness" in publishing his works and even in keeping his inventories in good order forced the dismissal of this exceptional scholar from his job at the Louvre. It may have been his indolence that impelled Longpérier to advise against purchase. Indeed, the immense number of ancient objects, and the staggering tasks of inventory and publication they presaged, may well have over-whelmed the unenergetic curator; perhaps he attempted to forestall the purchase out of self-defense.

Longpérier's lack of interest in the Campana collection may also have been due in part to his awareness of the emperor's indif-ference to the acquisition, for although England and Russia were quick to send emissaries to Rome, the French had long remained aloof. As early as 1858 the Alsatian painter Victor Schnetz, direc-tor of the French Academy in Rome, who had suggested that France acquire the entire collection, had been told by Charles Lenor-mant, archaeologist and inspector of the Fine Arts Department, that the emperor was not interested. Writing from Paris on January 16, 1859, Lenormant, who had seen the collection while on an unofficial visit to Rome, informed Schnetz that the minister of state had told him "the thought of the acquisition is more and more distant from the mind of the Emperor. This indication has been confirmed by our friend [Prosper] Mérimée, on his return from Compiègne. Despite all his efforts, he had not been able to have a serious discussion of the project with the Emperor."[27]

Schnetz, in February 1859, wrote directly to the emperor urg-

ing the purchase as a great coup for the French leader; he argued
that by adding the Campana collection to the riches already pos-
sessed by the Louvre, the emperor would "be blessed by all those
who love the arts, who cultivate them and who have their hearts set
on France's leading the nations by her artistic riches just as she does
by her military and other glories."[28] After this persuasive begin-
ning, director Schnetz pointed out that, though the collection was
expensive, its renown justified the price; it would bring people to
Paris since "it is known and has been admired by all the intelligent
people of Europe."[29] To Schnetz the Prince of Wales's presence in
Rome was evidence that the British Museum was interested in the
collection, and he urged the emperor not to let the English acquire
a collection of which they were not worthy. Schnetz closed his letter
with the contention that the Campana objects would act as models
to inspire both art and industry in France. Thus the Schnetz appeal
proposed two possible uses of the objects: to fill gaps in the Louvre
holdings, and to transform the Campana collection into a French
version of the South Kensington Museum. Schnetz also indicated
that the French government had not yet sent experts who could
properly evaluate the collection, since Lenormant, though enthusias-
tic, had examined the works unofficially and had to avoid public
advocacy in order not to offend the minister of state.[30]

The Schnetz letter appears to have had an immediate echo in
the Parisian art press. The new art periodical *Gazette des Beaux-
Arts*, founded in January 1859 by Charles Blanc and Edouard
Houssaye, published an article from Rome signed J. Doucet de-
scribing the Campana collection, which the author had visited in
the company of the marchese Campana. This article, like Schnetz's
letter, played up the rivalry between France and England. It in-
cluded an illustration of the Niobid frieze, an admired classical
work which the Russians would later take as part of their portion
when they closed their purchase. In his essay Doucet cited the
frieze as an example of the high quality of works available in the
Campana collection and suggested that France should buy the col-

lection rather than let England, which already owned the Parthenon friezes, become its proud possessor.[31]

Doucet's essay in *Gazette des Beaux-Arts*, though intended to inspire French interest in acquiring the collection, failed to move the emperor, if indeed it was shown to him. However, it was rumored in Rome that after receiving Schnetz's letter, the emperor gave him an audience at Chalons. The meeting did not go well, and Schnetz returned to Rome where, according to a friend, he may have unintentionally leaked to the Russian ambassador, Kisselev, his opinion as to which objects were the most important in the Campana collection.[32]

In the end, it was hardly Schnetz's letter that moved the emperor to consider buying the collection. The crucial impetus probably was the news that the Russians had closed a deal with the Vatican. That report came to Napoleon III through Hortense Cornu, a woman with whom he had very old and close ties, and with whom he probably shared a friendship with the Campana family dating back to his days in Ham.

Hortense Lacroix Cornu *(Fig. 18)* was the daughter of one of the ladies-in-waiting to Napoleon III's mother, when she was queen of Holland. A goddaughter and namesake of the queen, the young Hortense was brought up with Louis Napoleon in the castle of Arenenberg. During their childhood the unprepossessing Hortense, a hunchback with bulging eyes, dominated the weak and indecisive boy, a year her senior. While he was in the fortress at Ham, she visited him often and assisted him with his book on artillery. During that time she may well have known the future Marchesa Campana and her mother, who were among the supporters of Louis. On his escape, Madame Cornu joined him in England and continued to see him when he returned to France.

Though deeply attached to Louis, Hortense Cornu was a woman of passionate views of her own. A dedicated republican in politics, with a strong feeling for the working classes, and a Voltairian anticlerical, she could not countenance the coup d'état,

about which she had never been consulted. Her friend the historian Ernest Renan described her as "having all the noble faults of the time of her youth. She loved Italy; she loved Poland; she had an aversion against the strong and a preference for the weak, seeing always in weakness a presumption of right."[33] When Napoleon III visited her in Vincennes after the coup, Madame Cornu refused to see him: She shouted from the stair landing that she did not want to receive assassins in her house. For some dozen years she remained estranged from Louis but softened somewhat after the birth of the imperial prince, in 1856. Even while she kept aloof, she maintained indirect relations with Louis and admitted to an English friend, Nassau Senior, "we correspond. I serve as his intermediary between several German scholars. I procure information for his book as I did in Ham for his book on artillery." These comments were made in 1861, the same year as France's purchase of the Campana collection. No doubt the correspondence to which she alluded touched on the Campana collection as well as on details of Caesar's biography for Napoleon's forthcoming book.[34]

Madame Cornu enjoyed great power over Napoleon in 1860 when they corresponded about the Campana collection, for the emperor was eager to regain her favor. Confident of the emperor's ultimate support, Hortense spoke in February 1861 to Léon Heuzey, a young archaeologist who, at her suggestion, was gathering material on Caesar's military campaigns for the emperor and planned to stop in Rome on his way to an archaeological mission in Macedonia. She asked Heuzey to investigate the status of the Campana collection. On March 3 he telegraphed her and on March 6 and 11 sent two detailed letters with the news that Russia had bought part of the collection. These communications were brought to the attention of Napoleon III at the same time that the Duke de Gramont, French ambassador in Rome, brought him a similar report, having been informed by Schnetz. The emperor's reaction was to direct Léon Renier to go to Rome to negotiate for the purchase; Renier was an expert on Ptolemy who, at Madame Cornu's recommendation, had

done research for the emperor on the Caesar project. Probably in gratitude for Madame Cornu's intervention on his behalf, Renier asked that her husband Sébastien be allowed to accompany him on the new mission. Cornu was a third-rate painter from Lyons who had studied with Ingres in Paris; he knew Rome, where he had lived between 1829 and 1835 and had met Hortense. Returning to Paris in 1835 he had led a difficult life: His rather dry, colorless paintings brought him scant success.

Renier and Cornu left for Rome on March 22; they kept their visit secret because Mr. Newton from the British Museum was in Rome, and the French did not want to arouse his suspicions. Apart from whatever flair they may have shown as secret agents, the two French emissaries were ill-equipped to evaluate the collection. A more likely candidate would have been the director of the Louvre Museum, Count de Nieuwerkerke. The emperor's decision to bypass Nieuwerkerke was to have disastrous consequences, for the count was not a man to forgive a slight. ᘜ

7

THE AMOROUS
MUSEUM
DIRECTOR

Count Alfred-Emilien de Nieuwer-
kerke, born in Paris in 1811, came from a Dutch family that had
settled in France at the end of the reign of Louis XV. Nieuwerkerke
claimed to be descended from a woman who had shared the king's
bed. His father, at least, was no stranger to the royal bedroom, for
he was a gentleman of the bedchamber to Charles X, and as a boy
the future art administrator had served as a page at court. Under
the July Monarchy of Louis Philippe, Nieuwerkerke began to study
sculpture with the Italian sculptor Baron Carlo Marochetti and
showed in the Salon of 1843 a bust of Count de Ganay, which
Princess Mathilde *(Fig. 19)* admired. He continued to exhibit his-
torical portraits in the Salon and became known as a modish sculp-
tor specializing in portraits of beautiful women. However, for Prin-
cess Mathilde, the sculptor would outshine his works; she resolved
to play a warmblooded Galatea to his Pygmalion. In her eyes he
epitomized the Renaissance ideal of an artist as a man of cultivation
and charm. His elegant manners and melodious voice (not to men-
tion his compulsive womanizing) made him a favorite among Pari-
sian hostesses and helped him to advance with spectacular speed in
the fashionable art world. Mathilde said of him in later years, "At
dominoes it is always he who has the double-six."[1]

A tall, powerfully built man with a barrel chest and the erect carriage of a military officer, Nieuwerkerke was called by Parisians le beau Batave (the handsome Dutchman) because of his striking looks and his full blond beard. His friend Arsène Houssaye, the editor of *L'Artiste* and later director of the Comédie Française, declared that "Nature had given him one of the finest of human forms."[2] The suave count's title came from his grandfather, who had married the illegitimate daughter of the duc d'Orléans, but the erect bearing with which he carried his six-foot frame he learned from his father, a cavalry captain before he became a member of Charles X's court.

The count and the princess first met in the Place Vendôme residence of Mathilde's uncle Prince Paul of Würtemburg. Mathilde was impressed not only with the thirty-four-year-old sculptor's looks and urbanity but also with his poetic way of speaking about art, a subject dear to the princess, who had studied watercolor painting as a girl and would later enjoy collecting art and socializing with artists. When they were first introduced Mathilde was still married to the rich and insensitive Russian Anatole Demidov. She had been betrothed to Demidov two years after her engagement to Louis Napoleon was broken off by her father, Jerome Bonaparte, indignant over the embarrassment caused to the family by the Strasbourg conspiracy. Jerome had arranged Mathilde's marriage to the Russian millionaire in the hope that Anatole would cover his father-in-law's many debts in return for a family link, through Mathilde, to the house of Würtemberg and to the Russian czar.[3] The announcement of Mathilde's wedding in 1840 came as a blow to Louis Napoleon, then imprisoned at Ham. Mathilde, who had grown up with Louis, was saddened by the turn her destiny had taken but took heart when she reflected that marriage to him would have kept her an exile not only from Paris but also from Italy, where he was regarded as a dangerous political agitator. To her, Paris was the center of life, the place where she most wanted to

live. As the wife of Demidov she believed her wish would be granted.

Shortly after the wedding, however, Mathilde discovered to her surprise that Demidov planned to reside in Italy. No sooner had the newlyweds arrived in Rome than the irascible Demidov managed to insult papal officials. The hot-tempered young husband was ordered home by the Russian government, to give an accounting of his behavior. Mathilde saved the day for Anatole by making a favorable impression on the Saint Petersburg court and the czar, to whom she appealed for a winter in Paris. Since the pair were not welcome in Italy for the moment, the czar gave Mathilde her wish, and it was during this 1841 visit to Paris that Mathilde first saw Nieuwerkerke. Two years later they met again in San Donato, where Mathilde played hostess to Nieuwerkerke and the count de Chambord, whom he was escorting on a grand tour of Italy. Mathilde welcomed the travelers to the Demidov collection at San Donato; Nieuwerkerke took her on a guided tour of the museums and churches of Florence and even tutored her in her study of painting, an avocation she had renewed on her return to Italy as a means of escaping from her uncouth and unfaithful husband.

By 1846 Mathilde's marriage had become unbearable. Her husband's abuse and humiliation of her in public impelled her to petition the czar for a separation. After what seemed like an interminable wait, the czar acquiesced; she was separated from her husband and given an annuity as large as she had had during her marriage. She was now free to invite Nieuwerkerke to her Parisian home, at 10 rue de Courcelles, and with his help established one of the city's great salons (*Fig. 20*), where she entertained Sainte-Beuve, Gautier, Flaubert, and the Goncourts, as well as favorite artist friends.

When in 1848 Louis Napoleon arrived in Paris to stand for election to the presidency, Mathilde lost no time in ingratiating herself with her ex-fiancé. She sold her jewels to help him finance

his campaign and introduced him in her salon to the movers and shakers of Paris. The entree Mathilde provided him, coupled with his active press campaign and his numerous appearances throughout the country at the openings of bridges and railway stations, enabled Louis, who had actually spent little time in France, to persuade the diverse elements of the French public that he could give them the leadership they wanted. Elected by an overwhelming majority, he was happy to grant Mathilde her wish, communicated to him within a week of his taking office, to make Nieuwerkerke director of the fine arts. The minister of the interior, M. de Malleville, however, refused to honor Mathilde's request, even when delivered by the president himself. The princess and her lover were furious at being turned down, and Nieuwerkerke made his feelings known to many of his friends. This episode demonstrated to knowing observers that Mathilde would stoop to anything, including the most blatant influence-peddling, to please Nieuwerkerke. A foreign aristocrat residing in Paris wrote perceptively: "He [Nieuwerkerke] has established a tyrannical system of pressure against the poor princess. He has become the absolute master in her house."[4] In the end, the princess's lover received a more limited title when Louis Napoleon, despite opposition from many quarters, appointed Nieuwerkerke in 1849 director general of the national museums.

Nieuwerkerke, who had a talent for self-promotion, was quick to include the entire imperial family in his portrait gallery. First he made an equestrian sculpture of Napoleon I and then another of Louis Napoleon, which was ready at the time of his coronation. He also wasted no time in making a bust of Eugénie (Fig. 21) before she married Louis. Nieuwerkerke even went so far as to invite Napoleon III to view this work in his atelier and flattered the emperor on his taste in feminine beauty.

Thus the new director general helped to pave the way for his own ascent in the art administration under the Second Empire. But there was an obstacle in the path of his ambition—the notoriety of his protracted liaison with Princess Mathilde. Nieuwerkerke's be-

havior toward his mistress was considered very déclassé by those
who witnessed the two together at her salon. There Nieuwerkerke
presided from his favorite chair and openly behaved like the man of
the house before all visitors, while Mathilde spoke of him as
though he were her husband. Though he kept separate lodgings,
his subordinate at the Louvre and distant relative, Count Horace de
Viel-Castel, daily observed a museum guard leaving to deliver the
director's evening clothes to the princess's house, where he had a
dressing room, and commented: "All Paris recognized this porter
in imperial livery who promenaded the clothing of the Pasha [Nieu-
werkerke] and all Paris laughed aloud at it."[5] Parisian gossips were
delighted to dine out on stories of the couple's outrageous behavior,
much to the embarrassment of the Bonaparte family, including the
emperor and his very proper Spanish wife *(Fig. 22)*. Thus, al-
though Mathilde was constantly intriguing for new promotions to
boost her lover up the administrative ladder, the emperor was often
inclined to play dumb and ignore his cousin's protégé.

In 1853, although Mathilde had just obtained Nieuwerkerke's
election as a member of the Academy of Fine Arts, his name did
not appear on the roster of the government commission headed by
her brother, Prince Napoleon (known as Plon Plon), for the plan-
ning of the International Exposition of 1855. Mathilde, angered at
the slight to her lover, berated the man who was probably responsi-
ble for the insult, M. Achille Fould, Napoleon's minister of state
and minister of the emperor's household, who was Nieuwerkerke's
superior and responsible for the governmental supervision of the
arts.[6] The overlapping duties that had developed over the years be-
tween Nieuwerkerke's and Fould's positions led to a fierce antago-
nism between the two administrators, which Mathilde's complaint
only exacerbated. She told Fould that "all over Europe people would
say that he [Nieuwerkerke] hadn't been put on the list because he
was her lover; that she didn't intend to be treated like this." She
added: "Go and tell all that to the Emperor, or else I'll go and tell
him myself, more bluntly."[7]

Her remarks hardly helped restore peace, for Fould retaliated in 1855 by persuading the emperor to prepare a decree that more explicitly subordinated the functions of the director of museums to the authority of the division of fine arts under Fould's administration. The decree clearly stated that, although the director general was appointed by the emperor, Nieuwerkerke was to report to the Ministry of State, that is, to Fould. Signed by Napoleon and Fould, the decree was a slap in the face to Nieuwerkerke, whose duties were clearly spelled out and whose submission to the minister was published for all to see.[8]

Thus Mathilde's outburst to Fould had only increased the tension between Nieuwerkerke and the minister. She probably angered the minister further by repeating her hostile remarks at her salon, for they were recorded for posterity in the *Mémoires* of one of her frequent visitors, Viel-Castel, who was charmed by Mathilde's honesty and her passionate expression of her feelings. Viel-Castel had little regard for Mathilde's protégé, whom he viewed as a courtier motivated by vanity and ambition:

> Art has only been a means to him Nieuwerkerke likes brilliance, show, appearance, in a word he has too many little vanities ever to be a serious man. He is preoccupied with his waistcoat buttons, his shirt buttons, the lapis-lazuli buttons that he puts on his gaiters in summer, with his watchchain, his suit, etc. He likes dress and the first thing he thought of after his election [to the academy] was his new uniform . . .[9]

Indeed, Nieuwerkerke's interest in dress was captured in several portraits, for artists vied to portray this vain and powerful man. Ingres made a drawing of the count in his academic robes with his vast chest adorned with medals *(Fig. 23)*. The drawing hung by Nieuwerkerke's bed in his apartment in the Louvre, which he had designed to resemble the interior of a Renaissance Venetian palace and lighted with torches for the winter Friday soirées that dazzled the artists and writers whom he received. In fact, the count

had at first planned to dress for the Ingres portrait in a rich Vene-
tian cloak and to pose à la Van Dyck, though he ultimately chose
modern attire. In 1856 when the count's apartment was redecor-
ated, Théophile Gautier wrote a description for *L'Artiste* of the
princely setting Nieuwerkerke had devised for himself:

> The first salon, in addition to two full-length portraits of the
> Emperor and the Empress, contains old master paintings that
> have not found a place in the Museum galleries: a Giorgione, a
> Titian, a portrait of the school of Raphael, which many attrib-
> ute to Raphael himself, an Albano, two lively Paninis and
> some views of Venice by Canaletto and Guardi Several
> intricately worked ebony cabinets, Renaissance dressers covered
> with sculpture reminiscent of Jean Goujon, Chinese porce-
> lains, elegantly mounted, panoplies of rare arms, ample red
> velvet curtains, an aubusson rug complete the furnishings with
> a severe richness to which art gives its stamp. In the back-
> ground appears a monumental fireplace in marble veined with
> red and white and displaying on its mantelpiece a bas-relief in
> gilt metal. The bedroom beyond the salon is arranged also
> with great taste and style; a bed with ebony columns, cur-
> tained in Indian damask, occupies the background. At each
> side of the bed, to which two projecting cabinets form a kind
> of alcove, are displayed a portrait and a drawing by M. Ingres.
> One is the portrait of M. de Nieuwerkerke . . . the other has
> for its subject *Philemon and Baucis* After the bedroom is
> a small salon decorated in the Louis XVI style, for intimate
> conversations. It is in the salon where M. Biard's painting of a
> Friday at M. de Nieuwerkerke's *(Fig. 24)* is placed. The canvas
> was painted a long time ago, and already among the numerous
> figures some are only shades!¹⁰

Gautier's description of the apartments was probably written
after he attended the director's first "Friday" following the redecora-
tion of his lodgings. These soirées, in which writers, artists, diplo-

mats, collectors, and government officials mingled, were for men only, except for performers from the opera and the stage, such as Rachel, the famous tragedienne. Nieuwerkerke did not, however, fail to accommodate Mathilde, who watched from behind a bull's-eye window, sitting in a special loggia (reached by an interior stairway) from which she could view the proceedings and not be seen. Her perch looked out on the Museum's Pastel Gallery where the entertainment took place. Having left their wraps in the Miniature Gallery, the visitors proceeded to the Pastel Salon where they listened to the concert while looking at works by Chardin, Maurice Quentin de Latour, and Nanteuil.

At the close of the evening Nieuwerkerke and a few chosen friends would gather in the suite of low-ceilinged rooms squeezed between the ground floor and the first floor where Viel-Castel lived and worked. There, just up the stairway from the director's apartment, the artist Eugène Giraud, a close friend of Nieuwerkerke and art tutor to Mathilde, would make sketches of one or two members of the group. As his subjects conversed, Giraud would execute his amusing half-caricatures under the lamplight. Edmond de Goncourt recalled how Giraud "rendered with a marvelous modelling, strokes of the most luminous gouache, with ironies of very witty drawing, and exaggerations accenting, emphasizing, so to speak, the likenesses of the men."[11] Most of the visitors consented with good grace to be painted, but Sainte-Beuve, perhaps out of vanity, resisted, asking for a week's delay in order to improve his complexion. Eventually Princess Mathilde donated some 160–odd "Friday" portraits to the Louvre. Most show the signature of the sitter, and sometimes the date, beside Giraud's name. The subjects range from Academic painters like Gerôme and Meissonier, favored by Nieuwerkerke, to Delacroix, the great Romantic, who was received as a guest though Nieuwerkerke did little to promote his career. Artists were delighted to attend the Friday soirées in hopes of rubbing shoulders with the powers in the art administration through whom they might receive commissions or other favors.

Writers also coveted invitations to the inner sanctum of the museum. Flaubert donned his white gloves to socialize with the elite of Paris, and Gautier, as we have seen, wrote a glowing description of the setting for the readers of *L'Artiste*. Even the poet Théodore de Banville was enthralled by his host and proclaimed with awe that in Nieuwerkerke "universal knowledge, lively Parisian wit and elegant benevolence are strangely allied with energetic power of feature and the massive stature of the gentleman of ancient times. . . . He has been just what he should have been: a great lord among artists, governing his estates of the Louvre."[12] This literary portrait of the count demonstrates the success of his self-promotion. Though in actuality he was subordinated to the power of Minister Fould, particularly since the 1855 decree, Nieuwerkerke created the impression through his Fridays that all Paris was at his feet. He became in the eyes of Banville and his other guests the "lord among artists" possessing, in the words of his successor Philippe de Chennevières, a "rare and precious gift of authority, of natural authority," which emanated from his commanding presence. As an art administrator, sensitive to the rivalry between Nieuwerkerke and Fould, Chennevières also noted that the Louvre director had "gotten the jump" on Fould, who remained "locked away in his office" at the ministry, while Nieuwerkerke's visibility and social cachet gave him the appearance of complete supremacy in the art world of the Second Empire.[13] His talent for devising amusements for his visitors enhanced his image. He offered his guests spectacles they could see nowhere else, such as midnight walks through the darkened sculpture galleries where they viewed the Venus de Milo "caressed by torchlight," an entertainment the director may well have copied from similar tours established to view antiquities in Rome. The museum evenings were so prized by his guests that one sculptor bewailed: "What a pity that each week has only one Friday."[14]

Nieuwerkerke's social strategies were an important element in his grand design for advancement. Though he had a direct line to

the imperial family through Mathilde, he knew he had enemies among the Bonapartes who resented their liaison. Therefore he felt impelled to build up his constituency in the art, literary, and governmental circles of Paris. He was in the vanguard of a long tradition of museum directors whose positions are won by social charm rather than professional competence. After his election to the Academy in 1853 he confided in Viel-Castel that "he hoped to be a Councillor of State before long and that in four or five years the Emperor would probably make him a senator." His subordinate commented wryly in his *Mémoires*: "If things go on this way the nation will no doubt make him Emperor in ten years time."[15]

Indeed, ten years later, in 1863, Mathilde campaigned for still another title for her lover and a position that would give him powers beyond his circumscribed authority as the director of museums. In considering her demand Napoleon III was torn between conflicting loyalties: While he did not wish to arouse Mathilde's ire, he also had to consider the feelings of other relatives who despised Nieuwerkerke. In a letter found among her papers dated only June 22, the emperor tried to explain his dilemma to her.

> My dear Mathilde,
> I am very sorry to tell you that after much hesitation I am
> obliged to refuse you the position you asked for your protégé.
> But I find such resistance *on every side* that I cannot follow the
> dictate of my heart which would be to do everything I could to
> please you. As an example I am sending you an extract from
> [Prince] Napoleon's letter . . .

After reading his apologetic letter, Mathilde then scanned with chagrin her brother Plon Plon's message to the emperor:

> My dear Louis,
> Yesterday evening, I was assured, though I cannot believe it,
> that the Minister of the Interior was to propose a Mr. de *Nieu-*

werkerke for some or other place in the Fine Arts! I cannot give
you many details in writing, but I do not want *to lose a minute*
in telling you that such a nomination would be a *scandal* for
our family, and especially *for me, I beg you to prevent it.*[16]

No doubt the Emperor sympathized with Plon Plon's embar-
rassment. Yet his attachment to Mathilde was strong, and in the
end, after much vacillating, he acceded to her wishes. On June 29,
1863 (perhaps, in fact, only a week or so after these letters), Napo-
leon III appointed Nieuwerkerke to the newly created post of super-
intendent of the fine arts, responsible for administration of the im-
perial museums as well as the art collections belonging to the state
and to the emperor. Thus Nieuwerkerke had finally won out against
the Ministry of State, three years after Fould's resignation. In the
intervening period Napoleon, in an effort to centralize art adminis-
tration, had overburdened the Ministry of State, so in 1863 he
determined to move all art services to the Ministry of the Emper-
or's Household. From 1863 on, the emperor kept a close watch on
art administration, and his initials appeared on every decree issued
by this ministry.[17]

Thus, under the emperor's supervision, Nieuwerkerke was fi-
nally in a position of immense power in the arts. While ministers
of state had changed over the years, Nieuwerkerke had remained in
place at the Louvre, the most important museum in France, and
worked aggressively to enlarge his institution. Though regarded by
most art critics as a dilettante and mistrusted by artists, he still
managed to bring about an enormous expansion of the Louvre col-
lection, adding some 45,000 artworks and increasing the 89 galler-
ies to 142.

Although he was successful in building the collection, his
taste as a connoisseur was criticized by his friends the Goncourts
and his knowledge of art ridiculed by the journalist and antiquities
expert Henri de Rochefort, who recalled that Nieuwerkerke's "igno-
rance in ancient art was crass."[18] His arrogance served to cover his

mistakes, however, and when he bought a modern terra-cotta statu-
ette thinking it a work of the sixteenth century, he brashly re-
marked that he would be happy to spend 1,500 francs again for
another work of as good quality. His glib comment could not hide
the fact that Nieuwerkerke, a mediocre sculptor, had shown himself
inadequate as a connoisseur even in his own craft.[19]

During the 1860s when he had attained the pinnacle of power
in arts administration, his interest in the day-to-day workings of
the Louvre diminished, and he began to occupy himself with
building his own private collection of arms and decorative arts.
Viel-Castel recorded in his diary (April 5, 1863) that the superin-
tendent left the museum at ten in the morning and that "three
quarters of the time he returned only to sleep. He left for the coun-
try in June, for Italy in September and returned only at the end of
October."[20] Not only was Nieuwerkerke absent from the Louvre,
but as far as his duties went he accomplished little according to
Viel-Castel who, it must be recorded, penned these observations in
the heat of anger after being fired in 1863 for disloyalty to Nieu-
werkerke's regime. According to his subordinate, the 200,000
francs annually at Nieuwerkerke's disposal produced little in the
way of artists' commissions, just "some engravings executed for the
Louvre and two or three mediocre paintings," which depicted Nieu-
werkerke's private collection as it was displayed in his apartments.[21]
It was for this collection that he spent as much as 100,000 francs a
year and sometimes twice that on amassing medieval and Renais-
sance arms (Fig. 25).

Sensitive to misinterpretation of such activity on the part of a
museum director, and no doubt remembering the fate of Fouquet,
Nieuwerkerke carefully retained all his invoices. But soon the pub-
lic was aware that he had put together a collection that rivaled the
emperor's. Questions were raised concerning the ethical position of
Nieuwerkerke, whose duty it was to scout for objects for the em-
peror to buy. The Marquis de Belleval remarked: "The Superinten-
dent looked, made his choice and the Emperor was left the resi-

due."[22] Thus a steady stream of dealers would appear at the Louvre
each morning carrying swords and pictures of armor, many of
which would later be displayed not in the galleries but in the pri-
vate apartments of the superintendent. By 1865 the size of Nieu-
werkerke's collection necessitated the expansion of his quarters, and
the Paris *Guide* of 1867–68 described his collections as equaling
those of the Rothschilds. A catalog was published from which ex-
cerpts appeared in the *Gazette des Beaux-Arts*, where the uninten-
tionally ironic comment was made that M. de Nieuwerkerke pos-
sessed enough armor "to enrich a museum."[23]

In 1871, after the fall of the Second Empire, the collection
did in fact enrich a museum, but not a French one. Nieuwerkerke,
who by 1869 was the subject of press attacks for his negligence in
allowing Louvre pictures to be lent to members of the imperial
family and for the poor quality of picture restoration at the Louvre,
began to think about resignation from his post. He confided in the
Goncourts in March that he was planning to build a house where
he could keep his collection away from the public eye, and he re-
duced his collecting expenditures sharply. In 1870 he moved to 11
rue Murillo, after having been demoted to director of the imperial
museums with the creation of a new ministry of fine arts. Within
the year the Second Empire fell and Nieuwerkerke fled France for
London disguised as a valet. There he sold his entire collection to
Sir Richard Wallace, the illegitimate son of the fourth marquess of
Hertford, who in the 1850s had been a guest at the Louvre soirées
and had had his portrait sketched by Giraud. Wallace acquired at
cost, calculated from the original receipts, over 300 objects from
Nieuwerkerke's collection of medieval and Renaissance European
arms and armor, as well as decorative objects in glass, majolica,
enamel, and wax. Thus Nieuwerkerke's collection, which had, in
the eyes of his enemies, distracted him from his responsibility to
the collections of the state and of the emperor, ended by enhancing
one of the great private museums in England. ☙

8

THE FIRST

PALACE:

THE NAPOLEON III

MUSEUM

On May 20, 1861, only a few months
after the arrival of Renier and Cornu in Rome, the contract for
France's acquisition of the remaining Campana objects was signed
by the duke de Gramont and Secretary of State Antonelli. News of
the impending purchase was noted by Viel-Castel in his diary entry
of April 27: "The Emperor has decided on the acquisition of the
Campana collection for the sum of 4,000,000 francs. Nieuwerkerke
will go to Rome to try to obtain it next month."[1] But before
Nieuwerkerke had a chance to travel to Rome, the deal was com-
pleted. In an effort to salvage his pride and the dignity of the
Louvre, Nieuwerkerke set out for Rome on May 22, two days after
the contract was signed.

Nieuwerkerke could hardly have been pleased when he first
heard that Cornu and Renier, two men outside his jurisdiction,
were in the process of making a major art purchase, which was
referred to in the press as a new museum. As an entity independent
of the Louvre, the Campana collection would be subject to the su-
pervision of the minister of state, Count Alexandre Walewski, not
under the authority of Nieuwerkerke.[2] Walewski, an illegitimate
son of Napoleon I, was appointed after Achille Fould's resignation
in 1860; though not a talented administrator, he was given im-

mense power by the emperor, who desired to unify his arts administration. Both Walewski and the new minister of the emperor's household and the fine arts, Maréchal Jean-Baptiste Philibert Vaillant (a military man whose appointment, following the death of his predecessor Frédéric Mercey, raised the fine arts to a ministry rank), had little confidence in Nieuwerkerke's administration at the Louvre. This fact was made painfully clear to Nieuwerkerke on March 18, a month before he heard about the pending Campana purchase, when Vaillant set up a consultive commission to control the funds of the imperial museums. This new body included not only Nieuwerkerke and his curators but also nine independent experts.[3] The completion of the Campana purchase without his participation was a new humiliation for Nieuwerkerke; he tried to retrieve his prestige by departing immediately for Rome, with Longpérier in tow, to take control of the collection.

The situation in Rome was confused. The public was angry at the sale of the bulk of the Campana treasures, which they had hoped would remain in Italy. The papal authorities were still reticent about certain objects desired by the French, in particular the Lydian Tomb, the famous Etruscan terra-cotta sarcophagus with painted statuary, which France finally obtained only through imperial intervention.[4] Indeed Cornu and Renier did not know with certainty how much of the collection was actually included in the purchase, as they had not been allowed to see everything. Charles Clément, an art historian and critic for the *Revue des deux-mondes*, was sent to Rome in May to help inventory and ship the works to Paris.[5] The arrival of Nieuwerkerke and Longpérier at this juncture would hardly have been welcome to the Cornu faction, who must have complained quickly to Paris, for Nieuwerkerke departed on June 2, only ten days after his arrival, having been informed that the purchase and shipment were to be administered by the ministry of state. Longpérier remained to sort out the objects; however, the continued presence of the Louvre curator caused Cornu to telegraph

his wife for stronger backing. Hortense was able to pressure the emperor into naming her husband provisional administrator (and Clément only provisional deputy administrator) of the Musée Napoléon III, as the Campana collection was called after it came under French ownership. The announcement of these official titles had the desired effect: Longpérier returned to Paris in a huff.

Although both Louvre administrators quickly returned to France, they had staked a claim to bureaucratic supremacy while still in Rome; in a communiqué to Paris they had transmitted their evaluation of the Campana collection and their plans for its exhibition in Paris. Edmond Taigny, an art expert who had accompanied Nieuwerkerke to Italy to help inventory the collection, published on May 31, 1861, one of the first descriptions of the collection to appear in the French press. Addressed to the editor of the official government journal, the *Moniteur*, the report characterized the collection as "in the category of exceptional creations which go beyond the limits of things possible or foreseen."[6] The fact that the Campana collection was an assemblage of broad categories of objects of varying quality rather than a selection of masterworks was also taken into consideration by Taigny, who mentioned its value for the industrial arts: "[F]rom the point of view of industrial imitation, the Campana collection is the most precious acquisition since that of the Borghese museum by Napoleon I."[7] Taigny praised the emperor for his determination not to allow the Louvre "to stand outside the movement of progress and expansion which has during the last ten years marked all institutions in France destined to propagate both taste and instruction."[8] The utilization of artworks from the past as models for modern manufacture, as exemplified in the South Kensington Museum, should be carried out in France, according to Taigny, within the walls of the Louvre rather than in a separate museum. The idea of an educational museum must have been in the air at the moment that Taigny wrote. From the point of view of the Louvre curators a study collection housed within the

Louvre and shaped by Nieuwerkerke and his staff was clearly prefer-
able to the establishment of a separate "anti-Louvre," not far from
their door.[9]

Unlike many other experts, Taigny admired not only the anti-
quities but also the early Renaissance paintings, which he asserted
were unjustifiably disdained. Taigny appraised the different catego-
ries of works in the Campana collection in terms of the lacunae they
would fill in the Louvre collection. He concluded that although the
archaeologists of Rome would regret the loss of the Campana rari-
ties, they would prefer France to have the collection (rather than
England, presumably) because "everyone knows with what liberal
earnestness the Louvre practices hospitality."[10]

Taigny's article clearly promoted the idea, dear to Nieuwer-
kerke, that it was the emperor's intention for the collection to go to
the Louvre. Writing as a member of Nieuwerkerke's entourage,
Taigny footnoted his letter to the press with this explanation:

> The Count de Nieuwerkerke has taken possession of the Cam-
> pana museum [in Rome] in the month of May 1861. We had
> the honor of accompanying him in this rapid inventory, which
> had to be terminated in less than a week, and which was made
> particularly laborious by the scattering of objects in distant cit-
> ies and in the galleries of the Monte di Pietà. If this short
> survey which appears in the *Moniteur* is not current in all the
> developments that relate to this interesting collection, it has
> the good fortune to reveal for the first time the extent of the
> artistic riches that the French government has just given to the
> Louvre.[11]

This report published in the official newspaper within a week
of Nieuwerkerke's arrival in Rome may well have been generated by
fears that possession of the Campana artworks would soon be relin-
quished to the Cornu faction. No mention was made of Cornu and
Renier, who were in charge of transporting the collection. Instead,

Nieuwerkerke's hurried inventory in Rome was offered as evidence that the Louvre administration was on the scene and that therefore the new collection was under its control. It seems likely that Nieuwerkerke had had a hand in spelling out so forcibly for the public the Louvre's asserted control over the Campana purchase. Indeed, in his introductory remarks Taigny praised Nieuwerkerke's administration:

> Beside its great collections, the administration of the museum, on the enlightened initiative of its director, has not ceased during the last ten years to enrich itself by minor purchases each time private sales offered the opportunity. Nevertheless certain parts of the museum still present lacunae The Campana palace brings together a great part of the indigenous riches gathered for thirty years; its holdings include Etruscan monuments of the first order which have been missing until now from all museums. Such a collection could not escape the attention of the Emperor, who himself pursues the solutions of the most difficult historical problems . . .[12]

The Taigny letter to the *Moniteur* was the first in a series of press communiqués that attempted to bolster the Louvre's right to determine the future of the Campana acquisition.

Before the collection was shipped from Rome the new administrators tried to enrich it with other works available on the Roman market. The renaming of the Campana collection as the Musée Napoléon III indicated to those in the know, but not to the general public, that the collection had been augmented beyond the original purchase. Indeed, Renier and Cornu were given permission to add many other works to the 11,835 objects in the Campana acquisition. The most important addition was a Crivelli painting, which Cornu bought in Rome. Other objects, including some beautiful engraved cisterns, appeared to have been brought in order to make the original collection encyclopedic.[13] This last-minute infusion of

works was perhaps also an attempt to turn the Campana collection into a blockbuster, thereby justifying the huge expense of the original purchase. The fact that these additions were made secretly would become a bone of contention with those who opposed an independent administration of the Napoleon III Museum.

An imperial decree providing for 4,800,000 francs to be budgeted to the Ministry of State for the purchase of the Campana collection passed the Legislative Body (*Corps Législatif*) on June 26 with only one negative vote. This sum covered the cost of the collection, 4,360,440 francs (or 812,000 Roman scudi), plus additional money for shipping. On June 27 the decree was presented to the Senate, where the report prepared by Marquis d'Espeuilles favored ratification, using words that would later haunt the administrators of the Napoleon III Museum: "As rich as it was, our Museum [Louvre] had regrettable gaps; the Campana acquisition is intended to overcome a part of them."[14] The Senate passed the bill unanimously. This was not, however, the end of the controversy. Although the collection was now owned by the French, the intention of the legislature would be disputed in the future. Was the money set aside to augment the Louvre collection as the marquis d'Espeuilles had suggested, or would the Musée Napoléon III remain a separate institution? The art historian Salomon Reinach, who published a sketch of the history of the Campana collection, remarked in recounting the passage of the legislation authorizing the purchase: "The Campana Museum now belonged to France; nothing remained but to curse its acquisition."[15]

The idea that the Campana collection would fill the gaps in the Louvre, first propounded in the Senate, would later be advanced by the Louvre administration as the reason for Napoleon III's approval of the purchase. The emperor had shown a strong interest in the Louvre from 1852 when as prince-president he gave orders for its unification with the Tuileries palace, a construction project estimated to cost at least 25 million francs.[16] In taking on this major

building project, he was probably inspired by the Napoleonic tradi-
tion; Bonaparte had hoped to unify the two palaces, but his plans
were cut short with his downfall. Thus Napoleon III completed the
ambitious scheme envisioned by his ancestor.

When the Louvre was first opened to the public as a museum
in 1793, its collection, largely of royal provenance, was quickly
augmented by trophies Napoleon I had garnered on his military
campaigns. In honor of its chief benefactor the museum was re-
named Musée Napoléon in 1803. By labeling the Campana works
purchased in 1861 the Musée Napoléon III, the emperor reminded
the French public that he was following the Bonaparte tradition.

The fact that Napoleon III had acquired a Roman collection
also had special patriotic meaning for France, since Napoleon I had
brought to the Louvre from Italy many of the most famous master-
pieces in the world. Indeed, even before Napoleon I had set out for
Italy, one of his art advisers had said, on the arrival of paintings
looted during the Belgian campaign: "Certainly, if our victorious
armies penetrate into Italy the removal of the *Apollo Belvedere* and of
the Farnese *Hercules* would be the most brilliant conquest."[17] This
remark revealed that Bonaparte's curators, headed by the Louvre
director Baron Vivant Denon, had a shopping list prepared before
the military campaigns began. Although the French succeeded in
bringing back the *Apollo Belvedere* as a trophy of war among other
famous works from the Vatican collection, they never managed to
pry loose the Farnese *Hercules* from Naples.

Rome had yielded much more to Napoleon than other Italian
cities: From the Vatican and the Capitoline museums came many
celebrated ancient marbles, including the *Laocoon* and the *Dying
Gaul*. Furthermore, private collectors like Prince Borghese, hus-
band of Napoleon's sister Pauline, had been pressured to sell a part
of their collections to France. The famous Borghese *Warrior* was a
prize for which the French were willing to pay handsomely.[18] The
prominence of art from the Vatican and other Roman collections in

Bonaparte's haul may have made the Vatican-owned Campana collection particularly attractive to his nephew. It must certainly have pleased the emperor to read in a scholarly article published in 1862 by two French archaeologists that the Napoleon III Museum acquisition was "the most important that France has made since that of the marbles of the Borghese collection."[19]

During the twenty years between the Louvre's establishment as a public art museum in 1793 and the final shipments of loot from abroad in 1813, the Musée Napoléon and its branch museums in the provinces were expanded to house an immense quantity of war booty featuring some of the most famous artworks in the world. The value of these works as educational tools essential to the maintenance of French artistic standards was offered as the reason for the huge growth of the collections. In support of its instructional function, artists were allowed to visit the Musée Napoléon on certain days when the public was excluded. The purchase of the Napoleon III Museum would similarly be defended in the Senate by the marquis d' Espeuilles as a means of providing visual resources for French artists. With great drama he described to his fellow legislators the mysteries of ancient art that the new collection would reveal to its viewers. "Our artists will find there specimens of unknown schools lost in the night of time, of which no date reveals the epoch, but of which the asiatic imprint gives a wide range to all kinds of conjectures."[20]

The needs of French artists had traditionally been cited to justify France's ownership of artworks, whether or not it was legitimate. After the Bourbon restoration, when the Vatican and royalty throughout Europe pressed the French to return much of their war booty, some art critics and museum administrators opposed restitution, which they viewed as unfairly depriving French artists of educational resources to which they were entitled. In 1815 Pope Pius VII sent the famous sculptor Antonio Canova to Paris to recover the Vatican's holdings, but Louis XVIII at first refused to comply with

the request for restitution. It was only after Austria, Prussia, and England came to Canova's aid that he succeeded in salvaging the pope's property. The French vigorously resisted efforts for removal of the artworks; the Louvre director Baron Vivant Denon ignored demands and pretended he did not know the whereabouts of requested objects. Not until Prussian troops arrived to take away works of art by force did he give up. Although about half of the Italian art hoard remained in France, the Musée Napoléon within a period of three months was stripped of huge numbers of confiscated masterpieces.[21]

After restitution many of the French continued to feel that the art trophies were rightfully theirs, bought with the blood of their soldiers. Furthermore, the Bourbons were criticized by some art critics for permitting some 2,000 objects to return to their rightful owners.[22] French pride in the country's artistic tradition seemed to legitimize Napoleon's plunder. Denon's angry words, quoted at his funeral by the painter Baron Gros, demonstrate France's feeling of preeminence in matters pertaining to art: "Let them take them then. But they have no eyes to see them with, France will always prove by her superiority in the arts that the masterpieces were better here than elsewhere."[23] To many of the French, the arrival in Paris of 860 large cartons containing the Napoleon III Museum collection must have called up memories of the historic arrival of Bonaparte's trophies, which were paraded through the city some sixty years before.[24]

Since no railroad yet existed to link Rome with Paris, the 860 crates were shipped by boat to Marseilles and then conveyed to the Louvre, where it became evident immediately that there was insufficient space for unpacking and exhibition. It was decided to display the collection temporarily in the empty Palais de l'Industrie, which had been constructed on the Champs-Elysées for the Universal Exposition of 1855. To help with the unpacking and installation of the works a young antiquarian and writer for *Gazette des Beaux-Arts*

and *Magasin pittoresque*, Edmond Saglio, was appointed assistant to Cornu and Clément, having been recommended to Madame Cornu by the editor of *Magasin pittoresque*.

The immense task of uncrating the 11,835 objects, categorizing them, and arranging them in exhibits showing a historically logical sequence was carried out during the winter of 1861–62 within the unheated Palace of Industry. This grueling and bone-chilling work was completed by May 1, when the new museum opened its doors to the public.

Members of the art world waited impatiently for the first words from the Parisian critics on the quality of the collection that had already aroused international interest. In February, a few months before the scheduled opening, the *Gazette des Beaux-Arts* offered a preview of the terra-cotta collection. Charles Blanc, founding editor of this influential art periodical, had shown an early interest in the Campana collection. In the second issue of his magazine, that of February 1859, he included an article by J. Doucet that described a tour of the collection, which was still scattered through the Campana storehouses in Rome, and illustrated the Niobid frieze, which had since been bought by Russia.[25] Writing on the eve of the opening of the Napoleon III Museum in Paris, Blanc focused on what he considered France's prize, the ancient terra-cottas. He described these works as "the richest, most interesting, most precious that had ever existed in this medium."[26] He especially admired the Etruscan sarcophagus showing husband and wife resting together on a couch, known as the Lydian Tomb, which would remain one of the highlights of the collection. Blanc closed his short review with high praise for the new museum and its administrators:

> In traversing this new museum, when it will have been put in order and knowledgeably interpreted by the very able curators who are in charge, artists will be tempted, we hope, to revive in honor and usage the art of terra-cotta, which lends itself to

all fantasies, permits a sort of improvisation, and escapes the
rigors of criticism because it is less related to reality than to
the spirit of forms, and which is truly for the sculptor what
watercolor is for the painter.[27]

This rave review presented a tantalizing glimpse at works that
were strong enough in Blanc's opinion to revitalize the interest of
French manufacturers in terra-cotta, a medium that had been ex-
tremely popular in French decorative arts during the eighteenth
century. Blanc's article supported the philosophical stance that
would be taken by the new museum's directors: that exposure to
the ancient objects in the Campana collection would exert a benefi-
cial influence on the industrial arts of contemporary France.

The May 1 inauguration of the Napoleon III Museum took
place on the same day that the Universal Exhibition of 1862
opened in London. On May 3 an announcement in the *Moniteur*
proclaimed the opening of the new free museum and included the
following information on special student privileges granted on Tues-
days when museums were customarily closed to the public: "The
temporary administration of the Museum, delivers, on written re-
quest, study cards for Tuesdays to scholars, artists, heads of stu-
dios, as well as to workers recommended by their bosses."[28] Al-
though on the surface this notice appeared to be benign, it was
probably perceived as menacing to the Louvre administration, for it
showed that the Napoleon III Museum was an independent entity
targeting an audience particularly favored by the emperor: artists
and workers. For the workers and their employers the new museum
offered ancient utensils that could serve as models for modern man-
ufacture. This dedication to industry and the worker was in keep-
ing with Napoleon III's public image and with that of his famous
ancestor, who had allowed artists to use museums on days when the
public was excluded. When he escaped from Ham, Louis had dis-
guised himself as an ordinary worker; earlier in a pamphlet pub-
lished in 1844 entitled *On the Extinction of Poverty in France*, he had

espoused a socialist utopia that would ensure a better place in society for the worker. The laboring class would become "a class of property-owners," and they would at the same time become educated: "it is necessary to give that class rights and a future, education, discipline."[29]

The Emperor's concern for the education of the working class could be made broadly visible by linking industry with art; he had previously demonstrated the interdependence of the two fields in the 1855 Exposition, when an art exhibition was included alongside the demonstrations of scientific progress in France's industry. By 1862 this concept of art for the sake of industry had become the basis of Henry Cole's South Kensington Museum. The opening of an English museum dedicated to elevating the artistic designs of modern manufacture influenced the administrators of the Napoleon III Museum, always wary of British advances in the decorative arts, to adopt a similar focus. The selection of the opening date to coincide with the London industrial exhibition of 1862 may have been intended to suggest the unique power of the new museum to link art and industry and thereby elevate the quality of French decorative arts.

The augmentation of the Campana artworks through other Italian purchases gave the new museum an appearance of an all-inclusive collection designed to show the historic growth of the industrial arts in many different media. The Cornu circle of scholars were quick to prepare catalogs that included the new acquisitions from scientific missions to Asia Minor, Macedonia, Thessaly, Phoenicia, and elsewhere. This rapid succession of catalogs pointed up the indolence of the Louvre staff, who seldom bothered to publish their collections. The compiler of the painting catalog, probably Cornu himself, apologized for not producing a more complete work because of lack of time and instead gave a somewhat abridged translation of the Campana catalog published earlier in Italian. He acknowledged that many of the attributions were debatable but asserted erroneously that the catalog was no less than a complete his-

tory of Italian Renaissance art, "represented by works as remarkable
as in any European museums."[30] This was an outrageous exaggera-
tion, since among the 646 paintings listed there were few by artists
whose names would be recognizable to the French public.

Annoying as these catalogs may have been to the Louvre
administration, it was a series of articles written by Ernest Desjar-
dins, a young student of Léon Renier and a member of Madame
Cornu's circle, that incited open warfare. These articles appeared
first in the *Moniteur* on May 1, 7, and 8, and later were sold as a
brochure in the museum. The publication's debut in the *Moniteur*
endowed it with quasi-official status in the eyes of the Louvre ad-
ministrators, who were probably not very pleased with the philoso-
phy expressed in its pages. According to Desjardins, the Musée
Napoléon III, by its unique capacity to offer an overview of the
entire history of art, was distinguished from all other museums,
which he described as merely collections of tasteful art objects. The
educational potential of the new museum lay in the fact that the
historic progression of art might be followed from ancient times and
in many different media. The author proceeded to give a gallery-
by-gallery tour of the collection, a "Promenade in the galleries,"
pointing out the effect of the ensemble, which was quite different
from that of the isolated masterworks of other museums.

The promenade through the galleries began with antique
sculpture, which was divided between the lower and upper vesti-
bules as well as in several galleries including one rather insensitively
titled *le salon carré,* after the famous gallery of masterpieces at the
Louvre. This gallery contained, besides sculpture, 1,200 pieces of
Etruscan, Greek, and Roman gold jewelry *(Fig.26)* which, Desjar-
dins predicted, "will not be without influence on the contemporary
jewelry trade."[31] He noted the forthcoming catalog by Clément and
Stromwald on bronzes and another by his mentor, Léon Renier (con-
taining a thousand previously unpublished funerary inscriptions).[32]
Desjardins's references to future publications, some of which never
materialized, intensified the threat to the Louvre curators, who

hardly wanted to be compared in scholarly energy with their un-welcome rivals.

In his review of paintings (already cataloged by Cornu) Desjar-dins drew attention to the works of the fourteenth and fifteenth centuries, which made up the bulk of the collection and which were little known by the French public. The Napoleon III Museum of-fered for the first time in France, according to Desjardins, "a chronological ensemble almost without gaps and composed of the most beautiful specimens" of Italian "primitive" art.[33]

Desjardins's tour of the gallery was rather sketchy, being in-tended to highlight outstanding works for the visitor: For what he lacked in detail, however, the author more than compensated in the breadth of his claims of the new museum's importance:

> The same day when England opens the great Universal Exhibi-tion of Industry, France opens to the intelligent and enlight-ened public the most interesting artistic exhibition that one has yet seen, in terms of the variety and historical importance of its riches. In London, marvels of contemporary industry; in Paris, marvels of art of all times.[34]

The brochure asserted that such a survey of the history of art could not only be offered by a massive collection, like that of the Musée Napoléon III, capable of demonstrating "successive develop-ments of art" and teaching the viewer that "from the age of their infancy and their youth, art and industry were inseparable twins, one of whom never proceeded without the other."[35] The idea of showing an entire sequence of works from the same period made it necessary, according to Desjardins, to maintain the integrity of the collection, as pruning or dispersal would ruin its educational valid-ity: "We repeat here the wish that we expressed at the outset to see preserved together the riches of these collections, whose ensemble makes its interest entirely special and raises the artistic value of the Napoleon III Museum."[36]

In late May the *Revue Contemporaine* published an article by
archaeologist A. Noel Des Vergers (who had sold some Etruscan
jewelry to the museum) that praised the museum's administrators
for their care in shipping fragile antiquities and for their meticulous
installation, which he had assisted.[37]

Other complimentary articles appeared in the pages of the *Ga-
zette des Beaux-Arts*. In the June 1 issue Louis Ronchaud began a
series of articles extolling the "many museums in the Campana mu-
seum."[38] He suggested that, though the Louvre might desire some
of the works for its own galleries, it could in turn lend to the
Napoleon III Museum some objects suited for ensembles of schol-
arly interest. Commending the zeal of the Napoleon III Museum
administration in arrangement of exhibits and in their publication
of catalogs that were soon to appear, Ronchaud stated with scath-
ing irony: "We note with as much pleasure the activity expended
by the administrators of the museum on the Champs-Elysées,
which forms a striking contrast to the majestic tardiness with
which another administration carries out its work."[39] Clearly the
Gazette des Beaux-Arts was mustering its forces against the Louvre
in the growing battle for the independence of the new museum.

The scholarly enthusiasm for the new museum was seconded
by the interest of the public. A report to the emperor recorded
impressive attendance figures: 600 permits had been given to stu-
dents, and in June attendance averaged 1,000 per day and 6,000 on
Sundays.

Foreign journalists, however, were less favorably impressed;
perhaps out of envy, the English, Belgian, and German periodicals
attempted to denigrate the collection. Even in France there was
harsh criticism of the emperor's new museum, mainly from legiti-
mist and Orleanist circles.[40] Some art critics took a negative stand
as well. Jules Antoine Castagnary, a champion of realist art, dis-
liked the museum's emphasis on antique art as a model for contem-
porary artists. In a satiric review, his mouthpiece, "an original"
who disliked antique art, warned that the Campana collection

would retard French painting by twenty years and suggested that it
be sold off to those who wanted to furnish their flats in the antique
style. "What was bought for 5 million, one can easily resell for
15." The profits would go, after reimbursing the state, to the fol-
lowing causes: "a million in the treasury of the Society of Friends of
the arts . . . five million to found . . . five new schools
And, with the four million remaining , I shall commission pictures
of all kinds from our painters," with the understanding that they
must produce painting which is "neither Greek, nor Roman, nor
Florentine, nor Venetian, nor Flemish, nor antique, nor medieval,
nor Renaissance, but uniquely and simply French."[41] The imaginary
spokesman's proposal horrified his listener, who ended the comic
dialogue crying, "Stop, sacrilege!"[42] Castagnary was not alone. The
Journal amusant published a cartoon by Henri Oulevay *(Fig.27)*
showing the collection as a mass of bric-a-brac visited by the stage
character Monsieur Prudhomme, who notes among the numerous
items "a lot of terra-cottas and an innumerable quantity of pieces of
broken glass of the highest price."

While the subject of the new museum kept journalists busy
and drew throngs of people to the Napoleon III Museum, a battle
to determine its destiny was being fought behind the scenes be-
tween the administrators of the new museum and those of the
Louvre. The Louvre administration applied pressure on the emperor
to bring the rival museum under its control. The struggle for the
emperor's favor was waged between the two women who had close
ties with Napoleon III, his cousin Princess Mathilde and his child-
hood friend Hortense Cornu. Madame Cornu, who had not yet
completely reconciled with Napoleon, tried to save her husband's
administration from a takeover by Nieuwerkerke and his aides.
Princess Mathilde, on Nieuwerkerke's behalf, worked diligently to
confirm the Louvre's authority over the Napoleon III Museum. In
the end the Louvre faction triumphed, partly because of the per-
suasive powers of Princess Mathilde but also, according to the los-
ers, because of false attendance records reported to the emperor.

These reduced numbers, allegedly presented to the emperor by the Louvre administrators, appeared to support their view that the interest of the public in the new museum had been short-lived.

The future of the Napoleon III Museum seems to have been unclear even during the exhibition at the Palace of Industry. For Nieuwerkerke the opening display at the Palace of Industry was simply a temporary exhibition of objects that would eventually become part of the Louvre collection. In the eyes of the emperor, on the other hand, the museum, at least at the time of its opening, was a separate entity from the Louvre, placed under the jurisdiction of the minister of state and the provisional administration.[43]

As the date of the closing of the inaugural exhibition neared, the question of the future of the collection had to be settled. Originally set for August 1, the closing was postponed to October 31, 1862, but by the end of June the emperor had already decided to merge the Napoleon III Museum with the Louvre. That decision and the decree that implemented it did not, however, quiet the new museum's supporters, who continued to accuse the Louvre administration of unfair tactics. Thus even after the emperor had announced his decision, the advocates of a separate museum claimed that the Louvre curators had delayed public notice of the exhibition extension in order to discourage crowds and also had purposely falsified earlier attendance figures.[44] Even as late as the autumn of 1862 the opponents of the Louvre apparently hoped for a reversal of the emperor's decision.

Whether the emperor was motivated by the public's supposed lack of response to the new museum or, as Reinach suggests, by a desire to have peace in the art world where his earlier bypassing of the Louvre curators in the purchase of the collection had caused much tension, will remain a mystery. Certainly the emperor had enough political problems in 1862 with troubles in both Mexico and Italy not to need more strife at home.[45]

A further argument for giving control to the Louvre staff was that through the network of official museums they would be able to

distribute the Campana works to provincial museums effectively, thereby creating goodwill for Napoleon III in outlying areas of France. Another consideration that may have swayed the emperor was the undoubted fact that Nieuwerkerke (though snubbed in the Campana purchase) remained the one stable figure in the national arts administration. Other ministers had resigned and been replaced, but Nieuwerkerke had continued in charge of the Louvre, enlarging it and making the "nouveau Louvre" a symbol of Napoleon III's dedication to art. The creation of a separate Napoleon III Museum under an administration independent of the Louvre would endanger the policy of centralization in arts administration to which the emperor had adhered from the beginning of his reign. In the end he resolved to let Nieuwerkerke assume control of the Campana collection and choose from it objects worthy of exhibition within the Louvre in separate galleries that retained the name Napoleon III Museum.

The emperor's decision to merge the two museums was made barely two months after the Napoleon III Museum had opened to the public. Cornu, hearing of the decision, tendered his resignation on June 26 only to have the minister of state defer consideration of the matter until July 10. On July 5 Napoleon III wrote to Madame Cornu explaining that although he admired her husband's skills he was following his original intention of putting the Campana collection under the aegis of the Louvre. He explained that after "thirty million" francs had been spent on renovating the Louvre, it would not be proper to place such an important collection as the Campana "in any old building." He added that much as he would have liked the exhibition at the Palace of Industry to go on longer, Minister of State Walewski "had run out of funds and we would not be able to demand more. There is the question in its simple truth." He closed the letter by suggesting that Hortense Cornu help him in finding a job for her husband that would suit "his tastes and talents." This was an olive branch that he extended "not only because of the

friendship which I have for him but in the interest of art and of science."[46]

On the following day, Hortense replied that the opposition to the integration of the Campana collections into the Louvre was "based on the certainty, held by serious and competent people, that the accumulation of riches in the Louvre serves only the curiosity of the public, and that scholarship, except for painting scholarship, derives no profit from it." She went on to accuse the Louvre administration of being unable to stem the decline in French taste of which the emperor himself had been aware. It was to cure this problem that the purchasers of the Campana collection sought out the "objects of daily use" that could be helpful in elevating industry and national taste. The crowds that thronged the museum proved its value as did the complaints expressed since the emperor's decision to award control to the Louvre.

Madame Cornu wrote of her deep unhappiness at her husband's treatment. She defended his refusal to serve with the Louvre administrators on the commission charged with culling the Campana collection for the Louvre galleries and expressed her anger at the failure of the Louvre administrators to inform the public that the Napoleon III Museum would remain open later than originally planned. She complained also about the lack of appreciation and the rude treatment accorded to Clément and reminded the emperor of the diligence of both Cornu and Clément, who had worked under extremely difficult conditions in the unheated galleries to ready the opening exposition. Hortense also questioned the truth of the allegations that there was a shortage of funds to keep the exhibition open, citing the ministry's refusal to answer her husband's requests for financial information: "The ministry is not so poor that it cannot find 14,000 francs [cost of keeping the museum open] in the interest of scholarship."[47] Blaming "intrigue" and "jealousy" directed against those who "actively and usefully tried to serve Your Majesty and the country," Madame Cornu accused the minister of

state of "letting himself be fooled."[48] She urged the emperor to postpone the closing of the museum for two months, as a "moral reparation" for her husband and an acknowledgment to the public of the emperor's interest in the workers; she attached a petition to this effect signed by industrial leaders. In conclusion the proud wife thanked Napoleon III for offering to find a job for her husband but sought a deferment of the offer until Cornu had had time to recover from his "sad apprenticeship in the pleasures of administration."[49]

This letter, which demonstrated Hortense's assurance in speaking her mind to her childhood friend, bears Napoleon III's penciled comment on the top margin of the first sheet: "I send you in confidence this letter, try to salve the wound. N." Less than a week after Madame Cornu's letter was written, however, the emperor put his decision into law. ꙮ

9

THE SECOND
PALACE:
THE LOUVRE

Persuasive though Hortense Cornu was, she was no match for her powerful opponent at court, Princess Mathilde, who undoubtedly advanced the claims of her lover Nieuwerkerke. The princess had acted as the arbiter of taste in art for the royal couple from the beginning of their reign. Neither Napoleon nor Eugénie felt confident in making decisions about art, so it was natural for Mathilde, who considered herself a painter and who peopled her salon with artists and writers, to play the role of arts adviser to the court.

In enlisting Princess Mathilde's assistance for his cause, Nieuwerkerke sought to remedy the humiliation he had suffered at the hands of the government during the negotiations for purchase of the Campana collection. If his ambition and pride had not been wounded, he would have been the last person to seek out new responsibilities.[1] His slipshod administrative style was noted by his enemy Viel-Castel, who recorded in his diary in 1863 that it had been three or four years since Nieuwerkerke had met with his curatorial staff, preferring to delegate authority and not to concern himself with the details of Louvre operations.[2] Still, his curators probably made him aware of their irritation at the frequent publications being issued by the Napoleon III Museum. With the exposi-

tion at the Palace of Industry nearing its closing date, the Louvre administration found it a propitious time to end Cornu's tenure at the new museum and to take control of its collection.

Mathilde was the ideal person to persuade the emperor to integrate the two musuems. Unlike Madame Cornu, who was still on rather formal terms with the emperor, Mathilde did not need to put her thoughts on paper but could communicate them directly to Napoleon. Since her arguments were not recorded, we can only speculate as to the line she took.[3] Knowing Napoleon's perpetual desire for administrative peace, she probably argued that by incorporating the collection into the Louvre, Napoleon would end the friction in the museum world at the same time as he enhanced the national museum to which he had already made a substantial monetary commitment. Furthermore, such a decision was consistent with earlier steps he had taken to centralize his arts administration. Finally, by distributing among provincial museums those Campana objects considered by the curators to be unworthy of display in the Louvre, the emperor would gain politically with his constituency outside Paris.

When the decision to close the Napoleon III Museum was finally made, it was presented to the public not as a change of policy but rather as simply the implementation of the emperor's original intention. The exhibition at the Palace of Industry was characterized by official propagandists as merely a temporary display of the collection before its predestined distribution to the Louvre and the provincial museums. The government's explanation appeared in the *Moniteur* in November 1862, in response to the hue and cry that the decree aroused:

> Never had there been a question of creating a special museum
> outside of the Louvre; on the contrary in all discussions on
> funding for the acquisition of the Campana collections, it had
> always been established that these collections would come to

complete the artistic riches of the same kind which the Louvre possessed.[4]

This defense was patently inaccurate because there never had been legislative or administrative discussions of the future of the collection; the decision to buy had been made by the emperor himself without consulting either the legislature or the art bureaucracy.[5] Indeed if the Louvre experts had been consulted, they might well have winnowed the collection in Rome and purchased only works that filled gaps in the Louvre's holdings.

The emperor's decree of July 12, signed by the emperor the night before at Vichy, ordered that "the objects composing the Campana museum be reunited with the Imperial collections to form the Napoleon III Museum," which would be situated within the Louvre. Campana objects that were "duplicates or considered useless for the collections of the Louvre" would be placed "at the disposition of the Minister of State in order to be granted to state establishments or to departmental [provincial] museums." The minister of state (Walewski) and the minister of the emperor's household (Vaillant) were charged with executing the decree.[6]

The provincial museums had been founded by Napoleon Bonaparte (on the advice of his minister of interior, Jean-Antoine Chaptal) to house the overstock of paintings in the Louvre and at Versailles from collections confiscated both in France and abroad. With the understanding that "Paris must retain the greatest works in every category," Chaptal suggested that "the inhabitants of the provinces may also claim an inviolable share of the fruits of our conquests," and proposed fifteen depots for pictures, including Brussels, Geneva, and Mainz.[7] The decree, signed by Bonaparte on September 1, 1800, initiated the distribution of 846 paintings to the designated depositories. Although additional paintings were dispersed to the provinces in 1811, the provincial museums were largely ignored by later administrations until 1850, when Nieuwer-

kerke requested that the post of inspector of the provincial museums be created, and then bestowed it on his protégé Philippe de Chennevières in 1852.

The newly appointed inspector was to find that local mayors, unaccustomed to visits from arts administrators, often refused him entry to their museums. His problem was solved by Napoleon III's decree of July 12, 1862, authorizing distribution of surplus Campana objects to departmental museums. This action eased relations between the central administration and the provincial museum directors who, after receipt of the Campana objects, "began to understand that artworks, in attracting scholars and tourists, could become a source of much more considerable revenue than had been suspected previously."[8]

Minister Walewski was charged with appointing a commission to determine which objects were to be considered superfluous and therefore available for provincial museum collections. His list of appointees included Nieuwerkerke as president; the novelist and arts administrator Prosper Mérimée and Baron de Saulcy, both of whom were senators and members of the Institute of France, as vice-presidents; and arts administrators including three Louvre curators—Longpérier, curator of antiquities, Reiset, curator of paintings and drawings, and Viel-Castel, curator of medieval and Renaissance objects—as well as Alfred Darcel, a medievalist on the Louvre staff. Other notables included Viollet-le-Duc, inspector general of diocesan monuments, and Henri Courmont, head of the division of fine arts in the Ministry of State (who was to act as Walewski's representative). Clément, Cornu, and Renier were also named to the commission but refused to serve.[9]

Before the publication of the decree, the *Moniteur* announced that the exposition in the Palace of Industry would close on August 1. The Cornu circle, as Hortense's letter revealed, had advance notice of the impending decree and of the composition of the commission. On July 8, four days before the official announcement, a protest against dispersal of the Musée Napoléon III appeared in

the *Journal des Débats*. Nieuwerkerke replied in an unsigned notice in the July 12 *Moniteur*, reiterating that from the beginning the temporary exhibition was intended to be followed by installation of the Campana works in the Louvre and provincial museums. He reassured artists that the principal artworks would be well installed in the Louvre where the "Administration of the Imperial Museums will put at the artists' disposal all the means of study necessary to them."[10]

The day before Niewerkerke's answer another angry protest against the impending decree appeared in the *Indépendance Belge*; besides stating that the closing flouted the wishes of "artists, workers, and all those concerned with the fine arts or archaeology," its anonymous writer asserted that the collection would be "dismembered" and "frittered away" between provincial museums and the galleries of the Louvre. Accusing "unknown influences" on the minister of state of destroying the work that the emperor had initiated and citing, with some exaggeration, the many visitors still crowding the museum, the letter deplored the fact that workers who had begun their studies in the galleries would be forced to leave their work unfinished. Appended to the article was a petition of the Society for the Progress of Industrial Art, which called for the preservation of the Campana collection as a separate entity. The petition called attention to the carelessness of the Louvre's curators in handling objects, noting that a marble statue found in Nîmes had been sent to the Louvre only to disappear from sight, as had many ethnographic holdings.[11] The letter closed with the suggestion that the galleries of the Dupuytren Museum, emptied by the removal of its anatomical collection to the medical school, be used to house the Campana collection. A postscript noted that Cornu had resigned and that Renier had refused to become part of the "committee of dismemberment," the name given by the protestors to the official commission appointed to carry out the decree.

The Belgian letter was probably written by Paul Foucher, Victor Hugo's brother-in-law, on the basis of material leaked to him by

Alfred Darcel who, though on the staff of the Louvre, was also a member of the *Gazette des Beaux-Arts* circle.[12] Victor Hugo and Napoleon III were sworn enemies; even in exile France's leading writer refused to stop mocking the emperor, whom he had nicknamed Napoleon the Little.

The attack in *Indépendance Belge* drew a prompt response from Nieuwerkerke, in the form of a letter to the *Moniteur* published on July 17. Nieuwerkerke angrily labeled information offered on the transfer of objects as "lying assertions" and remarks about the administration of the imperial museums as "odious calumnies," and denied reports of "alleged disappearances of objects of art which our anonymous correspondent imputes to the administration that I direct."[13] Nieuwerkerke was understandably upset about the article, and the claims made were very likely exaggerated, although it was well known in art circles that certain Louvre curators were in the habit of taking museum objects home for closer observation and study.[14]

Perhaps the press campaign against the integration of the two museums induced Nieuwerkerke to act hastily and ruthlessly in transferring the Campana works to his control as soon as the decree was signed. He lost no time in forcing the resignation of Charles Clément. Without being permitted to make an inventory, Clément was instructed to hand over the keys to the Campana collection to Walewski's representative, Courmont. When Clément protested by letter to Walewski, saying he would not take any responsibility for the works since he had not been allowed to make a proper transfer, Nieuwerkerke directed his curators to take over the collections while the exhibition was still open to the public. This so incensed Renier that he wrote directly to the emperor, enclosing a letter from Clément to Nieuwerkerke objecting to the way the transfer was being carried out. Renier also enclosed recent attendance records in an attempt to correct the misinformation he claimed had been given about the number of visitors at the museum. Renier claimed 4,148 visitors had appeared on the previous Sunday despite "the

great heat."[15] He further protested the carelessness of Nieuwerkerke and his staff in moving the collection and cited possible damage to the terra-cottas. Like the Belgian correspondent, Renier tried to discredit the Louvre curators by attributing the brusque manner of their takeover to lack of respect for the objects in their charge.

During the summer and fall of 1862, while the doors to the Campana exposition remained open to the public, the press was bombarded with articles arguing both sides of the issue. Although the emperor's decree was final, the volume of the public debate indicated that many in the art world feared or hoped that Napoleon was still vacillating. A detailed reappraisal of the Campana holdings that upheld the Louvre administrators' views on the uneven quality of the collection was published by Ludovic Vitet (*Fig. 28*) in the *Revue des deux-mondes* in September 1862. Vitet had enormous prestige both as an art historian and as a political figure; he had held the position of vice-president of the Council of State from 1846 until 1848 and had been the first inspector general of historic monuments of France under the July Monarchy. During the Second Empire he retired from politics and wrote for the *Revue des deux-mondes,* where he set high standards for criticism, evincing a marked preference for Christian art of the French medieval period. His strongly held belief in the sovereignty of French art prejudiced him against all but the most outstanding Italian paintings in the Campana collection. Furthermore, his noted disdain of "vulgar forms of art,"[16] gave him scant tolerance for the many domestic utensils in the Campana purchase.

When Vitet's article appeared, the Louvre curators were in the process of taking over the collection, which was still on display in the Palace of Industry. Although the Louvre had triumphed, there was still much bad feeling in the art world. Vitet, who assumed an impartial tone, attempted to allay the fears of those who still believed that the Napoleon III Museum collection would lose its value if divided among the galleries of the Louvre and the provincial museums.

Vitet's first salvo was aimed at the reputation of the Campana collection, which he regarded as overblown. He acknowledged the fame of the collection but asserted that its tremendous prestige derived from the secrecy surrounding its contents and its inaccessibility to experts. Vitet claimed that the marchese Campana never intended to create a museum reflecting the complete history of art through methodical acquisitions, but instead had amassed his huge collection in a makeshift manner. Except for the marchese's favorite series—jewels, vases, and bronzes—which were displayed in his palace on via del Babuino, his vast holdings represented a conglomeration of objects crammed into palaces, attics, and the Monte di Pietà. According to Vitet, Campana's mania for collecting was so obsessive that he had no time to keep track of the objects that were often bought *en bloc* and not examined for many years. In fact the marchese had acquired many ordinary and fragmentary works along with important ones. All was stowed away as though accumulated by an antiques dealer, and like such a dealer he employed an army of restorers who worked only for him. Finally, according to Vitet, Campana's failure to keep track of his purchases through inventories or catalogs demonstrated the absurdity of the claims that he was trying to assemble a collection that would illustrate the history of art.

Vitet's article appeared to be partly a response to the Desjardins brochure, which had stressed the documentary significance of the integral Campana collection. Vitet, by contrast, advocated a pruning of the collection, which he considered a mixed bag with only a small number of works worthy of the Louvre. Having seen the collection five years earlier in Rome, he had now had the opportunity to evaluate it at leisure, and his second look was withering. His unfavorable analysis was much more painstaking than Taigny's hurried survey or the catalogs hastily put together by Napoleon III Museum curators. Because of his professional and public eminence, Vitet's harsh critique must have had a chilling effect on the supporters of the Napoleon III Museum. Even more disturbing,

though, were the aspersions that he cast on the motives of those opposed to the integration of the two museums; he accused Cornu's circle of self-interest pure and simple.

To keep their jobs, Vitet charged, the new museum's administrators had mounted a bloated public relations campaign. If they had only honestly admitted that the collection after "a severe choice and a rigorous triage" could fill "two or three galleries of the Louvre . . . with objects of exquisite finesse, of evident rarity and of incontestible value, the critics would have laid down their arms."[17] Vitet blamed the derisive comments of the foreign press on the fact that the Musée Napoléon III's administration had made a *coup de théâtre* by opening a large museum named after the sovereign, in which they displayed a profusion of repetitive objects aimed at showing the taxpayers what they had received for their money. He then went on to attack the administrators by name, although showing more deference to Charles Clément, his well-respected colleague on the *Revue des deux-mondes*, than to Cornu and his associate Saglio. All three, however, "had made their debut with a masterly coup, with a zeal of neophytes and a cleverness that one would have taken for experience."[18] He added in a patronizing tone: "It is certainly not their fault if the success has not been greater, if this unfortunate system of producing and displaying everything without choice or measure has repelled the public which one thought to dazzle."[19]

Perhaps to balance his harsh words for the provisional administrators, who had already left their posts, Vitet voiced one fear regarding the merging of the two collections, that in reaction against the former administration the Louvre curators would thin out the collection more than was appropriate: "Without being completely indivisible, this gallery, above all in certain of its parts, has its type of individuality, a unity less magisterial than one dreamed for it, a unity of character and provenance only, but which it would be inopportune not to respect to some degree."[20]

Recognizing that he was one of Vitet's targets, Desjardins re-

sponded by appealing to French national pride in his new brochure
*Du Patriotisme dans les arts. Réponse à M. Vitet sur le Musée Napoléon
III*. Desjardins accused the distinguished Vitet of political bias in
his low evaluation of the French purchase and of lack of patriotism
in his overblown appraisal of the Russian and English holdings.
Furthermore, he branded Vitet a partisan of the Louvre administra-
tion and claimed that he relied on its misinformation regarding
attendance statistics at the Napoleon III Museum. In defense of the
Campana collection, Desjardins asserted that the marchese was not
the haphazard purchaser portrayed by Vitet but rather a knowledge-
able collector as demonstrated by the catalog he had compiled in
Rome. He cited many respected admirers of the Campana artworks,
including Ingres, Delacroix, and Gleyre, to bolster his view that
although the collection's uniqueness lay in its historical value, it
contained many works of great artistic merit.[21] By contrasting Vi-
tet's assessments with those of art experts and renowned artists,
Desjardins implied that Vitet was lacking in aesthetic expertise, an
inadequacy, he suggested, that stemmed from his career as a his-
tory professor rather than a connoisseur.

The rash young Desjardins, however, went beyond questioning
Vitet's competence as a judge of art; he closed the brochure with
the insinuation that Vitet was motivated primarily by political con-
siderations. Portraying Vitet as a "man of politics," Desjardins
charged that he was therefore "always, and often unconsciously, ill
at ease praising what is done under a regime which he does not
like, which he attacks through interest or through conviction, and
against which he nourishes a grudge that deprives him of all free-
dom of judgment."[22] Desjardins clearly suggested that Vitet, who
had served as a deputy under Louis Philippe and remained an Orle-
anist, was disloyal to the emperor in his negative appraisal of the
French purchase and in his support for the dismemberment of the
museum founded in the emperor's name. The Desjardins pamphlet
even accused Vitet of favoring the Russian acquisition over the
French: "If my humble notice can guide the visitor in a first prome-

nade in the Palace of the Exhibition in Paris, your [Vitet's] article
can serve him as a detailed catalog for the Hermitage of Saint Pe-
tersburg."[23]

Desjardins's intemperate words did not go unanswered. In a
letter in the October 1 issue of the *Revue de deux-mondes*, Vitet dis-
missed Desjardins's brochure and denied his charges of partisan-
ship. Pointing out that his opponent had admitted the Campana
collection was uneven, Vitet urged that the best Campana objects
be incorporated in the Louvre, thereby strengthening its collection
of antiquities while avoiding the pitfall of "two incomplete mu-
seums, which would be jealous of each other and indisposed to give
each other aid."[24] Vitet tried to assume the role of peacemaker, bent
on ending the feud between the opposing museum administrations.

On September 1, the same day that Vitet's article appeared in
the *Revue des deux-mondes*, Emile Galichon, a wealthy and well-
traveled connoisseur and collector, published a protest against the
closing of the Musée Napoléon III in the *Gazette des Beaux-Arts*.[25]

Galichon, who was impressed as well as concerned by the
rapid progress in English decorative arts, stressed once again the
important function that the Napoleon III Museum could have
served in an overall educational program aimed at improving the
decorative arts in France. Basing his vision of art education on
Henry Cole's Schools of Design, Galichon expressed his profound
disappointment at the closing of the Musée Napoléon III which, in
his view, could have been the focal point of a similar network of
educational institutions in France. The announcement of the merg-
ing of the museum with the Louvre had, in his words, "destroyed
all hopes" of "reaffirming our taste and maintaining abroad the
preeminence of our products."[26]

To Galichon the Louvre was not the proper setting for a study
museum, since its collections belonged to the imperial household
and objects were constantly disappearing from public view in order
to decorate one of the royal palaces. The curators also were not
accustomed to publishing catalogs, a necessity for a study collec-

tion, and they would find a teaching display uncongenial. Control of the Napoleon III Museum should therefore be given not to the Louvre but to the city of Paris, which had a strong interest in maintaining a competitive position in the market for applied arts.[27]

Galichon was not the first to view with misgivings England's progress in the field of applied arts. As early as 1857 Prosper Mérimée had noted in an article in *Revue des deux-mondes* that the English were gaining in knowledge of drawing through state-supported schools of design that reached some 34,000 students. Mérimée described Henry Cole's program to his French readers and noted that some of the models used by English artisans were plaster casts of ornaments from French monuments, models that could no longer be found in Paris.[28] He warned that if the English machines could produce cheaper articles than the French, the French must maintain their supremacy of taste by instruction of workers throughout the nation, not only in Paris.

The competition with England became even more intense by 1862 with the opening of the International Exhibition in London. A report of the London exhibition was published in a series of three articles in *Gazette des Beaux-Arts*, beginning in October.[29] The author, Alfred Darcel, made a point of comparing works on display there to objects in the Campana collection that he cited as examples of good design. His introductory remarks asserted that the English "have made immense progress during the last ten years,"[30] of which the English themselves were well aware, as evidenced by the comments Darcel quoted from a speech made by Lord Granville at a banquet in honor of Prince Napoleon: "Gentlemen, I hope that you will pardon English industrialists for having profited from lessons that you have given them at the exhibitions of 1851 and 1855."[31] Darcel's articles cautioned the French audience that though France still held supremacy in the decorative arts, England was catching up fast. Darcel's communiqués from London, with their frequent references to the Campana collection, appeared alongside articles on the Napoleon III Museum.[32]

One of the latter articles was contributed by Henri Delaborde, who began his writing career under the supervision of Vitet at the *Revue des deux-mondes* and continued to write for that journal. An artist turned scholar, he was one of the few French experts in the field of Italian primitives. Since the late fifties he had held the position of director of the print department at the Bibliothèque Nationale and later became a member of the Institute of France and perpetual secretary of the Academy of Fine Arts. He scoffed at attempts to pinpoint attributions of individual Campana works without more profound research than was possible at this early date. Instead he evaluated the collection as a whole on the basis of its broad presentation of a period little understood or even exhibited in French museums. Delaborde showed unusual percipience in noting the lack of expertise in the attribution of Italian Renaissance art. Even Walter Pater's study of 1868 on Leonardo was inaccurate, as Kenneth Clark points out: "In a long paragraph devoted to his [Leonardo's] drawings [Pater] contrives not to mention a single one which is by Leonardo."[33]

Delaborde was only one of many experts publishing critiques favorable to the Napoleon III Museum in the *Gazette des Beaux-Arts* during the autumn of 1862. Charles Blanc marshaled his stable of writers to defend the concept of maintaining the Napoleon III Museum as an autonomous industrial arts museum with different goals from those of the Louvre. The polemics were far from over and would eventually involve not only museum officials and art critics but also some of France's greatest artists. ᔰ

10

INGRES AND
THE ACADEMIES

As the battle between the supporters of the Napoleon III Museum and the Louvre administration raged in the press, the emperor found himself in an uncomfortable position. His heavy financial commitment to the purchase of the Campana collection had brought him nothing but headaches. Although he had expected international applause for his bold action in bringing the famous collection to Paris, foreign journalists had sneered at the quality of the French purchase, and their attitude had even been taken up by distinguished art historians like Vitet.

On the other hand, the supporters of the Napoleon III Museum were so strongly opposed to the emperor's decision to merge their museum with the Louvre that they had mounted a campaign to embarrass Napoleon III with the French workers he was trying to woo politically. The letter in *Indépendance Belge* had accused his government of betraying workers in the applied arts by closing the exhibition prematurely. Advocates writing in *Gazette des Beaux-Arts* had warned that bringing the museum's collection into the Louvre would deprive French decorative artists of a vital resource in their competition with the English. The new museum's forces had even contended that the closing of the exhibition and the merging of the museums had been engineered by the self-serving Louvre adminis-

trators, and the suspicion lingered that the emperor had been fool-
ish enough to be manipulated by the clever Nieuwerkerke.

Although Vitet had defended the combination of the two mu-
seums, his disparagement of the collection's value could hardly have
pleased the emperor, who did not relish being known as the Vati-
can's dupe. Furthermore, the disparity between the evaluations that
opposing experts, such as Desjardins and Vitet, had published
must have given the emperor qualms about the proper allocation of
the artworks among the French museums. While Vitet and the
Louvre party viewed the French acquisition as the dregs of the
Campana collection, from which only a small number of works
would be suitable to be displayed in the Louvre, the Cornu faction,
which included many distinguished critics in the *Gazette des Beaux-
Arts* circle and scholars, held the acquired works in much higher
regard.

Napoleon III was in a quandary. Once he had made up his
mind to bring the Napoleon III Museum under Louvre control, he
still had to make sure that the collection that bore his name and on
which he had lavished state funds would be preserved in an appro-
priate manner; otherwise the whole enterprise would be considered
a disaster. He was determined to involve as many experts as possible
in the final distribution of the works.

The emperor had another reason to involve outsiders in the
distribution process; when caught in the middle of a controversy, it
was typical for him to try to please both sides. Partly to mollify the
supporters of the Napoleon III Museum, he included in the Vichy
decree a provision for the establishment of a commission to super-
vise the dispersal of the objects. But when he appointed the ex-
administrators of the Napoleon III Museum to the commission,
they declined petulantly, leaving the field to their opposition. Still,
the very appointment of the commission, regardless of its member-
ship, reflected Napoleon's lack of confidence in Nieuwerkerke's im-
partiality in carrying out the distribution of the collection that he
and his curators viewed with scorn.

The emperor continued to receive complaints from the Cornu faction following the abrupt takeover by the Louvre curators of the Napoleon III Museum. The grievances of the displaced administrators probably reinforced Napoleon's uneasiness regarding the implementation of his decree. His worst fears were realized when the commission's report was presented to the Ministry of State. The opening paragraph of the document contained a revisionist explanation of the Campana purchase, stating that the government's original intention was "not only to augment the collections of the Louvre, but also to propagate the taste for the arts and for archaeological studies by gifts made to different cities."[1]

This statement, fabricated to make the dispersal appear to have been part of the emperor's initial thinking at the time of purchase, was patently untrue. In the margin beside that paragraph, the word *Non* appears in Napoleon's handwriting.[2] The emperor's comment revealed his sensitivity to the commission's bias in favor of the Louvre administration. Napoleon took the trouble to record his negative reaction to the report at the top of the first page over his initial *N*: "I do not find the report prepared in a good spirit. I do not want to decide on this dislocation of the museum without having another opinion."[3]

In search of further advice the emperor again compromised between the two opposing factions. He had given in to the Louvre faction by allowing them control of the Campana collections, but the strong line they took in the commission report hampered their effort to gain a free hand in distributing the works; instead, it spurred the irresolute emperor to throw a bone to the opposition. His annoyance at the prejudiced tone of the commission's findings led him to introduce two other official bodies into the distribution process. He ordered the dispersal of the collection delayed so that he could invite the Academy of Fine Arts and the Academy of Inscriptions and Belles-Lettres to take part in the process.

Both of these academies were part of the Institute of France, a learned body established by the revolutionary government in 1795

to replace the suppressed Royal Academies. However, the two academies differed sharply in their orientation. The Academy of Fine Arts, made up of "forty immortals" including painters, sculptors, engravers, composers, and architects, controlled the training of art students at the state-sponsored School of Fine Arts in Paris and at the French Academy in Rome. The school's faculty was chosen from the members of the Academy of Fine Arts, which also supervised the prizes awarded to promising students and ran the official Salon. The institutions over which the Academy of Fine Arts had authority were funded by the state. The Academy of Inscriptions and Belles-Lettres, on the other hand, was composed of scholars in the fields of ancient history and literature who had no particular expertise in art. This group had as its members archaeologists and historians whose training was based on classical texts. Thus while the members of the Academy of Fine Arts numbered among their ranks the leading artists of the day, with strong views on aesthetic quality, the scholars from the Academy of Inscriptions, although expert in deciphering the historical meaning of archaeological finds, must have felt out of their depth when it came to making aesthetic judgments.

In the early days of September the emperor submitted to the two academies the commission's report, together with its lists of objects proposed to be retained by the Louvre and of those recommended for shipment to the provinces. It was now the task of the two academies to accept or revise the commission's recommendations.

To the members of the Cornu group, the emperor's decision to consult the academies was a hopeful sign, for it revealed his lack of confidence in both the Louvre staff and the commission members, the majority of whom were Nieuwerkerke's supporters. Nieuwerkerke harbored a strong dislike of the Academy of Fine Arts for failing to grant him membership as a sculptor; he was not admitted until 1853 when he had become an arts administrator, and his admission bore an obviously political coloration. Although during

the fifties he had good relations with the academy, by 1860 the academy's attacks on his over-restoration of Louvre paintings incurred Nieuwerkerke's ill-will.[4] With relations between the academy and the Louvre noticeably strained in 1862, the decision to bring in the academic experts was certainly not to Nieuwerkerke's liking.

It was probably Hortense Cornu who persuaded Napoleon to consult the academies.[5] She never missed the meetings of the Academy of Inscriptions, which she covered for a German periodical, and her salon was frequented by many academicians.[6] The Cornu faction, as its power ebbed, looked for public support from major figures in the art world. Cornu, who had studied with the dean of French painters, the formidable Ingres (*Fig. 29*), now in his eighties, probably applied to his former teacher for help at this crucial juncture. Ingres was the most important artist in France, still working on the last of his odalisque paintings, *The Turkish Bath*, in 1862. He had held the important post of director of the French Academy in Rome from 1834 until 1840. In 1855 he had been made grand officer of the Legion of Honor, and in 1862 he became a senator; he was still a professor in the School of Fine Arts. Ingres threw his tremendous prestige behind Cornu and his allies by writing to the Academy of Fine Arts, of which he was a distinguished member, concerning the breakup of the Napoleon III Museum collection:

Meung, 8 September, 1862

Monsieur President, Gentlemen and dear colleagues:
 Although absent from you at this moment, I always take a lively interest in the business of the Institute, and the important matter that will come before it impels me to rush to the aid of the art that you are going to defend and to join my voice to yours in order to sustain the honor of the Academy. It is a matter of the Campana Museum, of this collection whose value has already been confirmed for many years by the admiration of

the most distinguished artists and archaeologists from Italy, Germany, England and France.

It appears to me impossible to divide this collection and I believe, Gentlemen, that this thought will be yours and that your authority will be respected, although some have characterized our Academy as a coterie incapable of judging arts and would prefer the judgment of individual experts.

They affirm that they wish to separate, to dismember, finally to destroy this museum, and can one believe it? The administration of the imperial museums itself misjudges, contests its value.

We know by experience, Gentlemen, how works of art are treated at the Louvre, and despite the experts who surround them, the disastrous blunders to which they fall victim! That is sufficient reason to appreciate the enlightened care and love of those to whom they [the Campana artworks] were confided; and I do not wish to recall here the past occasions of our regret and our astonishment.

But when erroneous judgment or petty vanities wish to annihilate a collection of this importance, in order to secure the triumph of biased or misguided interest, it is our duty to state our thoughts openly and to save, if it is possible, a justly famous collection.

Ingres[7]

The rather awkwardly phrased letter was published in *Correspondance littéraire* on September 25, 1862, to the great embarrassment of Nieuwerkerke. Ingres's remarks about the "disastrous blunders" referred to the restoration of Rubens paintings that had caused a public furor resulting in the unfortunate removal of Frédéric Villot as painting curator.[8]

Viel-Castel also joined the fray. Nieuwerkerke had dismissed him from his Louvre post in March 1863 under enigmatic circumstances that disgraced the curator and embittered him against his former director. On April 5, 1863, Viel-Castel, whose opinions

must be discounted because of his personal animosity, had many unpleasant comments to make on the outcry about the restoration and the role of the Academy of Fine Arts in the affair: "Nieuwerkerke detests the Academy of Fine Arts and he fears it, because it has blamed and denounced to the Emperor the disastrous restoration of paintings of the Louvre and because it has demanded the exhibition in the museum of the entire Campana collection."[9] Viel-Castel went on to record how he tried many times to get Nieuwerkerke to:

> stop the painting curator's furor for restoration and warned him [Nieuwerkerke] that public opinion would be stirred up against this restoration; I have also said the same to the Princess; Nieuwerkerke was furious and after three days of sulking, he came one morning into my office and reproached me for having disapproved a measure of useful conservation done in excellent conditions and for which he laid claim to the initiative; he did more, he conducted the Princess through the galleries of the Louvre, he guided a great number of people through and praised extensively the most complete of the restorations.[10]

In the end, despite all these defensive tactics, Nieuwerkerke bowed to public opinion, as Viel-Castel recounts: "However, some months later, he replaced Villot, curator of painting with the myopic Reiset, curator of drawings, and had the minister approve a rule providing that the Academy of Fine Arts would henceforth be called to pronounce on the necessity of restorations."[11] According to Reinach, Villot was unjustly sacrificed by the Louvre administration because of the arousal of public opinion against the restoration of the Rubens paintings, acts of conservation that in Reinach's view were entirely appropriate. Intense controversy over the proper limits of painting conservation continues to the present day, as can be seen in the recent dispute regarding the cleaning of Michelangelo's Sistine Chapel frescoes.

Although Ingres's letter embarrassed Nieuwerkerke with its allusions to the restoration imbroglio, its effect on Napoleon III may have been lessened because it echoed so slavishly the views of the Cornu group. In 1852 Napoleon III had commissioned Ingres to decorate the ceiling of the Hôtel de Ville with *The Apotheosis of Napoleon I*, demonstrating that like his uncle Napoleon Bonaparte, he too could command works from the great neoclassical master. Yet much as he admired Ingres, the emperor probably recognized the hand of Sébastien Cornu guiding his aged teacher in composing his not too grammatical argument.

Perhaps to many nonpartisans who read Ingres's letter in the press, the painter's defense of the Campana collection appeared to be the natural outcome of his interest in past art. His strong antiquarian penchant, which led him to introduce ancient artifacts into his history paintings, could certainly have explained his support for the display of ancient domestic utensils in the Napoleon III Museum. In his youth Ingres, after copying some of the frescoes in the Campo Santo cloister at Pisa, had declared his admiration for the Italian primitives: "It is on one's knees that one must copy these masters."[12] This taste for early Italian painting continued to the end of his career: "the very last drawing Ingres did, a day or two before his death in 1867, was a tracing of Giotto's fresco of the Deposition of Christ in the Cappella dell'Arena so persistent with him was the bias which owed its origin to the associations of his early youth and was inspired by the initiative and teaching of Séroux d'Agincourt."[13] This continued fascination with early Italian painting could account for the value he placed on the Campana collection, which he had visited in Rome. Thus, many art lovers could have concluded that Ingres's support for the collection arose from principle rather than from his friendship with Cornu.

However, Nieuwerkerke was determined to weaken the impact of Ingres's letter by spreading the story that the old artist was being manipulated by Cornu's coterie. In a letter written to Ingres on October 11 and published in *Opinion nationale* on October 26,

Nieuwerkerke vigorously defended his administration and asserted that he himself was "one of the most ardent promoters of the acquisition of the Campana collections from the day they came up for sale."[14] He mouthed the party line that from the beginning the emperor had planned for the Campana collections to enrich the Louvre, which had ample space, due to its recent enlargement, to hold the entire collection if it were worthy of being exhibited. Nieuwerkerke further maintained that the Louvre was hospitable to the public as well as to scholars and workers: "Do you know any place where the public enters daily with more liberty, where greater facilities are given to scholars, to artists and to industrial workers?"[15] he asked. The proof of the Louvre's educational efforts could be seen in the fine French decorative objects on view in the International Exhibition in London. Nieuwerkerke claimed that the Louvre collection outshone that of the Napoleon III Museum as a resource for French artisans who had the "good taste to choose their models in our galleries of antiques or in those containing objects of the Renaissance."[16]

Returning to the question of the "dismemberment" of the Napoleon III Museum, Nieuwerkerke asserted that from the moment the *Corps législatif* had been asked for funds to purchase and transport the Campana collections, "the government was engaged in a preliminary way in dividing among the provincial museums the overflow of the Musée Campana."[17] This claim was a remaking of history, similar to the approach taken in the commission report that had disturbed the emperor. Nieuwerkerke praised the commission as being "composed of perfectly competent men" who worked conscientiously for fifty-three days on the report submitted to Napoleon III. Nieuwerkerke explained that Napoleon has subsequently given the academies final authority over division of the collection because of his desire to provide that "if some objects worthy of the Louvre had, by chance, escaped the attention of the commission, they [the academies] were charged with pointing them out."[18] According to Nieuwerkerke's letter, the emperor was perfectly satisfied

with the commission's report and simply wanted to be absolutely
certain that no errors had been made. Ingres himself would have
agreed with the choices made by the commission if he had not let
himself be swayed by "persons interested in spreading lying ru-
mors. It would be easy to believe that they had dictated your letter,
where I find so much of their malevolence."[19]

According to Viel-Castel, Nieuwerkerke was not satisfied with
publicly reprimanding Ingres for his partisanship; he also took re-
venge on the artist's paintings: "Ultimately, in order to play the
role of Pasha to this artist, Nieuwerkerke and the famous Chenne-
vières [director of the Beaux-Arts after 1874] have retired all the
master's paintings from the gallery of the Luxembourg and placed
them in a poorly lighted salon. M. Ingres has complained to the
Emperor."[20]

Ingres himself wrote no more on the Campana controversy.
But the Cornu circle could not leave unchallenged the insulting
implication that the distinguished painter was their puppet. Their
answer appeared on October 31 in *Opinion Nationale* in a letter
signed by Cornu, Clément, and Saglio. The three signatories had
not mailed the letter to the journal but had served it by a sheriff's
officer pursuant to court order, relying on an 1822 law that gave
them the right to have a response inserted within three days of the
appearance of a defamatory publication. The editor prefaced the re-
sponse with the comment that the legal methods used were unnec-
essary and insulting to his journal.

Cornu and his colleagues began their letter with a protest
against Nieuwerkerke's attack on their administration and reviewed
the history of the Napoleon III Museum, emphasizing that like the
South Kensington Museum it had striven to bring practical teach-
ing of art to industrial workers. They argued that this type of mu-
seum should be established in a part of Paris frequented by stu-
dents, and suggested several alternative sites. They particularly
favored its location on the Left Bank, near the School of Fine Arts;
there it could function as an annex under the supervision of the

Institute of France's Academy of Fine Arts so that "as in antiquity the arts and industry would be inspired by the same sources, animated by the same spirit."[21] This suggestion must surely have infuriated the Louvre contingent. The institute's Academy of Fine Arts, from whose ranks the faculty of the School of Fine Arts was chosen, also played an active role in advising the government on other matters pertaining to the fine arts. As an enemy of the academy already engaged in trying to break its power, Nieuwerkerke could hardly have appreciated the suggestion of linking the museum to the School of Fine Arts.

The letter of Cornu and his associates reiterated the much publicized view that the English were fast gaining supremacy over the French in the decorative arts: "These developments are due to the teachings of the Kensington Museum and to the 82 schools of design created some years ago in England."[22] Cornu and his two consignatories tried to show that because of the success of this educational program in England, many Frenchmen active in the applied arts wanted the Napoleon III Museum to become the nucleus of a similar program in France. They emphasized that the original project of purchasing the Campana collection had been conceived by the emperor without the advice of the Louvre; it had been "the sole and personal initiative of the Emperor to purchase the Museum, a desire formulated by the press and by public opinion for the creation of a Museum of practical teaching in Paris, where so many artists and workers from the provinces come to study (this desire has been shared and expressed by us)."[23] These words summed up the heart of the Cornu defense against the Louvre takeover: that the Louvre had not been involved in the original purchase; that the educational concept of the museum had developed from public demand based on the success of the English model; and that the audience for the collection needed a different type of museum from the Louvre.

But while the ex-administrators were arguing, the process of distributing the Campana works continued. Though the emperor

had made up his mind in late August to consult the academies, Nieuwerkerke dragged his feet in convening a meeting with the members. Instead he invited the emperor to visit the Palace of Industry to view the selection made by the commission, choosing 3 P.M. on a Saturday, the customary meeting hour of the Academy of Fine Arts. Warned of this rendezvous by Hortense Cornu, Charles-Ernest Beulé, the perpetual secretary of the Academy of Fine Arts, excused himself from the academy and arrived out of breath at the Palace of Industry, where he saw a crowd of functionaries gathered around Nieuwerkerke and the emperor. " 'Sire,' said Nieuwerkerke solemnly, 'Does Your Majesty approve of the work of the commission?' Beulé advanced, protested against these unilateral proceedings, and reminded the emperor that he had determined to submit the final decision to the Academy of Fine Arts. 'But the Academy has no competence in such matters!' cried Nieuwerkerke flushed with anger. 'Monsieur,' answered Beulé, 'the Academy is the first of all judges in matters of art: you are the last person to contest that since you have the honor of belonging to it.' The Emperor tried to hide his discomfiture. 'It is indeed impossible not to consult the Academy,' he said. 'Monsieur de Nieuwerkerke will take his advice from you.' "[24]

On the pretext that everyone was on vacation in August, Nieuwerkerke delayed the meeting until autumn. The shrewd administrator then embarked on a strategy of divide and conquer; he wrote first to the Academy of Fine Arts and a week later to the Academy of Inscriptions, inviting them to meet separately for the purpose of reviewing the commission's recommendations. The letter to the Academy of Inscriptions, dated October 15, asked its members to name a date when they would be able to view the exhibition at the Palace of Industry in order to determine "if, among the objects eliminated [from the Louvre collection] any would be regretted by the Musée du Louvre."[25] Nieuwerkerke explained that this consultation was desired by the emperor, who wished to make sure

that no errors had been made by the commission. He ended his letter by noting that since the exhibition was due to close at the end of October the matter was urgent and apologized for the short notice, blaming the members' late summer absences.

After reading Nieuwerkerke's communication, the perpetual secretary of the Academy of Inscriptions complained about the tight deadline. Considering that the Academy of Fine Arts had been given a week's lead time and had already held several meetings at the Palace of Industry, he hoped that the two academies could confer on common areas of work to be done as well as on standards for selection. Longpérier, the Louvre curator who had served on the original commission, tried to gloss over the problems facing the Academy of Inscriptions by stating that since the ministerial commission had eliminated the duplicates, only final revisions were now required, a procedure that had almost been completed by the Academy of Fine Arts; he urged the Academy of Inscriptions not to slow down this process. Longpérier, however, was opposed by Beulé, a member of both academies, who demanded that the members of the Academy of Inscriptions be given more time to accomplish their mission with care and insisted that both academies should study the works separately and only afterward ratify the choices together. Ultimately a group of six members from the Academy of Inscriptions, none of whom had belonged to the ministerial commission, was dispatched in haste to the Palace of Industry to begin deliberations.

On October 24, the delegation from the Academy of Inscriptions reported to the members that Nieuwerkerke and Longpérier had shown them the objects the ministerial commission had recommended for distribution to the provincial museums. Set aside in a separate room, the works on display included about sixty antique vases, about sixty terra-cotta reliefs, and a number of small Etruscan urns. At their meeting with the Louvre officials, which lasted for only about a quarter of an hour, the representatives of the Acad-

emy of Inscriptions were informed that better examples of such
works were being retained for the Louvre collection. They were fur-
ther told that the Louvre had already selected for its galleries jew-
elry, glass, ancient paintings, bronzes, and Greek or Latin inscrip-
tions. Asked whether the integrity of the collection would be
preserved within the Louvre, Nieuwerkerke assured the delegation
that the Campana objects would be a distinct collection under the
name Napoleon III Museum and installed near the Antiquities Mu-
seum. After taking a short time—not more than fifteen minutes—
to glance at objects judged to be fake or altered, as well as frag-
ments and vases that the emperor planned to use for exchanges, the
delegation agreed to abide by the decision of the original minister-
ial commission. The Academy of Inscriptions expressed no opinion
on antique statues or on Italian paintings, however, since the mem-
bers were not professionally equipped to pass judgment on these
works.

The Academy of Fine Arts was not so passive. The members
revised the lists compiled by the ministerial commission, adding to
Longpérier's antiquities department thirty-nine ancient sculptures
as well as some faiences and majolicas that had been excluded by
the commission. The most telling rebuke to the commission was
the Academy's decision to add 206 paintings to the group of 97
that the commission had proposed to retain for the painting depart-
ment of the Louvre under the curatorship of Reiset (*Fig. 30*). Long-
périer and Reiset resented these academic decisions as a public slur
on their professional judgment, since both had served on the com-
mission. Other Louvre partisans attacked the academy's conclu-
sions, claiming that Reiset knew more about painting than anyone
else in Paris and that the academicians were not skilled in connois-
seurship.[26] Reiset reflected his anger in the preface to his 1863
catalog introducing the exhibition of the Campana paintings in the
Louvre galleries. The painting curator complained about the acade-
my's choice: "The decisions of this illustrious body [the Academy of

Fine Arts] are made without giving us the right of appeal, and we would hope our duty lies in merely transcribing its judgments."[27] Reiset, one of the best connoisseurs of his time, did a commendable job of attributing authorship of the paintings added by the academy to his department, though he peevishly indicated he would rather have remained silent about the identification of these works that had been thrust upon him.[28] In order to make it clear, however, that he did not approve of the academy's choices, Reiset insisted on separating those paintings chosen by the ministerial commission from those selected by the academy by marking the former with a *C* and the latter with an *A*. Although comparison of the paintings under these designations indicates that the works chosen by the commission are in general of higher quality than those added by the academy, the list reveals that seven signed and dated fourteenth- and fifteenth-century Italian paintings would not have entered the Louvre if not for the revisions of the Academy of Fine Arts (*Fig. 31*).

When the Campana objects were transported to the galleries of the Louvre, Longpérier took charge of the antiquities assisted by Pennelli, the restorer employed by Campana himself. Pennelli, who did most of the work of integrating the Campana works into the department of antiquities, had become de facto custodian to the collection during the imprisonment of its owner. His knowledge of the Campana collection was profound, since he had been on the scene from the beginning, carrying out all the restorations the marchese had ordered. He had come to Paris hoping to be named "adjunct-curator" of the Louvre but instead was appointed head of the conservation laboratory. Perhaps Pennelli should have been invited to participate in the deliberations of the academicians; but fortunately for Longpérier's professional reputation, the curator subsequently relied on Pennelli's expertise in assessing the Campana works retained by the Louvre. When Longpérier decided, after smarting under complaints by the Cornu faction regarding the in-

frequency of his publications, to inventory the Campana antiquities, he enlisted the aid of the old restorer. The first statue to be cataloged was an Etruscan warrior that had been exhibited in the Palace of Industry reclining on a bed shaped in the form of a gridiron. " 'Write,' dictated Longpérier to Pennelli, 'an Etruscan warrior lying down on his bed . . .' Penelli interrupted: 'Do not speak of the bed, Monsieur de Longpérier, it is I *who have made it*!' " [29] ꙮ

LETTERS FROM

DELACROIX

⌒⌒⌒ The next champion of the Campana
collection was the leader of the French Romantic artists, Eugène
Delacroix *(Fig. 32)*. On November 9, 1862, the *Journal de Débats*
published Delacroix's letter in praise of the Campana artworks to
Charles-Ernest Beulé, the perpetual secretary of the Academy of
Fine Arts. [1]

Whether the letter was solicited by Beulé, or more likely by
Madame Cornu, is hard to prove, but the academy's acquiescence in
its publication demonstrated that body's continued opposition to
Nieuwerkerke and Walewski. Indeed Beulé, an archaeologist with
high administrative ambitions, may have even hoped eventually to
succeed Nieuwerkerke. His adamant stand against the Louvre per-
haps reflected not only the rift between the museum administration
and the Academy of Fine Arts but also his own careerist strategy,
which may have banked to some extent on the influence wielded by
Madame Cornu. [2] Certainly it was a coup for the Cornus to have
gained the support not only of the Academy of Fine Arts but also
of both leading painters of the day, Ingres and Delacroix, who rep-
resented opposing schools in the art world. In his letter, written on
September 28, 1862, three weeks after Ingres's intervention, Dela-
croix had been uncharacteristically gracious in announcing his sup-

port for "the illustrious M. Ingres," in expressing concern for the protection of "this beautiful collection" and in testifying to his "wish for the conservation of the Napoleon III Museum."[3]

Delacroix's outspoken criticism of Ingres's neoclassical style of painting had earlier hampered his election to the Academy of Fine Arts, which was dominated by classicists. Indeed it had taken seven applications to the academy, from 1839 to 1857, before Delacroix was finally elected. Two years before his admission, he had been honored with a retrospective of his work in the Universal Exposition of 1855. This exhibition had changed his reputation; he was no longer a rebellious Romantic but an artist approved by the government. It appeared the Imperial Commission had decided in 1855 to give equal time to many diverse factions of the art world, an eclectic attitude supported by the count de Morny (the Emperor's half-brother, who served as president of the jury) and the novelist Prosper Mérimée, both friends of Delacroix.[4] By allowing special retrospective exhibitions to artists of differing stamp, such as Ingres, Delacroix, Alexandre Descamps, and Horace Vernet, the Imperial Commission had declared all viewpoints equal and thereby attempted to moderate the divisions in the art world; loyalty to the empire was now the sole issue. In taking this stance at the 1855 exhibition, the government followed the same line to which it had hewn in politics, trying to attract to its banner leaders from many different factions.[5] The exhibition catalog stated that all opposing forces were counterbalanced: "There are no longer any violent discussions, inflammatory opinions about art, and in Delacroix the colorist one no longer recognizes the flaming revolutionary whom an immature [Romantic] School set up in opposition to Ingres."[6]

Thus Delacroix at last was welcomed officially to the Second Empire's art world. Furthermore, as a Bonapartist he was received socially by the emperor (who named him a councillor of Paris) and by Princess Mathilde. His prestige at court became a professional weapon: Nieuwerkerke had had to give in to Delacroix's insistence

on exhibiting his *Liberty Leading the People* in the 1855 exhibition, following the mediation of Napoleon III. Despite this setback, Nieuwerkerke was proud to claim friendship with the artist who, he told Viel-Castel, could even make him overlook bad weather: "When I chat with Delacroix, I forget myself for two hours at a time under an umbrella."[7]

Despite his professed enthusiasm for the charm of Delacroix's conversation, Nieuwerkerke must have found little cause to rejoice in Delacroix's letter to Beulé. Delacroix began by praising the emperor's decision to purchase the Campana collection, "famous throughout Europe," and to put it "under his special protection in giving it his name." The unique character of the collection was that it was composed not of masterpieces, but rather of works of lesser quality making up groups of objects that gave the viewer the unusual opportunity "to follow and to judge the gropings by which art has arrived at its perfection."[8] Among the groups Delacroix singled out was "the curious collection of Italian paintings," which had been "condemned by people who did not sufficiently understand its relative importance and the light which it sheds on the origins and the progress of the Italian schools."[9] This kind of educational exhibit could be seen nowhere else in Paris, and the comparisons afforded by the juxtaposition of these early paintings would be possible only if the integrity of the Campana purchase were respected. Delacroix pointed out the similar importance of exhibiting in groups the extensive collections of majolicas, the painted vases, faiences, and the terra-cottas. While emphasizing the advantages of seeing a full range of objects displayed, Delacroix ridiculed the Louvre's excuse that space was a problem.

On October 4 Delacroix wrote again to Beulé expressing his appreciation for the care that the academician intended to take in the publication of his letter. He added an editorial suggestion: "In your conversations with these gentlemen [the staff of the *Journal des Débats*] insist on the silliness of the reproaches made to the [Cam-

pana] Museum concerning the quantity of supposed repetitions. It is in that attribute, in my opinion, that a great part of its originality consists."¹⁰

In an earlier draft of the October 4 letter, recently discovered, Delacroix had stated his views with even more force: "This type of redundancy constitutes precisely the originality of this Museum. It has this great advantage over all others . . . that one feels everywhere interest and life, one finds on all sides the action of a unique will that has presided over this apparent profusion and that in a way affirms each object by the proximity of analogous ones." Unlike museums composed of rarities "encased coldly and without links between each other, like monuments in cemeteries," the Campana museum was unique, according to Delacroix, as a living ensemble of artworks. The quantity of majolica (*Fig. 33*), "a humble dish, a pot, or a basin for every day use," decorated by obscure artists with images from the paintings of Renaissance masters, disclosed to the viewer "an idea of the civilization and refinement of the Renaissance in Italy." This link between fine art and applied art was demonstrated in "the great number of objects" which gave "the best proof of the generality of this taste spread among the masses. What does it matter if some inestimable pieces are in Petersburg where one will not go to search them out? The Campana Museum is in Paris, and its importance, its singularity appears unique to me. And one would extract from it other choice pieces in order to send them [Delacroix crossed out the harsher phrase "to bury them"] to the Louvre where they will disappear as in a whirlpool!"¹¹ The plan to scatter secondary works among provincial museums would require art lovers "to search in the four cardinal directions" to see the objects which could remain in Paris in a separate museum. Indignation was the only possible response to the "human motives" that had brought about "savage wrongs to the unhappy collection and had finished by disorienting the public."¹²

Although in the finished letter Delacroix deleted his thoughts on the social value of art as demonstrated by Campana's large col-

lection of majolica, his emphasis on the educational role of a series of works displayed for comparison by the viewer must have upset the Louvre administration, whose battle cry had been to rid the collection of redundancy. That one of the leading artists of the day should cite the repetitions within the series as the museum's distinctive contribution was a serious blow to their position. Furthermore, Delacroix's insistence that all the objects remain in Paris was a direct attack on the Louvre's plan for dispersal to the provincial museums. Delacroix's letter could not go unanswered.

Ernest Chesneau, Nieuwerkerke's public relations representative, replied on behalf of the Louvre. Chesneau, who was derided by the press for his "Ernestine communiqués," now turned his hand to an evaluation of the Napoleon III Museum collection that reflected the views of Nieuwerkerke and his staff. [13]

In the introduction to his pamphlet entitled *Popular Interests in Art. The Truth on the Louvre. The Musée Napoléon III and Industrial Artists*, Chesneau presented himself as well qualified to take a position on the future of the Campana collection because of his familiarity with the South Kensington Museum, the prototype of the industrial arts museum to which the Napoleon III Museum had been compared by its supporters.

Chesneau told of the "painful astonishment" with which he read Delacroix's letter in the *Journal des Débats* "for, in this letter, the greatest painter of the contemporary French school supported with his name a measure in our view disastrous to our policies." [14] Nieuwerkerke's spokesman commented ironically that this was the first time he had observed an agreement between the famous opponents Delacroix and Ingres. [15] The reason for this, he declared, was that the Napoleon III Museum administrators had proposed putting their museum under the direction of the Academy of Fine Arts, thereby stirring such intense collegial sentiments among that "illustrious body" that even these two old adversaries had fallen into line.

Delacroix misunderstood the goal of the distribution commis-

sion, Chesneau asserted; it never intended to send to the provinces "any works that even if absolutely inferior had any educational value, were of relatively superior quality, or reflected the state of the arts of a given period." On the contrary, those dispersed would be "objects that debased a particular period by their mediocrity."[16]

The publicist claimed that Delacroix had been influenced in his support of the Napoleon III Museum by his friendships with wealthy collectors who wanted special museums to house their collections instead of donating them to the Louvre. Delacroix was also misguided in divining any order or sequence in the Campana collection which, in Chesneau's view, had many gaps due to the sudden interruption in the marchese's collecting activity. Finally, Delacroix lacked firsthand knowledge of the collection, since he was not in Paris at the time and had not participated with the other academicians in reviewing the commission's choices.

Chesneau had more than tough words for Delacroix; he took the entire academic camp to task. In reality, he argued, the difficulties facing French art had nothing to do with the museum world but rather with the training of artists. The source of the problem was the Academy of Fine Arts, whose members controlled the School of Fine Arts: It was here, he asserted, that reform was needed. The School of Fine Arts, he declared, "pretends to govern teaching and teaches nothing. There is the wound to dress, there is the evil, and it has already caused terrible ravages."[17] Chesneau's solution was drastic: to remove the school from the jurisdiction of the academy. "It is the Academy of Fine Arts to which we must turn, it is from this illustrious body that we must demand a sacrifice, cruel for the moment, profitable for the future." He went on to demand the recruitment of "true friends of art" to bring about this reform, identifying in a footnote as one such friend Eugène-Emmanuel Viollet-le-Duc, the architect and medievalist, whose articles on the subject of art training had recently appeared in the *Gazette des Beaux-Arts*.[18]

Chesneau's exhortation for teaching reform was an early warning to the academy of a proposal, which was probably already being shaped by Nieuwerkerke and Viollet-le-Duc, to strip the academy of its long-established authority over the training of artists. The decree of November 13, 1863, which would revolutionize the French art world the following year, was probably already in the planning stages when Nieuwerkerke's spokesman penned his threat in the heat of anger over the academy's opposition to the Louvre's plans for the Napoleon III Museum. An old rift between the academy and the Louvre had widened during the Campana controversy when the academicians mobilized their leading celebrities in outspoken opposition to Nieuwerkerke's administration.

Both Nieuwerkerke and Viollet-le-Duc harbored a personal resentment against the academy. Although Nieuwerkerke entertained artists at his Louvre soirées, he was never fully accepted as their colleague. Furthermore, he had suffered at the hands of the academy when it attempted to overrule his authority by halting the Louvre's restoration of Rubens's paintings. Now, the Academy of Fine Arts opposed the Louvre faction once again, concerning the Napoleon III Museum.

Viollet-le-Duc too had a long history of hostility to the Academy of Fine Arts. As a staunch medievalist, he objected to the classicist leanings of the academicians under the domination of Ingres and his pupils. For this reason, he had decided not to study at the School of Fine Arts and had obtained many government commissions to restore Gothic buildings after having been introduced to the imperial couple by his friend and sponsor Prosper Mérimée, who served as vice president of the Commission of Historic Monuments.[19] Although Viollet-le-Duc received numerous honors abroad, the Academy of Fine Arts took no notice of him. The battle lines were drawn when in 1852 he published an article criticizing the School of Fine Arts's architectural training.[20] More recently, in his articles in *Gazette des Beaux-Arts* of 1862, to which Chesneau

had referred in his rejoinder to Delacroix, he had outlined his phi-
losophy of art training, which emphasized developing the original-
ity of the artist and opposed the academic method of training based
on copying classical models.[21] Essentially, Viollet-le-Duc blamed
the academy for what he viewed as the diminution of originality
among young artists. He argued that since both the faculty of the
School of Fine Arts and the prize juries were under the jurisdiction
of the academy, success was possible only for artists submissive to
its dictates. In order to end this stifling of talent, this perpetuation
of "honest mediocrity," he proposed that teachers and juries be
named by the state to broaden the faculty and to lessen the control
of the academy over teaching and prize-giving.[22]

Viollet-le-Duc pointed out that reform was long overdue at
the School of Fine Arts, where the "superannuated system" had not
been changed since 1819. In his view the school must turn the
students' attention from antiquity to modern life and expand the
architectural curriculum to include modern industrial materials and
structural engineering techniques.[23] He also called for the academy
to abandon its attempt to retain supremacy over the arts and urged
that "diverse branches of the plastic arts" should be brought to-
gether.[24] A model for reform, which would bring about this com-
munity of the arts, was now available in England, where the recent
Great Exhibitions of 1851 and 1862 had demonstrated the effec-
tiveness of the English teaching methods in the applied arts.[25] The
most serious obstacle to such change was, according to Viollet-le-
Duc, "the ignorance of the public. . . . The public knows nothing
of this organization of the School of Fine Arts, of this state of
patronage under which the students live."[26]

Viollet-le-Duc's ideas were based on those of his friends and
fellow courtiers, Count Léon de Laborde and Prosper Mérimée, who
had pressed during the 1850s for reform of the French teaching
system based on the English model. As head of a commission
charged with reviewing the Great Exhibition of 1851 Laborde had
published a voluminous report in 1856.[27] An art historian, mem-

ber of the Academy of Inscriptions, and diplomat, Laborde served as curator of medieval, Renaissance, and modern sculpture at the Louvre, where he was considered to be the next in line for director-ship should Nieuwerkerke make a misstep. However, a year after his report appeared, he left the Louvre to become director of the Na-tional Archive. In his 1,000-page report, to which he brought a brilliant and creative mind, Laborde stressed, as Viollet-le-Duc would later do, the importance of the unity of art and industry for the benefit of the applied arts. He also urged educational reforms that would elevate national taste and, in the case of the fledgling artist, allow for the expression of originality and individuality.[28]

The year following the appearance of Laborde's report, his friend Prosper Mérimée published an article entitled *The Fine Arts in England*, which sounded the alarm that the English might soon surpass the French in the applied arts because of the high priority the British government had given to reforms in art instruction.[29] The fear of English competition was heightened when the 1862 Universal Exhibition opened in London. The improved quality of the British products on view gave these French reformers the am-munition they needed to put their ideas into practice. Their think-ing formed the foundation for the art education decree that Nieu-werkerke would win from the government in 1863.[30]

That Viollet-le-Duc and Nieuwerkerke took vindictive pleasure in proposing reforms designed to diminish the power of the Acad-emy of Fine Arts is suggested by the secrecy of their lobbying ef-forts. A letter to Nieuwerkerke from Courmont stressed that for the sake of appearances the reform should purport to be the result of collaboration with many experts; his plea for camouflage revealed that the plan was actually hatched by a small group of conspirators who shared a common purpose, enunciated rather openly in Cour-mont's letter: "to decimate" the Academy.[31]

Looking back on the secrecy surrounding the art education decree, Philippe de Chennevières recalled that in August 1863, three months before the decree was made public, he had learned of

the plan while strolling with Viollet-le-Duc after dinner at a country inn at Pierrefonds. The architect had revealed to Chennevières that a radical change was in the works. "The School of Fine Arts will be shaken up from top to bottom," he had predicted, and indicated some of the people who would carry out the reorganization. His listener would later marvel at how effectively the plan was concealed until the November announcement: "How the secret of the conspiracy was so well kept, was a miracle; in any case, it exploded like a bomb, and God knows with what an uproar! Never had the world of the arts been stirred up so violently."[32]

When the decree was announced on November 13, 1863, the art world was stunned. In one blow the academy's power over art instruction was destroyed. The School of Fine Arts was to be administered by a director named by the government, and state officials, including the superintendent of fine arts (Nieuwerkerke's new title dating from June 1863), were to be among the members of the important committee set up to review teaching institutions and determine the composition of juries. The school's curriculum was changed to diminish the authority of the classicists and to allow for more freedom of development on the part of the students.

Whatever personal animosities may have inspired the plan, it was undoubtedly greeted with relief by many independent and avant-garde artists, who deplored the academy's tight control of art instruction and exhibition. From the perspective of the present day, we can appreciate how important this reorganization was in enabling modern movements to flourish in France at the end of the nineteenth century. The classicists' stranglehold on the School of Fine Arts was broken, allowing artists to study without slavishly imitating antique models. The new faculty endorsed the progressive ideas of Viollet-le-Duc, such as the necessity for the study of painting out-of-doors, which would be of great importance for the Impressionists.[33] The decree set in motion reforms that would facilitate the development of experimental artists at the same time as it

supported the unity of art and industry, an idea that had been anathema to the academy.

Understandably, the reaction to the decree was not completely positive. Ingres and his followers, who immediately lashed out against the changes, were readily supported by many of the students who were already enrolled in the academy under the old system. These aspiring artists were unwilling to accept the revisions in their education authorized by the decree. The appointment of Viollet-le-Duc, the archcritic of the School of Fine Arts, to its faculty met with an unruly protest. When Nieuwerkerke, Mérimée, and Gautier accompanied Viollet-le-Duc to his first lecture before the assembled students, they were horrified to find themselves surrounded by an audience that shouted down the speaker and then proceeded to chase the dignitaries from the building all the way back to the courtyard of the Louvre. On the way the young artists chanted lewd slogans referring to Nieuwerkerke's affair with Princess Mathilde. "One group sang the first verse of the famous aria from *William Tell*: '*O Ciel! tu sais si Mathilde m'est chère!*' [O god! you know how dear Mathilde is to me!] A second group answered immediately by a slanderous parody: '*A sa Mathilde, o ciel qu'il coûte cher!*' [To his Mathilde, Oh God how expensive he is!] Then the song was interrupted, and after an instant of silence all together shouted 'Oh! Castor!' [hey Beaver]. . . . Nieuwerkerke leaned over to Théophile Gautier (who later recounted the episode) and said to him: 'Hey, Beaver! What does that mean?' "[34] Gautier pretended not to know, but the allusion that he deliberately avoided explaining to Nieuwerkerke derived from the fame of the beaver as an animal that built his house by the use of his "tail."[35]

Although Nieuwerkerke did not fully understand all the insults aimed at him, he was quick to conciliate the protestors: Viollet-le-Duc was dropped from the faculty and replaced by the historian Hippolyte Taine. While Nieuwerkerke was, no doubt, deeply embarrassed by the student protest and somewhat surprised to find

the young artists to be such stalwart supporters of the old guard, still he had won a substantial victory over the academy and strengthened his own position in the government. To quiet his detractors, he had his mouthpiece Chesneau publish a pamphlet shortly after the education decree was signed, in which the impact of the reforms on the training of artists was presented in glowing terms to the French public. Chesneau gave assurance that Nieuwerkerke's decree would bring about a realignment in the art world, providing a greater voice for artists unaffiliated with the academy. The decree was of great significance, "because it is an attempt to secure the regeneration of art by artists themselves, with the concurrence of the top administration. It brings about the fusion of these views generally considered opposed: the administration and free art."[36]

This new alliance between the state and independent artists against the conservative academy gave the government art officials an appearance of liberalism that must have appealed to Napoleon III. Earlier that year the emperor had seen fit to punish the academicians who sat on the 1863 Salon jury by allowing the entries that they had rejected to be installed as a Salon des Refusés, so that the public could judge the works for themselves. With this gesture the emperor had shrewdly allied himself with the public and the scorned artists against the Academy of Fine Arts. Although Nieuwerkerke, who had headed the jury, resented the emperor's intrusion, he was clever enough to realize that general dislike of the academy among both professionals and the public could be mobilized to strengthen his own administration. By advertising that his educational reforms fashioned a closer link between his administration and the progressive art community, Nieuwerkerke followed the path that the emperor had indicated by his handling of the dispute over the 1863 Salon.[37]

But before he could fulfill his plan to wrench power from the academy, Nieuwerkerke had to lay the Campana question to rest. While the winds of controversy swirled around them, the Louvre

curators proceeded decisively toward the liquidation of the Campana collection. Although accustomed to working in a slow and deliberate fashion, they had moved quickly in the final months of 1862 to install the first portions of the Campana collection in the Louvre. In the closing section of his brochure, Chesneau proclaimed a fait accompli: "Already a part of the Campana collections, one of the most precious, the series of jewels, is on exhibition in the Louvre. . . . The studies begun in the Palace of Industry have for two weeks been taken up again in this gallery where the jewels have been immediately displayed, while waiting for their definitive place to be made ready among the other riches from the new Napoleon III museum."[38] From the Louvre's point of view, the Campana war was over. ᘯ

12

THE DIVIDED
TRIPTYCHS

In September 1862, the uproar over
control of the Napoleon III Museum registered a minor aftershock:
a quarrel between staff members of the opposing museums concern-
ing an unauthorized German publication of Campana objects. The
author of the controversial article, a twenty-seven-year-old archaeol-
ogist, Wilhelm Froehner, had held a temporary position in Long-
périer's antiquities department since February. According to rumor,
Froehner was hired because, as a foreigner, he could be easily dis-
missed when the time came for Longpérier's son to fill his post.[1]
The ambitious young archaeologist, perhaps emboldened by his po-
sition at the Louvre, saw no reason to obtain official approval before
publishing the texts of Greek and Latin inscriptions then still on
view in the Napoleon III Museum. At a meeting of the Academy of
Inscriptions, Léon Renier denounced this unauthorized disclosure of
antiquities, which had been brought from Syria by Ernest Renan
and from Macedonia and Thrace by Léon Heuzey. Renier demanded
that the young man be punished for what he viewed as a usurpation
of first publication rights belonging to the staff of the Napoleon III
Museum. When the complaint was forwarded to the minister of
state, it was dismissed out of hand.

In December 1862, a few months after this academic tempest in a teapot, Froehner came forward with another article, this one a hostile critique of Flaubert's novel *Salammbô*, set in Carthage. The budding curator took exception to archaeological inaccuracies in the novelist's description of the ancient Phoenician city.

Flaubert's interest in archaeology, piqued during his trip to Egypt in 1850, was reinforced by his friendship with Hortense Cornu, whose circle of scholars was deeply involved in assessing the latest excavations of Phoenician cities. Ernest Renan and Charles Beulé both longed to dig at Carthage, Beulé finally working there at his own expense in 1859. Carthage was, no doubt, a subject frequently discussed in the Cornu salon, of which Flaubert was a frequent visitor. The Cornu group may therefore be credited with inspiring both the conception of *Salammbô* and the savage criticism of Froehner, who had not forgiven the drubbing he had received at the hands of Madame Cornu's academic friends. Froehner's personal animosity was reflected in the irrelevant attack on the administration of the Napoleon III Museum with which he opened his review: "Providence, which will here be aptly called Indifference, has rid us for a time of these terrible scholars who threaten to create for us an antiquity totally new and such as one has never seen."[2] The flaws in Flaubert's description of Carthage were due to the poor research underlying the "bric-a-brac" that made up the Napoleon III Museum. Froehner accused the novelist of practicing the same deception of which the museum staff had been guilty, the bedazzlement of the public with pseudodocumentation (for which, in Flaubert's case, he coined the word *Carthachinoiserie*). Flaubert recognized that more was involved in this review than a critique of his novel; he wrote to Hortense: "The attack comes from the Louvre."[3]

At the time that Froehner's review appeared, he was also hard at work in Longpérier's department, divesting the Louvre of Campana antiquities. The department contrived to distribute vases, reliefs, and sculpture to forty-nine provincial museums. On the

handwritten list entitled "Etat de distribution des objets provenant des collections Campana," shipments were grouped by geographical *départements*; the entries showed dates of delivery and the museums to which artworks were sent but included only sparse descriptions of the objects. An example is the consignment to the Musée d'A-lençon, identified simply as "75 objects: vases, lamps, bas reliefs, heads etc. in clay, 1 statue in marble, 2 busts in marble."[4] The failure to register objects with precision was in part due to the general negligence with which Longpérier ran the department of antiquities; an additional factor, however, was probably the speed with which the distribution was carried out. All the shipments were made early in 1863, the dates clustering around the last days of January, February, and March. What may have been the final deliveries are recorded in a series of orders from the minister of state to the Department of Fine Arts dated April 4, 1863, which list shipments to museums of "duplicate" vases, terra-cottas, majol-icas.[5] The dispersion of the less valuable antiquities to provincial museums was justifiable from a practical point of view, for the cost of displaying thousands of Campana pieces would have been prohib-itive. The Louvre curators must have felt pressed to sweep their collections clean of unwanted objects before the official opening of the Napoleon III Museum collection in the Louvre galleries, sched-uled for the emperor's birthday on August 15.

Longpérier installed a stunning display of Campana antiquities in the new galleries: 300 marbles, 1,000 inscriptions, 600 bronzes, and 1,600 terra-cottas. He exhibited the Campana terra-cottas *en masse* in the cases along the walls of the Gallery of the Guards (later known as the Lacaze gallery). In this installation (*Fig. 34*) the cura-tor followed Vitet's advice to "maintain and exhibit as an ensemble, in the same space, if possible, these innumerable terra-cottas," which Vitet had admired for their "genius of ornamentation" and their "charming application of art to industry."[6] A quantity of an-tique vases and other objects were exhibited in galleries looking out

on the Seine, revealing to the public that with the Campana collection of some 4,000 vases the Louvre had become "the richest depository of antique ceramics in the world."[7]

In the painting department Frédéric Reiset was readying his catalog for the opening of the Campana painting galleries in the Louvre. Indeed, of all the Louvre curators Reiset was the only one who conscientiously published the Napoleon III Museum accessions by opening day. His catalog of 282 entries, however, revealed a sharp reduction in the 646 Campana paintings that had been displayed in the Palace of Industry.[8]

Reiset embarked with alacrity on the dispersal of the secondary paintings in the Campana collection. Rightly believing that the academy, fresh from its recent victory over the museum administration, would be looking over his shoulder, Reiset at first played strictly according to the rules; he doomed to exile only works that were not allocated to the Louvre by the reports of the academy's experts. After dividing the museums into three classes, Reiset then scattered 300-odd paintings to 67 provincial museums across France.[9]

The distribution appears to have been made without plan or pattern. Operating with the mindlessness that is permitted when actions are ruled by administrative fiat, Reiset showed himself to be unheeding of the interests and needs of the provincial museums and disrespectful of the integrity of the art objects.[10] In forming the collections, Campana had created ensembles of related objects that could teach historical styles and genres, but Reiset showed no interest in preserving this educational dimension for the provincial museums; the donee institutions received objects selected arbitrarily, without regard to their relationship to others in the same shipment. Still more reprehensible was Reiset's disregard of scholarly documentation establishing that certain paintings in the collection were parts of a single artwork. With malice aforethought he separated pictures that the artist had intended would remain together.

Among Reiset's worst offenses in the Campana shipments was his division of altarpiece panels, which Campana had searched through convents and churches across Italy to acquire. These polyptychs and triptychs, which were often in a state of disrepair, with wings and predella panels separated in Rome or during the shipment to Paris, should have been rejoined when they entered the Louvre or before being sent to provincial museums. Reiset, however, did not order the reintegration of the altarpieces and instead decreed that the constituent paintings would be scattered to the four winds.

One altarpiece sundered by the Louvre curator was the beautiful triptych by the 14th-century Venetian painter Paolo Veneziano (*Fig. 35*), the central panel of which had been designated by the academy for the Louvre collections. Whether the members of the academy knew that this painting was the centerpiece of a triptych is an open question. Already detached from its wings, the panel may have been presented to the academy as a separate work. Reiset, following the academy's instructions, kept the central panel at the Louvre; however, he sent the two wings to different museums—the right wing to the museum of Ajaccio, Corsica, and the left to the museum of Toulouse.[11] Reiset appears to have done this in defiance of earlier scholarly testimony. In the catalogs of both Campana and Cornu the wings and the central panel were listed under a single number (314) with the footnoted explanation, "they form the wings of a triptych."[12] Since the wings were banished from the Louvre and no mention of them was made in Reiset's catalog entry on the central panel, the curator had succeeded in erasing the memory of their very existence.[13]

Reiset proceeded in similar fashion with many altarpieces. Instead of sending two panels from a polyptych by Andrea di Bartolo to a single museum, Reiset separated the pair, which had been listed consecutively in the Campana and Cornu catalogs, sending one to Avignon and the other to Le Havre.[14] He also separated the

two lateral panels from an altarpiece attributed to an artist of un-
certain identity (possibly Jacopo del Tedesco); listed consecutively in
the earlier catalogs, one panel was dispatched to Tarbes and the
other to Riom.[15] Panels of more complex polyptychs were also dis-
persed widely. Campana had purchased ten panels from a polyptych
by Niccolo da Foligno; the central panel of this altarpiece was
owned by the Vatican. What Campana had gathered through sev-
eral purchases, Reiset separated. Beginning in 1863 the curator
distributed the ten panels, usually in pairs, to a total of six mu-
seums.[16]

The very rare *Madonna in Majesty with Six Angels and Donors
(Fig. 36)* was purchased by the singleminded Campana while he
was imprisoned and awaiting trial. Though the date of 1310 in the
inscription on the foot of the throne should have been enough to
keep this panel in the Louvre, Reiset sent the painting to the mu-
seum of Angers. The artist, still known only as the Master of 1310
(an appellation derived from this painting, which is considered his
masterpiece), is now recognized as the leader among the painters of
Pistoia in the first half of the trecento because of his ability to
integrate into the conservative style of the Pistoian school realistic
elements derived from Giotto.[17]

Although Campana tried to build a collection representing
many different schools of Italian painting, Reiset had little interest
in works produced outside Tuscany. A work that reveals the influ-
ences of innovative Renaissance art on painters outside Florence is
the dramatic *Saint John the Baptist with a Donor (Fig. 37)*, painted
by an artist from the Marches. It was Bernard Berenson who recog-
nized in 1907 that this superb work, which Campana and Cornu
had attributed to Crivelli, was painted by the less well-known art-
ist Girolamo di Giovanni da Camerino, who spent time in Padua in
1450. There he came under the influence of such major painters as
Mantegna and Piero della Francesca. The classical architectural set-
ting in the painting recalls a similar archway in Mantegna's *As-
sumption* in the church of Eremitani in Padua, where Girolamo di

Giovanni was employed. The use of light in the painting, as in the shadow of the saint's right arm across his chest, shows the painter's understanding of the light effects developed by Piero della Francesca. Despite its progressive elements, this panel was relegated to the museum of Tours.[18]

Although the academy had insisted that the Louvre retain several signed and dated works, one such painting, Marco Palmezzano's *Calvary with Penitent Saint Jerome (Fig. 38)*, which displays a card on the base of the cross inscribed with both the painter's name and the date 1505 (at the height of the artist's career), appears to have passed unnoticed by the academy and was transferred to the Bordeaux museum. It is remarkable that this important painting, already published in 1809, was discarded by Reiset, for in 1863 he acquired for his department a smaller and less ambitious work by the same artist, *Dead Christ Sustained by Two Angels*, signed and dated 1510.[19]

During his preparations for the opening of the Campana galleries, Reiset was preoccupied not only with the dispersal of the Campana paintings to other museums but also with the attribution of authorship for those that remained under his care. In the introduction to his catalog, he spoke of his "perplexity" when it came to ascribing authorship to those paintings chosen by the academy, blaming his difficulties on the academy's failure to give him the benefit of its expertise. He asserted that he had hoped to "transmit" the "judgments" of the academy but that "this hope has been disappointed."[20] Reiset's pretense of bewilderment was simply an attempt to emphasize that the academy's choices were ill-founded. The task of authenticating the new acquisitions belonged not to the academy but to the paintings curator, who was considered to be, "with Morelli, the best connoisseur of his time."[21] Reiset downgraded the attributions of many of the Campana paintings, especially those that had been urged on the Louvre by the academy. In many cases Campana and Cornu had exaggerated the importance of a picture by assigning it to a well-known artist. But in many in-

stances Reiset arbitrarily reduced authorship from known artists to regional schools: Florentine, Sienese, or even simply Italian of a particular century. In this manner he prepared the way for future shipments to the provinces of works that in 1863 he had plunged into anonymity.

Before he could further deplete the Campana collection, however, Reiset had to install the newly acquired paintings in the galleries of the colonnade, where they would be unveiled for the opening on Napoleon III's birthday, August 15, 1863. Of the paintings that entered the Louvre in 1863 many remain today as outstanding works in the museum's collection of Italian painting. The Campana pictures were not, however, the first early Italian paintings to enter the Louvre. In fact, it was under Napoleon Bonaparte that the museum, then known as the Musée Napoléon, first exhibited Italian "primitifs."

The emerging interest in early styles of art among David's students in the first decades of the nineteenth century seems to have influenced two key figures at the Louvre, the director, Dominique Vivant Denon, and his curator of antiquities, Ennius-Quirinus Visconti, who had emigrated to France after having served as Pope Pius VI's antiquarian.[22] Visconti began to search out examples of fifth-century Greek sculpture, while Denon looked for quattrocento paintings.[23] Though Visconti failed to acquire the sculptures of Aegina and Bassae, Denon, on an expedition to Italy in 1811, amassed a large collection of early Italian paintings. Aided considerably by Napoleon's suppression of the monasteries a year earlier, Denon was able to obtain many paintings from these monasteries as well as from other sources. In the course of his tour he managed to extract from the Franciscan church at Pisa both a Giotto and a Cimabue, which still hang in the Louvre today.

In 1814 Denon installed his series of Italian pictures in the Grande Galerie. This impressive display was accompanied by a catalog in which the director stressed a historical approach to these unfamiliar paintings, which he noted might have only "slight ap-

peal" due to their "austerity" and to the preconceptions of the public not accustomed to viewing such works.[24]

With the fall of the empire and the return of many pictures to their original owners, the Louvre again had major lacunae in its collection of early Italian painting. However, the museum was lucky enough to keep about half of the pictures Denon had acquired in Italy; due to the lack of interest on the part of Tuscany in recovering those paintings dating from Cimabue to Perugino, the Louvre retained many of the Florentine masterpieces.[25]

The Napoleon III Museum introduced to the Louvre galleries works by early Italian artists not previously represented in the museum's collection. Among Florentine painters whose pictures were exhibited in the Louvre for the first time were Bernardo Daddi[26] (*Fig. 39*), Filippino Lippi,[27] Sebastiano Mainardi,[28] and Jacopo del Sellajo.[29] The most outstanding Florentine work to enter the collection was Paolo Uccello's *The Battle of San Romano (Fig. 40)*. The only Uccello in the Louvre, this masterpiece was part of a series of three panels commissioned by Cosimo de' Medici for his palace; the other two belong to London's National Gallery and to the Uffizi. The Uccello *Battle* was a star of the Campana collection, and there was no doubt about its attribution.[30] Another Florentine panel, whose authorship is still in question, is the beautiful *Annunciation (Fig. 41)*, commissioned from Verrocchio and originally thought to be by the young Leonardo but now generally given to Lorenzo di Credi, another of Verrocchio's students. This is only one of many Campana paintings on which experts continue to disagree.

Sienese painters unrepresented before the acquisition of the Campana collection included Taddeo di Bartolo,[31] Sano di Pietro,[32] the anonymous Maître de Monteoliveto,[33] and Bartolo di Fredi.[34] Reiset, who correctly changed the attribution of the beautiful *Presentation in the Temple (Fig. 42)*, from Lorenzo Monaco to Bartolo di Fredi, noted in his catalog entry with uncharacteristic enthusiasm "the most elegant architecture" of the interior scene.[35]

Northern Italian artists had not been well represented in the

Louvre collection because Vivant Denon's travels had centered on Tuscany and the area around Rome. The Campana collection remedied this deficiency to some extent by introducing several important Venetian works. One was the beautiful central panel from the polyptych by Paolo Veneziano (*Fig. 35a*), unfortunately shorn of its wings before it went on display in Reiset's gallery.[36] Another major Venetian painting was the *Madonna and Child*, signed and dated 1372, by Lorenzo Veneziano (*Fig. 31*), which entered the Louvre only because it had been chosen by the academy. Finally, the *Saint John of Capistrano*, signed and dated 1459, was a rare solo work by Bartolomeo Vivarini, who generally worked in partnership with his brother Antonio.[37]

Works from other northern centers included a signed *Ecce Homo* by Bartolomeo Montagna, who was the leading painter of Vicenza at the end of the fifteenth century, and whose work shows the influence of several Venetian artists including the Vivarini family.[38] A dozen panels by an artist known only as the Master of the Scenes from the Life of the Virgin (a name based on this ensemble) compose a rare series from a polyptych showing the influence of Jacopo Bellini and Antonio Vivarini. Probably originally superimposed in pairs on three levels around a large central panel, these architecturally complex scenes may have been organized to depict on the left the childhood of the Virgin and on the right scenes linked with the birth of Christ.[39] A lively mythological scene, *The Abduction of Europa (Fig. 43)*, painted on a cassone panel by Liberale da Verona, was of particular interest as an example of a secular subject in Renaissance art. In 1863 the Louvre also owned a pendant, *The Abduction of Helen*, which would later be relegated to the provinces.[40] The outstanding Campana masterpiece from the Northern Italian schools to enter the Louvre was the *Pietà (Fig. 44)*, the lunette of an altarpiece by Cosimo Tura, the leading painter from Ferrara, a town outside the area of Vivant Denon's expedition. Tura, who worked for the Este Court, introduced northern expressive qualities into his art, which was strongly influenced by the taut style of

Mantegna. Originally crowning a monumental altarpiece painted
for Lorenzo Roverella, the lunette came from Tura's most important
commission. Its rich colors and strong gestures, echoing the pathos
in the outspread arms of Christ, make this a profoundly moving
work.[41]

The Tura masterpiece, however, drew a mixed reaction from
the *Revue des deux-mondes* critic, Charles Timbal, when he viewed
the newly installed Campana collection in the Louvre's *Sept-Mètres*
gallery in 1874. Though he realized its importance, the critic re-
marked on the "strange" *Pietà* of Cosimo Tura, "where one recog-
nizes the needless precision of the Germans with their patient and
unconscious imitation of ugliness."[42] Timbal gave grudging praise
to the Campana collection for having introduced into France "un-
known names . . . just at the moment when the beautiful studies
of Rio [whose *Christian Art* had aroused interest in Pre-Raphaelite
painting] brought to light artists of the schools of Siena and of
Lombardy."[43] But the Campana works, in his view, had failed to
make up for the deficiencies in the Louvre's holdings of early Italian
painting. Although the Campana catalog had "promised marvels.
. . . Alas! [The collection] had to be reattributed when the judges
were called for verification. Disappointment exceeded hopes: 40
paintings scarcely lived up to such showy promises. The Academy
showed itself to be more indulgent, it chose almost 300 paintings;
a new and prudent triage has given to only a hundred the long
awaited honor of entering definitively into the great gallery of the
Louvre."[44]

The "new and prudent triage" referred to by Timbal, which
reduced the Campana works to a mere hundred-odd paintings, was
carried out in 1872. Reiset had waited patiently, until under the
Third Republic he launched a second attack on the Campana collec-
tion. It was no doubt Reiset who inspired the then director of the
Department of Fine Arts, Charles Blanc, to propose the distribu-
tion of a large portion of the Louvre's paintings (including Cam-
pana items), many of which were already in storage. Blanc, who as

founder and editor of the *Gazette des Beaux-Arts* had in 1862 pub-
lished many articles on the Napoleon III Museum, seemed to have
lost his enthusiasm for the Campana collection by 1872 when, as a
powerful art administrator, he was engaged in furthering his own
projects. Blanc's interest in didactic museums, which had focused
his attention on the Napoleon III Museum in the sixties, had devel-
oped by 1871 into a scheme for establishing in Paris a museum of
painted copies of masterpieces of European art for the instruction of
the budding French artists of the day. Coincidentally, the short-
lived Museum of Copies, nicknamed by some *le Musée des horreurs*,[45]
was scheduled to open to the public in 1873 in the same building
that had housed the Napoleon III Museum. Like its predecessor,
the Museum of Copies was quickly closed, and its founder, Charles
Blanc, was fired.[46]

In 1872, at the time of the new excisions from the Campana
collection, Blanc was still busy commissioning from second-rate
French artists an array of copies of famous paintings, which in the
end overran the space available in the Palace of Industry. With his
enthusiasm for replicas of High Renaissance and Baroque pictures,
Blanc appears not to have worried too much about the fate of origi-
nal early Italian paintings that the Louvre was eliminating from
storage.

On July 8, 1872, Jules Simon, minister of public instruction
and of fine arts, signed the order to send out from the Louvre to
the provincial museums most of the paintings then in storage. Pub-
lished in the *Officiel* of August 8, this shipment of 1,355 paintings
included 141 paintings from the Campana collection.[47] The public
announcement drew no reaction from scholars, artists, or the acad-
emy. The Campana issue was forgotten; in 1872, with no commis-
sion keeping watch over the integrity of the Campana collection,
Reiset was able to banish from Paris paintings of higher quality
than had been dispersed in 1863, including many works that the
academy had expressly designated to become part of the Louvre col-
lection.

Blanc, in his report to Minister Simon, explained that the provincial museums would be ranked and would receive paintings according to their needs. Although the names of museums in the two highest categories were published, the authorities were sufficiently diplomatic not to list those museums designated in the two lower grades. Campana paintings were divided equally between upper- and lower-ranked museums.[48] The villages Reiset chose for the formation of new museums that would receive Campana paintings were at the time so minor as to be ignored by even "postmen or travelling salesmen."[49] These museums numbered over one hundred, of which seventy were then still in the process of formation in localities ranging in population from 1,900 at Varzy to 5,700 at Bernay.

Three examples indicate the quality of the paintings shipped to these minor museums in 1872. Sent to Rennes, one of the museums in the top category, were a pair of cassone panels by Domenico di Michelino depicting the story of Susanna (*Fig. 45*), probably executed in 1450 for the celebration of the wedding of Alessandra Strozzi to Giovanni Bonsi.[50] To Périgueux, a museum not in the upper grades, went the beautiful *Madonna and Child (Fig. 46)*, attributed by Campana and Cornu to Fra Filippo Lippi. Having already reduced its status to a work by the "school of Lippi," Reiset felt entitled to exclude it from the Louvre. Today this canvas is considered to be an early work by Sandro Botticelli, showing the influence of his teacher Fra Filippo Lippi and of Verrocchio. In 1932 Berenson changed the attribution from Lippi to "studio of Botticelli, early." Only in the 1950s did the experts Roberto Longhi and Michel Laclotte attribute it definitively to Botticelli.[51]

Although the doubtful attribution of the Botticelli may have played a part in its removal from the Louvre, there was no such excuse for the relocation of Carpaccio's *Holy Family (Fig. 47)*. Bought by Campana from the Fesch collection auction in Rome in 1845, the painting was signed by Carpaccio on the seat of the figure on the left. This superb painting, among the treasures chosen

for the Louvre by the official commission on which Reiset served, was inexplicably dispatched to the museum at Caen, ranked in the first category by the authorities, in the triage of 1872.[52]

Unfortunately, Reiset's second distribution was not the final assault on the Campana collection. By 1876 Reiset had become director of the national museums under Philippe de Chennevières, director of fine arts. In that year the Louvre curator of paintings, Both de Tauzia, with Reiset's concurrence, sent thirty-eight Campana paintings to provincial museums, leaving a mere hundred works in the Louvre. Reiset's goal had been attained: "One could then believe that even the memory of the Campana collection would forever be effaced."[53]

Why would Reiset, considered an outstanding connoisseur and scholar by his colleagues, wreak such havoc on the Campana holdings?[54] Chennevières, who admired Reiset's taste and discernment, said of him: "To prune and to expurgate seemed to have been his motto."[55] This "pruning," which in the case of the Campana works ended in the destruction of a painting collection, was not the result of ignorance or of distaste for Italian Pre-Raphaelites. Reiset himself had put together a fine private collection of early Italian pictures, which he sold eventually to the duke d'Aumale.[56] Was it the rivalry of an envious collector that impelled him to banish some of Campana's best paintings? Or was it the umbrage he had taken at having his connoisseurship second-guessed by the academy? Whatever Reiset's motive, Reinach seems amply justified in accusing the curator of

> . . . a veritable crime against the interests of the Louvre and those of art. What did one or two primitive Italian paintings signify when relegated to Melun, to Nevers, to Bourges, to Bagnols sur Cèze, to so many other places where no one even suspected their existence, where their isolation deprived them of all interest, whereas sent out in a series, they would have been, if not attractive, at least instructive? One must say very

clearly: the dispersion of the Campana paintings was a folly, a petty vengeance, the more revolting that in their haste and their negligence, the men who presided over this nefarious work did not even take the trouble to document the distribution with reference to the Italian catalogue of 1858.[57]

Had Reiset retained only those Campana works chosen by the two commissions, by 1900 the Louvre's collection of Pre-Raphaelite paintings would have numbered 383, surpassing the combined accumulations of the Uffizi and the Pitti Palace, which at that time totaled 322. By the turn of the century the Italian primitives in the Louvre would have exceeded the holdings in Florence, Berlin, or London, "if not for the quality of the works, at any rate by the number of specimens."[58]

13

CAMPANA'S
QUEST
FOR JUSTICE

❧ While the Louvre curators began divesting lesser Campana objects, some of the marchese's finest ancient works were being acquired by museums outside France. France's negotiators thought they had bargained for all the Campana collections that remained after the Russian and English purchases, but either the marchese or the papal government put a different construction on the transaction. Campana inscriptions and marbles continued to surface on the art market, and sales of such works were made through dealers in Rome and Brussels.[1]

The most valuable antiquities that Campana retained for later sale were a series of 436 gold coins covering the period from the Roman emperor Augustus to the Byzantine emperors. Campana was vague in accounting for the disposition of the coins when questioned in 1875 by a numismatic expert: "What the papal government spared was taken away by unfaithful agents to whom I had confided these treasures." Only the already published imperial series remained, and that, Campana asserted, was "sold by the municipality of Rome and one can see it now at the Capitoline, the only debris of so many riches forever lost."[2] Campana's reply raises as many questions as it answers. Reinach doubted the legality of the sale of these coins: "How and to whom had the municipality of

Rome sold these pieces which were not for sale, since France was the legitimate owner of them?"[3]

Museums in Florence and Brussels also managed to acquire some of Campana's Greek pottery. In 1871 Campana sold in Florence several cases containing fragments of vases that had been left "unnoticed in a corner." Heydemann, who saw these fragments in 1883, claimed they could be used to reconstruct some 222 vases.[4]

The Brussels museum acquisition was particularly shocking, since it involved complete vases of great renown. In 1863 Belgium was able to purchase for approximately 7,000 francs some seventy-seven Greek and Etruscan vases.[5] The Belgians made no effort to conceal the source of their acquisition, announcing in the *Bulletin of Royal Commissions of Art and Archaeology* in 1864 that their purchase was "part of a considerable and reserved collection deriving from the Marquis Campana."[6] The Belgians proudly identified among the acquired objects a *stamnos* (wine or water vessel) signed by the painter Smikros and a *kantharos* (drinking cup) signed by Douris.

Neither Cornu nor Renier, who were in charge of the Campana negotiations, had the requisite archaeological background to recognize the absence of these major vases from collections delivered to the French. Longpérier, on the other hand, who was a scholar in the field and had all the publications of the Archaeological Institute at his fingertips, had no excuse for failing to notice that a work such as the Douris *kantharos*, already published in 1855, was missing from the shipments of Campana objects to Paris. The only explanation is that Longpérier was either negligent or willfully closed his eyes to the fact that Campana had withheld some of his most valuable antiquities. Rumor had it that Nieuwerkerke, on hearing of the Belgian purchase, asked Longpérier for a report on the subject. No trace of such a report, however, remains in the Louvre archives.[7]

The appearance of Campana treasures on the market must have been a great embarrassment to the Louvre administration. Gossip in museum circles maintained that Campana's old restorer

Pennelli, who had entered Longpérier's service at the Louvre, had unsuccessfully offered to act as an intermediary in a secret deal between Campana and Longpérier to buy the vases that eventually went to Brussels. Apparently Pennelli intended to save the curator public discomfort by proposing in this highly irregular fashion to sell the Louvre some of the antiquities remaining in Campana's reserve.[8]

The Louvre's forbearance in allowing Campana objects to enter other museums may well have been due to the emperor's sympathy for his old friend Emily Rowles and her husband. It was probably understood among the Louvre administrators that close scrutiny of the Campana reserves would not meet with the emperor's approval. The likelihood of this policy of silence is supported by Reiset's laxity in pursuing a supposed Raphael that Campana was hawking in Geneva from 1865 to 1867, which was eventually acquired by a private Swiss collector, Revilliod. Ultimately, the papal government, not the Louvre, raised objections to Campana's right to sell the painting.[9]

Reiset's lack of interest in Campana's "Raphael" may have been due in part to administrative motives. Having been forced by the academy to retain some 200 more paintings than he had wanted from the original purchase, he was probably not in the mood to hunt for any additional works from the marchese's collection. His energies were instead devoted to exiling to the provinces those works not already allocated to his galleries by the two commissions.

Campana's wanderings were as tortuous as those of his remaining treasures. When he was freed in early 1859, Campana went to live in Naples, the capital of his royal patron Ferdinand, who died in May. Naples did not, however, become the Campanas's permanent residence, for they traveled in the course of their remaining years to many cities that remained sympathetic to their cause—Florence, Paris, and Geneva. Family expenses were met in part by a pension that the grateful Napoleon III awarded Emily until 1870. The Campanas, however, appear to have lived apart after 1864;

Emily settled in Saint-Germain-en-Laye near Paris and the march-ese moved to Geneva. Emily spent much of her time during her last years in literary activity, publishing an edifying tract entitled *Manual of Elizabeth* and the fruit of local historical research, *The Last Stuarts at Saint-Germain-en-Laye* (1870). She died in 1876.[10]

After leaving Emily behind in France, the marchese lived in Geneva for many years in a condition bordering on destitution. The Swiss collector Revilliod recalled that he had often fed Campana at the same table with his aged female servant.[11]

To the marchese life's meaning was reduced to a single ruling passion: to rectify the wrong that had been done to him through the forced surrender of his collection to the papal government. If the agreement he had signed in prison could not be undone in its entirety, thus giving him the right to recover all the sale proceeds, he was determined to recover the surplus that the Monte di Pietà had received over and above the amount of Campana's debt as fixed by the Criminal Court.

In December 1866, while the marchese was residing in Paris, his lawyer filed suit in the Roman Civil Court to void the agree-ment for the conveyance of the Campana museum. The terms of the contract, the complaint alleged, had been "dictated by a party that could impose the law, and the Complainant by necessity had to subject himself [to such terms] since he was then in prison and under the harsh threat that his liberation, so often promised, would not have taken place if this transaction had not first been arranged." It was a rescript of the prison governor that had authorized Cam-pana to enter the agreement. Every fiction had to yield to fact, and the fact was that "the Complainant had to sign in the prison where he was held, and two gendarmes acted as witnesses." In the sub-stantive provisions of the contract "visible traces of coercion" also appeared, since the conveyance to settle the debt of 900,000 scudi included not only the twelve collections comprising the Campana museum but all other antique and art objects and personal property

except the pieces of furniture that were reserved for the Marchese in an addendum.

The papal authorities had seized collections far exceeding the amount of Campana's debt, the complaint asserted. The government had refused to have the assets properly appraised and, in the subsequent resales, had not only violated applicable regulations but had transgressed as well "the common diligence that the humblest householders do not neglect to employ in their business affairs." In any event, it was not equitable to permit the monte to retain 37,000 scudi of sale proceeds in excess of the total debt, as well as remaining art objects having an aggregate value of at least 150,000 scudi. Therefore, Campana prayed for the recovery of the surplus proceeds and of the unsold artworks.[12]

In a second complaint filed concurrently, Campana sought to overturn the 1858 judgment purporting to fix the amount of his debt to the monte. In support of this claim Campana cited a host of procedural irregularities: The amount of the debt had been calculated by an expert in the employ of the prosecution, and the defense had been denied access to documents and expert services that would have enabled the marchese to establish a more accurate figure.[13]

On January 16, 1867, Filippo Maria Salini, procurator of the Monte di Pietà, filed a "special appearance" in the Civil Court on behalf of the monte for the sole purpose of urging that the court had no jurisdiction to consider either of Campana's claims.[14] Decision was stayed on January 29 pending Campana's petition to the pope regarding the jurisdictional issue.[15] This appeal failed, and on February 15 the Civil Court confirmed its lack of jurisdiction, thereby excluding Campana's claims from further consideration.[16]

Neither the marchese nor his original defense counsel Marchetti were prepared, however, to give up the campaign for justice. In 1870, Campana was in a Roman court again, seeking redress from the newly established government of the Kingdom of Italy, as

successor to the Papal States. A decade of procedural wrangles fol-
lowed, but Campana was resolved to persevere. At last his tenacity
appeared to have been rewarded, for in October 1880 the first ar-
guments on the merits of his claim were scheduled. This victory
was to prove ruthlessly hollow, for on the eve of the court hearing,
Campana died. Like the litigants of Dickens's *Bleak House*, he had
worn his heart out through hope long deferred.[17]

14

THE LAST
PALACE:
AVIGNON

In 1858, the year a Campana catalog
appeared in Rome with a section devoted to "the Renaissance of
Painting in Italy," an American novelist residing in Florence re-
corded his view of early Italian painting. Nathaniel Hawthorne,
after seeing Duccio's *Rucellai Madonna* in the Church of Santa Maria
Novella, wrote in his notebook: "The picture was brought to the
church in triumphal procession, in which all Florence joined . . . it
would relieve my mind and rejoice my spirit, if the picture were
borne out of the church, in another triumphal procession and rever-
ently burnt. This should be the final honor paid to all human works
that had served a good office in their day; for when their day is
over, if still galvanized into false life, they do harm instead of
good."[1] Hawthorne's outlook probably reflected the attitudes of
most American tourists in Italy in the mid-nineteenth century. Cer-
tainly at that time there were only two significant American collec-
tors of early Italian painting: Thomas Jefferson Bryan and James
Jackson Jarves. Bryan, who opened his collection to the public, dis-
playing his pictures and acting as guard in his private museum on
Broadway, was the model for Lewis Raycie in Edith Wharton's no-
vella *False Dawn* (1924).[2] Raycie returns from a grand tour of Italy
in the 1840s with a collection of Pre-Raphaelite pictures that hor-

rify his father, who has funded the purchase and whose taste runs
to High Renaissance and Baroque painting:

> America was a long way from Europe, and it was many years
> since Mr. Raycie [Senior] had traveled. He could hardly be
> blamed for not knowing that the things he admired were no
> longer admirable, still less for not knowing why. The pictures
> before which Lewis had knelt in spirit had been virtually un-
> discovered, even by art-students and critics, in his father's
> youth. How was an American gentleman, filled with his own
> self-importance, and paying his courier the highest salary to
> show him the accredited "Masterpieces"—how was he to guess
> that whenever he stood rapt before a Sassoferrato or a Carlo
> Dolci one of those unknown treasures lurked near by under
> dust and cobwebs?[3]

Because of the "rubbish" he brought home from Italy, Lewis is dis-
inherited by his father, but the novel's ending demonstrates the
change in attitude toward early Italian painting, with the collection
being sold off by a descendant for 5 million dollars. In the 1840s,
however, when Bryan and Jarves were shopping in Italy, these pic-
tures were considered oddities by most American travelers.

James Jackson Jarves's interest in "gold background pictures,"
as he called them, had been piqued by the writings of Rio, Ruskin,
Lord Lindsay, and Mrs. Jameson.[4] Inspired like Bryan with the
missionary vision of "carrying" this Christian art to America,
Jarves began buying pictures with funds advanced by his mother
from his father's legacy. In the sixties, when Jarves tried to sell his
collection, he discovered, unfortunately, the accuracy of his moth-
er's warning that his taste "was half a century too soon."[5] Little
interest existed in either Boston or New York in his collection of
over a hundred paintings, purchased at the cost of some $60,000.
Eventually he was forced to convey it to Yale University for a third
of that amount.[6]

Jarves's book, *Art Studies: The "Old Masters" of Italy,* probably had a stronger impact on his contemporaries than his collection. Published in 1861 and dedicated to Charles Eliot Norton of Harvard, an art historian and Dante scholar who shared Jarves's enthusiasm for the "primitives," the book surveyed the history of Italian painting, using as illustrations many of the misattributed works in the author's collection. Jarves warned the unwary American collector against dishonest dealers and called for the establishment of educational collections of Italian art in American museums.[7] This was the first important American study of early Italian Renaissance art. It was followed in 1864–66 by the publication in England of *A New History of Painting in Italy from the Second to the Sixteenth Century,* by Crowe and Cavalcaselle, an Anglo-Italian team who documented the work of a broad range of hitherto unknown Italian artists.[8]

In the seventies the appetite for the Renaissance was stimulated by the appearance of two major European publications: Walter Pater's aesthetic appreciation of Renaissance art, *Studies in the History of the Renaissance* (1873), and Jacob Burckhardt's cultural history, *The Civilization of the Renaissance in Italy* (1878). The aesthetic cult of the Renaissance received additional support with the appearance in 1882 of John Addington Symonds's *Renaissance in Italy: The Fine Arts.*[9] Toward the end of the century the growing appreciation of "primitives" as art objects rather than mere illustrations of past history influenced American collectors. Italian Renaissance pictures, so remote from the materialism of industrialized America, were prized as marks of the cultivated taste of their owners. But warned by Jarves of the pitfalls in store for the novice, the new American collectors, with social ambitions and the funds to match, needed an expert to help them make well-informed choices.

That arbiter of taste appeared in the eighties in the person of Bernard Berenson, who had been inspired by Pater and had also learned Giovanni Morelli's connoisseurship techniques, based on the study of the artist's habitual method of rendering details. Trained in Norton's courses at Harvard, which stressed the ethical

rather than the aesthetic aspects of Renaissance art, but refused entrance by Pater to a seminar at Oxford, the young connoisseur soon became one of the protégés of the wealthy socialite Isabella Stewart Gardner. Berenson was quick to seize the opportunity of advising Mrs. Gardner on her purchases of Italian paintings, and in 1896 he highlighted her collection of pictures in an article published in *Gazette des Beaux-Arts*. Entitled "Italian Paintings of New York and Boston," the article analyzed several public collections, including the holdings of the New-York Historical Society, the Metropolitan, and the Boston Museum of Fine Arts, and downgraded many previously accepted attributions. Berenson also discussed several private collections, including those of Professor Norton and Mrs. Gardner, whose paintings he described as "capable of arousing the envy of all the European museums."[10] This rather self-serving appraisal no doubt pleased Berenson's client, whose collection was now accorded international attention. But flattering Mrs. Gardner was only one of Berenson's goals; his opening remarks were intended to attract other American collectors to Italian Renaissance painting and, presumably, to tout Berenson's services as picture agent. He sounded the alarm that the supply of primitives was drying up; stating that European museums had been actively acquiring Renaissance paintings at inexpensive prices, Berenson warned that within twenty years "there will remain on the market for American buyers very few paintings of the first order." He urged American collectors to begin to buy before it was too late, so that their museums would be able to exhibit Italian art for the benefit of "young artists" who would no longer have to "cross the Atlantic in order to learn their profession."[11]

Published in France, this article introduced to European colleagues Berenson's genius in attributing Renaissance painting. Berenson's introduction to the *Gazette des Beaux-Arts* had been provided by his friend Salomon Reinach, who continued to commission articles from Berenson and acted as his translator, smoothing out Berenson's slangy style in accordance with more elegant French usage.

Reinach, a French philologist, archaeologist, and art historian, was
a prominent member of the artistic and literary circles of Paris.
Seven years older than Berenson, Reinach helped Berenson gain ad-
mission "to all sorts of private collections."[12] A member of the
Academy of Inscriptions and holder of the chair of archaeology at
the Ecole du Louvre, Reinach published several indexes to antiqui-
ties and was also keenly interested in Renaissance art. He admired
Berenson's perceptive eye even though he often disagreed with his
friend's moral judgment.[13] A much-published scholar, whose his-
tory of art, *Apollo* (1904), was the most popular survey of the field
for a generation, Reinach sat on the advisory boards of both the
Gazette des Beaux-Arts and the *Burlington Magazine.* While director
of the museum of Saint-Germain-en-Laye, he published from 1905
to 1910 an illustrated index of medieval and Renaissance paintings
in Europe and America. It was while he was at work on this survey
in the fall of 1904 that Reinach published in *Revue Archéologique* (of
which he was codirector) the first of five installments of his histori-
cal sketch of the Campana collection. With his strong background
in ancient and Renaissance art, his role as a museum director, and
his current project of fixing the whereabouts of medieval and Ren-
aissance paintings, Reinach was well suited to tell the story of the
formation and dispersion of this major collection.

Reinach's association with Berenson heightened the French-
man's awareness of the increasing vogue of early Italian art in
America. During the winter of 1903–1904 Berenson and his wife,
Mary, had embarked on a six-month trip to America in search of
collectors whom they might interest in Renaissance painting. Mary
recorded their horror at the Havemeyer collection of modern art:
"an awful Tiffany house!—Rembrandts, Monets, Degases ad infini-
tum—no real taste. . . ."[14] In an effort to turn collectors toward
the old masters, Mary lectured at museums and private clubs on
such topics as Art Collections in America and their Influence on
National Taste and Art, while Bernard reattributed collections,
both public and private.[15] Although museum administrators were

seldom pleased with Berenson's views on their holdings, private collectors were more willing to follow the expert's advice, and eventually Berenson acted as adviser to wealthy art lovers including the Wideners and John G. Johnson in Philadelphia; Henry Walters in Baltimore; and Carl Hamilton, Samuel and Rush Kress, Percy Straus, and Robert Lehman in New York. [16]

With Berenson's success as adviser and agent to American tycoons, the prices of Italian paintings rose sharply. The passion for early Italian painting in America reached its height in the years before World War I. Reinach, through his contact with Berenson, was aware that it would be more and more difficult for European museums to compete with rich Americans for the early Renaissance paintings. Yet France already had a quantity, some 500 such paintings, which had been dispersed and forgotten in the provinces during the nineteenth century. Reinach, in publishing his historical sketch of the Campana collection, sought to draw the attention of scholars to this hidden treasure. At the same time, Berenson was studying many of the Campana pictures that he would include in his writings from 1907 on. Reinach, though, went further in his zeal, advocating an effort to reconstitute the scattered collection so that it could be seen and studied by the French for whom it had originally been purchased. He ended the fourth installment of his Campana history with the proposal that the Department of Fine Arts publish a catalog identifying Campana works in provincial museums as a basis for an exhibition that would put what remained of the collection on display in Paris. [17]

The obstacles to the rediscovery of the Campana collection were formidable. Reinach had been unable to find any register showing the location of all the works, although he had found a list of those paintings sent out in 1872. [18] He described his embarrassment when queried by scholars: "I have often had to answer questions from connoisseurs who wished to know what had become of some painting formerly in the Campana collection; I have always been ashamed to admit that no register exists to which one can

refer to obtain such information."[19] Information on Campana antiquities was somewhat more accessible due to the efforts of Froehner; the listings according to vase type, however, were too vague to allow precise identification.[20] Reinach was thankful for the publication in 1872 by the adjunct curator of the national museums, Count Louis Torterat Clément de Ris, of the names of the cities that had received Campana paintings in 1863, and he reprinted the list for his readers.[21]

In 1906 the *Revue Archéologique* published an article by Maurice Besnier entitled "The Campana Collection and the Provincial Museums." Citing Reinach's assertion that no registers existed for tracing the Campana paintings, Besnier had set about identifying Campana works through reviewing catalogs published by provincial museums, working with curators, and searching in their archives. He limited his investigation to ten museums whose collections had been listed in the *General Inventory of the Riches of Art in France,* published under the auspices of the Ministry of Public Instruction and Fine Arts between 1878 and 1890,[22] and compiled as best he could a list of paintings and antiquities in these museums with date of shipment, museum location, and identifying numbers in the catalogs of Cornu and Reiset.[23]

While Besnier was at work on his rather narrow abstract based on the *General Inventory,* two other scholars, Paul Perdrizet, professor at the University of Nancy, and René Jean, librarian of the Central Union of Decorative Arts, embarked on a more ambitious survey of the Campana collection. Having found lists in the archives of the Department of Fine Arts that recorded, museum by museum, the shipments from 1863, 1872, and 1876, which Reinach and Besnier had failed to find, Perdrizet and Jean were able to reconstruct the location of some 500 paintings in provincial museums. Thus they produced a concordance among the Campana, Cornu, and Reiset catalogs, complete with bibliographical references, including citations to Crowe and Cavalcaselle (who had visited the Campana gallery in Rome and described some of the pictures in

their *History of Italian Painting*). Perdrizet and Jean also produced a list of dismembered works with the hopes that museums might regroup "what ignorance, or haste, or evildoing had dispersed."[24] The two scholars presented their results as a sketch for a more complete book, which would reproduce pictures of all 646 Campana paintings listed in their catalog. Although this book never appeared, the research of Perdrizet and Jean, inspired by Reinach's articles, would help future generations repair the damage done to the Campana collection in the 1860s and '70s.

After 1945, in connection with the postwar reorganization of museums, Jean Vergnet-Ruiz, inspector general of the provincial museums (1945–1961), resolved to reassemble the Campana collection of Italian paintings, which had been scattered for over eighty years. Vergnet-Ruiz had served successively as curator at Versailles (1930), a member of the painting department of the Louvre (1933), director of the Laboratory of the Museums of France (1937), and curator of the Château de Compiègne (1942), before taking charge of the provincial museums. In the late forties he began to teach a course at the Ecole du Louvre on the history of the provincial museum collections, which inspired him to right the wrongs of the earlier Louvre administration. On visiting Avignon in 1949 in the course of his inspection rounds, Vergnet-Ruiz discussed his vision of a recreation of the Campana painting collection with the then director of the Calvet Museum, Georges de Loÿe, who suggested Avignon as the site for the collection of Campana primitives.[25]

Before the site was finally determined, however, the paintings had to be studied and restored, and a decision made as to which ones should be included in the reconstituted Campana collection. The first public showing of a portion of the Campana paintings was held at the Orangerie in Paris from May to July of 1956. This exhibition, entitled *De Giotto à Bellini: les primitifs italiens dans les musées de France,* brought together the most important fourteenth- and fifteenth-century Italian paintings from the provincial museums

of France (whose holdings numbered more than similar collections in any museums of Europe outside of Italy and London).[26] Of approximately one hundred works in the catalog, over forty were Campana paintings, giving a partial, but tantalizing, survey of what the fully reunited collection would contain. This exhibition served not only to display the outstanding Italian paintings but also to instill a spirit of cooperation among the participating provincial museums in the difficult process of reassembling the Campana treasures.

The exhibition was organized by Michel Laclotte, an expert on Italian painting of the fourteenth and fifteenth centuries (as well as on the French primitives). In the course of his distinguished career Laclotte served as inspector of the provincial museums (1955–1965) and later as the chief curator of the painting department of the Louvre (1966–1987), who oversaw during his tenure the creation of the musée d'Orsay; he is now the director of the Louvre. In connection with the Italian painting exhibition of 1956, Laclotte brought together for the first time many of the dismembered altarpieces from the marchese's collection. Several predella panels were reunited, including a pair by the Sienese painter Benvenuto di Giovanni (*Fig. 48*), one shipped to Blois in 1872 and the other to Aix-en-Provence in 1876.[27] A pair of predella panels by Niccolo Rondinelli were contributed to the exhibition by the museums of Mans and Perpignon, where they had been shipped in 1872. In the course of his research prior to the exhibition, Laclotte discovered that these paintings may well have been part of an altarpiece, of which the central panel is now at the Brera in Milan. When the altarpiece was described in 1783 as one of the treasures in the church of San Domenico in Ravenna, the predella was already separated and stored in the sacristy.[28]

After the Orangerie exhibition closed, these reunited predella panels were destined for the new "Campana Museum." However, in some cases pictures retrieved from provincial museums were returned to the Louvre collection. The rare *Saint Francis of Assisi* by

Giovanni da Milano (*Fig. 49*), which had been sent to the Bor-
deaux museum in 1863, was brought back to the Louvre as an
important example of Florentine art of circa 1360. The Louvre also
reclaimed the two wings separated from the Paolo Veneziano central
panel (*Fig. 35,* discussed in Chapter 12), which had been kept by
the Louvre. Recovered from museums in Ajaccio and Toulouse and
shown with the Louvre panel in the Orangerie exhibition, these
three panels, thought by Campana and Cornu to comprise a trip-
tych, were discovered, in fact, to be part of a major polyptych
made up of probably seven or nine panels. The two side panels now
join the central panel in the Louvre as a portion of what was origi-
nally a much larger altarpiece.[29]

The scholarly work of art historians who participated in the
exhibition resulted in the reconstruction in the catalog of many
other dismembered altarpieces, all the parts of which were not
available for exhibition. Laclotte noted that the fragmentation of
works of art was not uncommon during the nineteenth century:

> Though it is spectacular, the case of the Campana collection is
> not isolated in the nineteenth century. The consciousness, how-
> ever rational, of the integrity of the work of art is an acquisi-
> tion of modern sensibility. In fact, the history of collections of
> Italian paintings in the eighteenth and nineteenth centuries is
> made up of dislocations, of separations which the museological
> mind judges barbarous. With the exception of certain polyp-
> tychs which remained in place or passed "en bloc" into Italian
> museums at the moment of the Revolution, almost all the
> great altarpieces of the Trecento and Quattrocento were ac-
> tually dismembered, in whole or in part. Disdained during the
> Baroque period, laid aside or abandoned at the back of a sac-
> risty or a gallery, they were handed over, during the turmoils
> at the beginning of the nineteenth century, to dealers, collec-
> tors, or even ordinary visitors. The hazards of sales and the
> practical necessities of the art market (two Giottos separated
> sell better than a single Giotto in two parts) completed this

dispersion throughout the world of ensembles conceived by
their authors as unities. [30]

Granted that the dismemberment of altarpieces was common in the
past, such barbarities had seldom before been committed by mu-
seum administrators. Laclotte expressed his indignation at the frag-
mentation of Campana polyptychs: "One of the most absurd conse-
quences of the dispersion of the Campana collection into the
provinces during the last century was the cutting up of certain
polyptychs, the separation of certain pendants, and of certain re-
lated predella panels. The exhibition of the Italian Primitives in the
Museums of France has allowed the rectification, at least provision-
ally, of some of these errors, before the definitive regrouping of the
collection in a single 'Campana Museum.' " [31]

Many of the Campana pictures in the Orangerie exhibition
were later permanently rejoined with their related panels. However,
there were of necessity some exceptions to the plan. [32] Beginning in
1953 and continuing after the exhibition closed in 1956, exchanges
were negotiated with museum curators and mayors in cities where
Campana paintings were located. Museums that gave up paintings
were recompensed with artworks chosen to enhance their collections
geographically, historically, or artistically. The reclamation of Cam-
pana paintings from the provincial museums was a delicate task
that could only be accomplished in a country like France where top
museum administrators such as Vergnet-Ruiz and later Laclotte had
a responsibility for both central and regional museums. These two
museum officials were in a position to balance the needs of the
projected museum with those of the Louvre and of the provincial
museums as they amassed the 300 paintings that would form the
new Campana collection.

The choice of Avignon as the site of the Campana museum
was appropriate for a collection of early Italian painting, because
during the fourteenth and fifteenth centuries, at the time these
works were created, Avignon was the center through which Italian

art entered France. In 1309 Pope Clement V, who was crowned four years earlier by Philip the Fair of France, moved his court to Avignon in Provence, chosen because the city lay outside France and close to the Comtat Venaissin, a domain that had belonged to the popes since the Crusade of 1272. In Avignon, the popes ruled under the protection of the count of Provence, who was also king of Sicily and vassal of the Holy See. In 1348 Countess Joanna of Provence deeded the city of Avignon to Pope Clement VI, and it remained papal property until 1791. With the papal court came many functionaries, courtiers, travelers, pilgrims and, of course, artists. The population of the city soon grew to more than 30,000 as Avignon became one of the most brilliant centers of humanism in Europe. Although Petrarch criticized the materialism and corruption of the pontifical court, Froissart described the papal palace, begun around 1335 with walls from six to thirteen feet thick, as "the most beautiful and most strongly built house in the world."[33]

Papal patronage attracted many famous Italian artists to Avignon. A contemporary document claimed that Giotto himself traveled there, a statement accepted by Vasari but still not verified. The most famous Italian painter whose work in Avignon has been documented is the Sienese master Simone Martini, who spent his last years there from about 1336 to his death in 1344. He is credited with having painted the frescoes on the entry porch of Notre Dame des Doms. His presence in Avignon is also recorded by Petrarch, whose sonnet on Simone Martini's portrait of Laura (a canvas now disappeared) is well known. Petrarch also noted that Simone Martini made a portrait of the Italian cardinal Napoleone Orsini, which was presented to Clement VI.[34]

Although Simone Martini probably did not participate in the decoration of the Palace of the Popes, undertaken under the reign of Benedict XII, certain innovations in the frescoes in the pope's chamber on the third floor of the Tower of the Angels demonstrate that the Italian rendering of perspective space had modified the

two-dimensional French style. In the deep embrasures of the windows are trompe l'oeil paintings of bird cages hanging in illusionistic space, an ornamental motif going back to Tuscan painting.[35] The decoration of the Pope's Wardrobe Chamber executed during the reign of Clement VI was the work of a team of artists who created tapestrylike scenes of fishing and hunting that at the same time suggest three-dimensional space. These courtly scenes from French literature are presented in an Italianate manner, or as Laclotte puts it, "a French idea translated into the Italian language."[36]

The murals of the pope's palace under Clement VI were painted by a team of artists led by Matteo Giovannetti of Viterbo. It was he who created the frescoes in Clement VI's private chapel dedicated to the life of Saint Martial. Located adjacent to the *Salle du Grand-Tinel* (banquet hall), these frescoes present strongly illusionistic architectural settings, which derive from the compositions of the Sienese Lorenzetti brothers. In their emphasis on individualized portraits, elaborately ornamented clothing, and gothic linear rhythms, these works also show the impact of Simone Martini.

The papal commissions in Avignon thus produced between 1330 and 1365 an art that combined the French tradition of courtly subjects with the Italian rendering of space. This elegant International Gothic style, with its curvilinear patterning and courtly themes, would spread across Europe to England, Catalonia, Bohemia, and France in the late fourteenth century.[37] The art of Italy continued to influence painters in Avignon into the fifteenth century. In Avignon after the departure of the popes in 1377, a style derived from a fusion of Italian and Franco-Flemish sources was practiced by artists such as Nicolas Froment and Enguerrand Quarton, whose *Pietà of Villeneuve-lès-Avignon* is one of the great masterpieces of the Louvre.

Avignon's crucial role in the introduction of Italian innovations into Northern European art made it an ideal setting for the Campana paintings. In 1949 when the site of Avignon was first

discussed, George de Loÿe suggested to Vergnet-Ruiz that the museum be established in the city's Petit Palais, which was then used as a vocational school.[38]

This palace, situated on the same square as the Palace of the Popes, was built as a large residence by Cardinal Bérenger Frédol between 1318 and 1320. After the cardinal's death in 1328, it was purchased and enlarged by a nephew of Pope John XXII, Cardinal Arnaud de Via; in 1335 it was acquired by Pope Benedict XII who, having decided to build the Palace of the Popes nearby, used it to house the episcopal seat. However, it was not until 1364 that the archbishop of Avignon, Anglic Grimoard, brother of Pope Urban V, completely reorganized the plan of the building to create four sections around a trapezoidal cloister, flanked on the northeast and southeast by two wings whose extremities, backing up on the Rock of the Doms, create a service court. At this time the building was called the Petit Palais, or the Archbishop's Palace, in contrast to the neighboring residence of the popes, called the Grand Palais.

During the turmoil of the Great Schism beginning in 1378 and lasting until 1411, the Petit Palais was used as a citadel and withstood many damaging attacks. In the middle of the fifteenth century many interior changes were made, but in 1474 the palace was completely remodeled in Renaissance style by Cardinal Giuliano de la Rovere, who was promoted quickly by his uncle Pope Sixtus IV from bishop to archbishop and ultimately to legate (deputy of the pope) at Avignon. In his dual role as archbishop and legate he had both palaces at his disposal. Though he eventually moved to the Grand Palais, he took an active role in modernizing the Petit Palais where he lodged many of his important guests, including Caesar Borgia, Queen Isabella of Naples, and Archduke Philip of Austria, the future king of Castille. Giuliano demolished the medieval facade looking out on the square and replaced it with one placed further forward in Renaissance style, while on the west he covered the old exterior with a more modern facade, making that section of the building more pleasing to the eye of this aesthetic

prelate. He also added a tower some 45 meters high, which fell in
1767. The palace (*Fig. 51*), though remodeled at various times,
remains essentially as it was redesigned by Giuliano, who returned
to Rome in 1503 as Pope Julius II, remembered today primarily as
Michelangelo's patron. In 1650, however, a gunpowder explosion at
the citadel of Saint Martin demolished the upper parts of the build-
ing on the eastern side and destroyed the falconry murals within.

During the French Revolution, when Avignon was annexed by
France, the Petit Palais was sold as property of the state. In 1826,
it again became the site of a religious institution, when it was
bought by the archbishop to house a seminary. Nationalized in
1904 and changed into a technical and vocational school, the build-
ing was put under the aegis of the Department of Historic Monu-
ments in 1959 and work was begun to restore it and convert it into
a museum.[39]

Opened in 1976, the Petit Palais Museum exhibits works
drawn from two sources: the Campana collection and Avignon's
Calvet Museum.[40] The section formerly housed in the Calvet mu-
seum is devoted to Avignon painting and sculpture from the
twelfth to the beginning of the sixteenth century, including about
60 very rare paintings by Quarton, Jean Lieferinxe, and other mas-
ters, and some 600 works of sculpture from Roman to Gothic pe-
riods. Related to these Avignon works from the Calvet Museum is a
series of fourteenth-century frescoes from a house in Pont de
Sorgues, 10 kilometers from Avignon, which were derived from the
hunting frescoes in the Chamber of the Stag from the Palace of the
Popes. These frescoes, acquired by the Louvre in 1937, demon-
strate the importance of Avignon in the creation and dissemination
of the International Gothic style.

The Campana collection is installed in the palace by region,
beginnning with the second half of the thirteenth century.[41] Dating
from circa 1270 is the *Last Supper* (*Fig. 50*), from the studio of the
anonymous Master of the Madeleine; it was acquired by Campana
from a private collection in Arezzo.[42] Other early Tuscan paintings

are the large *Madonna in Majesty* (*Fig. 36*), by the Master of 1310 from Pistoia,[43] and the Florentine *Madonna and Child,* probably a central panel of a small polyptych made for a private altar by Giotto's student and collaborator, Taddeo Gaddi.[44] Also from Florence is the *God the Father* by Giotto's contemporary, the Master of Figline. This panel, probably the central pinnacle of a polyptych, may have been painted before 1330 for a chapel in Santa Croce.[45]

In the first half of the fourteenth century, Bologna became an important art center, much under the influence of the Rimini school, which would disappear after the Black Death. A *Crucifixion* (*Fig. 52*), dated around 1330, is considered an early work by Pseudo Jacopino di Francesco, a Bolognese artist influenced by the Rimini school.[46] This rare work had been shipped to Moulins in 1872. A later Bolognese painting is the small *Coronation of the Virgin* signed by Jacopo di Paolo and probably executed around 1400.[47] This panel, which had been noted by Crowe and Cavalcaselle, was also exiled from the Louvre in the 1872 dispersion.

While both these paintings from Bologna were restored before entering the museum, a small panel from Venice dated between 1340 and 1350, and now attributed to Paolo Veneziano, was in remarkably fine condition. The half-length *Madonna and Child* (*Fig. 53*) was probably the central panel in a small polyptych, hypothetically reconstructed by Laclotte from several panels now in American collections.[48]

The Sienese tradition is represented by four tondos by Simone Martini that were acquired for the Petit Palais Museum on the art market in 1982; the most striking is the intensely expressive head of King David.[49] From the Campana collection there are several works in the tradition of Simone Martini. One is the half-length *Saint John the Baptist* (*Fig. 54*) by Paolo di Giovanni Fei, executed between 1380 and 1390 as part of a polyptych.[50] Others are several works by Taddeo di Bartolo, including a central panel of *Madonna and Child* (*Fig. 55*) with a beautifully flowing scarf draping the Virgin's shoulders, and a *Saint Peter,* which may be the left part of

the same polyptych, dating from the years of the artist's maturity, 1400–1405.[51]

After the Black Death of 1348, there were many commissions for artists from churches, convents, and wealthy individuals in Florence. Painted around 1365–1370 by Jacopo di Cione is the *Mystic Marriage of Saint Catherine,* a subject popular in the legends of the saints beginning around 1337.[52] This painting, given by the Louvre from its Campana holdings, provides an interesting comparison with a triptych on the same subject by the flourishing Florentine workshop directed by Jacopo di Cione.

The Louvre provided other Florentine works to the Avignon museum, including the central panel of the triptych by the anonymous Master of Santa Verdiana, which had been retained by the Louvre since the Campana acquisition. The side panels of this altarpiece, which had been sent out to Rouen in 1872, are now rejoined to the *Madonna and Child Surrounded by Eight Angels.* Commissioned in the late fourteenth century for the Hospital of Bonifazio in Florence by the city's mayor, Bonifazio Lupi, who appears as a donor with his second wife, these panels were stored in the church of Santa Croce after the suppression of religious establishments at the end of the eighteenth century.[53] Labels on the back of the wings reveal that the altarpiece had belonged in the early nineteenth century to Carlo Lasinio, the curator of the Campo Santo of Pisa, whose publications made a profound impression on the English Pre-Raphaelites. It was probably from Lasinio that Campana purchased the altarpiece which, though separated in 1872, was identified as a triptych by Berenson in 1932 and is now permanently reunited in Avignon.

In Florence the International Gothic style made its appearance around 1400. An example of this style is the *Triptych of Saint Lawrence,* composed and drawn by Lorenzo Monaco but executed by his students in 1407.[54] According to Carlo Strozzi's writings, it was displayed in the seventeenth century on the main altar of the church of San Salvatore di Valle of Monteloro, in the val d'Arno; it

remained among the Campana works in the Louvre until sent to
Avignon in 1976.

The International Gothic style also had a strong impact in the
Marches. This region is the source of an uncommon depiction of
the Virgin, *The Madonna of Mercy* (*Fig. 56*) by Pietro di Domenico
da Montepulciano.[55] This painting is in the form of a processional
standard (originally double-faced) created for a company of flagel-
lants, who are shown kneeling beneath the Virgin's enveloping
cloak; many such religious confraternities existed in the Marches.
The International Gothic style persisted in Siena into the late fif-
teenth century, as demonstrated by the several panels by Giovanni
di Paolo, notably his *Saint Clement* (*Fig. 57*), which was probably
executed between 1455 and 1460, during the height of the artist's
career.[56]

Among the reunited ensembles on view in the museum is the
beautiful Rinieri altarpiece (*Fig. 60*) by the Florentine Francesco
d'Antonio, of which the predella panels had been divided between
Carcasonne and Bourges and the central panel sent to Grenoble.[57]
Painted around 1430, it is composed of a large panel above a series
of small predella scenes showing the life of Saint Jerome. The shape
of the altarpiece frame, carved at the top in a triple arch, reflects
the transition from the Gothic triptych to the single-panel altar-
piece of the High Renaissance.

Another altarpiece featuring a single major panel (here set be-
tween Renaissance pilasters and surmounting a series of predella
panels) is an important work by an anonymous pupil of Fra Ange-
lico, the Master of the Madonna of Buckingham Palace (*Fig. 59*),
who painted it for the Church of the Order of Saint Jerome in Fie-
sole.[58] When the order was suppressed in the seventeenth century,
the church and the convent were eventually acquired by private
owners. In 1852 the altarpiece, then considered to be a major work
by Fra Angelico, was sold to Campana. Although this attribution
was immediately questioned, the painting with its jewellike colors,

glittering gold touches, and tapestrylike setting of an enclosed gar-
den shows the strong influence of Fra Angelico. Commissioned by
the Medici, as their coat of arms on both ends of the predella signi-
fies, this beautiful "holy conversation" strongly recalls the composi-
tion of an earlier Medici commission from Fra Angelico, the *Anna-
lena Altarpiece*. Through the generosity of the Louvre this painting
was moved from Chartres, where it had been sent in 1939, to
Avignon to enhance the Florentine collection of the Petit Palais.

The interest in perspective, which developed in the fifteenth
century in Florence, is illustrated in the lunette (*Fig. 58*) of an
altarpiece by Bartolomeo della Gatta showing an *Annunciation* in
which the receding floor tiles and open archway suggest deep
space.[59] Transferred to the Avignon museum from Périgueux where
it had been sent in 1863, the lunette is thought to have come
originally from the same altarpiece as an *Adoration of the Shepherds*
now in the Kunsthistorisches Museum in Vienna.

Another Florentine *Annunciation* (*Fig. 61*), which remained in
the Louvre until 1976, is an important work by Cosimo Rosselli
dated 1473.[60] The composition is dominated by an architectural
frame that encloses a pair of saints in shell niches on either side of a
central opening showing the annunciation in deep perspective
space, as though it were a picture within a picture.

From Périgueux came the Botticelli *Madonna and Child* (*Fig.
46*), which had been considered a workshop piece until the
1950s.[61] Amiens provided the *Madonna and Child* (*Fig. 62*) by
Francesco di Giorgio, a Sienese artist aware of Florentine innova-
tions, as the landscape background and the Verrocchio-like group-
ing of the figures indicate.[62] The treasure of the Avignon collection,
the exquisite signed and dated Carpaccio (*Fig. 47*), which Campana
had purchased from the famous collection of Cardinal Fesch, was
moved from Caen where it had been since 1872.[63]

Campana's interest in collecting cassoni panels is well illus-
trated in the Avignon museum collection. Besides those by Domen-

ico di Michelino, Liberale da Verona, the Master of Lecceto, and the Master of the Whittemore Madonna, perhaps the most impressive examples are the four panels (*Fig. 63*) painted by the anonymous Master of the Campana cassoni. These magnificent panels from two early sixteenth-century cassoni tell the story of Theseus and the Minotaur, beginning with Pasiphae and ending with Ariadne at Naxos. In 1872 the two pairs of panels were separately shipped to Besançon and Marseille. The unknown painter, who was very likely of French origin, as suggested by the northern character of the background buildings, was well versed in Tuscan art and may have worked in Florence.[64]

Unlike the crowded palaces in Rome that originally housed the marchese's collection, the Petit Palais (*Fig. 64*) allows the beautifully installed paintings ample space. The whitewashed walls of this old palace, contemporary with the Campana works, make an ideal backdrop for the marchese's pictures, rescued at last from their diaspora. Although reinforced by modern lighting, clear natural light floods the galleries from windows looking out on the Rhone River and Villeneuve. Walking through these vaulted chambers, sometimes bending through small doors to emerge into vast fourteenth-century rooms that still show the traces of frescoes, the visitor has no difficulty imagining the era when Avignon welcomed Italian painters to decorate its sumptuous buildings. The new museum reminds us of the pilgrimage those Italian artists made to the popes' court in Avignon; Campana's early Renaissance paintings, once exiled from palaces in Rome and Paris, have now fittingly come to rest at last in the Petit Palais.

But the reunited pictures in the Archbishop's Palace are, after all, only a small portion of that encyclopedic collection amassed by the marchese. His dream of a vast Campana museum in Rome was never realized. Today, however, his holdings form a great museum-without-walls, spanning many countries. One must travel to Leningrad to see his ancient sculpture in the Hermitage Museum, to London for a view of his masterpieces of Italian Renaissance sculp-

ture in the Victoria and Albert Museum, and then to Paris where his collections of ancient jewels, vases, terra-cottas, bronzes, and marbles as well as Renaissance painting masterpieces and majolica wares are scattered through the departments of the Louvre. The final stop on this journey of discovery is Avignon, where art lovers acknowledge their debt for a collection of priceless paintings that were once regarded as inadequate collateral. ᔕ

AFTERWORD

ECHOES OF THE
CAMPANA AFFAIR

⟨◠⟩ Between the times of the two Calvis
there is a span of over four centuries. More than the same name,
though, links Friar Giovanni da Calvi, the founder of the Roman
Monte di Pietà, with Roberto Calvi, the Milanese banker found
hanging from London's Blackfriars Bridge on June 18, 1982. Rob-
erto Calvi's still mysterious death[1] triggered the collapse of the
Banco Ambrosiano and the public disgrace of the Vatican Bank,
demonstrating once again (as the history of the Monte di Pietà had
already shown) the baleful Italian penchant for combining bank
administration with religious and political favoritism.

Like the Roman monte, both the Banco Ambrosiano and the
Vatican Bank, with which it was closely affiliated, were founded
with religious aims. The Banco Ambrosiano was conceived in 1896
as a "Catholic" bank in distinction from "lay" financial institu-
tions, and to prevent a takeover by secular interests its shareholders
were required to submit a baptismal certificate and a parish priest's
recommendation before being entitled to vote.[2] The Vatican Bank
(whose formal name is the Institute for Religious Works) was cre-
ated by Pope Pius XII in 1942. During Roberto Calvi's years at the
Banco Ambrosiano (crowned by his accession to chairman in 1975),
the relations between his bank and the Vatican Bank became inter-

twined to a degree that baffled regulatory scrutiny. The marchese
Campana prized his many public honors, but Roberto Calvi's high
standing at the Vatican was eloquently summed up by his nick-
name, God's Banker.

By 1981 Calvi's banking empire faced imminent ruin.
Through a network of shell (nominee) companies organized overseas
(many of them owned by the Vatican Bank) Calvi bought large
blocks of Ambrosiano shares both to forestall possible raiders and to
prop up the stock price. The share purchases were financed by loans
obtained from European financial institutions and funneled through
Banco Ambrosiano's foreign banking subsidiaries to the shell com-
panies. By 1981, the amount of the shell companies' indebtedness
greatly exceeded the most optimistic market valuation of the Am-
brosiano shares that had been pledged as collateral; it was feared
that the lenders would demand immediate payment. Just as Cam-
pana had done in a similar crisis, Calvi turned for help to Vatican
financial officials. Following the example of his nineteenth-century
predecessors Galli and Ferrari, Archbishop Paul Marcinkus, direc-
tor of the Vatican Bank, responded in a manner that blended com-
fort with deniability. He issued so-called letters of patronage in
which he calmed the worries of the foreign lenders by acknowledg-
ing the Vatican Bank's direct or indirect control of the indebted
shell companies and its "awareness" of the amounts that they owed.
Concurrently, however, he obtained from Calvi a counterletter assur-
ing the archbishop that the Vatican Bank would suffer no "further
loss or damage" by reason of its issuance of the letters of patronage.

In the Campana affair the papal treasury officials had been just
as adept at protecting their bureaucratic flanks; Minister Galli had
preserved his ability to disown responsibility for the marchese's
ruinous borrowings by delivering an ambiguously worded rescript,
and Treasurer Ferrari had promised nothing but sympathy in return
for the confessions of debt he had extracted from Campana. Both
officials ultimately betrayed the trust of the monte's embattled di-
rector, for when he stood on trial for embezzlement they had noth-

ing to say in his defense. In the aftermath of the Banco Ambrosiano debacle, the Vatican Bank officials took a more moderate course: After initially denying any responsibility under its letters of patronage, the Vatican Bank ultimately agreed in May 1984 to pay creditors a "voluntary contribution" of $250 million, which together with proceeds of the sale of Ambrosiano assets satisfied about two-thirds of the total debt.[3]

Still, the extent of the Vatican's complicity in each of the two great banking scandals remains unknown. The comments of a Calvi biographer on the downfall of the Banco Ambrosiano are fully as applicable to Campana's maladministration:

> Probably the full truth about the Vatican bank's relations with Calvi would never be known. . . . Indeed it was possibly in too many people's interest that it would not be. Documents abounded to prove many things, but not the spirit in which they were written. Undoubtedly, Calvi tricked the Vatican; the question remained: where did negligence and naïvety end and collusion begin.[4]

The issues of the Campana case also continue to resound internationally in the current controversies over the appropriateness and profitability of institutional investments in artworks. In the spring of 1989 the sky-high auction prices for paintings, drawings, and bronzes accumulated as investment assets of the British Rail Pension Fund were greeted with a round of cheers before soberer thoughts intervened; the "real return on the fund's entire art portfolio, assessed at $90 million, was about 3 percent a year—worse than stocks, only marginally better than real estate."[5] Economists calculated that by instead investing in stock, the British Rail fund could have increased total assets by a factor of 6.2, double the return from the splashy art sales.[6]

Despite the vagaries of the art market and risks of illiquidity, major banks and other institutions have shown a lively interest in

financing art investments. Citibank, for example, reportedly "offers a soup-to-nuts art service for its wealthiest private customers, everything from loans for new acquisitions to expert advice on shipping and insurance"; and Sotheby's "allows customers to borrow against the value of art works."[7] One of Sotheby's loans was prominently in the news in October 1989; its advance of $27 million to Australian financier Alan Bond for half the purchase price of Van Gogh's *Irises* was not fully paid and the auction house had retained possession of the painting in an undisclosed storage place.[8] By January 1990 *Irises* was back on the market because Bond's debt had not been fully liquidated, and Sotheby's announced that it would no longer take an artwork as collateral until paid for and owned for at least ninety days.[9] Art dealer Richard Feigen had commented disapprovingly on Sotheby's original financing policy, "It's exactly like buying on margin. The problem is, there are regulations in the securities market that are not in the art market."[10] Eugene V. Thaw, a New York dealer and former president of the Art Dealers Association of America, opined that it was not conservative to lend money on art and that "it is the ethic of our time that is encouraging living out on the edge of credit."[11] In other words, many of our contemporaries have constructed their own models of the Villa Campana.

Of all the art buyers figuring in recent art investment controversies, the man who should feel the most empathy for the marchese is David L. Paul, chairman of CenTrust Savings Bank of Miami, described in 1989 as the largest savings-and-loan institution in the southeastern United States. Florida bank regulators were alarmed to discover that the bank (which had reported losses of more than $13 million in its last two quarters) had assembled a $28 million art collection, including Rubens's *Mars* purchased in a private sale from Sotheby's for $13 million. Although the collection was accounted for as part of the bank's "furniture and fixtures," several paintings including the Rubens were hanging in Chairman Paul's home. Asked to explain the location of his bank's artworks,

Paul made a statement similar to Campana's justification for his
failure to deliver collateral to the monte: "It is impossible to find an
art storage vault in Florida. We have a huge humidity problem here
and many of the works are painted on wood. My house is dehumi-
dified. But by mid-May, when renovations on the bank's building
are completed, we anticipate that all of the art will be installed
there."[12]

Like Campana, Paul was given a period of time to arrange a
sale of the collection; but he failed to meet the regulators' six-
month deadline that expired in early October 1989. The Florida
comptroller, who asserted that CenTrust had no right to acquire the
paintings in the first place without having sought special dispensa-
tion, stepped up the pressure for prompt sale.[13] The *Wall Street
Journal* speculated that "the art collection might have come to rival
the Medicis' had the Florida comptroller not got wind of Mr. Paul's
aesthetic adventure."[14]

When Paul still delayed, the comptroller responded, not with
criminal action such as Campana had faced but with an administra-
tive complaint ordering CenTrust to turn over the collection to an
art expert who would act to expedite sale. Within hours of the
filing of this complaint the Miami thrift itself completed the sale;
in a press release the CenTrust spokesman grumbled that the bank
had been forced to dispose of the bulk of the collection at "less
favorable" prices than it had intended.[15]

Wholly apart from its financial implications, the history of the
Campana collection should serve as a cautionary tale for art mu-
seums that are controlled by bureaucrats rather than scholars. Nieu-
werkerke, who was ultimately responsible for the brutal treatment
meted out to the Campana museum, was the prototype of art ad-
ministrator as bureaucrat. With no professional qualifications for
the job of museum director, no scholarly attainments or connois-
seurship (except in the area of his private collecting of weaponry),
Nieuwerkerke used his post at the Louvre to rise to the position of
virtual dictator of the French art world under the Second Empire.

His success was based on his social connections, his style, and his talents as a politician and courtier.

Despite his political power, Nieuwerkerke never gained the respect of the art world. Artists and scholars criticized his lack of expertise in collecting and preserving artworks, taking him to task for buying fakes and over-restoring paintings; his energies were spent instead in amassing personal and institutional power. Although he was credited with greatly enlarging the Louvre collection, his administration produced little in the way of scholarly publications, and many of his staff failed to keep adequate records of the objects under their care. In his last years in office his irresponsibility in curatorial matters extended to the lending of museum artworks to members of the court for the purpose of ornamenting their homes. Nieuwerkerke's response to those scholars in the Cornu circle who questioned his administration was, as we have seen, to retaliate by political means, such as breaking the power of the Academy of Fine Arts (which had given a forum to his opponents) or dispersing the Campana collection, which he viewed as a rival to his museum.

Fortunately, this last act of bureaucratic vengeance has been rectified. The Louvre administration in the twentieth century has displayed the best qualities of museum leadership in regathering the Campana paintings. Vergnet-Ruiz and Laclotte, two highly regarded scholars, applied their knowledge, energy, and administrative skills to the reconstitution and restoration of the scattered Campana painting collection. In the process of creating a new museum of international importance, Laclotte has sought every opportunity to encourage scholarly inquiry into the Campana paintings, as demonstrated by his own exhibitions and publications and by his establishment of a research center in the Avignon museum. The success of this complex undertaking is the result of expert museum leadership by professionals with strong scholarly accomplishments.

In sharp contrast to this French achievement is the current scandal in another important international gallery, London's Victo-

ria and Albert Museum. This institution, which served as the
model for many similar study museums throughout Europe and
America in the nineteenth and early twentieth centuries (including
the Musée Napoléon III), was in 1989 threatened at its very foun-
dations by a plan for restructuring that would "abandon the pre-
eminence in object-based research which the V&A represents."[16]

The director sponsoring this reorganization is not an art histo-
rian, and her appointment was allegedly made with no regard for
civil service regulations requiring "that the director was to be a
recognized scholar of international standing."[17] The board that
chose the director was largely drawn by the government from the
business sector of the community and, according to a former mem-
ber, is expected by "the present government . . . to promulgate
policies which reflect the economic values of the market place."[18]

With concern for economy paramount, a plan was devised in
which the curators' housekeeping chores would be given to non-
professional managers. This separation of scholarship from object
management revealed the director's lack of understanding of the
central value of curatorial expertise in the operation of an art mu-
seum and resulted in the resignation of eight senior curatorial staff
members.[19] The fact that the reduction of curatorial staff was envi-
sioned as part of the plan (indeed apparently financed by allocating
to resignation settlements funds earmarked for building mainte-
nance) was kept secret from most of the trustees. This disregard of
the board led to the resignation of Martin Kemp, a Leonardo expert
and professor of art history at Saint Andrews University as well as
chair of the Association of Art Historians. He relinquished his
trusteeship because "by taking what had been written and said at
face value, I had failed to protect the cause of scholarship and
scholars in the museum."[20] According to Kemp the board was
given a mere half-hour to read and approve the restructuring of the
museum.[21] These pressure techniques, although carried out by "a
smart young man from Saatchi and Saatchi,"[22] were not unlike
Nieuwerkerke's method of presenting to the academy, with short

preliminary notice and little time for consideration, the works pre-
viously selected by the official commission for exile to the prov-
inces. The cast of characters may change, but the high-handedness
of the bureaucrat-director follows the same pattern today.

Following the reorganization at the Victoria and Albert, arts
organizations around the world protested in the press. The editors
of a prestigious art periodical, *The Burlington Magazine,* deplored
the departure of the senior staff members: "The loss to curatorial
expertise is enormous and the damage to morale in the Museum
and to its international reputation has been incalculable."[23] The
charges against the new director were reminiscent of those made
against Nieuwerkerke. Critics faulted the director for allegedly al-
lowing the mishandling of objects within museum galleries and for
indiscriminate lending of artworks to commercial establishments
without proper control over display conditions.[24] Though today the
recipients of such loans are powerful business interests—not the
courtiers or the provincial museums that Nieuwerkerke wooed with
Louvre objects—the story is the same: The bureaucratic museum
director fails to protect museum objects from being used as com-
modities for political expediency.

Just as the academy mounted a public challenge to Nieuwer-
kerke's plan to take over and dismember the Campana collection, so
today concerned arts organizations and leading art historians have
voiced their dismay. A past director of the V&A, the distinguished
scholar Sir John Pope-Hennessey, traced the start of the museum's
problems to its coming under governmental control in 1984 when
"the museum ceased to be part of the Department of Education and
Science, and was provided with a board of trustees selected by the
prime minister."[25] These trustees, unfortunately for the institution,
were "conceived from the first as a means of imposing government
policy on the museum." When the previous director resigned, a
"strong professional director" should have been appointed; instead,
"the least qualified candidate, a librarian who had successfully com-
puterized the National Art Library" was chosen "because the trust-

ees were seeking a manager not a director" to carry out board poli-
cies.[26] Pope-Hennessey further commented on the new director's
plans: "To divide research from the normal work of curatorial de-
partments and to inhibit access of the curatorial department to the
works of art of which they are in charge are recipes for visual and
intellectual sterility."[27]

Although the proponents of the V&A reorganization cited
American precedents, Pope-Hennessey (who has recently held the
post of consultative chairman of the European paintings department
at the Metropolitan Museum) responds by attributing the achieve-
ments of outstanding American museums to the high professional
standards of their directors:

> Every notable museum in the United States is administered by
> a professional director, from whom it derives its character. The
> three most prominent examples are the Metropolitan Museum
> of Art in New York, the National Gallery of Art in Washing-
> ton, and the Kimbell Art Museum in Fort Worth, all of which
> owe their supremacy to their directors.[28]

Though beset by escalating costs, these top American directors
have continued to nurture scholarship in their museums. Philippe
de Montebello, director of the Metropolitan Museum of Art, in an
article published in 1984, warned of the "depreciation of stan-
dards" that might occur when the demands of blockbuster tempo-
rary exhibitions draw staff attention from its curatorial duties to the
permanent collection: "Basic museum work—conservation, re-
search, cataloging, scholarly publications—gives way to the effort
that goes into realizing special events with their quantifiable re-
sults. . . ."[29] Montebello expressed fears that ". . . such unglam-
orous yet indispensable museum skills as basic cataloging of the
collections may either not be learned or not be done."[30] As shown
by the Campana dispute, cataloging collections was becoming a lost
art among some of the nineteenth-century Louvre curators, such as

Longpérier. Indeed, the energetic production of catalogs by the Musée Napoléon III staff was viewed as a threat by the Louvre curators, whose director was uninterested in such mundane activities. The Second Empire "blockbusters" that distracted the politically ambitious Nieuwerkerke from his responsibilities at the Louvre were the Universal Expositions of 1855 and 1867, in which he and his protégés played an important role.[31]

Montebello's article, written five years before the Victoria and Albert crisis, was prophetic of emerging tensions in the museum world today. He expressed concern that emphasis on business management, brought about by economic pressures, would have a deleterious effect on fundamental museum practices: "Cost accounting, universally applied and carried to an extreme, will clearly inhibit independent study, routine but basic relabeling and housekeeping, travel unrelated to projects, scholarly articles and many other worthwhile programs." Today's professional director must hold to the conviction that, as Montebello urged, "what is needed is not only understanding but also unfeigned belief . . . on the part of trustees, supporters, cultural leaders and museum administrators—including directors—in the fundamental principles on which our museums have been built." Unlike the bureaucrat-director, outstanding museum professionals understand that "the nourishment of the intellectual capital, unfortunately much beleaguered, . . . is one of the most valuable assets of a museum."[32]

The basic museum activity of cataloging collections has not always held high priority in American museums. In 1975 Yale professor George Heard Hamilton complained:

> The scholarly achievements of American museums are, to say the least, spotty. The Metropolitan Museum had been in existence for almost seventy years before a series of *catalogues raisonnés,* not yet completed, began appearing for its paintings. The Museum of Fine Arts in Boston has no catalogue of its paintings; the checklist issued by the Art Institute of Chicago

contains no detailed information about condition, provenance, previous publications, etc. which a scholar needs.[33]

Hamilton cited the Frick Collection as having "established a standard of scholarship and quality of book production which are irreproachable."[34]

Economic pressures on the museum world today have resulted not only in threatening art scholarship in the museum setting but also in menacing more tangible museum assets, the collections themselves. With the art market soaring beyond the reach of many museum acquisition budgets and U.S. tax laws making deductible gifts less attractive, many museums are finding that expanding their collections has become difficult. A quick solution to many of their financial problems has been to reap the benefits of the current astronomical art prices by deaccessioning works not deemed essential to the collection but capable of commanding a high price on the market. The current fever among American museums for selling off unwanted objects has generated much public discussion and led one professor to suggest that contemporary society appears to be "taking the work of art out of the museum and returning it to its proper usage in the marketplace."[35]

The history of the Campana collection could prove instructive to those who see the dismantling of museum collections as a solution to the economic realities of the 1990s. Although the Musée Napoléon III, as a state purchase, could not be sold off by the Louvre, the dispersal of the collection to provincial museums was a remedy similar to the deaccessioning practiced by today's museums. The justifications for exiling supposed duplicates to the provinces resemble the excuses offered today by curators and directors for disposing of museum holdings in the marketplace.

A pitfall of deaccessioning is that changes in taste or reassessment of authenticity may make artworks more valuable in the future than supposed at the time of sale. This is, of course, exactly what occurred in the Campana case. With the impact of American

interest in primitives, the value of Campana's Italian paintings rose dramatically. A measure of the enormous price rise in Italian primitives is demonstrated in the sales history of a small-scale *Crucifixion* attributed to Duccio, purchased by Lord Lindsay, the 25th earl of Crawford, in 1863 for approximately $1,313 at the current market price. Bought by one of the earliest collectors of such works at a time when primitives were not greatly sought after, the painting would be sold by his descendant, the 29th early of Crawford, in 1976 for $1,780,000.[36] Such a steep rise in market value reflects the profound reversal in collecting taste that occurred in the field of Italian primitives and reminds us that "an object of little interest to one generation may be treasured by the next."[37] If changes in taste occur in other, now unpopular, fields (or expanding knowledge leads to reassessment of authenticity and importance of formerly scorned paintings), modern museum directors may be compelled to confess errors not as happily reversible as Nieuwerkerke's.

Campana, like Lord Lindsay, was collecting in an unpopular field where prices remained low. This method of collecting remains an available course for a museum to counter the current rise in art prices. The Metropolitan has chosen this path, as Montebello explains: "What we are doing is buying works of high quality in fairly arcane and tangential areas and buying where the expertise of our curators enables us to buy well."[38] To make this strategy work, according to Montebello, curatorial expertise is the key: "Our acquisitions policy, despite the climate in Washington, D.C., with respect to museums and despite the pace of the art market, has continued to succeed because the currency of greatest value at the Metropolitan remains the expertise provided by our curatorial staff."[39]

For museums that have taken the deaccessioning route, change in the value of objects sold is only one of many potential dangers of the current art market. The temptation to raise funds by selling marketable objects has led to some unfortunate sales that brought in only a fraction of the value of the holdings, as in the Hermitage

sales of the 1930s, which (fortunately for America) ultimately en-
riched, among other museums, the National Gallery.[40] This experi-
ence has been repeated many times over the years. A recent disaster
was the sale of American furniture from the Henry Ford Museum.
"An American sofa that was sold for $16,500 at an auction house
in Chicago (an unlikely marketplace for American furniture) was
placed in a well-known New York gallery for $1,000,000."[41]

Selling off museum holdings for the purpose of covering oper-
ating expenses has been generally conceded to be unethical. The
recent attempt on the part of the New-York Historical Society "to
sell between $15 million and $20 million worth of property from
the museum's collections . . . to meet the museum's deficit and
replenish the endowment . . . brought forth protests from museum
directors and curators." In this case, "critics feel that museum di-
rectors and boards have no right to cannibalize collections to escape
financial traps they have set for themselves."[42]

There are other dubious reasons for selling off museum ob-
jects, which should be more closely scrutinized. The justification of
deaccessioning "duplicates" recalls the official reason given for the
Campana dispersal. Some of the artworks considered duplicates by
Nieuwerkerke and Reiset were not evaluated as redundant by the
academy committee. In a 1973 article, Egbert H. Begemann,
chairman of the art history department at Yale, rejected the whole
notion of artistic duplication: " As for duplication, no work of art is
a duplicate of another. . . . In painting, sculpture and other media
the concept does not exist." He went on to assert that "the concept
of redundance is a ready excuse for letting go of whatever a curator
or director does not like for one reason or another."[43] This judgment
would certainly apply to the official explanation for the breakup of
the Campana collections.

Another questionable practice is the sale of objects because of
alleged space limitations, a reason Reiset relied on when he sent out
in the 1870s Campana works that he had placed in storage even
though they had been approved by the academy. Today, with Amer-

ican museums dominated by business thinking, "storage is often considered 'dead inventory,' visible to few, an institutional asset waiting to be struck from the debit side of the ledger and turned into cash."[44] The possibility that these works might someday find a place in expanded galleries, be included in temporary exhibitions, put on loan to other institutions, or made available for study purposes is often disregarded. A salutary exception is the Metropolitan Museum's grouping of secondary works in the Henry Payne Bingham study galleries of Italian Renaissance paintings. Here paintings are displayed with labels explaining problems of condition or quality that place them outside the masterpiece category but still within the area of interest for the student of Renaissance painting.

The concept of exhibiting more than just the top-quality holdings has been strongly supported by leading English art historians, who in 1954 submitted a memorandum in favor of revoking the National Gallery's power to sell works of art. A key argument was the importance of comparison among works from the same period: "A picture is necessarily produced within a particular historical context, and no art historian would deny that familiarity with the general stylistic language available to its painter is essential for its true assessment. Accordingly, quantity is a valuable quality for the attainment of balanced views. . . ."[45]

The current emphasis by American museums on "refining" their collections toward the highest aesthetic level has worked against the broad contextual display which was so popular in the nineteenth century (at the South Kensington Museum and the Musée Napoléon III). Today, the audiovisual tour and the wall label supply the context, while only the best objects are offered for exhibition.

Some museums have indicated a commitment to keeping the broader context on view. Thus the reinstallation of the Egyptian galleries at the Metropolitan in 1983 included "40,000 objects, from the tiniest beads and tools to the colossal statuary of sphinxes, goddesses and kings . . . installed in 32 galleries."[46] With this

installation the museum has shown itself to be concerned with ac-
cessibility of objects to scholars: "As a rule, works of major esthetic
and historical interest are exhibited in the primary galleries. The
rest of the 40,000 objects have been placed in display cases in adja-
cent study galleries so that experts can have access to the entire
collection and incipient archaeologists can test themselves on the
mountain of shards that may be one of the most imposing jigsaw
puzzles in New York."[47] This is the kind of exhibition that the
Napoleon III Museum curators intended for Campana's antiquities;
the Metropolitan's installation demonstrates that it is possible to
show major objects for the general public without excluding the
study collections so important for scholars. Instead of ridding them-
selves of stored objects, museums might consider design solutions
that allow for accessibility to study collections as well as display of
such objects in a contextual setting.

Emphasis on restricting the exhibition to "masterpieces"
seems particularly ill-advised at a time when scholars are reassess-
ing so many periods of art from a broader perspective. Michael
Conforti, director of the curatorial departments of the Minneapolis
Institute of Art, makes the point succinctly: "It is a paradox that
the deaccessioning fever comes at a time when many art historians
are expanding the canon of works of art, allowing objects little
considered in the past to share cultural and aesthetic reinterpreta-
tion with long accepted masterworks."[48] France is one of the leaders
in developing more inclusive exhibitions in its museums. The Avig-
non museum is one example of the regathering of "forgotten trea-
sures" and their presentation in an aesthetic, educational, and his-
torical setting. A better-known example is the new Musée d'Orsay,
where an expanded collection of nineteenth-century French art is
displayed. This broadened presentation reflects the revised view of
the nineteenth century promulgated by recent art scholarship. Con-
forti notes that "France is currently capitalizing on the longstand-
ing relationship between its national pride and national collections.
. . . . With the completion of the Beaubourg, the Orsay, and now

the new Louvre, tourism is thriving. . . . The respect derived from these self-confident museum enterprises has made France more of a driving force in international culture than at any other time in recent memory."[49]

Nevertheless, deaccessioning remains a controversial temptation as the art market reaches new highs. There should be no disagreement, though, that any sales must respect the integrity of the art object, a consideration grossly violated by the division of the Campana altarpieces. Today art historians seek to reunite and exhibit ensembles that have been separated over time. Yet surprisingly these scholarly concerns are not always shared by art-market professionals. As horrified as twentieth-century curators are at Reiset's divided triptychs, such barbaric treatment of art objects continues: When Sotheby's breaks up a Hubert Robert sketchbook so it will fetch a higher price at auction, one imagines that the ghosts of Reiset and Nieuwerkerke have returned to haunt us. The disassembling of the sketchbook has been compared by one art expert to the nineteenth-century practice of "splitting up of medieval manuscripts. . . . Here we have a book that remained together for more than two centuries, something that was intended as a book, and that is being split up." His conclusion could well stand as the final lesson of the Campana case: "Just because people did awful things in the past is no excuse for doing it today."[50] ༆

ABBREVIATIONS

Arguments and Depositions

Campana Trial Arguments and Depositions. "Causa di Peculato contro G. P. Campana" n. 2091, Tribunale Criminale, buste 2149–2150. Archivio di Stato di Roma, Camerale III, pt. 2, title 4.

Causa Campana

Documenti della Causa Campana. Mag. P. 3406, L'Istituto archeologico germanico, Rome, 1858–59.

Chennevières

Chennevières, Philippe de. *Souvenirs d'un Directeur des Beaux-Arts.* 2 vols. Paris: 1883–1889 (reprint Arthena, 1979).

Dizionario Biografico

Dizionario Biografico degli Italiani. Rome: Istituto dell'Enciclopedia Italiana, 1974.

Eiland

Eiland, William Underwood. "Napoleon III and the Administration of the Fine Arts." Ph.D. diss., University of Virginia, 1978.

Laclotte and Mognetti

Laclotte, Michel, and Mognetti, Elisabeth. *Avignon, musée du Petit Palais, Peinture italienne.* 3rd. ed. Paris: Editions de la Réunion des musées nationaux, 1987.

Reinach

Reinach, Salomon, "Esquisse d'une histoire de la collection Campana." 5 pts. *Revue Archéologique* 4th ser., vols. 4 and 5: pt. 1, 4 (Sept.–Oct. 1904): 179–200; pt. 2, 4 (Nov.–Dec. 1904): 360–84; pt. 3, 5 (Jan.–Feb. 1905): 57–92; pt. 4, 5 (March–April 1905): 208–240; pt. 5, 5 (May–June 1905): 343–64.

Viel-Castel

Viel-Castel, le comte Horace de. *Mémoires du comte Horace de Viel-Castel sur le règne de Napoléon III, 1851–1864.* ed. L. Léouzon le Duc, 6 vols. Paris: Chez tous les libraires, 1883–84.

NOTES

PROLOGUE

1. Jasper Ridley, *Napoleon III and Eugenie* (New York: Viking Press, 1980), 112.

2. Ivor Guest, *Napoleon III in England* (London: British Technical & General Press, 1952), 41.

3. Ridley, 186–92.

4. Georges de Loÿe, *Le Musée du Petit-Palais: Son Histoire, ses collections,* extract of Mémoires de l'Académie de Vaucluse, vol. 9, 1976 (Avignon: Aubanel, 1978), 8. Guest, 62. Crawford is presumed to be the name of Mrs. Rowles's second husband. Henry Rowles committed suicide in 1840. Guest, 41n.

5. *Causa Campana,* pt. 1, pp. 108–09. The *Causa Campana* is a handwritten narrative defense of the marchese and includes a collection of printed documents of his trial. Page references are to handwritten page numbers, except with respect to printed documents, where printed page numbers are cited.

6. André Castelot, *Napoléon Trois. Des prisons au pouvoir* (Paris: Librairie Académique Perrin, 1973), 625.

CHAPTER I

THE PAWNSHOP

1. Donato Tamila, *Il Sacro Monte di Pietà di Roma* (Rome: 1900), 20–25.

2. Tamila, 25–30.

3. Tamila, 47–50.

4. Tamila, 77–83.

5. Tamila, 53–54.

6. See Reinach, 183–184. *Causa Campana,* pt. 1, p. 6.

7. Tamila, 57–62; *Dizionario Biografico,* 17:349.

8. Reinach, 185–86.

9. *Dizionario Biografico,* 17:349; *Causa Campana,* pt. 2, Defense Brief, pp. 23–25.

10. Tamila, 107–111; *Dizionario Biografico,* 17:350.

CHAPTER 2

THE COMPULSIVE COLLECTOR

1. As quoted in *Dizionario Biografico,* 17:350.

2. Professor Michaelis judged the excavations "unsuccessful." A. Michaelis, *A Century of Archaeological Discoveries,* trans. Bettina Kahnweiler, Preface Percy Garner, Litt.D. (London: John Murray, 1908), 72.

3. Michaelis, 73. *Dizionario Biografico,* 17:350-51.

4. Michaelis, 73.

5. Michaelis, 73.

6. Dietrich von Bothmer, "Greek Vase-Painting: Two Hundred Years of Connoisseurship," *Papers on the Amasis Painter and His World, Colloquium Sponsored by the Getty Center for the History of Art and the Humanities and Symposium Sponsored by the J. Paul Getty Museum* (Malibu, California: The J. Paul Getty Museum, 1987), 196.

7. Michaelis, 75.

8. Giovanni Pietro Campana, marchese di Cavelli, *Antiche opere in plastica, discoperte, raccolte, e dichiarate dal marchese G. Pietro Campana,* 2d ed., 3 vols. in 2 (Rome: 1851), 1:ii. See also *Dizionario Biografico,* 17:351. The first edition of this book appeared in Rome in 1842.

9. Eveline Schlumberger, "L'Inépuisable collection Campana," *Connaissance des Arts* (February 1964): 41. See twelve-part catalog, Giovanni Pietro Campana, marchese di Cavelli, *Cataloghi del Museo Campana* (Rome: n.d. [c. 1858]) for entries in various sections of collection. Reinach, 365, gives totals from this catalog, including the following totals for the largest sections: Etruscan and Italo-Greek vases, 3,791; jewels, engraved stones, and coins, 1,582; Greek, Roman, and Etruscan terra-cottas, 1,908.

10. Robert Rosenblum, *Transformations in Late Eighteenth Century Art* (Princeton: Princeton University Press, 1967), ch. 4, esp. 163.

11. Rosenblum, 166 n. 62.

12. For the English interest in Italian art, see J. R. Hale, *England and the Italian Renaissance: The Growth of Interest in its History and Art* (London: Faber and Faber, n.d.), 81–82 on Patch. See also Rosenblum, 165.

13. Hale, 109. See also Kenneth Clark, *The Gothic Revival* (Harmondsworth: Penguin Books, 1964), 76 and n.1.

14. Alexis-François Artaud de Montor, *Considérations sur l'état de la peinture en Italie dans les quatres siècles qui ont précédé celui de Raphael*, 2d ed. (Paris: Gagnard, 1811). The third edition of this work, appearing in 1834, he entitled *Peintres primitifs*, coining the term "primitive" in reference to the early Italian artists whose work he collected.

15. Artaud de Montor, 9.

16. Artaud de Montor, 7 n. 1.

17. Francis Haskell, *Rediscoveries in Art: Some Aspects of Taste, Fashion and Collecting in England and France* (Ithaca: Cornell University Press, 1976), 37–39. On collecting Italian primitives at the beginning of the nineteenth century, see Giovanni Previtali, *La Fortuna dei primitivi dal Vasari ai Neoclassici* (1964; rev. ed., Turin: Einaudi, 1989).

18. André Chastel, "Le Gout des 'PréRaphaélites' en France," in Michel Laclotte, *De Giotto à Bellini; Les primitifs italiens dans les musées de France* (Paris: Orangerie, 1956), ix-xi.

19. Tancred Borenius, "The Rediscovery of the Primitives," *Quarterly Review* 239 (April 1923): 266–67. See also Melinda Curtis, "The Pursuit of Primal Purity in the 19th Century," *Search for Innocence* (College Park, Maryland: University of Maryland Art Gallery, 1975), 30–31. For the influence of Paillot de Montabert on the *primitifs* in David's studio, see George Levitine, *The Dawn of Bohemianism: The 'Barbu' Rebellion and Primitivism in Neoclassical France* (University Park and London: Pennsylvania State University Press, 1978), 100–107.

20. See Chastel, xi, for Artaud de Montor's discussion of the variety of Italian schools of painting and for the differentiation of these schools in the theoretical writings published in 1812 by Paillot de Montabert.

21. Artaud de Montor, 16–17. See also Borenius, 266.

22. Chastel, vii; Hale, 114–15.

23. Haskell, 81–82. On the Fesch collection, see Dominique Thiébaut, *Ajaccio, musée Fesch, les Primitifs italiens* (Paris: Editions de la Réunion des musées nationaux, 1987).

24. Haskell, 81. Laclotte and Mognetti, 18–19.

25. For Alexis-François Rio, *De la poésie chrétienne dans son principe, dans sa matière et dans les formes*, 2 vols. (Paris: 1836), later published as *De l'art chrétienne*, 4 vols. (Paris: 1861), see Curtis, 54, and Chastel, 16–17.

26. See Haskell, 51–54.

27. As quoted in E. H. Gombrich, *Ideals and Idols: Essays on Values in History and in Art* (Oxford: Phaidon, 1979), 195.

28. *Causa Campana*, pt. 2, Defense Brief, pp. 103–111, and Appendix, pp. 63–64.

29. *Dizionario Biografico,* 17:351–52.

30. *Causa Campana,* pt. 1, pp. 40–42.

31. *Causa Campana,* pt. 2, Defense Brief, Appendix, p. 63.

CHAPTER 3

THE ARREST OF THE MARCHESE

1. *Causa Campana,* pt. 1, Trial Account, pp. 20–28; pt. 2, Defense Brief, p. 27.

2. *Causa Campana,* pt. 1, Trial Account, p. 23.

3. *Causa Campana,* pt. 1, Trial Account, p. 19.

4. *Causa Campana,* pt. 1, Trial Account, pp. 19–20.

5. *Causa Campana,* pt. 1, Trial Account, pp. 38–40.

6. *Causa Campana,* pt. 1, Trial Account, pp. 31–32.

7. *Causa Campana,* pt. 2, Defense Brief, Documentary Summary, para. 31.

8. *Causa Campana,* pt. 1, Trial Account, p. 47.

9. Arguments and Depositions, Second Trial Account, pp. 21, 23.

10. *Causa Campana,* pt. 1, Trial Account, p. 53.

11. *Causa Campana,* pt. 2, Defense Brief, Documentary Summary, para. 95.

12. *Causa Campana,* pt. 1, pp. 43–45.

13. *Causa Campana,* pt. 1, p. 46.

14. *Causa Campana,* pt. 1, p. 62.

15. *Causa Campana,* pt. 1, p. 67.

16. *Causa Campana,* pt. 1, pp. 67–69.

17. Arguments and Depositions, police memo, 29 November 1857.

18. *Journal de Débats,* Paris, 8 and 18 December 1857.

CHAPTER 4

TRIAL AND TRIBULATIONS

1. *Causa Campana,* pt. 1, p. 70.

2. *Causa Campana,* pt. 1, p. 72.

3. *Causa Campana,* pt. 1, pp. 72–77.

4. *New Catholic Encyclopedia* (New York: McGraw-Hill, 1967), 1:642.

5. William Roscoe Thayer, *The Dawn of Italian Independence,* 2 vols. (Boston: Houghton Mifflin, 1893), 2:32.

6. *Causa Campana,* pt. 1, pp. 78–82.

7. *Causa Campana,* pt. 1, pp. 82–85.

8. *Causa Campana,* pt. 1, p. 87.

9. *Causa Campana,* pt. 1, pp. 87–88.

10. *Causa Campana,* pt. 1, pp. 88–92.

11. *Causa Campana,* pt. 1, pp. 95–96.

12. *Causa Campana,* pt. 1, Trial Account, p. 34.

13. Arguments and Depositions, Second Trial Account, pp. 12–13.

14. *Journal de Débats,* 18 December 1858.

15. *Causa Campana,* pt. 1, pp. 100–01.

16. *Causa Campana,* pt. 1, pp. 104–05.

17. *Causa Campana,* pt. 1, pp. 106–07.

18. *Causa Campana,* pt. 1, p. 108.

19. *Causa Campana,* pt. 1, pp. 53–56.

20. *Causa Campana,* pt. 1, Trial Account, pp. 58–59.

21. *Causa Campana,* pt. 1, Trial Account, pp. 54–55.

22. *Causa Campana,* pt. 1, Trial Account, pp. 62–63.

23. *Causa Campana,* pt. 1, Trial Account, pp. 71–74.

24. *Causa Campana,* pt. 1, pp. 108–10.

25. *Causa Campana,* pt. 1, pp. 111–12.

26. *Causa Campana,* pt. 1, p. 246.

27. *Causa Campana,* pt. 1, pp. 247–50.

28. *Causa Campana,* pt. 1, pp. 250–54.

29. *Causa Campana,* pt. 2, Defense Brief, pp. 3–4.

30. *Causa Campana,* pt. 2, Defense Brief, pp. 25–26.

31. *Causa Campana,* pt. 2, Defense Brief, p. 35.

32. *Causa Campana,* pt. 2, Defense Brief, Opinion of Giovanni Di Falco. See *Brown v. Bullock,* 194 F. Supp. 207 (S.D.N.Y.), *aff'd,* 294 F.2d 415 (2d Cir. 1961); *Cambridge Fund, Inc. v. Abella,* 501 F. Supp. 598 (S.D.N.Y. 1980).

33. *Causa Campana,* pt. 3, pp. 1–2.

34. *Causa Campana,* pt. 3, p. 3.

35. *Causa Campana,* pt. 3, pp. 5–18.

36. *Causa Campana,* pt. 3, p. 18.

37. *Causa Campana,* pt. 3, pp. 18–22. One member of the panel had favored a harsher penalty for Marchetti.

CHAPTER 5

THE COSTLY PARDON

1. *Causa Campana,* pt. 3, pp. 22–26.

2. *Causa Campana,* pt. 3, p. 26.

3. *Causa Campana,* pt. 4, chs. 1–3.

4. *Causa Campana,* pt. 4, ch. 4.

5. *Causa Campana,* pt. 4, ch. 6.

6. *Causa Campana,* pt. 4, ch. 7.

7. *Causa Campana,* pt. 4, ch. 8.

8. *Causa Campana,* pt. 4, ch. 9.

9. *Causa Campana,* pt. 4, ch. 10.

10. *Causa Campana,* pt. 4, ch. 11.

11. *Causa Campana,* pt. 4, ch. 12.

12. *Causa Campana,* pt. 4, ch. 13.

13. *Causa Campana,* pt. 4, ch. 14.

CHAPTER 6

THREE NATIONS GO SHOPPING

1. Reinach, pt. 2, 364.

2. Frank P. Brown, *South Kensington and Its Art Training* (London: Longmans, Green, 1912), 13.

3. Elizabeth Bonython, *King Cole: A Picture Portrait of Sir Henry Cole, KCB 1808–1882* (London: Victoria and Albert Museum, n.d.), 2. On the museum in the context of its day, see Kenneth Hudson, *Museums of Influence* (Cambridge: Cambridge University Press, 1987), Chapter 3.

4. K. J. Fielding, "Charles Dickens and the Department of Practical Art," *The Modern Language Review* 48 (1953): 270–77.

5. As quoted in Fielding, 272-73.

6. Quentin Bell, *The Schools of Design* (London: Routledge and Kegan Paul, 1963), 256.

7. John Ruskin, *Fors Clavigera,* Letter 79 in *The Works of John Ruskin,* Wedderburn and Cook, eds. Library edition (London: George Allen, 1905–1907) 29:154.

8. John Pope-Hennessey, "The Fall of a Great Museum," *New York Review of Books* (27 April 1989), 10.

9. Reinach, 370f.

10. John Steegman, *Victorian Taste: A Study of the Arts and Architecture from 1830 to 1870* (London: Thomas Nelson, 1970), 225.

11. J. C. Robinson, *South Kensington Museum: Italian Sculpture of the Middle Ages and the Period of Revival* (London: Chapman and Hall, 1862), xi.

12. Robinson, xi.

13. Pope-Hennessey, "The Fall of a Great Museum," 10.

14. Pope-Hennessey, "The Fall of a Great Museum," 10.

15. John Pope-Hennessey, *Donatello's Relief of the Ascension with Christ Giving the Keys to Saint Peter* (London: His Majesty's Stationery Office, 1949), 4. Pope-Hennessey speculates, p. 12, that the relief may have been designed for the predella of the altar of the Brancacci Chapel, where Massaccio's frescoes, to which it is closely related, were painted in the Church of the Carmine in Florence. See also John Pope-Hennessey, *Italian Renaissance Sculpture* (1958; reprint, New York: Random House, Vintage Books, 1985), 15–16, 252.

16. John Pope-Hennessey, *Luca della Robbia* (Oxford: Phaidon, 1980), 44.

17. Pope-Hennessey, *Italian Renaissance Sculpture*, 47, 280, 282.

18. Pope-Hennessey, *Italian Renaissance Sculpture*, 282.

19. Ernest Desjardins, *Du patriotisme dans les arts, réponse à M. Vitet sur le Musée Napoléon III* (Paris: Dentu, 1862), 29–30.

20. *London Times*, March 1860, as quoted in Winslow Ames, *Prince Albert and Victorian Taste* (New York: The Viking Press, 1968), 126.

21. "Sightseeing and Sneezing," *Punch or the London Charivari* (6 April 1861), 139. See also John Physick, *The Victoria and Albert Museum* (Oxford: Phaidon/Christie's, 1982), 39.

22. Reinach, 376. See p. 366f for other rumors considered false by Reinach about prices quoted to France for sale of the collection.

23. Michaelis, 76.

24. S. Guédéonoff, "Notice sur les objets de la Galerie Campana à Rome, acquis pour le Musée Impérial de Saint-Pétersbourg," *Gazette des Beaux-Arts* 11 (July 1861): 87.

25. For unsubstantiated claim of papal reserve of works including the Lydian sarcophagus, see Alexandre Bertrand, "Le Musée Campana," *Revue Archéologique* 1 (April 1862): 269. See also Reinach, 366.

26. Chennevières, pt. 2, 111.

27. As quoted in Reinach, 367.

28. As quoted in Reinach, 367–68.

29. As quoted in Reinach, 368.

30. Félix Chambon, "Notes sur Prosper Mérimée" (Paris: privately printed, 1902), 357.

31. J. Doucet, "Le Musée Campana. Les Niobides," *Gazette des Beaux-Arts* 1 (February 1859): 151.

32. See Reinach, 369, for speculation that this information may simply be gossip, since Schnetz remained director of the academy in Rome until 1866, so that clearly no blame was attached to his name.

33. Ernest Renan, "Madame Hortense Cornu," *Journal des Débats* (18 June 1875), as quoted in Marcel Emerit, *Madame Cornu et Napoléon III d'après les lettres de l'Empéreur conservées à la Bibliothèque Nationale et d'autres documents inédits* (Paris: les Presses Modernes, 1937), 13.

34. E. d'Eichthal, "Mme Cornu et Napoléon III," *Revue de Paris* 4 (1897): 195ff, as quoted in Reinach, 59. See p. 60 on the reconciliation between Hortense and Napoleon III on March 5, 1863, after he wrote to her saying that he could not bear the thought of dying before she had embraced his son, who was to celebrate his seventh birthday.

CHAPTER 7
THE AMOROUS MUSEUM DIRECTOR

1. Ferdinand Bac, *La Princesse Mathilde* (Paris: Hachette, 1928), 166.

2. Joanna Richardson, *Princess Mathilde* (New York: Charles Scribner's, 1969), 110.

3. Richardson, 34–36.

4. Comte Rodophe Apponyi, *Vingt-cinq ans à Paris (1826–1852)*, vol. 4 (Paris: Plon, 1926), 441, as quoted in Richardson, 59.

5. Viel-Castel, 6:209.

6. Chennevières, pt. 2, 103.

7. Richardson, 75; Viel-Castel, 2:299.

8. Eiland, 91f, Appendix III.

9. Viel-Castel, 2:285f.

10. Théophile Gautier, "Les Soirées du Louvre," *L'Artiste*, 7th ser., 3 (1858): 69–70.

11. P.-A. Lemoisne, "Les Soirées du Louvre, Aquarelles d'Eugène Giraud conservées au Cabinet des Estampes," *Bulletin de la Société de l'histoire de l'art français* (1920), 296.

12. Richardson, 110.

13. Chennevières, pt. 2, 90.

14. Chennevières, pt. 2, 90–91.

15. Viel-Castel, 2: 286.

16. As quoted in Richardson, 109.

17. Eiland, 93–97.

18. Suzanne Gaynor, "Comte de Nieuwerkerke, A Prominent Official of the Second Empire and His Collection," *Apollo* 122 (November 1985): 373. On Nieuwerkerke's collecting, see also Carol Forman Tabler, "Vollon's 'Curiosités' and

the Comte de Nieuwerkerke: Official Patronage and Private Pleasure," *Burlington Magazine* 124 (August 1982): 505–07.

19. Richardson, 109.

20. Viel-Castel, 6:201.

21. Viel-Castel, 6:208.

22. Gaynor, 374.

23. Emile Galichon et Edouard de Beaumont, "Collection de M. le comte de Nieuwerkerke," *Gazette des Beaux-Arts* 24 (1 May 1868): 410.

CHAPTER 8

THE FIRST PALACE: THE NAPOLEON III MUSEUM

1. Viel-Castel, 6:126.

2. Eiland, 195.

3. Eiland, 92–94, 193.

4. Eiland, 196.

5. For biographical material on Clément, see Lorenz Eitner, "Introduction," *Charles Clément: Géricault* (1879; reprint, Paris: Léonce Laget, 1973), v–xiv.

6. Edmond Taigny, "Collection Campana," *Mélanges Etudes littéraires & artistiques* (Paris: Hachette, 1869), 209.

7. Taigny, 211.

8. Taigny, 211.

9. Viel-Castel, 6:201.

10. Taigny, 243.

11. Taigny, 208, 209 n. 1.

12. Taigny, 212–13.

13. Reinach, 382.

14. As quoted in Reinach, 383.

15. Reinach, 384.

16. Christiane Aulanier, *Le Nouveau Louvre de Napoléon III*, vol. 4 of *Histoire de Palais du musée du Louvre* (Paris: Editions des musées nationaux, 1953), 12.

17. As quoted in Cecil Gould, *Trophy of Conquest: The Musée Napoléon and the Creation of the Louvre* (London: Faber & Faber, 1965), 41.

18. Gould, 59.

19. A. Berty and L. Lacour, "Le Musée Campana," *Annuaire de l'Archéologique de l'Antiquaire et du Numismate* 1 (1862): 89.

20. As quoted in Reinach, 384.

21. Gould, 128–29.

22. See Henri de Latouche on this subject in Helen Osterman Borowitz, *The Impact of Art on French Literature* (Newark: University of Delaware Press; Toronto, London: Associated University Presses, 1985), 80–81.

23. As quoted in Gould, 123.

24. On the festival celebrating the arrival of Napoleon's booty from Italy in July 1798, see Patricia Mainardi, "Assuring the Empire of the Future: The 1798 Fête de la Liberté," *Art Journal* 48 (Summer 1989): 155–63.

25. Doucet, "Le Musée Campana," 142–51. On this article, see above Chapter 6.

26. Charles Blanc, "Les terres cuites de Musée Campana," *Gazette des Beaux-Arts* 12 (February 1862): 190.

27. Blanc, 192.

28. Reinach, 62.

29. Louis-Napoléon Bonaparte, *De l'extinction du pauperisme en France,* as quoted in Eiland, 20–21.

30. [Sébastien Cornu], *Catalogues des Tableaux des sculptures de la Renaissance et des Majoliques du Musée Napoléon III* (Paris: Firmin-Didot, 1862), 1–2.

31. Ernest Desjardins, *Notice sur le Musée Napoléon III et promenade dans les Galeries* (Paris: Dentu, 1862), 17. Desjardins's prediction was correct, as demonstrated in the designs of Prosper-Eugène Fontenay, who used Campana pieces as models for jewelry exhibited in the Exposition Universelle of 1867. See *The Second Empire 1852–1870: Art in France under Napoleon III* (Philadelphia Museum of Art, 1978), III–21.

32. Desjardins, *Notice,* 40. See also Reinach, 65, where it is noted that this, like other promised publications by Renier, never appeared.

33. Desjardins, *Notice,* 52.

34. Desjardins, *Notice,* 5.

35. Desjardins, *Notice,* 7.

36. Desjardins, *Notice,* 68.

37. A. Noel Des Vergers, *Notice sur le Musée Napoléon III*, extract from the *Revue Contemporaine* (31 May 1862): 30. See "Musée Campana 1861–1862, Ordonnances de Payement," F 70 89, Archives Nationales, for order of payment #1097 from Minister of State to Vergers of 4,380 francs for "acquisition de divers bijoux étrusques pour le Musée Campana."

38. Louis de Ronchaud, "Musée Napoléon III. Collection Campana," *Gazette des Beaux-Arts* 12 (June 1862): 489.

39. Ronchaud, 494.

40. Reinach, 67.

41. Jules Antoine Castagnary, *Les Libres propos* (Paris: A. Lecroix, Verboeckhoven, 1864), 62.

42. Castagnary, 63.

43. Elisabeth Mognetti, "La Collection Campana," in Laclotte and Mognetti, 22-23.

44. Desjardins, *Du patriotisme dans les arts,* 17–18.

45. Reinach, 75.

46. As quoted in Reinach, 76.

47. As quoted in Henri de Rothschild, "Un Document inédit sur l'histoire de la collection Campana," *Revue Archéologique* (1913): 117.

48. As quoted in de Rothschild, 117.

49. As quoted in de Rothschild, 118.

CHAPTER 9
THE SECOND PALACE: THE LOUVRE

1. Reinach, 71.

2. Reinach, 74, See also Viel-Castel, 6:201.

3. Reinach, 74.

4. As quoted in Reinach, 76.

5. Reinach, 76.

6. L. Clément de Ris, *Les Musées de province: Histoire et description* (Paris: Jules Renouard, 1872), 7. See Reinach, 77.

7. As quoted in Gould, 76. See Clément de Ris, 2, for text of decree.

8. Clément de Ris, 9.

9. Reinach, 77.

10. As quoted in Reinach, 79.

11. *Indépendance Belge,* 11 July 1862; see also Reinach, 80f.

12. Reinach, 81–82.

13. As quoted in Reinach, 82.

14. Reinach, 82 n. 1.

15. As quoted in Eiland, 216–17.

16. Louis Gonse, "M. Vitet," *Gazette des Beaux-Arts*, 2d per. 8 (July 1873): 129.

17. L. Vitet, "La Collection Campana," *Revue des deux-mondes* 41 (1 September 1862): 166–167.

18. Vitet, "La Collection Campana," 167.

19. Vitet, "La Collection Campana," 167.

20. Vitet, "La Collection Campana," 168.

21. See Desjardins, *Du patriotisme dans les arts*, 25–26, on the views of Dr. Henzen of the Archaeological Institute in Rome; 47–49 on the views of G. F. Waagen, director of the National Gallery of Prussia, who admired the early Italian paintings.

22. Desjardins, *Du patriotisme dans les arts*, 53.

23. Desjardins, *Du patriotisme dans les arts*, 33. Vitet gave a detailed evaluation of the Russian and English purchases, and suggested that the Musée Napoléon III remove the label designating one of their vases as the famous Cumean vase, which had to be admitted was lost to Russia. See Reinach, 89–92, on uncertainty as to whether the political attack on Vitet was generated by the Cornu faction or by Desjardins. Reinach, who was a student of Desjardins, recalled that his teacher never referred to this brochure and was probably in his later years embarrassed by this intemperate publication of his youth.

24. L. Vitet, "Lettre au Directeur," *Revue des deux-mondes* 41 (October 1862): 751.

25. Charles Blanc, "Emile Galichon," *Gazette des Beaux-Arts*, 2d per. 11 (March 1875): 201–08, describes Galichon, who became the proprietor of *Gazette des Beaux-Arts*, as enlarging the scope of the magazine to include discussions involving arts administration and management of museums.

26. Emile Galichon, "De la Création d'un nouveau musée," *Gazette des Beaux-Arts* 13 (September 1862): 223.

27. Galichon, "De la Création d'un nouveau musée," 227. In November 1862 an expanded version of Galichon's article appeared: *Des Destinées du Musée Napoléon III, Fondation d'un musée d'art industriel* (Paris: Dentu, 1862). See p. 15, where Galichon demanded closer supervision of museums citing examples of poor administration at the Louvre, and insisting that an industrial art museum should belong to the state rather than to the Louvre.

28. Prosper Mérimée, "Les Beaux-Arts en Angleterre," *Revue des deux-mondes* 11 (15 October 1857): 876.

29. Alfred Darcel, "Les Arts industriels à l'exposition de Londres," *Gazette des Beaux-Arts* 13 (October 1862): 313–31; (November 1862): 437–45; (December 1862): 538–55.

30. Darcel, 313.

31. Darcel, 313.

32. The series was announced in Ronchaud, "Musée Napoléon III. Collection Campana," 489–502 (see above Chapter 8 n. 38), where the names of eminent scholars (many of whom had worked on catalogs for the Musée Napoléon III) and their topics were listed.

33. Kenneth Clark, "Bernard Berenson," *Burlington Magazine* 102 (September 1960): 381.

CHAPTER 10

INGRES AND THE ACADEMIES

1. "Monsieur le Ministre," Commission report, Dossier 2, F 21, 572, Archives Nationales, first page (unpaginated).

2. "Monsieur le Ministre," first page.

3. "Monsieur le Ministre," first page.

4. Patricia Mainardi, *Art and Politics of the Second Empire: The Universal Expositions of 1855 and 1867* (New Haven and London: Yale University Press, 1987), 123–24.

5. Emerit, 96f.

6. Emerit, 109.

7. As quoted in Reinach, 208–9.

8. Reinach, 209. Villot, though he suffered over the restoration incident, wrote the first serious catalog of paintings, which has been the basis of revised editions from 1851. See Frédéric Villot, *Notice des tableaux exposés dans les galeries du Musée National du Louvre* (Paris: Charles de Mourgues, 1851).

9. Viel-Castel, 6:207.

10. Viel-Castel, 6:207.

11. Viel-Castel, 6:207.

12. As quoted in Amaury-Duval, *L'Atelier d'Ingres* (Paris: Charpentier, 1878), 225.

13. Borenius, "The Rediscovery of the Primitives," 267.

14. As quoted in Reinach, 210.

15. As quoted in Reinach, 211.

16. As quoted in Reinach, 211–12.

17. As quoted in Reinach, 212.

18. As quoted in Reinach, 212.

19. As quoted in Reinach, 212.

20. Viel-Castel, 6:207f.

21. As quoted in Ernest Chesneau, *Les intérêts populaires dans l'art: la vérité sur le Louvre, le Musée Napoléon III et les artistes industriels.* (Paris: Dentu, 1862), 44.

22. As quoted in Chesneau, *Les intérêts populaires dans l'art*, 44.

23. As quoted in Chesneau, *Les intérêts populaires dans l'art*, 45. See also Reinach, 213.

24. From a letter from Beulé to Mme. Cornu, 14 December 1862, as quoted in Emerit, 99.

25. As quoted in Reinach, 218.

26. Chesneau, *Les intérêts populaires dans l'art,* 47; see also Reinach, 222–23.

27. F. Reiset, *Notice des tableaux de Musée Napoléon III exposés dans les salles de la colonnade au Louvre* (Paris: Charles de Mourgues frères, 1863), 9.

28. Reinach, 223.

29. Reinach, 232.

CHAPTER 11

LETTERS FROM DELACROIX

1. See Chesneau, *Les intérêts populaires dans l'art*, 48, for text of article in *Moniteur,* 4 November 1862, approved by Walewski probably at Nieuwerkerke's insistence, stating that "in all the arguments which were put forward in support of the request for funds to acquire the Campana collections, it has always been made plain that these collections would come to complete the artistic riches of the same nature that were held by the Louvre."

2. Reinach, 210. Emerit, 97ff.

3. Reinach, 217. Yves Sjöberg, "Eugène Delacroix et la Collection Campana," *Gazette des Beaux-Arts*, 6th per. 68 (September 1966): 155.

4. Mainardi, *Art and Politics of the Second Empire,* 46.

5. Patricia Mainardi, "The Political Origins of Modernism," *Art Journal* 44 (Spring 1985): 14. See also Theodore Zeldin, *The Political System of Napoleon III* (London, Toronto: MacMillan; New York: St. Martin's Press, 1958), esp. Chapter 4.

6. As quoted in Mainardi, "The Political Origins of Modernism," 15.

7. As quoted in Louis Hautecoeur, "Delacroix et l'Académie des Beaux-Arts," *Gazette des Beaux-Arts*, 6th per. 62 (December 1963): 358.

8. As quoted in Reinach, 215.

9. As quoted in Reinach, 215.

10. As quoted in Sjöberg, 156.

11. As quoted in Sjöberg, 156–57.

12. As quoted in Sjöberg, 157.

13. Chennevières, pt. 2, 87–88 n. 1.

14. Chesneau, *Les intérêts populaires dans l'art,* 19.

15. Chesneau, *Les intérêts populaires dans l'art,* 19, 20.

16. Chesneau, *Les intérêts populaires dans l'art,* 22.

17. Chesneau, *Les intérêts populaires dans l'art,* 32. See also 33 for his attack on Mme. Cornu: "The soul of the whole movement is not perhaps even M. Sébastien

Cornu . . . but, beside him, a very active, very energetic, very influential person, surrounded with longstanding friends who have, here and there, some public influence, above all, abroad." He went on to describe this "person" in sexist terms as wearing a dress although acting as one who wore pants.

18. Chesneau, *Les intérêts populaires dans l'art,* 32 n. 1.

19. Mérimée served as inspector general of historic monuments from 1834–1852. In 1853 he gave up the post when named a senator, but remained vice president of the Commission of Historic Monuments until his death in 1870. On Mérimée and Viollet-le-Duc, see A. W. Raitt, *Prosper Mérimée* (New York: Charles Scribner's, 1970), 137–54.

20. See E. Viollet-le-Duc, "Un mot sur l'architecture en 1852," *Revue générale de l'architecture et les travaux publics,* 10 [1852]: col. 374, as noted in Albert Boime, "The Teaching Reforms of 1863 and the Origins of Modernism in France," *Art Quarterly* n.s. 1 (Autumn 1977): 7 n. 59.

21. E. Viollet-le-Duc, "L'Enseignement des Arts: Il y a quelque chose à faire," *Gazette des Beaux-Arts* 12, pt. 1 (May 1862): 393–402; pt. 2 (June 1862): 525–33; 13, pt. 3 (July 1862): 71–82; pt. 4 (September 1862): 249–55.

22. Viollet-le-Duc, "L'Enseignement," 531–33.

23. Viollet-le-Duc, "L'Enseignement," 78–79.

24. Viollet-le-Duc, "L'Enseignement," 250.

25. Viollet-le-Duc, "L'Enseignement," 254–55.

26. Viollet-le-Duc, "L'Enseignement," 255.

27. On Laborde, see Chennevières, pt. 4, 42–68.

28. On Laborde's report, *De l'union des arts et de l'industrie. Exposition universelle de 1851. Travaux de la commission française sur l'industrie des nations* (Paris, 1856), see Boime, "The Teaching Reforms of 1863," 4–7. See also Nikolaus Pevsner, *Academies of Art Past and Present* (Cambridge: Cambridge University Press, 1940), 249–51.

29. See Prosper Mérimée, "Les Beaux-Arts en Angleterre," 866–80. See Chapter 9 above.

30. See Boime, "The Teaching Reforms of 1863," esp. 1–10.

31. Boime, "The Teaching Reforms of 1863," 2–3.

32. Chennevières, pt. 2, 96.

33. Boime, "The Teaching Reforms of 1863," 8.

34. Maxime DuCamp, *Souvenirs d'un demi-siècle,* 2 vols. (Paris, 1949), 1:223.

35. DuCamp, 1:223.

36. Ernest Chesneau, *Le Decret du 13 Novembre et l'Académie des Beaux-Arts* (Paris, 1864), 13, as quoted in Boime, "The Teaching Reforms of 1863," 3.

37. That a tie existed between the teaching reforms and the Salon des Refusés was suggested by Beulé as noted by Boime, "The Teaching Reforms of 1863," 27 n. 17.

38. Chesneau, *Les intérêts populaires dans l'art*, 48.

CHAPTER 12

THE DIVIDED TRIPTYCHS

1. Reinach, 226 n. 1, 227.

2. Wilhelm Froehner, "Le roman archéologique en France," *Revue contemporaine* (3 December 1862): 854, as quoted in Emerit, 130.

3. As quoted in Emerit, 130.

4. "Etat de distribution des objets provenant des collections Campana," 1863, F21 572, Archives Nationales.

5. Drafts and finished "Arrêtés," 4 April 1863, F21 572, Archives Nationales, listed objects sent to the eleven museums. Vases were classified simply as "Etruscan" or "Greek." Some terra-cottas and majolicas were also listed.

6. Vitet, "La Collection Campana," 187–88. Reinach, 86, states that Longpérier took credit for Vitet's idea of highlighting the terra-cottas as an ensemble in his installation.

7. Dietrich von Bothmer, "Les vases de la collection Campana," *Revue du Louvre* 27 (1977): 213.

8. See Reiset, *Notice,* 9, for explanation of reduction of 303 painting entries to 282 due to having combined works under one number by the same hand. For an analysis of differences between the Campana and Cornu catalogs, see Paul Perdrizet and René Jean, *La Galerie Campana et les Musées français* (Bordeaux: Feret et fils, 1907), 6.

9. The exact number of paintings appears to be in question. In Laclotte and Mognetti, 24, the number is given as "approximately 322." See "Musée Napoléon III. Distribution des Tableaux dans les Musées des départements," 1863, in "Musées. Distribution d'objets provenant des collections Campana." F 21 572, Archives Nationales, for two-page handwritten list, approved by Walewski, minister of state, of the following totals of paintings sent to museums organized by class: first class, 109; second class, 95; third class, 105; Cluny, 17; with the final total 326 paintings.

10. In "Musée Napoléon III. Distribution des Tableaux dans les Musées des départements," the three classes of museums received paintings in mechanically set numbers, so that paintings were divided more or less equally between classes and between departmental museums: Of seventeen museums in first class, one received

eight, five received seven, and eleven received six; of the nineteen museums in second class, each received five; of the thirty-one museums in third class, two received five, eight received four, and twenty-one received three. Cluny, the only museum in Paris, received seventeen.

11. Laclotte, *De Giotto à Bellini*, 19–20. After this exhibition, in which the entire altarpiece was exhibited, the wings were brought back to the Louvre.

12. Campana, *Cataloghi del Museo Campana*, pt. 8, Pre-Raphaelite Painting {*Opere del Risorgimento della Pittura in Italia dall' Epoca delle Scuole Bizantine fino a Raffaello cioè da circa il 1200 al 1500*}, #314. [Sébastien Cornu], *Catalogues des tableaux*, #314.

13. Reiset, *Notice*, #38.

14. See Laclotte and Mognetti, 43–44, Andrea del Bartolo, #12 *Saint Anthony Abbott* and #13 *Bishop Saint*.

15. Laclotte and Mognetti, 120–21, Jacopo del Tedesco ?, #106 *Saint Bartholomew*, #107 *Saint Lawrence*.

16. Laclotte and Mognetti, 176–178, Niccolo da Foligno #187 *Angel of the Annunciation* and #188 *Virgin of the Annunciation* not sent out until 1872 (having received academy approval). Other panels sent out in 1863: #189 *Saint Paul* and #190 *Saint Nicholas* to Caen; #191 *Saint Anthony* and #192 *Saint Victor* to Laval; #193 *Saint Stephen* and #194 *Bishop Saint* to Melun; #195 *Nativity* (predella) to Moulins; #196 *The Ascension* (predella) to Compiègne.

17. Laclotte and Mognetti, 133, #124 *Madonna of Majesty with Six Angels and the Paci Donors*.

18. Laclotte and Mognetti, 115, #98 *Saint John the Baptist with a Donor*.

19. For Palmezzano's *Calvary*, see Laclotte and Mognetti, 185, #200. For Palmezzano's *Dead Christ*, see *Catalogue sommaire illustré des peintures du musée du Louvre, II Italie, Espagne, Allemagne, Grande-Bretagne et divers*, ed. Arnauld Brejon de Lavergnée and Dominique Thiébaut (Paris: Editions de la Réunion des musées nationaux, 1981), 212.

20. Reiset, *Notice*, 9.

21. Reinach, 223.

22. See Chapter 2 above on the interest in collecting Italian primitives among the French in Rome.

23. Gould, 109.

24. As quoted in Gould, 113. See Joseph Alsop, *The Rare Art Traditions: The History of Art Collecting and Its Linked Phenomena wherever These Have Appeared*, Bollingen Series vol. 35, no. 27, Princeton University Press (New York: Harper & Row, 1982), 121, 123, for the role played by Denon's subordinate at the Louvre, Léon Dufourny (a friend of Séroux d'Agincourt), who may have suggested the

exhibition of primitives in art-historical order, derived from the Uffizi's Quarto Gabinetto.

25. Gould, 127f.

26. Bernardo Daddi's *The Annunciation* had been attributed to Simone Martini by Cornu and to Agnolo Gaddi, another of Giotto's students, by Reiset. Chosen by the commission.

27. Filippino Lippi's *Three Scenes from the Story of Virginia*, cassone panel attributed by Cornu to Botticelli, Filippino's teacher, while Reiset demoted it to Florentine school, fifteenth century. This was the first solo work by Filippino to enter the Louvre; however, an altarpiece on which he worked with two other artists had been acquired in 1814. Chosen by the academy. Another panel from the same cassone, *Scenes of the Life of Lucretia*, belongs to the Pitti Palace, Florence.

28. Sebastiano Mainardi's *Madonna and Child Surrounded by Saint John the Baptist and Three Angels* was attributed by Cornu to Domenico Ghirlandaio and by Reiset to Ghirlandaio's student Mainardi. Chosen by the commission.

29. Jacopo del Sellajo's *Saint Jerome in the Desert* was attributed by Cornu to Andrea del Castagno and by Reiset to Florentine school, fifteenth century. Chosen by the commission.

30. See Alsop, 121, for disposal of two companion panels of Uccello *Rout of San Romano* in a "sale of Medici leftovers," because one panel was considered "enough to illustrate Uccello's *Prospettiva*."

31. Taddeo di Bartolo's *Crucifixion* predella panel was attributed by Cornu to school of Giottino, by Reiset to school of Siena, fourteenth century. Chosen by the academy.

32. Sano di Pietro's five predella panels from an altarpiece of 1444, executed for the convent of the Gesuati di San Girolamo in Siena, represent scenes from the life of Saint Jerome. The rest of this altarpiece is in the Siena Art Museum, and there was no doubt about attribution. Chosen by the commission.

33. Maître de Monteoliveto, *Madonna and Child Enthroned, Surrounded by a Female Saint, Saint Paul, Saint Peter, Saint Dominic, and Two Kneeling Donors* was classified as Giottoesque by Cornu and attributed to Sienese school fourteenth century by Reiset. Chosen by the academy.

34. Bartolo di Fredi's *Presentation in the Temple* purchased from the Fesch collection was attributed by Cornu to Lorenzo Monaco and by Reiset to Bartolo di Fredi. Chosen by the academy.

35. Reiset, *Notice*, #36. See Claudie Ressort, Sylvie Béguin, Michel Laclotte, *Retables italiens du XIII au XV siècle* (Paris: Edition de la Réunion des musées nationaux, 1978) #17, for derivation from Ambrogio Lorenzetti painting of same subject (1342) for the Siena cathedral.

36. Paolo Veneziano's *Madonna and Child* was attributed by Cornu to Ottaviano da Faenza and by Reiset to Stefano Veneziano. Chosen by the academy.

37. Bartolomeo Vivarini's *Saint John of Capistrano* was chosen by the commission.

38. Bartolomeo Montagna's *Ecce Homo* was chosen by the commission.

39. See Ressort, Béguin, Laclotte, #23. The panels were attributed by Cornu to Gentile da Fabriano and by Reiset to school of Gentile da Fabriano. Chosen by the academy.

40. Liberale da Verona's panels were given by Cornu to Urbino school and by Reiset to Italian school, end of fifteenth century. The pendant was shipped to Le Havre in 1876. Chosen by the academy.

41. See Ressort, Béguin, Laclotte, #27, pp. 44–47, which include photographic reconstruction of the Roverella altarpiece.

42. Charles Timbal, "La Réorganisation du Musée de Peinture au Louvre," *Revue des deux-mondes* 9th ser., 6 (December 1874): 696.

43. Timbal, 695. See Chapter 2 above on Rio.

44. Timbal, 692–93.

45. Albert Boime, "Le Musée des Copies," *Gazette des Beaux-Arts* 6th ser., 64 (October 1964): 247 n. 20.

46. See Boime, "Le Musée des Copies," 238–40, on political reasons for closing the museum.

47. Perdrizet and Jean, 9.

48. According to Perdrizet and Jean, 9 n. 1, this study of the provincial museum holdings was never made.

49. Loÿe, *Le Musée du Petit-Palais*, 13.

50. See Laclotte and Mognetti, 86–87, #65 *Susanna and the Elders* and #66 *The Judgment of Susanna*. Attributed by Cornu to Gentile da Fabriano, by Reiset to Italian fifteenth century. Chosen by the academy.

51. Laclotte and Mognetti, 69, #39 *The Madonna and Child*. Chosen by the academy.

52. See Laclotte and Mognetti, 78–79, #49 *Holy Conversation*, for fact that this painting had been included in Crowe-Cavalcaselle. See also Michel Rutschowsky, "Deux icônes de la collection Campana attribuées à Théodore Poulakis au musée des Beaux-Arts de Caen," *Revue du Louvre* 34 (1989): 343–49, for two icons which were also sent to Caen in the 1872 shipment.

53. Laclotte and Mognetti, 24.

54. On Reiset as an expert on Italian art, see Reinach, 223. See also Chennevières, 90–101.

55. Chennevières, 92.

56. Chastel, "Le Gout des 'PréRaphaélites' en France," xx.

57. Reinach, 236.

58. Reinach, 235.

CHAPTER 13
CAMPANA'S QUEST FOR JUSTICE

1. Reinach, 343–44.

2. Letter from Campana, 9 November 1875, as quoted in Alexandre Boutkowski, *Dictionnaire Numismatique* 1 (Leipzig: T. O. Wigel, 1877): 43.

3. Reinach, 346.

4. Reinach, 347. Campana fragments have continued to interest classical archaeologists. In 1933 Sir John Beazley published *Campana Fragments in Florence*, the fruit of his research into the thousands of Campana fragments. His frontispiece shows a cup re-created on paper from fragments in Rome, Florence, Heidelberg, Brunswick, Baltimore, and Bowdoin College. See Bernard Ashmole, "Sir John Beazley (1885–1970)" in *Beazley and Oxford*, ed. Donna Kurtz (Oxford: Oxford University Committee for Archaeology, 1985), 67–68. What Beazley did on paper, Dietrich von Bothmer has realized through collaboration and exchanges with the Louvre. See Dietrich von Bothmer, "Les vases de la collection Campana," 213–21, on integration of Campana fragments into vases in the collections of the Metropolitan Museum and the Louvre.

5. Reinach, 350, 355.

6. As quoted in Reinach, 351.

7. Reinach, 356 n. 1.

8. Reinach, 355–56.

9. See Reinach, 356–60. The Vatican held up the sale for three years. Campana proved it was a wedding present to his wife and therefore not part of the collection confiscated by the Vatican, and the painting was sold for 100,000 francs to a collector, Revilliod.

10. Reinach, 199. It is a curious coincidence that Reinach was later the museum director in Saint-Germain-en-Laye, where the marchesa had resided.

11. *Dizionario Biografico*, 17:355. Reinach, 199.

12. Arguments and Depositions, Memorial of Filippo Maria Salini before papal Segnatura attacking jurisdiction, Summary of Documents, pp. 16–19 (1867).

13. Arguments and Depositions, Memorial of Salini, Summary of Documents, pp. 19–20.

14. Arguments and Depositions, Memorial of Salini, Summary of Documents, p. 21.

15. Arguments and Depositions, Memorial of Salini, Summary of Documents, p. 25.

16. *Dizionario Biografico*, 17:355.

17. *Dizionario Biografico*, 17:355.

CHAPTER 14

THE LAST PALACE: AVIGNON

1. As quoted in Francis Steegmuller, *The Two Lives of James Jackson Jarves* (New Haven: Yale University Press, 1951), 132. The picture, now in the Uffizi, was then attributed to Cimabue.

2. See Alsop, *The Rare Art Traditions*, 122, for Bryan's having purchased many wrongly attributed pictures from Artaud de Montor's collection. See n. 130 on transfer of best of Bryan's collection from New-York Historical Society to the Metropolitan Museum of Art.

3. Edith Wharton, *False Dawn* (New York, London: D. Appleton, 1924), 81–82. See also Paul R. Baker, *The Fortunate Pilgrims: Americans in Italy 1800–1860* (Cambridge: Harvard University Press, 1964), 141–45. On nineteenth-century views of Italy, see A. William Salomone, "The Nineteenth-Century Discovery of Italy: An Essay on American Cultural History. Prolegomena to a Historiographical Problem," *The American Historical Review* 73, no. 6 (June 1968): 1359–1391; C.P. Brand, *Italy and the English Romantics: The Italianate Fashion in Early Nineteenth-Century England* (Cambridge: Cambridge University Press, 1957).

4. Steegmuller, 121. Rio's ideas (see Chapter 2) were popularized in England by Alexander William Crawford, Baron Lindsay, who collected "primitives" and published his three-volume *Sketches of the History of Christian Art* in 1847. Rio and Lord Lindsay were sources for John Ruskin's *Stones of Venice* of 1851. Mrs. Anna Brownell Jameson wrote several books on religious iconography beginning in 1847. Other English collectors in this field were Prince Albert and Sir Charles Eastlake.

5. James Jackson Jarves, *The Art-Idea: Part Second of Confessions of an Inquirer* (New York: Hurd & Houghton; Boston: Walker, Wise, 1864), xxxii, as quoted in Steegmuller, 147.

6. On Yale acquisition, see Steegmuller, 226–65.

7. Steegmuller, 187–88.

8. On Crowe and Cavalcaselle, see Haskell, *Rediscoveries in Art*, 91–92.

9. On Symonds, see Hale, *England and the Italian Renaissance*, 169–96.

10. Bernhard Berenson, "Les Peintures italiennes de New-York et de Boston," *Gazette des Beaux-Arts* 3rd per., 15 (March 1896): 206.

11. Berenson, "Les Peintures italiennes," 195–96.

12. Berenson letter, 14 December 1894, as quoted in Ernest Samuels, *Bernard Berenson: The Making of a Connoisseur* (Cambridge, Mass.; London: Harvard University Press, 1979), 207.

13. See Samuels, 201, for Reinach's complaint about Berenson's duplicating the same review in two journals and 331 for Reinach's disappointment when in 1900 during the Dreyfus Affair he heard that, in Mary Berenson's words, Berenson "sat silent when the most outrageous things were said about Jews." Reinach's brother Joseph was a pioneer supporter of Captain Dreyfus, and his brother Theodore had published a history of the Jews in 1885.

14. Mary Berenson's journal, 3 March 1904, as quoted in David Alan Brown, *Berenson and the Connoisseurship of Italian Painting* (Washington, D.C.: National Gallery of Art, 1979), 17.

15. Brown, 18.

16. Berenson's relationship with Samuel and Rush Kress was somewhat more distant; however, his impact on the improvement of that collection was felt through John Walker, director of the National Gallery, who was in constant touch with his mentor, Berenson. See John Walker, *Self-Portrait with Donors: Confessions of an Art Collector* (Boston, Toronto: Little, Brown, 1969), 136.

17. Reinach, 240.

18. Reinach, 237.

19. Reinach, 236.

20. Reinach, 238–39.

21. Reinach, 236–37; Clément de Ris, *Les Musées de province*, 8.

22. Maurice Besnier, "La Collection Campana et les musées de province," *Revue Archéologique* 4th ser., 7 (January-June 1906): 34–47, for dates of publication of *Inventaire général des richesses d'art de la France*. The ten museums surveyed were: Angers, Besançon, Béziers, Dieppe, Grenoble, Lisieux, Montpellier, Nantes, Orléans, and Tours.

23. For this list, see Besnier, 48–49.

24. Perdrizet and Jean, *La Galerie Campana et les Musées français*, 12.

25. Loÿe, *Le Musée du Petit-Palais*, 14.

26. Laclotte, *De Giotto à Bellini*, v. In the exhibition of paintings from the provincial museums, four Louvre pictures and three pictures from museums outside France were included only because they were a part of polyptychs of which the provincial museums owned elements.

27. Laclotte, *De Giotto à Bellini*, 34–35, #49 and #50. Laclotte and Mognetti, 58–60, #28 and #29.

28. Laclotte, *De Giotto à Bellini*, 83–84, #112 and #113. Laclotte and Mognetti, 193, #210 and #211.

29. See Ressort, Béguin, Laclotte, *Retables italiens*, 22–23, #13, #14, #15.

30. Michel Laclotte, "A propos de l'exposition 'De Giotto à Bellini'," *La Revue des Arts* (June 1956): 76.

31. Laclotte, "A propos de l'exposition," 75.

32. One example is the Campana predella panel by Ambrogio Bergognone, which had been in Soissons from 1863 and was transferred to Nantes after the exhibition to rejoin it to a panel belonging to Nantes since 1810. The Nantes museum would cooperate by giving up several Campana paintings to the new museum.

33. As quoted in Michel Laclotte and Dominique Thiébaut, *L'Ecole d'Avignon* (Paris: Flammarion, 1983), 8. On Avignon under the popes, see Yves Renouard, *The Avignon Papacy: 1305–1403*, trans. Dennis Bell (London: Faber & Faber, 1970); G. Mollat, *The Popes at Avignon 1305–1378*, trans. Janet Love (London: Thomas Nelson, 1963).

34. See Laclotte and Thiébaut, 22, for the fact that this portrait and that of Laura are among the first examples since antiquity of individual portraiture in Western art.

35. Laclotte and Thiébaut, 25–27.

36. Laclotte and Thiébaut, 33.

37. Laclotte and Thiébaut, 56.

38. Loÿe, *Le Musée du Petit-Palais*, 14–15.

39. The history of the building is recounted in Elisabeth Mognetti and Georges de Loÿe, *Petit Guide du Musée du Petit Palais* (Avignon: Aubanel Borrione, 1986), unpaginated.

40. The museum also houses the library of the International Center of Documentation and Research of the Petit Palais of Avignon, which specializes in early Italian and Avignon-school painting.

41. In addition to the Campana paintings, the Louvre contributed Italian paintings not of Campana origin but appropriate to the collection, including Giovanni Massone's *Triptych della Rovere* commissioned by Giuliano della Rovere for his family's chapel in Savone, in which he and his uncle Pope Sixtus IV appear as kneeling donors on the wings. The Cluny Museum also gave several early paintings, including some not of Campana origin, which were more appropriate to the Avignon museum than to its own collection.

42. Laclotte and Mognetti, 143–44, #138.

43. Laclotte and Mognetti, 133, #124, discussed in Chapter 12.

44. Laclotte and Mognetti, 98–99, #77.

45. Laclotte and Mognetti, 139–40, #135.

46. Laclotte and Mognetti, 116–18, #101. Retrieved for the Louvre from the Campana dispersion is a similar but larger Bolognese painting, a triptych dated 1333, making it the earliest dated Bolognese work.

47. Laclotte and Mognetti, 120, #105.

48. For illustration of the reconstruction, see Laclotte, "A propos de l'exposition," 78. See also Laclotte and Mognetti, 186, #202, for different views on Laclotte's hypothesis.

49. Laclotte and Mognetti, 198–99, #220 bis.

50. Laclotte and Mognetti, 88, #68.

51. Laclotte and Mognetti, 202, #225, #226.

52. Laclotte and Mognetti, 118–19, #103.

53. Laclotte and Mognetti, 160–61, #161, #162, #163.

54. Laclotte and Mognetti, 128–29, #119.

55. Laclotte and Mognetti, 189, #205.

56. Laclotte and Mognetti, 108–9, #89.

57. Laclotte and Mognetti, 89–91, #69.

58. Laclotte and Mognetti, 144–45, #139.

59. Laclotte and Mognetti, 53, #23.

60. Laclotte and Mognetti, 194, #212.

61. Laclotte and Mognetti, 69, #39.

62. Laclotte and Mognetti, 96, #74.

63. Laclotte and Mognetti, 78–79, #49.

64. Laclotte and Mognetti, 135–37, #122–130. See also A. P. de Miramonde, "Cinq cassoni mythologiques de la collection Campana," *Revue du Louvre* 2 (1978): 91–92.

AFTERWORD

ECHOES OF THE CAMPANA AFFAIR

1. See *L'Omicidio Calvi* (Rome: Grandi Edizioni Italiane, 1985); Nick Tosches, *Power on Earth: Michele Sindona's Explosive Story* (New York: Arbor House, 1986).

2. Larry Gurwin, *The Calvi Affair* (London: Pan Books, 1984), 5–6.

3. *New York Times*, 26 May 1984.

4. Rupert Cornwell, *God's Banker: An Account of the Life and Death of Roberto Calvi* (London: Victor Gollancz, 1983), 233.

5. Lawrence Malkin, "Why Buy Art?," *Connoisseur* (October 1989), 166, 169.

6. Daniel Lazare, "Boom or Bust?," *Art & Antiques* (October 1989), 131, 143.

7. Lazare, 133. See also Robert Hughes, "Sold!," *Time*, 27 November 1989, 60–65.

8. Rita Reif, "Sotheby's Lent $27 Million to the Buyer of 'Irises,' " *New York Times*, 18 October 1989. See also Robert Hughes, "Anatomy of a Deal," *Time*, 27 November 1989, 66, 68.

9. Rita Reif, "Sotheby's Is Ending Its Art Sales on Margin," *New York Times*, 11 January 1990.

10. Reif, "Sotheby's Lent $27 Million," 13.

11. Reif, "Sotheby's Lent $27 Million," 13. Other recent developments in attitudes toward institutional participation in art investments point in opposite directions. In early 1989 it was reported that Chase Manhattan Bank was considering the formation of a $300 million art investment fund under the direction of art dealer Jeffrey Deitch. The idea was put on hold "perhaps due to the uninspiring performance of British Rail," Lazare, 143. On the other hand, in an article funded through the National Museum Act, it has been proposed that museums should consider buying and selling art for profit. See Michael O'Hare and Alan L. Feld, "Is Museum Speculation in Art Immoral, Illegal and Insufficiently Fattening?" *Museum News* 53 (May 1975): 24.

12. Grace Glueck, "Savings Unit Criticized for Its Art Investments," *New York Times*, 15 March 1989.

13. Martha Brannigan and Alexandra Peers, "Musty Masters: S&L's Art Collection, Ordered to Be Sold, Faces Skeptical Market," *Wall Street Journal*, 18 October 1989.

14. Brannigan and Peers, "Musty Masters," 12.

15. Martha Brannigan, "CenTrust Says Florida Forced It to Sell Its Art Collection at Unfavorable Prices," *Wall Street Journal*, 9 November 1989.

16. "Editorial," *Burlington Magazine* 131 (May 1989): 327.

17. Souren Melikian, "New V&A: Socks in the Museum, Silver at Harrods," *International Herald Tribune*, 11–12 March 1989.

18. Martin Kemp, "A Loss of Balance: The Trustee Boards of National Museums and Galleries," *Burlington Magazine* 131 (May 1989): 356.

19. "Editorial, Keepers or Housekeepers," *Burlington Magazine* 131 (March 1989): 187. See (Editor) "Letters," *Burlington Magazine* 131 (May 1989): 357, for the report that under the new plan the registrar and his managers would make decisions regarding object loans, with the curator given merely a consulting role.

20. Kemp, 356.

21. Peter Watson, "Attack on Crude Regime at V&A," *Observer*, 9 April 1989.

22. Kemp, 356.

23. "Editorial, Keepers or Housekeepers," 187.

24. A V&A innovation is the commercial exhibition in the museum, such as the sock exhibition funded by Sock Shop. See Souren Melikian.

25. Pope-Hennessey, "The Fall of a Great Museum," 11.

26. Pope-Hennessey, 12.

27. Pope-Hennessey, 14.

28. Pope-Hennessey, 12. See also 11, for his remarks on the importance of mutual respect between scholar-curators and director: "Before I left I warned my successor that the museum staff included a number of specialists of high reputation throughout the world, who knew more about their subjects than he knew about the subject with which he was associated. I urged that he should treat them with sympathy and with respect. In an effort to assert authority, however, he ran into the staff."

29. Philippe de Montebello, "The High Cost of Quality," *Museum News* 62, no. 6 (August 1984): 47.

30. Montebello, "The High Cost of Quality," 48.

31. Nieuwerkerke was appointed president of the admissions jury for both exhibitions, and rose from vice president in 1855 to president in 1867 of the International Awards Jury for the Fine Arts. See Mainardi, *Art and Politics in the Second Empire,* 126, 154.

32. Montebello, "The High Cost of Quality," 49.

33. George Heard Hamilton, "Education and Scholarship in the American Museum," in *On Understanding Art Museums*, ed. Sherman Lee (Englewood Cliffs, New Jersey: Prentice-Hall, 1975), 127.

34. Hamilton, 128.

35. As quoted in Michael Conforti, "Deaccessioning in American Museums, II," *Apollo* 130 (August 1989): 81.

36. Alsop, *The Rare Art Traditions,* 124.

37. "Editorial: The Sale of Works of Art out of Museums," *Burlington Magazine* 102 (January 1960): 3. The recent rise in appreciation for tribal sculpture and photography collections illustrates such changes in taste. Many such objects moved from study to primary collections.

38. As quoted in Lee Rosenbaum, "The Anxious Acquisitors," *Art News* 88 (March 1989): 148.

39. Philippe de Montebello, "Foreword," *The Metropolitan Museum of Art Bulletin* 47 (Fall 1989): 5.

40. See Francis Henry Taylor, *The Taste of Angels, A History of Art Collecting from Rameses to Napoleon* (Boston: Little, Brown, 1948), 215, for Andrew Mellon's purchase of thirty-three paintings for a reputed $19 million.

41. Conforti, 83.

42. Andrew Decker, "Museums under Scrutiny: Two Institutions Face Ethical Charges," *Museum News* 67 (November-December 1988): 26.

43. Egbert H. Begemann, "The Price is Never Right," *Museum News* 51 (May 1973): 34. See also Conforti, 82.

44. Conforti, 82. On recent deaccessioning by American museums, see Philip Weiss, "Selling the Collection," *Art in America* (July 1990), 124–131. For advocacy of deaccessioning with "procedural safeguards," see Stephen E. Weil, *Rethinking the Museum* (Washington, D.C., and London: Smithsonian Institution Press, 1990), 105–118.

45. As quoted in Begemann, 34. See also "Editorial: The Sale of Works of Art out of Museums," 3–4.

46. Michael Brenson, "The Metropolitan Unveils Its Full Egyptian Treasure," *New York Times*, 19 June 1983.

47. Brenson, 24.

48. Conforti, 84.

49. Conforti, 86.

50. Alan Wintermute, historian of eighteenth-century French art, associated with Colnaghi, New York, as quoted in Michael Kimmelman, "Sotheby's to Break up a Robert Sketchbook," *New York Times*, 31 October 1989.

SELECT

BIBLIOGRAPHY

ARCHIVAL SOURCES

Campana Trial Arguments and Depositions. "Causa di Peculato contro G. P. Campana" n. 2091, Tribunale Criminale, buste 2149–2150. Archivio di Stato di Roma, Camerale III, pt. 2, title 4.

Documenti della Causa Campana, Mag. P. 3406, L'Istituto archeologico germanico, Rome, 1858–1859.

Archives nationales, Paris:

F 21, Beaux-Arts, 572 Musée Campana:

"Au Ministre, Rapport de la répartition à faire des collections Campana," 1862.

"Etat de distribution des objets provenant des collections Campana," 1863.

"Distribution d'objets provenant des collections Campana," Decisions et arrêtés. Ministre d'etat, 1863.

"Monsieur le Ministre," Commission report, marked by Napoleon III, Dossier 2.

F 70 Ministère d'etat, 89:

Musée Campana 1861–1862, Ordonnances de Payement.

CONTEMPORARY PUBLICATIONS RELATED TO THE CAMPANA COLLECTION

Bertrand, Alexandre. "Le Musée Campana." *Revue Archéologique* 1 (April 1862): 268–72.

Berty, A., and L. Lacour. "Le Musée Campana." *Annuaire de l'Archéologique, de l'Antiquaire et du Numismate* 1 (1862): 78–90.

Blanc, Charles. "Les terres cuites du Musée Campana." *Gazette des Beaux-Arts* 12 (February 1862): 190–92.

Burty, Philippe. *Chefs-d'oeuvre of the Industrial Arts*. Edited by W. Chaffers. New York: D. Appleton, 1869.

Campana, Giovanni Pietro, marchese di Cavelli. *Antiche opere in plastica, discoperte, raccolte, e dichiarate dal marchese G. Pietro Campana*. 2d ed., 3 vols. in 2. Rome: 1851.

———. *Cataloghi del museo Campana*. Rome, n.d. [c. 1858].

Chennevières, Philippe de. *Souvenirs d'un Directeur des Beaux-Arts*. 2 vols. Paris: 1883–1889. Reprint Arthena, 1979.

Chesneau, Ernest. *Les intérêts populaires dans l'art: la vérité sur le Louvre, le Musée Napoléon III et les artistes industriels*. Paris: Dentu, 1862.

[Clément, Charles]. *Catalogue des bijoux du Musée Napoléon III*. Paris: Firmin-Didot, 1862.

Clément de Ris, L. *Les Musées de province: Histoire et description*. Paris: Jules Renouard, 1872.

[Cornu, Sébastien]. *Catalogue des tableaux, des sculptures de la Renaissance et des majoliques de Musée Napoléon III*. Paris: Firmin-Didot, 1862.

Delaborde, Henri. "Musée Napoléon III. Collection Campana. Les Tableaux." *Gazette des Beaux-Arts* 13 (December 1862): 481–511.

Desjardins, Ernest. *Du patriotisme dans les arts, réponse à M. Vitet sur le Musée Napoléon III*. Paris: Dentu, 1862.

———. *Notice sur le Musée Napoleón III et promenade dans les galeries*. Paris: Michel Levy, 1862.

Des Vergers, Noel A. *Notice sur le Musée Napoléon III*. Extract from the *Revue Contemporaine* (31 May 1862). Paris: 1862.

Doucet, J. "Le Musée Campana. Les Niobides." *Gazette des Beaux-Arts* 1 (February 1859): 142–51.

D'Escamps, Henry. *Description des marbres antiques du Musée Campana à Rome*. Paris: 1856.

Galichon, Emile. "De la création d'un nouveau musée." *Gazette des Beaux-Arts* 13 (September 1862): 223–27.

———. *Des Destinées du Musée Napoléon III. Fondation d'un musée d'art industrial*. Paris: Dentu, 1862.

Guédéonoff, S. "Notice sur les objets de la Galerie Campana à Rome, acquis pour le Musée Impérial de l'Hermitage à Saint-Petersbourg." *Gazette des Beaux-Arts* 11 (July 1861): 74–87.

Houssaye, Edouard. "Mouvement des Arts." *Gazette des Beaux-Arts* 10 (May 1861): 319–20; (11 October 1861): 381–83.

Jacquemart, Albert. "Musée Napoleón III. Collection Campana. Les Majoliques Italiennes." *Gazette des Beaux-Arts* 13 (October 1862): 289–312.

Lenormant, François. "Musée Napoléon III. Collection Campana. Les Bijoux." *Gazette des Beaux-Arts* 14 (February 1863): 152–63.

———. "Musée Napoléon III. Collection Campana. Les tableaux." *Gazette des Beaux-Arts* 14 (April 1863): 307–24.

Reiset, F. *Notice des tableaux du Musée Napoléon III, exposés dans les salles de la Colonnade au Louvre.* Paris: Charles de Mourgues, 1863.

Robinson, J. C. *South Kensington Museum: Italian Sculpture of the Middle Ages and the Period of Revival.* London: Chapman and Hall, 1862.

Ronchaud, Louis de. "Musée Napoléon III. Collection Campana." *Gazette des Beaux-Arts* 12 (June 1862): 489–502.

———. "Musée Napoléon III. Collection Campana. Bas-reliefs, statues et figurines antiques en terre cuite." *Gazette des Beaux-Arts* 13 (July 1862): 159–73.

Taigny, Edmond. "Le Musée Campana." Letter to *Moniteur universel* (31 May 1861) in *Mélanges Etudes littéraires et artistiques.* Paris: Hachette, 1869.

Timbal, Charles. "La Réorganisation du Musée de Peinture au Louvre." *Revue des deux-mondes* n.s. 6 (December 1874): 689–700.

Viel-Castel, le comte Horace de. *Mémoires du comte Horace de Viel-Castel sur le règne de Napoléon III, 1851–1864.* Edited by L. Léouzon le Duc. 6 vols. Paris: Chez tous les libraires, 1883–1884.

Vitet, L. "La Collection Campana." *Revue des deux-mondes* 41 (September 1862): 164–88.

Witte, J. de. "Musée Napoléon III. Collection Campana. Les vases peints." *Gazette des Beaux-Arts* 13 (September 1862): 193–205; (December 1862): 525–37; 14 (March 1863): 255–68; (April 1863): 362–77; 15 (November 1863): 420–38; 16 (February 1864): 130–43; (May 1864): 406–20.

BOOKS

Alexander, Edward P. *Museum Masters: Their Museums and Their Influence.* Nashville: The American Association for State and Local History, 1983.

Aubry, Octave. *The Second Empire.* Translated by Arthur Livingston. Philadelphia, New York: J. B. Lippincott, 1940.

Aulanier, Christiane. *Le Nouveau Louvre de Napoléon III.* Vol. 4 in *Histoire du Palais et du Musée du Louvre.* Paris: Editions des musées nationaux, 1947–1971.

Bell, Quentin. *The Schools of Design*. London: Routledge & Kegan Paul, 1963.

Bled, Victor du. *La Société française depuis cent ans: Quelques salons du second empire*. Paris: Bloud & Gay, 1923.

Boime, Albert. *The Academy and French Painting in the Nineteenth Century*. London and New York: Phaidon, 1971.

Brown, David Alan. *Berenson and the Connoisseurship of Italian Painting*. Washington, D.C.: National Gallery of Art, 1979.

Brown, Frank P. *South Kensington and Its Art Training*. London: Longmans, Green, 1912.

Catalogue sommaire illustré des peintures du musée du Louvre. Vol. 2 Italie, Espagne, Allemagne, Grande-Bretagne et divers. Edited by Arnauld Brejon de Lavergnée and Dominique Thiébaut. Paris: Editions de la Réunion des musées nationaux, 1981.

Cesare, R. de. *The Last Days of Papal Rome 1850–1870*. London: Constable, 1909.

Cornwell, Rupert. *God's Banker: An Account of the Life and Death of Roberto Calvi*. London: Victor Gollancz, 1983.

Delaborde, Henri. *L'Académie des Beaux-Arts*. Paris: Plon, 1891.

Duveau, Georges. *La Vie ouvrière en France sous le Second Empire*. Paris: Gallimard, 1946.

Eiland, William Underwood. "Napoleon III and the Administration of the Fine Arts." Ph.D. dissertation. University of Virginia, 1978. UMI Microfilm.

Emerit, Marcel. *Madame Cornu et Napoléon III d'après les lettres de l'Empéreur conservées à la Bibliothèque Nationale et d'autres documents inédits*. Paris: les Presses Modernes, 1937.

Gould, Cecil. *Trophy of Conquest: The Musée Napoléon and the Creation of the Louvre*. London: Faber & Faber, 1965.

Green, Frederick Charles. *A Comparative View of French and British Civilization (1850–1870)*. London: J. M. Dent, 1965.

Guest, Ivor. *Napoleon III in England*. London: British Technical & General Press, 1952.

Gurwin, Larry. *The Calvi Affair*. London: Pan Books, 1984.

Hales, E. E. Y. *Pio Nono: A Study in European Politics and Religion in the Nineteenth Century*. London: Eyre & Spottiswood, 1954.

Haskell, Francis. *Rediscoveries in Art: Some Aspects of Taste, Fashion and Collecting in England and France*. Ithaca: Cornell University Press, 1976.

Haskell, Francis, and Nicholas Penny. *Taste and the Antique*. New Haven and London: Yale University Press, 1981.

Hudson, Kenneth. *Museums of Influence*. Cambridge, New York, Melbourne: Cambridge University Press, 1987.

King, Bolton. *A History of Italian Unity*. 2 vols. London: James Nisbet, 1899.

Laclotte, Michel. *De Giotto à Bellini. Les primitifs italiens dans les musées de France*. Paris: Orangerie, 1956.

Laclotte, Michel, and Jean-Pierre Cuzin. *The Louvre: French and Other European Paintings*. Paris: Scala; London: Philip Wilson, 1982.

Laclotte, Michel, and Elisabeth Mognetti. *Avignon, musée du Petit Palais, Peinture italienne*. 3rd. ed. Paris: Editions de la Réunion des musées nationaux, 1987.

Laclotte, Michel, and Dominique Thiébaut. *L'Ecole d'Avignon*. Paris: Flammarion, 1983.

Levitine, George. *The Dawn of Bohemianism: The Barbu Rebellion and Primitivism in Neoclassical France*. University Park and London: The Pennsylvania State University Press, 1978.

Loÿe, Georges de. *Le Musée du Petit-Palais: Son Histoire, ses collections*. Extract of *Mémoires de l'Académie de Vaucluse*, vol. 9 (1976). Avignon: Aubanel, 1978.

Mainardi, Patricia. *Art and Politics of the Second Empire: The Universal Expositions of 1855 and 1867*. New Haven and London: Yale University Press, 1987.

Mollet, G. *The Popes of Avignon 1305–1378*. Translated by Janet Love. London, New York: Thomas Nelson, 1963.

Artaud de Montor, Alexis-François. *Considérations sur l'état de la peinture en Italie dans les quatres siècles qui ont précédé celui de Raphael*. 2d ed. Paris: Gagnard, 1811.

Perdrizet, Paul, and René Jean. *La Galerie Campana et les Musées français*. Bordeaux: Feret et fils, 1907.

Pevsner, Nikolaus. *Academies of Art*. Cambridge: Cambridge University Press, 1940.

Pinkney, David H. *Napoleon III and the Rebuilding of Paris*. Princeton, N. J.: Princeton University Press, 1958.

Piotrovsky, Boris. *The Hermitage: Its History and Collections*. New York: Johnson Reprint Corp., Harcourt Brace Jovanovich, 1982.

Pope-Hennessey, John. *Italian Renaissance Sculpture*. 1958. Reprint New York: Random House, Vintage Books, 1985.

Previtali, Giovanni. *La Fortuna dal primitivi dal Vasari ai Neoclassici*. 1964. Rev. ed., Turin: Einaudi, 1989.

Renouard, Yves. *The Avignon Papacy: 1305–1403*. Translated by Dennis Bell. London: Faber & Faber, 1970.

Ressort, Claudie, Sylvie Béguin, and Michel Laclotte. *Retables italiens du XIII au XV siècle*. Paris: Edition de la Réunion des musées nationaux, 1978.

Rheims, Maurice. *Les Collectionneurs*. Paris: Ramsay, 1981.

Richardson, Joanna. *Princess Mathilde*. New York: Charles Scribner's, 1969.

Ridley, Jasper. *Napoleon III and Eugenie.* New York: Viking Press, 1980.

Rosenblum, Robert. *Transformations in Late Eighteenth Century Art.* Princeton: Princeton University Press, 1967.

Samuels, Ernest. *Bernard Berenson: The Making of a Connoisseur.* Cambridge and London: The Belknap Press of Harvard University Press, 1979.

Steegmuller, Francis. *The Two Lives of James Jackson Jarves.* New Haven: Yale University Press, 1951.

Tamila, Donato. *Il Sacro Monte di Pietà di Roma.* Rome: 1900.

Thayer, William Roscoe. *The Dawn of Italian Independence.* 2 vols. Boston: Houghton Mifflin, 1893.

The Second Empire 1852–1870: Art in France Under Napoleon III. Philadelphia: Philadelphia Museum of Art, 1978.

Thiébaut, Dominique. *Ajaccio, musée Fesch, les Primitifs italiens.* Paris: Editions de la Réunion des musées nationaux, 1987.

Williams, Roger L. *Gaslight and Shadow: The World of Napoleon III.* New York: MacMillan, 1957.

Zeldin, Theodore. *France, 1848–1945.* Vol. 1, *Ambition, Love and Politics.* Vol. 2, *Intellect, Taste and Anxiety.* (The Oxford History of Modern Europe) Oxford: Clarendon Press, 1977.

―――. *The Political System of Napoleon III.* London: MacMillan; New York: St. Martin's Press, 1958.

ARTICLES

Angrand, Pierre. "L'Etat mécene. Période autoritaire du Second Empire (1851–1860)." *Gazette des Beaux-Arts* 6th per., 71 (May–June 1968), 303–48.

Berenson, Bernhard. "Les Peintures italiennes de New-York et de Boston," *Gazette des Beaux-Arts* 3rd per., 15 (March 1896): 195–214.

Besnier, Maurice. "La Collection Campana et les musées de province," *Revue Archéologique* ser. 4, 7 (January–June 1906): 30–51.

Boime, Albert. "The Teaching Reforms of 1863 and the Origins of Modernism in France." *The Art Quarterly* n.s., 1 (1977): 1–39.

Bonnefon, Paul. "Victor Schnetz et la collection Campana." *Le Bulletin de l'art ancien et moderne* no. 206 (27 February 1904): 72.

Borenius, Tancred. "The Rediscovery of the Primitives," *Quarterly Review* no. 239 (April 1923): 258–70.

Bothmer, Dietrich von. "Greek Vase Painting. Two Hundred Years of Connoisseurship." In *Papers on The Amasis Painter and His World.* Malibu: The J. Paul Getty Museum, 1987.

_____. "Les vases de la collection Campana." *Revue du Louvre* 27 (1977): 213–21.

_____. "The Vases of Nelson Bunker Hunt. Notes on Collectors of Vases." In *Wealth of the Ancient World*. Fort Worth: Kimbell Art Museum, 1983.

"Campana, Giovanni Pietro." *Dizionario Biografico deqli Italiani* 17:349-55. Rome: Istituto dell'Enciclopedia Italiana, 1974.

Conforti, Michael. "Deaccessioning in American Museums, II." *Apollo* 130 (August 1989): 81–86, 141.

Darcel, Alfred. "Les Arts industriels à Londres." *Gazette des Beaux-Arts* 13: pt. 1 (October 1862): 313–31; pt. 2 (November 1862): 437–45; pt. 3 (December 1862): 537–55.

Hautecoeur, Louis. "Delacroix et l'Académie des Beaux-Arts." *Gazette des Beaux-Arts* 6th per., 62 (December 1963): 349–64.

Laclotte, Michel. "A propos de l'exposition 'De Giotto à Bellini.' " *La Revue des Arts* (June 1956): 75–81.

Lemoisne, P.-A. "Les Soirées du Louvre, Aquarelles d'Eugène Giraud conservées au Cabinet des Estampes." *Bulletin de la Société de l'histoire de l'art français* (1920): 275–352.

Masson, Frédéric. "La Princesse Mathilde, Artiste et Amateur." *Les Arts* 3, no. 29 (1904): 2–8.

Mérimée, Prosper. "Les Beaux-Arts en Angleterre." *Revue des deux-mondes* 11 (15 October 1857): 866–80.

Montebello, Philippe de. "The High Cost of Quality." *Museum News* 62, no. 6 (August 1984): 46–49.

Pope-Hennessey, John. "The Fall of a Great Museum." *New York Review of Books*, 27 April 1989.

Poulot, Dominique. "La Visite au musée: un loisir édifiant au XIX siècle." *Gazette des Beaux-Arts* 6th per., 101 (May–June 1983): 187–96.

Reinach, Salomon, "Esquisse d'une histoire de la collection Campana." 5 pts. *Revue Archéologique* 4th ser., vols. 4 and 5; pt. 1, 4 (Sept.–Oct. 1904): 179–200; pt. 2, 4 (Nov.–Dec. 1904): 360–84; pt. 3, 5 (Jan.–Feb. 1905): 57–92; pt. 4, 5 (March–April 1905): 208–240; pt. 5, 5 (May–June 1905): 343–64.

Rothschild, Henri de. "Un Document inédit sur l'histoire de la collection Campana." *Revue Archéologique* (1913): 115–18.

Schlumberger, Eveline. "L'Inépuisable collection Campana." *Connaissance des Arts* (February 1964): 38–49.

Sjöberg, Yves. "Eugène Delacroix et la Collection Campana." *Gazette des Beaux-Arts* 6th per., 68 (September 1966): 149–64.

INDEX